Museums, Heritage a

MW01073914

Current discourse on Indigenous engagement in museum studies is often dominated by curatorial and academic perspectives, in which community voice, viewpoints and reflections on their collaborations can be under-represented. This book provides a unique look at Indigenous perspectives on museum community engagement and the process of self-representation, specifically how the First Nations Elders of the Blackfoot Confederacy have worked with museums and heritage sites in Alberta, Canada, to represent their own culture and history. Situated in a post-colonial context, the case study sites are places of contention, a politicized environment that highlights commonly hidden issues and naturalized inequalities built into current approaches to community engagement. Data from participant observation, archives and in-depth interviewing with participants brings Blackfoot community voices into the text and provides an alternative understanding of self- and cross-cultural representation.

Focusing on the experiences of museum professionals and Blackfoot Elders who have worked with a number of museums and heritage sites, *Museums, Heritage and Indigenous Voice* unpicks the power and politics of engagement on a micro level and how it can be applied more broadly, by exposing the limits and challenges of cross-cultural engagement and community self-representation. The result is a volume that provides readers with an in-depth understanding of the nuances of self-representation and decolonisation.

Bryony Onciul is a Lecturer in Public History at the University of Exeter, UK.

Routledge Research in Museum Studies

Museums, Heritage and Indigenous Voice

Decolonising Engagement

Bryony Onciul

Routledge
Taylor & Francis Group

NEW YORK AND LONDON

First published 2015
by Routledge
711 Third Avenue, New York, NY 10017

and by Routledge
2 Park Square, Milton Park, Abingdon, Oxon OX14 4RN

First issued in paperback 2017

*Routledge is an imprint of the Taylor & Francis Group,
an informa business*

Library of Congress Cataloging-in-Publication Data
The CIP data has been applied for

ISBN 13: 978-0-8153-4677-7 (pbk)
ISBN 13: 978-1-138-78111-5 (hbk)

Typeset in Sabon
by Apex CoVantage, LLC

This book is dedicated to Gerry Conaty (1953–2013) and Narcisse Blood (1954–2015) for their generous support, insight, guidance and good humour from the beginning, and to my family who have supported and encouraged me over the years.

Contents

Figures and Table

FIGURES

TABLE

Preface

During my research and in the reviews of this work, I have been frequently asked 'why Canada?', 'what drew you to work with the Blackfoot Confederacy?', 'how did you, as a British academic, become interested in this?'

This research came from a long held passion to understand the way history, and its representation, influences the present and how the future is imagined, particularly for Indigenous peoples in former British colonies. As a child I visited U'Mista Cultural Society in Alert Bay, BC, Canada, where I was both shocked and inspired by the history of cultural oppression and survival illustrated through the repatriated Potlatch collection that had been confiscated from the community. It had personal resonance for me, as over the past century my Scottish family had been migrant workers and immigrants to Canada. I also had the privilege to visit a Long House on Vancouver Island for a public event featuring traditional dance by local First Nations people and visiting Māori from New Zealand. This gave me a small glimpse into an international Indigenous world I had never before experienced.

As a young adult I travelled widely and studied for a semester at the University of Auckland, New Zealand, as part of my History and Politics degree from the University of Nottingham. There I learnt about Māori politics, Polynesian history and different approaches of museums and heritage. I travelled on to Australia and Asia and was inspired to research Indigenous political, social and cultural movements. These experiences gave me an introduction to international Indigenous history, politics and cultural heritage.

I followed my interest in Indigenous representation through an MA in Heritage Education and Interpretation at the International Centre for Cultural and Heritage Studies at Newcastle University. As part of the course I did an internship at the Glenbow Museum in Calgary, Alberta, Canada. I was familiar with Alberta and had visited Glenbow and Head-Smashed-In Buffalo Jump Interpretive Centre as a tourist. I was interested in Head-Smashed-In because it employed Blackfoot interpretive guides to tell the history of the site, and I selected this as the case study for my MA thesis. It was through my work with Head-Smashed-In and Glenbow that I made the personal connections that enabled the research presented in this book. Jim Martin, now the site manager of Head-Smashed-In, welcomed me and

introduced me to important members of the Blackfoot community working at the interpretive centre. Head-Smashed-In invited me to do their guide training with a group of new interpreters. The program was run by Head-Smashed-In staff and Blackfoot Elders. This opportunity was an incredible privilege that I did not come to fully recognise until later in my research. I had the honour of hearing Blackfoot history told by Elders such as Rosie Day Rider and Louise Crop Eared Wolf, recounting both traditional Napi stories and Blackfoot history passed down through oral traditions.

Shortly after this training I began my internship at the Glenbow Museum. Once again I was given a wonderful opportunity, the value of which I had no way of comprehending at the time. I was met at the entrance desk by my new line manager, Dr. Conaty, and welcomed into the Ethnology Department, which at the time included Head Curator Gerry Conaty, Curator Beth Carter and Technician Camille Owens. During my time at Glenbow, Gerry and Beth invited me to join them in attending Blackfoot ceremonies, enabling me to meet with key Elders in the Blackfoot community and witness for myself the importance of repatriating cultural material for community use. My PhD thesis and ultimately this book grew out of my experiences with Head-Smashed-In, Glenbow Museum and the Blackfoot community. Elders Narcisse Blood and Alvine Mountain Horse, along with many others, such as Frank Weasel Head, gave me their time, thoughts and guidance, and inspired this work. I have a great many people to thank for their guidance and support throughout the development, undertaking and publication of this research.

Acknowledgements

This book would not have been possible without the support, generosity and kindness of many people. In particular I must thank all the participants who shared their knowledge and experiences with me and the museums and heritage sites that allowed me to work with them.

I am forever grateful to the Blackfoot Elders who welcomed me and supported my work. To name but a few: Narcisse Blood, Alvine Mountain Horse, Frank Weasel Head, Sylvia Weasel Head, Allan Pard, Jerry Potts, Rosie Day Rider, Pete Standing Alone, Blair First Rider, Lorraine Good Striker, Reg Crowshoe, Harold Healy, Pam Heavy Head, Stan Knowlton and Clifford Crane Bear.

Particular thanks must be given to Narcisse Blood and Gerry Conaty, to whom this book is dedicated, for their lifetime of work in this field and their generosity in sharing their knowledge and contacts to support my research. Gerry introduced me to the Blackfoot Elders by taking me to ceremonies, which gave me both the opportunity and inspiration to do this research. I will always remember him for his humble, kind and humorous wisdom and guidance. Narcisse spent many mealtimes talking to me about Blackfoot culture and ways of knowing. He welcomed me and invited me to visit important people, events and sacred sites with him, always sharing his stories, wisdom and humour along the way.

I am also grateful to the team at Glenbow who welcomed me as an intern many years ago and continue to support my work. Jim Martin was instrumental in my involvement with Head-Smashed-In and the team have always been so generous and welcoming to me and my extended family. Jack Brink generously shared his experiences of working with Head-Smashed-In and the Royal Alberta Museum. Jack Royal and Bev Wright supported my work at Blackfoot Crossing and all the staff there kindly shared their offices and thoughts with me. Pete Brewster, Tony Starlight and Judy Bedford kindly supported my work on Buffalo Nations Luxton Museum. These are just a few of the people who have helped, guided and informed this work. I am forever grateful to all the people who have shared their lives and work with me and given me the opportunity to see the world with new eyes.

Thanks must also go to Rhiannon Mason, Gerard Corsane and the International Centre for Cultural and Heritage Studies at Newcastle University for the supervision of the doctoral work that informs the foundations of this book, and to the AHRC for generously funding the research.

I would like to thank the reviewers who guided the development of the book. In particular Heather Devine and Conal McCarthy gave generous support and guidance. Thanks must also go to Ashgate and Bloomsbury for allowing the reprinting of extracts from my previously published material.

Finally I must give unending thanks to my family for their support, tolerance and encouragement.

Introduction

In 1988 the Glenbow museum in Calgary, Alberta, Canada, became the centre of a political boycott over the exhibition the *Spirit Sings* which inspired a radical rethinking of Canadian museology and the relationships between First Nations peoples and their representation in museums. Nearly three decades on, relationships between Indigenous peoples and museums are still complex in Canada and around the world. Since the rise of new museology in the 1980s collaborations and engagements between museums and communities have become increasingly commonplace with varying outputs and levels of success. In post-colonial nations such as Canada, sharing power and authorship is increasingly used as a strategy by museums to attempt to pluralise, democratise and decolonise relations with, and representations of, Indigenous peoples. While honourable in its intentions, the increasingly ubiquitous practice of community engagement in museums has often been under-analysed, and its difficulties and complexities understated. Since the 1990s the literature on community engagement has bloomed[1] and Peers and Brown argue that:

> These relationships [between museums and source communities] are the most important manifestations of the new curatorial praxis, but the process of establishing them has not received much attention in the critical literature. Nor has the concept of 'source community' and its special needs in and rights to material heritage held in museum collections been a focus in the literature.
>
> (Peers and Brown 2007:531)

The literature thus far has brought awareness of the need for community inclusion in representation and some of the challenges this creates for museums. However, there has been a tendency to present inclusion as a solution rather than the start of a new form of relationship between museums and communities, and community perspectives on collaboration are often absent. Positive accounts of successful engagements often minimise critical analysis of the new power dynamics and theoretical and political issues created by the process of inclusion. While community engagement is a very important step forward, it is not an automatic solution to the issues and problems of

representing source communities formerly known simply as 'Others'. Collaboration creates new relationships between museums and communities that have their own issues and dynamics that deserve further exploration.

Museums, Heritage and Indigenous Voice: Decolonising Engagement critically analyses Indigenous community engagement in museum and heritage practice. It carefully unpicks the complexities and dilemmas, revealing the nuances of, and naturalised assumptions about, collaboration and self-representation. Power relations and their tangible manifestations in the form of exhibits, employment, relations and new curatorial practices are at the heart of the discussion. As a comparative study the research provides a cross-disciplinary analysis of mainstream and community museums and heritage sites through four case studies, detailed below. Each of the case studies engaged with First Nations Blackfoot communities in southern Alberta, Canada, through consultation, partnership, co-ownership or community control.

The book strives to make a new contribution to the field through its emphasis on community participants' perspectives; the importance of intercommunity collaboration; and the proposal of the concept of 'engagement zones'. Engagement creates risks and costs for participants and is not necessarily as empowering or beneficial as current discourse often purports. Understanding the current limits of engagement and restrictions to museum indigenisation may enable collaborative efforts to be strategically utilised to work within and go beyond current boundaries and facilitate reciprocities that can begin to decolonise relations and enrich both museums and communities. The research illustrates that sharing power is neither simple nor conclusive, but a complex and unpredictable first step in building new relations between museums and Indigenous communities.

INDIGENEITY

The book title *Museums, Heritage and Indigenous Voice: Decolonising Engagement* highlights some of the terminology that can mask the inherent complexities of engagement. 'Museums' and 'heritage' are used as shorthand for a myriad of different forms and approaches, both traditional and non-traditional, to caring for the past and managing historical and cultural material, knowledge and practice. Similarly, the term 'engagement' has been used to stand for everything from informing to 'citizens control' (Arnstein 1969). The term 'Indigenous voice' is used here to highlight community self-representation as well as the views and perspectives that can be heard through the interviews presented in this book. The term also speaks to larger international concepts of Indigeneity and survivance.

'*Indigènitude* is a vision of liberation and cultural difference that challenges, or at least redirects, the modernizing agendas of nation-states and transnational capitalism' (Clifford 2013:16). Clifford notes that this 'new public persona and globalizing voice' emerged in the 1980s and 1990s, works on multiple scales: 'local traditions', 'national agendas and symbols' and transnational activism

(Clifford 2013:16). Importantly this approach acknowledges that the images and 'shared symbolic repertoire' 'can lapse into self-stereotyping' and 'requires a degree of tactical conformity with external expectations and at least partial acceptance of multicultural roles and institutions' (Clifford 2013 16–17; Povinelli 2002). The book is entitled 'Indigenous voice' rather than 'voices' to highlight this strategic use of presenting a coherent voice to the public through museums, both to increase the potential of being heard and to meet the expectations of engagement approaches and museum audiences. It is strategic because like all communities, there is no single voice that can speak for all, but a myriad of differing perspectives, experiences, histories and understandings.

This links into notions of survivance (Vizenor 1999), a term that moves beyond mere survival to include resistance, revival and living vibrancy. It attempts to forge a path that moves away from the 'intractable double binds' such as the 'assumed contradiction between material wealth and cultural authenticity' that Indigenous people have to negotiate with in settler-colonial nations (Clifford 2013:17). Survivance 'means more than mere survival, more than endurance' it 'necessitates a sense of native presence over absence, nihility, and victimry' (Vizenor 2007:12–13). 'Survivance is an active sense of presence, the continuance of native stories, not a mere reaction, or a survivable name' (Vizenor 1999:vii) . 'Native American scholars and activists use the word 'survivance' to express continuity with the past coupled with an insistence that the Native American presence is a vital part of contemporary America, not a romanticised relic from how the West was won' (Pratt 2013: 28). These ideas speak to efforts and notions of decolonisation.

Clifford notes that 'transformative survival has required selective assimilation, resistance, transgression, and concealment' (2013:18). These concepts capture the continuity, adaptation and strategic negotiation of identity as it is represented in the public sphere, which is central to the discussions in this book. Museums have the potential to support efforts of decolonisation, Indigeneity and survivance, however their histories are interwoven with those of colonialism, invasion and oppression. As such they are highly complex public sites of historical memory, identity negotiation and representation which are brought to the fore through community engagement, as this book will explore. To understand the relevance of museology to Indigenous peoples and decolonisation efforts today it is necessary to highlight the historical and changing power and roles of museums in society.

THE ROLE OF MUSEUMS AND HERITAGE

Museums and heritage sites are places that are imbued with power and authority by the societies that build and authorise them. They are both mirrors and shapers of culture, nations and peoples. They are key locations where identity politics and efforts to (re)claim culture and history play out. As authorities on the past, museums are vested with special privileges to authorise histories, with the power to both remember and forget. They are

keepers of knowledge and collections about ourselves, others and the world in which we live. They provide platforms for representation that effect and reflect the society that created them and help people to envision the future. Consequently museums can have real social, political and legal influence over how a community is viewed and treated.

Inherently Western, the traditional modern museum was born from the European sixteenth century cabinets of curiosity, *Kunst- und Wunderkammer*, filled with treasures from the age of exploration and 'new found worlds'. 'Over the course of centuries intrepid naturalists shipped many boat loads of stuffed, pressed, pickled, and live plants and animals across the Atlantic to fill the 'cabinets of curiosity' in noble homes and the collections of early museums' (Martin 2001:4). These early collections provided the evidence for the development of modern taxonomy, which inscribed Western cultural concepts into the ordering of the world as portrayed by museums (Bennett 1988, 2004). These private collections formed the basis for the first public museums and embedded the values of viewing other cultures through a western cultural lens, as wonders and curiosities.

Museums have a legacy as educational institutions of civic reform through their association with power and government (Bennett 1995, 1998). This position in society enabled museums to present information as objective and neutral. As Richard Sandell has argued, 'objectivity is an elusive stance and a default position that imparts value through the invoked authority of the institution' (Marstine 2011:5; Sandell 2007). As such, museums are commonly viewed by the public as expert bodies that hold truths on culture, heritage and the past. This image is self-perpetuating as the museum 'tells the story it needs to tell about the past in order to place itself as both an outcome of and a means of continuing the ongoing dynamics of self-transformation that the logic of culture promotes' (Bennett 2006:56).

However, in recent years the role of the museum as a state sponsored educational authority on truth has come under criticism from an array of stakeholders, in particular groups who feel that their stories have not been told. The 1980s was the starting point for the most dramatic shifts in modern museology with the birth of 'new museology' and a 'radical reassessment of the roles of museums in society' (Rivard 1984; Davis, 1999:54). Vergo described it as 'a state of widespread dissatisfaction with the 'old' museology, both within and outside the museum profession' he argued that 'what is wrong with the 'old' museology is that it is too much about museum methods, and too little about the purposes of museums' (1989:3). The purpose of museums has been at the heart of many academic debates since, and it is a key question when considering the decolonisation and indigenisation of museums. What, and who, museums are for is an ongoing debate.

Notions of heritage, like museology, are imbued with Western epistemology and histories of empire and can create contention. Smith highlights the epistemological biases inherent in heritage through her analysis of the 'authorised heritage discourse' 'which takes its cue from the grand narratives of Western national and elite class experiences, and reinforces ideas of

innate cultural value tied to time depth, monumentality, expert knowledge and aesthetics' (Smith 2006:299).

Like museology, Laurajane Smith demonstrates that heritage is a discourse that is 'concerned with the negotiation and regulation of social meanings and practices associated with the creation and recreation of "identity"' (2006:5).

> At one level heritage is about the promotion of a consensus version of history by state-sanctioned cultural institutions and elites to regulate cultural and social tensions in the present. On the other hand, heritage may also be a resource that is used to challenge and redefine received values and identities by a range of subaltern groups.
>
> (Smith 2006:4)

In June 2012 the Association of Critical Heritage Studies was launched at an inaugural conference at the University of Gothenburg, Sweden, to bring together academics and practitioners interested in critically analysing heritage studies. This echoes earlier moves in museology and shows the relevance of these debates across different approaches to caring for the past.

With pressure to change traditional museology and heritage coming from within and beyond the museum via government policies, community pressure and shifts in the museological and heritage profession, museums are now considered to 'have special cultural responsibilities that come with their institutional positions of cultural and educational power within the communities in which they exist', as museums continue to be 'places of special authority and respect' (Hutcheon 1994:225). These responsibilities have come to include providing access and representation for all, and in particular, working to include those who were traditionally excluded to enable side-lined and minority voices to be heard.

In this era of critical reflexivity, inspired by the rise of critical theory, cultural studies and the radical transformations in anthropology, new forms of museums have been able to emerge and old models have undergone innovation. Ecomuseology was one such model coined by the French museologist Hugues de Varine in 1971 (Davis 1999:59–60), which emphasised the importance of going beyond the traditional walls of the museum and engaging with place and community. In North America, Indigenous Community Centres began to be developed in place of traditional museums, and in Australia models of Keeping Places were utilised by Aboriginal communities. In addition, Indigenous communities often continue to use their traditional approaches to cultural heritage management alongside, or instead of, museums. These efforts to decentralise the traditional museum model promoted critical analysis of the purpose and function of museums and has enabled more nuanced understandings of what museums are and can be.

Crucially this new age of reflexivity has allowed academics and practitioners within and beyond the museum to critically consider the politics of museums and the representations of the world they make. No longer do the traditional claims to objective neutrality apply to museums. 'Over the last

few decades, museums have begun to see themselves as cultural "texts" and have become increasingly self-reflexive about their premise, identity, and mission' (Hutcheon 1994:206).

> Wide-ranging studies—variously arguing from theory, from history and more rarely from empirical audience research—have attempted to show that museums of all kinds, including science museums that have made some of the strongest claims to objectivity, do not constitute 'neutral sheltering places for objects' (Duncan 1995:1) but rather that they generate ideological effects by constructing and communicating a particular vision of society.
>
> (Sandell 2007:3)

Tied to the history of exploration, empire and colonialism, museums are placed in a precarious situation in the current age of liberal multiculturalism, decolonisation and postcolonial critique. 'The new critical theory of museums problematizes the museum and museum practices, illuminating their Euro-centric, epistemological biases and assumptions' (Kreps 2003:2).

> In today's age of globalisation, museums around the world retain the older powers of treasure house, place of knowledge, sanctuary and shrine, in combination with a newer role as a forum and a vital role in democracy . . . While this democratic exchange can spark bitter controversy, since the museum in the socio-cultural landscape of the twenty-first century can be perceived as an icon of western colonialism in particular contexts, this effect is often in contradistinction to curatorial intentions.
>
> (Golding 2009:4)

The recognition of museums not as neutral objective venues of historical truths, but as political and social constructions of the world based on particular viewpoints, has opened the doors to a greater understanding of the importance of museums today to the societies and communities that support them and are collected by them. 'In general museums are now viewed as "contested terrain" where diverse communities debate what culture is, how it should be represented, and who holds the power to represent culture' (Kreps 2003:2). This has enabled Indigenous voices to begin to be heard in museums as communities participate in and challenge traditional museum forms and their colonial collections and histories.

VOICE AND AGENCY

Hall argues that 'the critique of the Enlightenment ideal of dispassionate universal knowledge' and 'rising cultural relativism which is part of a growing de-centring of the West and Western-orientated or Eurocentric grand narratives' has caused a revolution (Hall 2005:28). However, he notes that

the 'exhibiting of "other cultures"—often performed with the best of liberal intentions—has proved controversial' raising the questions—'Who should control the power to represent?', 'Who has the authority to re-present the culture of others?' which has provoked a 'crisis of authority' (Hall 2005:28). Traditional museums, that have for so long spoken for 'Others', be they from other times, places, cultures or subgroups within society, have come under pressure to allow communities to speak for themselves, moving from a passive voice of expertise to authored polyvocal exhibits.

Knowing who is speaking is important because the speaker's location (social and personal) has an 'epistemically significant impact on that speaker's claims' and 'affects the meaning and truth of what one says' (Alcoff 1991:6–7). The passive voice of the traditional museum 'erases agency that results in an erasure of responsibility and accountability for one's speech', and makes who is speaking for whom uncertain. Indigenous peoples have increasingly challenged the dominant group's right to speak on their behalf and have begun speaking for themselves in the public sphere through a range of media, from literature, film, academic papers, to museums. In 1986 Clifford noted that 'gone are the days . . . when anthropology (conceived of as apolitical and neutral) could speak "with automatic authority for others defined as unable to speak for themselves"' (Hutcheon 1994:107 quoting Clifford 1986:10). The changes in museology and the questions raised around the right to speak for 'Others', particularly challenges made from 'source communities' (Peers and Brown 2003), has encouraged a shift from the curator as expert to the curator as mediator between peoples, objects and knowledges to facilitate public understandings of the past and present.

It is worth noting that the inadequacies and bias found in representation (and its readings) are unsurprising given that exhibits are made up of a collection of fragments collated to resemble complex, fluid, nuanced and multilayered cultures and histories. Cultures are conceptual constructs, not physical entities available for collection. Cultures overlap and are ever changing, and individuals are often members of many different cultures and communities on different scales which reflect and effect different aspects of their identity. Bennett argues that 'culture, in simultaneously articulating a sense of sameness and difference, inscribes our identities in the tension it produces between inherited and shared customs and traditions, on the one hand, and the restless striving for new and distinguishing forms of individuality on the other' (2006:52). It can, therefore, be difficult for museums to know who to work with when attempting to pluralise representation, as communities, like cultures, are not discrete entities that exist in specific geographical locations, readily identifiable or accessible.

> There is no single national group; rather, collectively we form a myriad of sometimes shifting communities. Communities can be identified by activity, gender, interest, ability and economics; we move between these communities and sometimes feel uncomfortable in the categories we are

placed. Nevertheless, we need communities in order to build our experiences and forge our identities. Together these experiences produce 'communities of practise' in which knowledge and relationships are socially constructed (Falk and Dierking 2000:46).

(Crooke 2007:302)

Shelia Watson argues that personal identities are tied to communities: 'the essential defining factor of a community is the sense of belonging that comes to those who are part of it (Kavanagh 1990:68) and that, through association with communities, individuals conceptualise identity' (Watson 2007:3). Watson, like Crooke, notes that community membership is not always selected by the individual. 'We all belong to many different communities and our membership of these will change with circumstances. Some communities are ours by choice, some are ours because of the ways others see us' (Watson 2007:4). Others are forced upon us because of happenstance, such as the community you are born into.

First Nations, such as the Blackfoot, are nations within a nation. Thus when they work with museums to represent themselves they are 'Others' within the nation, not simply Canadian, nor a nation state outside of Canadian rule. As Hedican articulates: 'Aboriginal people have always felt a certain measure of ambiguity about living in Canada and being its first residents, yet not actually part of Canadian society' (1995:192). How the Blackfoot are presented in museums is crucially important because, as Witcome explains: 'museums need to be understood not as institutions which represent communities and cultures—which create a "place for all of us"—but as institutions which actually produce the very notion of community and culture' (Witcomb 2003:80).

Heritage sites and museums are important points of entry for Indigenous peoples' voices into mainstream society because they have the ability to validate identities, histories, culture and societies. 'The past validates the present by conveying an idea of timeless values and unbroken narratives that embody what are perceived as timeless values' (Ashworth and Graham 2005:9). 'Self-awareness and self-representation can empower people to make themselves present as agents in the struggle to expand their own possibilities and to struggle against injustice and intolerance' (Ames 2006:175).

In Phillips' discussion of five recent collaborative projects with Indigenous peoples, she highlights that 'exhibits play an important role in the construction of the identities by which [community] members become "known" to museum visitors' (Phillips 2011:189). These collaborative exhibits work hard to counter the colonial and neo-colonial history of Indigenous representation in museums and return voice and agency to the communities represented. This can go some way towards reconciling the dehumanising objectification of previous museum practice, affirming 'either implicitly or explicitly the need to repair the psychological damage that has been done in the past to individuals forced to negotiate negative stereotypes by creating new exhibits that disseminate more accurate (and usually positive) images of contemporary ways of life' (Phillips 2011:189).

Thus museum and heritage representations can validate a community's history and identity which in turn validates their current community identity. In the context of colonised Indigenous peoples, recognition of their culture and heritage can help win land claims, treaty rights and ultimately improve community life (Daniels 2009). This highlights why the engagement processes and case studies in this book are important not only to the Blackfoot peoples, but to wider efforts to decolonise museums and their representations of people formerly spoken about rather than listened to.

AN INTRODUCTION TO THE BLACKFOOT CONFEDERACY AND THE CASE STUDIES

This research specifically analyses museum and heritage engagement with members of the Blackfoot Confederacy in southern Alberta, Canada. 'Blackfoot' is a term used to refer to members of four Blackfoot Nations: Siksika[2] (Blackfoot or Northern Blackfoot); Kainai[3] (Bloods, Many Chiefs or Many Leaders); Piikani[4] (Apatohsipikani or Peigan); and Blackfeet[5] (Amsskáápipikani, Peigan or Southern Piikani).[6] Traditional Blackfoot territory was vast extending from the North Saskatchewan River in Alberta, south roughly six hundred miles to the Yellowstone river in Montana, and from the eastern slopes of the Rocky Mountains eastwards for an average of around four hundred miles to a point beyond the Great Sand Hills in Saskatchewan (Blackfoot Gallery Committee 2001:4). Today three of the nations, Siksika, Kainai and Piikani, have reserves in southern Alberta, Canada, with the fourth, Blackfeet Reservation, in northern Montana, America. Each reserve is governed by its own elected Chief and Council. Many Blackfoot members also live in urban areas beyond the reserves.

The four case studies analysed in this research fall within traditional Blackfoot territory and have each engaged with the Blackfoot community to help shape the representations of the peoples and the management of their cultural material and history. The book is based upon years of working with members of the Blackfoot Confederacy and museum and heritage professionals. A period of intense research activity for twenty-four months between 2006 and 2009 contributed significantly to the ideas and discussions in this book. The approach used can be described as 'theoretical museology' which 'seeks to locate itself at the intersection of theory and practice, as opposed to a mode of critique that stands outside looking inwards' (Mason 2006:29). As such, academic theory and 'real world' experience and practice are intertwined throughout the book to illuminate the limits and potential of both approaches. The research is primarily built upon forty-eight in-depth interviews with museum and Blackfoot community members, textual analysis of exhibits, and participant observation at the four case studies: Head-Smashed-In Buffalo Jump Interpretive Centre near Fort Macleod; Glenbow Museum in Calgary; Buffalo Nations Luxton Museum in Banff; and Blackfoot Crossing Historical Park on the Siksika Reserve. As the case studies and

the Blackfoot communities have living and dynamic relationships, this book captures a 'snapshot' in time, particularly the relationships as they were in 2008–9. The first two chapters frame the discussion, providing time depth and international context, and the final chapter brings the discussion to the present and looks towards the future. As organic ever-changing relationships, the discussions in this book do not aim to provide definitive static statuses of relations but highlight the many competing issues and interests that influence museum and communities and their relationships, with the aim of highlighting future potential problems as well as opportunities to decolonise engagement and representation.

As practice and theory are at the heart of the book, each of the case studies will now be introduced and returned to in-depth from chapter four onwards.

Head-Smashed-In Buffalo Jump Interpretive Centre World Heritage Site

The first case study, a provincial government-run heritage interpretive centre, presents Blackfoot history, employs Blackfoot staff and consults with Blackfoot Elders on the display and interpretation of Blackfoot culture. Head-Smashed-In Buffalo Jump Interpretive Centre is located in southwest Alberta where the foothills of the Rocky Mountains meet the plains, 18 kilometres northwest of Fort Macleod, adjacent to the Piikani Blackfoot Reserve.

Head-Smashed-In is one of the world's oldest, largest and best preserved buffalo jumps in known existence. 'There is solid evidence that ancient hunters inhabited the site more than nine thousand years ago' (Brink 2008:19–20). Archaeological digs at the site since 1938 have unearthed evidence of the cliff being used as a buffalo jump more than 5,800 years ago (Brink 2008:23). To help protect the site from vandalism and pothunters Head-Smashed-In was designated a National Historic Site in 1968 and was declared a Provincial Historic Site in 1979 (Reid 2002:24). It received world heritage status in 1981 and 890 hectares (2,200 acres) of the site are owned by the Province and covered by protective provincial legislation (Clarke 2009).

Head-Smashed-In is an important cultural site for the Blackfoot peoples. Along with the buffalo jump, the site includes drive lanes, a buffalo gathering basin, processing areas, campsites, petroglyphs and a vision quest that is still in use.

Following its World Heritage listing, the Government of Alberta funded a $9.82 million development of a seven-tiered, 2,400m² interpretive centre which opened on 23 July 1987. Head-Smashed-In is a popular tourist site and 'receives approximately 75,000 visitors each year, mostly between May and September' (Hassall 2006:29). Government managed and operated, the centre is predominantly subterranean, sunk into the cliff and is unobtrusive on the landscape (see Figures 1.1–1.6). Highly commended for its subtle in situ design, Head-Smashed-In's modest presence on the landscape conceals a large interpretive centre within the hillside at the cliffs (see Figure 1.6).

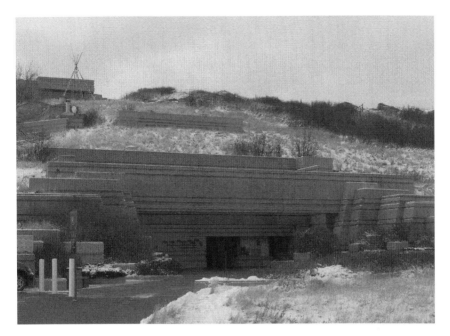

Figure 1.1 Head-Smashed-In entrance in winter.
(Photo by Onciul 2008). Courtesy of Head-Smashed-In Buffalo Jump World Heritage Site.

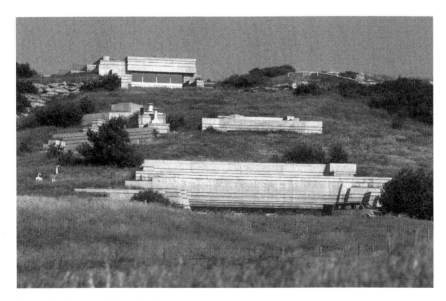

Figure 1.2 Head-Smashed-In in summer.
Courtesy of Head-Smashed-In Buffalo Jump World Heritage Site.

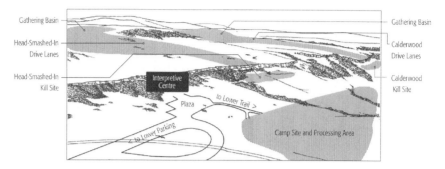

Figure 1.3 Map of Head-Smashed-In site.
Courtesy of Head-Smashed-In Buffalo Jump World Heritage Site.

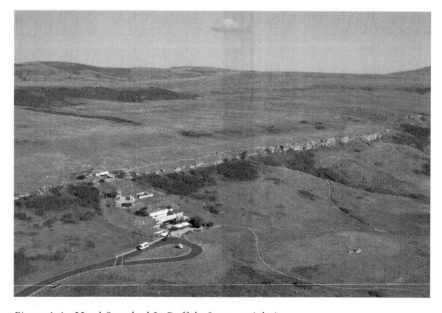

Figure 1.4 Head-Smashed-In Buffalo Jump aerial view.
Courtesy of Head-Smashed-In Buffalo Jump World Heritage Site.

The centre provides interpretation on the history of buffalo hunting and the Blackfoot culture. The interpretation is spread across five floors, and presents a chronological story of: the land formation; the use of the jump; contact; through to the archaeological digs at the site. The levels are themed and named: *Napi's World*; *Napi's People*; *The Buffalo Hunt*; *Cultures in Contact*; *Uncovering the Past*. Visitors are directed to watch an introductory film in the theatre to start their visit, which presents a re-enactment of a Blackfoot buffalo hunt at Head-Smashed-In.

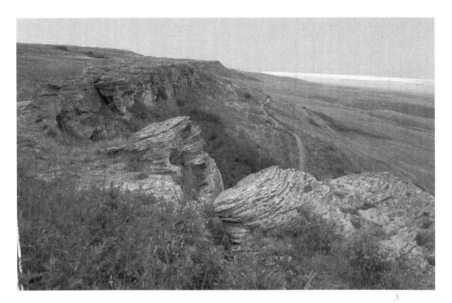

Figure 1.5 The Jump at Head-Smashed-In.
Courtesy of Head-Smashed-In Buffalo Jump World Heritage Site.

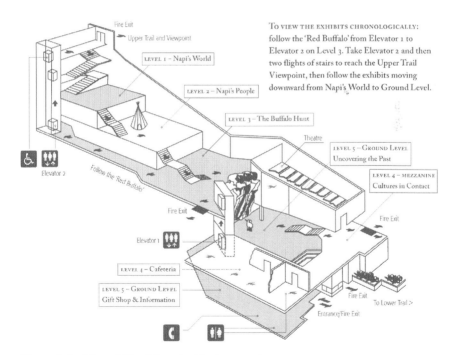

To VIEW THE EXHIBITS CHRONOLOGICALLY: follow the 'Red Buffalo' from Elevator 1 to Elevator 2 on Level 3. Take Elevator 2 and then two flights of stairs to reach the Upper Trail Viewpoint, then follow the exhibits moving downward from Napi's World to Ground Level.

Figure 1.6 Map of Head-Smashed-In interpretive centre.
Courtesy of Head-Smashed-In Buffalo Jump World Heritage Site.

The interpretation is complimented by short walks along the cliff top, and below the cliff, to view the Jump. The centre also offers an on-site tipi camp where visitors can stay overnight in the Old Man River Valley, below the visitor centre, and participate in Blackfoot cultural programming. Every Wednesday throughout the summer, Head-Smashed-In hosts First Nations dancing at the front of the building and 'Sunday at the Jump' activities aimed at the local community.

The interpretation was originally developed in consultation with Black-foot Elders from Kainai and Piikani Nations, and Head-Smashed-In employs Blackfoot staff. The recruitment process at Head-Smashed-In has adapted government requirements to include criteria specifically targeting Black-foot people, who are employed as interpretive guides at the site (Hassall 2006:31). Blackfoot Elders participate at the jump as part of the guide train-ing week, as advisors during consultation, at an annual Christmas dinner, and provide prayers and spiritual guidance.

Glenbow Museum

The second case study, a large urban museum, led the field in terms of its part-nership work with Blackfoot Elders to reinterpret the collection, co-create a gallery and adapt curatorial practice. The Glenbow-Alberta Institute, operat-ing as the Glenbow Museum, is a public museum housed in the Telus Conven-tion Centre, situated in traditional Blackfoot territory in the city of Calgary, Alberta (see Figure 1.7). The museum includes a library and archives, a shop and theatre area. 'With over one million artifacts and more than 30,000 works of art, the diverse collections of art, history and world cultures make Glen-bow the largest museum in Western Canada' (Glenbow Museum 2009:1). The museum consists of eight floors, five of which are open to the public, with three floors of dedicated exhibition space.

The museum was founded by 'the West's most notable philanthro-pist, petroleum entrepreneur and lawyer' Eric Lafferty Harvie (Glenbow Museum 2011). Oil was discovered on his land in the late 1940s and he used his wealth to collect cultural material from western Canada and Indig-enous North America. As 'probably the richest man in western Canada' Harvie 'collected the world' (Kaye 2003:98), 'extraordinary artifacts and art from Asia, West Africa, South America, and islands in the Pacific, eventually amassing a huge museum collection' (Glenbow Museum 2011). In 1954 he established the Glenbow Foundation with the vision to be 'Where the World Meets the West', and in 1966 he donated his collection to the Province of Alberta as a centennial gift (Kaye 2003:102). 'By the time of his death Eric Harvie had donated about half a billion dollars (in current value) to Canada' through his 'support for the creation of the Glenbow Museum, the Banff School of Fine Arts, the Luxton Museum, the Calgary Zoo, Heritage Park, and Confederation Square and Arts Complex in Charlottetown, P.E.I.' (Glenbow Museum 2011).

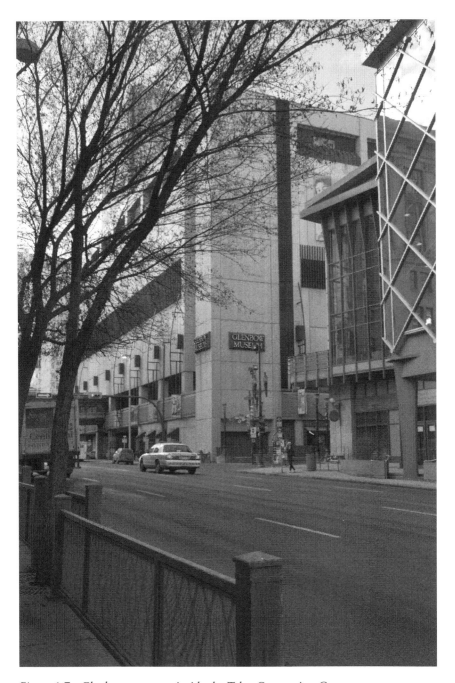

Figure 1.7 Glenbow entrance inside the Telus Convention Centre.

(Photo by Onciul 2010). Printed with permission of the Glenbow Museum. ©Glenbow, Calgary, 2014.

'Today, Glenbow Museum is one of the most entrepreneurial museums in Canada, playing an essential role in defining Western Canadian culture' (Glenbow Museum 2011). With 93,000 square feet of exhibition space spread over three floors, it presents its main collections: Native North America; Community History; Military and Mounted Police; World Cultures and Minerals; as well as visiting exhibitions. 2009–2010 the Glenbow received a total of 117,818 museum visitors and 7,711 Archives and Library users (Glenbow Museum 2010).

On the 3rd of November 2001 Glenbow opened a new 760m² $1.915 million gallery (Conaty 2003:238) called *Nisitapiisinni: Our Way of Life, The Blackfoot Gallery* which was developed in partnership with Blackfoot Elders from the four Nations over a period of four years (see Figure 1.8). This gallery is the focus of this case study and will be discussed at length. Glenbow also works with First Nations in its community gallery and has hosted temporary Blackfoot exhibits such as *Kaahsinnooniksi Ao'toksisawooyawa: Our ancestors have come to visit: Reconnections with historic Blackfoot shirts* (March 26– May 16, 2010); *The People and Places of Treaty 7* (July 16–August 16, 2009); *Honouring Tradition: Reframing Native Art* (February 16–July 13, 2008); *Tracing History: Presenting the Unpresentable* (February 16–June 22, 2008); *Situation Rez: Kainai Students Take Action with Art* (December 1, 2007– December 2008); *10 Grandmothers Project* (June 18, 2002). Glenbow has involved and employed Blackfoot people as Native Liaisons, Native Advisory Board members,[7] interpretive guides and school programmers.

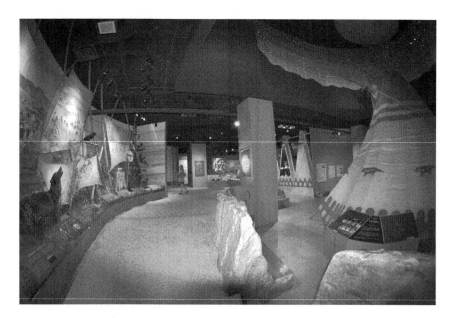

Figure 1.8 Nitsitapiisinni Gallery at Glenbow.

(Photo by Onciul 2009). Printed with permission of the Glenbow Museum. ©Glenbow, Calgary, 2014.

Buffalo Nations Luxton Museum

The third case study is an independent museum co-owned by Indigenous people, who acquired the building and collection from the Glenbow Museum. Buffalo Nations Luxton Museum, located in Banff, began life as Norman Luxton's personal collection of First Nations cultural material. Luxton was a 'local taxidermist and proprietor of the Sign of the Goat Curio Shop' (Wakeham 2008:81). He founded the shop in 1902, 'which specialized in Stoney Indian handicrafts and taxidermy specimens' (The Eleanor Luxton Historical Foundation 2010). Through his trade and his promotion of the Banff Indian Days[8] 1909–1950, Luxton developed connections and friendships with local First Nations. 'Luxton's relationship with Native people was undeniably paternalistic, but paternalism was virtually the only model available to him at that time' (Kaye 2003: 106). He was 'made an honorary chief of the Stoney [Nakoda] tribe and given the name Chief White Shield' (The Eleanor Luxton Historical Foundation 2010).

> Luxton's collections began as a by-product of his commercial ventures. He collected trophy heads of Rocky Mountain animals and mounted fish to add to the outdoorsy feel of the trading post. Stoney artists presented him with art objects as part of the exchange of gifts involved in traditional Native trade patterns . . . After nearly a half century of collection, he had amassed a formidable hodgepodge of material that

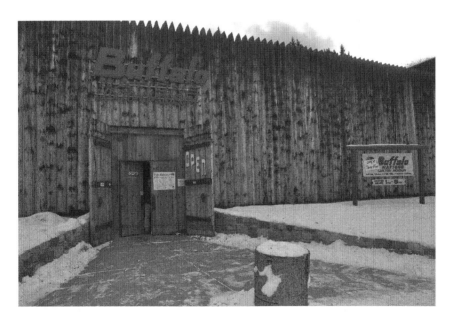

Figure 1.9 Entrance to Buffalo Nations Luxton Museum.
(Photo by Onciul 2010). Printed with permission of the Buffalo Nations Luxton Museum.

ranged from invaluable to worthless, rare to abundant. And had begun to wonder what would happen to his stuff after his death.

(Kaye 2003:106–107)

In 1953, with assistance from his friend Eric Harvie, Luxton established the Luxton Museum of Plains Indians. The building was constructed piecemeal, starting with the Old Banff Gun Club building being moved onto the museum site, then rooms being added in 1955, 1957 and 1960, to create a wooded fort-like structure (Figure 1.9). Harvie and Luxton built the 'museum in the shape of a Hudson's Bay Company log fort, thus carrying on the idea of the trading post' (Kaye 2003:108). In this museum he presented a collection of First Nations cultural materials, taxidermy animals and dioramas populated with Indigenous mannequins.

'The Luxton was leased to the Glenbow in February 1962' (Kaye 2003:115) and on October 26, 1962 Luxton passed away and Glenbow ran the Luxton museum as a satellite site. 'In September 1991 the Glenbow Institute stopped operating the Luxton' and in March 1992 it was sold to the Buffalo Nations Cultural Society for a nominal fee of one dollar (Kaye 2003:116). 'It has now been reopened and continues to exhibit much of the same material in the same fashion that it did in the 1960s' (Kaye 2003:116).

As a museum co-owned by Blackfoot people, with many Blackfoot representatives on the board and several Blackfoot presidents, this case study provides an intriguingly different perspective on Blackfoot community engagement.

Blackfoot Crossing Historical Park

The fourth case study is run for and by the Siksika Blackfoot Nation and is an example of 'citizens' power' (Arnstein 1969). Blackfoot Crossing Historical

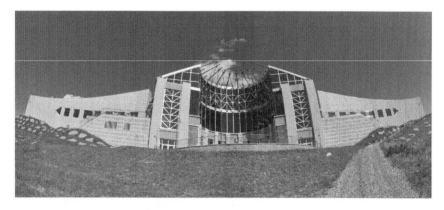

Figure 1.10 View of Blackfoot Crossing from the valley.
(Photo by Onciul 2009). Printed with permission of Blackfoot Crossing Historical Park.

Park opened in 2007 (Figures 1.10 and 1.11). As a $25 million 62,000 square feet facility located in 6,000 acres of historical parkland (BCHP 2007) Blackfoot Crossing presents a combined offer of park, museum, interpretive centre, archives, library, theatre, conference facilities, shop, restaurant, sacred keeping place, ceremonial space, *Annual World Chicken Dance* venue, cultural venue, meeting place, educational facility, archaeological site and tourist attraction. As 'a museum exhibition with recreational and other outdoor offerings [it] is an entirely new type of venture for the community and possibly unique in Canada' (Bell 2007:5). Jack Royal, President and General Manager of Blackfoot Crossing Historical Park, 'revealed that the total cost to open and operate the Park is estimated at $33 million making it the largest single First Nation cultural tourist attraction in Canada' (BCHP 2007).

Blackfoot Crossing is located on the Siksika Reserve, 110 kilometres east of Calgary in southern Alberta. It was developed by the Siksika community, for the community, with community money,[9] on community land, and it is run and staffed by the community. Blackfoot Crossing's development began in the 1970s, gaining momentum as a result of the interest in the valley due to the centenary commemoration of the 1877 treaty:

> The success of the Treaty No.7 Commemoration in 1977 intensified the Siksika (Blackfoot) Nation's vision of building a unique world-class tourist attraction designed to engage visitors in authentic cultural experiences with the Blackfoot people.
>
> (BCHP 2011)

The centre overlooks a river valley which has been an important place for Blackfoot peoples for generations. Literally a river crossing known as '*soyopowahko*, the ridge or bridge under the water,' it was used by buffalo and Blackfoot peoples and was a geographically and culturally significant part of Blackfoot territory (BCHP 2011). The land has been in continual use from pre-contact to today and is part of the Siksika Reserve. The Bow River Valley was 'a traditional camp site and focal point of trade' (Getz and Jamieson 1997:100) and was also a ceremonial site for the annual Sundance. Within the park there is also a Mandan Earth Lodge archaeological site which is currently under investigation and Blackfoot Crossing hosts University of Calgary archaeological study groups who work on the dig each summer. From the centre, visitors can see the site where Treaty 7 was signed in 1877. Siksika Chief Crowfoot negotiated to have the signing in Siksika territory and all the other Blackfoot, Tsuu T'ina and Nakoda Nations gathered here to sign the Treaty. Blackfoot Crossing has been designated as a National Historic Site and it has been recommended for World Heritage listing due to the importance of Treaty 7 (Hassall 2006:35). The valley has been relatively untouched and is one of the last pristine prairie river eco-systems (BCHP 2007).

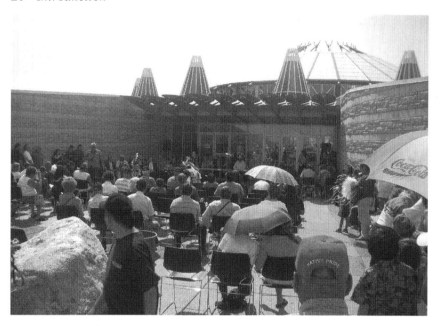

Figure 1.11 Blackfoot Crossing Historical Park opening celebration.
(Photo by Onciul 2007). Printed with permission of Blackfoot Crossing Historical Park.

OVERVIEW OF THE BOOK

The chapters that follow are designed to explore and unpick the complexities and nuances of museum/community relations, utilizing the case studies as examples of practice and interweaving this with the theory on engagement. To begin, the first chapter considers Indigenous relations with museums around the world and across time, through the exploration of different examples the chapter draws out the contentions and histories that continue to trouble modern relationships. Chapter two focuses specifically upon the Blackfoot, introducing Blackfoot culture and epistemology, and providing a brief history of Blackfoot/settler relations that have shaped museum collections and cross-cultural relations in Alberta.

The third chapter focuses upon engagement theory and introduces the idea of the 'engagement zone' as a new model for decolonizing and Indigenizing engagement. Chapter four then looks at these theoretical models in practice at the case studies. Chapter five analyses the processes of Indigenising museology and the limits to change, followed by chapter six which considers to what extent relationships between museums and communities can be institutionalized.

Chapter seven explores processes of decolonising representation, while eight and nine present a view from the other side by focusing upon the

experience of being a community member on display at a museum and the costs and consequences of engagement for individual participants and employees. Finally chapter ten considers where to go from here, considering the changes in museology and what the future holds for museums and Indigenous communities.

NOTES

1. To mention but a few: Ames 1987, 1990, 1992, 1999, 2000, 2006; Boast 2011; Brown and Peers 2006; Carnegie 2006; Clavir 2002; Clifford 1997, 2013; Conaty 1996, 2003, 2006, 2008; Conaty and Carter 2005; Conaty and Janes 1997; Cooper 2008; Crook 2007; Golding and Modest 2013; Harrison, Byrne and Clarke 2013; Hill and Nicks 1992a 1992b; Karp, Kreamer and Lavine 1992; Kreps 2003; Krmpotich and Anderson 2005; Krmpotich and Peers 2013; Lawlor 2006; Lewis 2005; Lonetree 2012; Lonetree and Cobb 2008; Lynch 2010, 2011; Lynch and Alberti 2010; McCarthy 2007, 2011; Mithlo 2004, 2006; Onciul 2013; Peers 2007; Peers and Brown 2003, 2007; Phillips 2011; Simpson 1996, 2006, 2007, 2009; Sleeper-Smith 2009; Tapsell 2011; Waterton and Watson 2011; Watson 2007.
2. The Siksika Nation has a population of approximately 6,000 members (Siksika Nation 2011) on a reserve of 432.8 square miles.
3. A new Kainai 'reserve was established in 1883 and, at 547.5 square miles, is the largest in the country' (Brown and Peers 2006:19) and is home to over 10,000 members (Blood Tribe 2011).
4. The Piikani Reserve is 267.37 square miles with a population of 3,500 with over 1,500 members living on the reserve (AANDC 2011).
5. The Blackfeet Reservation in Montana is 1.5 million acres with around 7,000 of the approximate 15,560 enrolled Blackfeet members living on the reservation (Montana Gov 2015).
6. There are discrepancies in the spellings of Blackfoot names. These spelling have been borrowed from the Glenbow's Blackfoot Gallery Committee (2001:2–3), with the exception of the spelling of Piikani, which is taken from the preferred spelling of Piikani interviewees at Head-Smashed-In Buffalo Jump Interpretive Centre.
7. The Native Advisory Board was not active at the time of interviewing in 2008.
8. See Meijer Drees (1993) for discussion of Banff Indian Days.
9. Initial Capital Contributions prior to 2008 to fund the development of BCHP were $9,174,523 from Siksika Nation, $6,000,000 from Federal government, and $4,500,000 from the Province of Alberta (Bell 2007:19)

REFERENCES

AANDC (Aboriginal Affairs and Northern Development Canada), 2011. *Piikani Nation Housing Authority*. [Online] AANDC. Available at: https://www.aadnc-aandc.gc.ca/eng/1309460062996/1309460454048

Alcoff, L., 1991. The problem of speaking for others. *Cultural Critique*, Winter Issue pp. 5–32.

Ames, M.M., 1987. Free Indians from their ethnological fate. *Muse*, 5(2) pp. 14–19.

Ames, M.M., 1990. Cultural empowerment and museums: opening up anthropology through collaboration. In S. Pearce, ed. *Objects of Knowledge*. London: The Athlone Press, pp. 158–173.

Ames, M.M., 1992. *Cannibal Tours and Glass Boxes: The Anthropology of Museums*. Vancouver: UBC Press.

Ames, M.M., 1999. How to decorate a house: the re-negotiation of cultural representations at the University of British Columbia Museum of Anthropology. *Museum Anthropology*, 22(3) pp. 41–51.

Ames, M.M., 2000. Are changing representations of First Peoples challenging the curatorial prerogative? In W.R. West, ed. *The Changing Presentation of the American Indian: Museums and Native Cultures*. Washington: Smithsonian Institution, pp. 73–88.

Ames, M.M., 2006. Counterfeit museology. *Museum Management and Curatorship*, 21 pp. 171–186.

Arnstein, S.R., 1969. A ladder of citizen participation. *JAIP*, 35(4) pp. 216–224.

Ashworth, G.J. and Graham B., 2005. Senses of place, senses of time and heritage. In G.J. Ashworth and B. Graham, eds. *Senses of Place: Senses of Time*. Aldershot: Ashgate Publishing Limited.

BCHP, 2007. *Museum Opening is Largest First Nations Tourist Attraction*. Press Release, 5 July 2007.

BCHP, 2011. *About Us*. [Online] BCHP. Available at: http://www.blackfootcrossing.ca/aboutus.html

Bell, C.E., 2007. That was then, this is now. Canadian Law and Policy on First Nations Material Culture. In M. Gabriel and J. Dahl, eds. *UTIMUT: Past Heritage—Future Partnerships: Discussion on Repatriation in the 21st Century*. Copenhagen/Nuuk: IWGIA/NKA, pp. 154–167.

Bennett, T., 1988. The exhibitionary complex. *New Formations*, 4(Spring) pp. 73–102

Bennett, T., 1995. *The Birth of the Museum: History, Theory, Politics*. London: Routledge.

Bennett, T., 1998. *Culture: A Reformer's Science*. London: Routledge.

Bennett, T., 2004. *Pasts beyond Memory: Evolution, Museums, Colonialism*. London: Routledge.

Bennett, T., 2006. Difference and the logic of culture. In I. Karp, C.A. Kratz, L. Szwaja, and T. Ybarra-Frausto, eds. *Public Cultures/ Global Transformations*. London: Duke University Press, pp. 46–69.

Blackfoot Gallery Committee, 2001. *Nitsitapiisinni: The Story of the Blackfoot People*. Toronto: Key Porter Books.

Blood Tribe, 2011. *About Blood Tribe*. [Online] Blood Tribe – Kainai. Available at: http://www.bloodtribe.org/

Boast, R., 2011. Neocolonial collaboration: museum as contact zone revisited. *Museum Anthropology*, 34(1) pp. 56–70.

Brink, J.W., 2008. *Imagining Head-Smashed-In: Aboriginal Buffalo Hunting on the Northern Plains*. Athabasca, Alberta: Athabasca University Press.

Brown, A.K. and Peers, L., 2006. *Pictures Bring Us Messages'/Sinaakssiiksi aohtsimaahpihkookiyaawa: Photographs and Histories from the Kainai Nation*. Toronto: University of Toronto Press.

Carnegie, E., 2006. 'It wasn't all bad': representations of working class cultures within social history museums and their impacts on audiences. *Museums and Society*, 4(2) pp. 69–83.

Clarke, I., 2009. *Periodic Report on the Application of the World Heritage Convention. Section II. Report on the State of Conservation of Head-Smashed-In Buffalo Jump*. [Online] Parks Canada. Available at: http://www.pc.gc.ca/eng/docs/pm-wh/rspm-whsr/rapports-reports/r4.aspx [Accessed 20 Aug 2011].

Clavir, M., 2002 *Preserving What Is Valued: Museums, Conservation, and First Nations*. Vancouver: UBC Press.

Clifford, J., 1986. Introducing: partial truths. In J. Clifford and G.E. Markus, eds. *Writing Culture: The Poetics and Politics of Ethnography*. Berkley: University of California.

Clifford, J., 1997. *Routes: Travel and Translation in the Late Twentieth Century*. London: Harvard University Press.

Clifford, J., 2013. *Returns: Becoming Indigenous in the Twenty-First Century.* London: Harvard University Press

Conaty, G.T. and Carter, B., 2005. Our story in our words: diversity and equality in the Glenbow Museum. In R.R. Janes and G.T. Conaty, eds. *Looking Reality in the Eye: Museums and Social Responsibility.* Calgary: University of Calgary Press, pp. 43–58.

Conaty, G.T. and Janes, R.R., 1997. Issues of repatriation: A Canadian view. *European Review of Native American Studies,* 11(2) pp. 31–37.

Cooper, K.C., 2008. *Spirited Encounters: American Indians Protest Museum Policies and Practices.* Plymouth: AltaMira Press.

Crooke, E., 2007. Museums, communities and the politics of heritage in Northern Ireland. In S. Watson, ed. *Museums and Their Communities.* London: Routledge, pp. 300–312.

Daniels, B.I., 2009. Reimagining tribal sovereignty through tribal history: museums, libraries, and archives in the Klamath River Region. In S. Sleeper-Smith, ed. *Contesting Knowledge: Museums and Indigenous Perspectives.* London: University of Nebraska Press, pp. 283–302.

Davis, P., 1999. *Ecomuseums: A Sense of Place.* London: Leicester University Press.

Duncan, C., 1995. *Civilizing Rituals: Inside Public Art Museums.* London: Routledge.

Falk, J.H. and Dierking, L., 2000. *Learning from Museums: Visitor Experiences and the Making of Meaning.* California: AltaMira Press.

Getz, T. and Jamieson, W., 1997. Rural tourism in Canada: issues, opportunities and entrepreneurship in aboriginal tourism in Alberta. In S.J. Page and D. Getz, eds. *The Business of Rural Tourism: International Perspectives.* London: International Thomson Business Press, pp. 93–107.

Glenbow Museum 2009. *Glenbow Museum Annual Report 2008–2009.* [Online] Available at: http://www.glenbow.org/media/2009_GLENBOW_AR.pdf

Glenbow Museum, 2010 *Annual Report 2009–2010.* [Online] Glenbow Museum. Available at: http://www.glenbow.org/media/GLENBOW-AR-2010.pdf

Glenbow Museum, 2011. *History of Glenbow Museum.* [Online] Glenbow Museum. Available at: http://www.glenbow.org/about/history.cfm

Golding, V., 2009. *Learning at the Museum Frontiers. Identity, Race and Power.* Surrey: Ashgate Publishing Limited.

Golding, V. and Modest, W. (eds), 2013. *Museums and Communities: Curators, Collections and Collaboration.* London: Berg Publishers.

Hall, S., 2005. Whose heritage? Un-settling 'the heritage', re-imagining the post-nation. In J. Littler and R. Naidoo, eds. *The Politics of Heritage: The Legacies of 'Race'.* London: Routledge, pp. 23–35.

Harrison R., Byrne S. and Clarke A. (eds.), 2013. *Reassembling the Collection: Ethnographic Museums and Indigenous Agency.* Santa Fe: SAR Press.

Hassall, K., 2006. Partnerships to manage conservation areas through tourism: some best practice models between government, indigenous communities and the private sector in Canada and South Africa. [Online] The Churchill Trust. Available at: http://www. compassodyssey.net/documents/Kate_Hassall_Churchill_Fellowship_May_2006.pdf

Hedican, E.J., 1995. *Applied Anthropology in Canada: Understanding Aboriginal Issues.* Toronto: University of Toronto Press.

Hill, T. and Nicks, T., 1992a. The Task Force on Museums and First Peoples. *MUSE,* X(2&3), pp. 81–84.

Hill, T. and Nicks, T., 1992b. *Turning the Page: Forging New Partnerships between Museums and First Peoples: Task Force Report on Museums and First Peoples.* 2nd ed. Ottawa: Assembly of First Nations and Canadian Museums Association.

Hutcheon, L., 1994. The post always rings twice: the postmodern and the postcolonial. *Textual Practice,* 8(2) pp. 205–238.

Karp, I., Kreamer, C.M. and Lavine, S.D., 1992. *Museums and Communities: The Politics of Public Culture.* London: Smithsonian Institution Press.

Kavanagh, G., 1990. *History Curatorship*. Washington DC: Smithsonian Institution Press.

Kaye, F.W., 2003. *Hiding the Audience: Viewing Arts & Arts Institutions on the Prairies*. Edmonton: University of Alberta Press.

Kreps, C.F., 2003. *Liberating Culture. Cross-cultural Perspectives on Museums, Curation and Heritage Preservation*. London: Routledge.

Krmpotich, C. and Anderson, D., 2005. Collaborative exhibitions and visitor reactions: The case of Nitsitapiisinni: our way of life. *Curator*, 48(4) pp. 377–405.

Krmpotich, C. and Peers, L., 2013. *This is Our Life: Haida/material Heritage and Changing Museum Practice*. Vancouver: UBC Press.

Lawlor, M., 2006. *Public Native America: Tribal Self-Representations in Casinos, Museums, and Powwows*. London: Rutgers University Press.

Lewis, C.M., 2005. *The Changing Face of Public History: The Chicago Historical Society and the Transformation of an American Museum*. Illinois: Northern Illinois University Press.

Lonetree, A., 2012. *Decolonizing Museums: Representing Native America in National and Tribal Museums*. Chapel Hill: University of North Carolina Press.

Lonetree, A. and Cobb, A.J., 2008. *The National Museum of the American Indian: Critical Conversations*. London: University of Nebraska Press.

Lynch, B.T., 2010. *Whose Cake Is It Anyway? A Collaborative Investigation into Engagement and Participation in 12 Museums and Galleries in the UK*. [Online] Paul Hamlyn Foundation. Available at: http://www.phf.org.uk/page.asp?id=1417

Lynch, B.T., 2011. Collaboration, contestation, and creative Conflict. On the efficacy of museum/community partnerships. In J. Marstine, ed., *The Routledge Companion to Museum Ethics. Redefining Ethics for the Twenty-First-Century Museum*. London: Routledge, pp. 146–163.

Lynch, B.T. and Alberti, S.J.M.M., 2010. Legacies of prejudice: racism, co-production and radical trust in the museum. *Museum Management and Curatorship*, 25(1) pp. 13–35.

Marstine, J., 2011. The contingent nature of the new museum ethics. In J. Marstine, ed., *The Routledge Companion to Museum Ethics. Redefining Ethics for the Twenty-First-Century Museum*. London: Routledge, pp. 3–25.

Martin, M., 2001. *A Long Look at Nature: The North Carolina State Museum of Natural Sciences*. Chapel Hill: The University of North Carolina Press.

Mason, R., 2006. Cultural theory and museum studies. In S. Macdonald, ed. *A Companion to Museum Studies*. Oxford: Blackwell, pp. 17–32.

McCarthy, C., 2007. *Exhibiting Māori: A History of Colonial Cultures of Display*. Oxford: Berg & Te Papa Press.

McCarthy, C., 2011. *Museums and Māori: Heritage Professionals, Indigenous Collections, Current Practice*. Walnut Creek: Left Coast Press.

Meijer Drees, L., 1993. "Indian's Bygone Past:" The Banff Indian Days, 1902–1945. *Past Imperfect*, 2 pp. 7–28.

Mithlo, N.M., 2004. "Red Man's Burden": the politics of inclusion in museum settings. *The American Indian Quarterly*, 28(3&4) pp. 743–763.

Mithlo, N.M., 2006. American Indians and museums: The love/hate relationship at thirty. In *Museums and Native Knowledges*. [Online] Arizona State University. Available at: http://nancymariemithlo.com/American_Indians_and_Museums/

Montana Gov, 2015. *Blackfeet Nation*. [Online] Montana Governor's Office of Indian Affairs. Available at: http://tribalnations.mt.gov/blackfeet

Onciul, B.A., 2013. Community participation, curatorial practice and museum ethos in Canada. In V. Golding and W. Modest, eds. *Museums and Communities: Curators, Collections and Collaboration*. London: Berg Publishers.

Peers, L., 2007. *Playing Ourselves: Interpreting Native Histories at Historic Reconstructions*. Plymouth: AltaMira Press.

Peers, L. and Brown, A.K., ed., 2003. *Museums and Source Communities: A Routledge Reader*. London: Routledge.

Peers, L. and Brown, A.K., 2007. Museums and source communities. In S. Watson, ed. *Museums and their Communities*. London: Routledge, pp. 519–537.

Phillips, R.B. 2011. *Museum Pieces: Towards the Indigenization of Canadian Museums*. London: McGill-Queen's University Press.

Povinelli, E.A., 2002. *The Cunning of Recognition: Indigenous Alterities and the Making of Australian Multiculturalism*. Duke University Press.

Pratt, S., 2013. *George Catlin: American Indian Portraits*. London: National Portrait Gallery.

Reid, G., 2002. *Head-Smashed-In Buffalo Jump*. Revised ed. Calgary: Fifth House Ltd.

Rivard, R., 1984. *Opening up the Museum—Toward a New Museology: Ecomuseums and 'Open' Museums*. Quebec City: Published by the author.

Sandell, R., 2007. *Museums, Prejudice and the Reframing of Difference*. London: Routledge.

Siksika Nation, 2011. *Oki, (Welcome) Official Website of the Siksika Nation*. [Online] Available at: http://www.siksikanation.com/

Simpson, M.G., 1996. *Making Representations: Museums in the Post-Colonial Era*. London: Routledge.

Simpson, M.G., 2006. Revealing and concealing: museums, objects, and the transmission of knowledge in Aboriginal Australia. In J. Marstine, ed. *New Museum Theory and Practice. An Introduction*. Oxford: Blackwell Publishing, pp. 153–177.

Simpson, M.G., 2007. Indigenous heritage and repatriation—a stimulus for cultural renewal. In M. Gabriel and J. Dahl, eds. *UTIMUT: Past Heritage—Future Partnerships: Discussion on Repatriation in the 21st Century*. Copenhagen/Nuuk: IWGIA/NKA, pp. 64–77.

Simpson, M.G., 2009. Museums and restorative justice: heritage, repatriation and cultural education. *Museum International*, 61 pp. 121–129.

Sleeper-Smith, S., ed. 2009. *Contesting Knowledge: Museums and Indigenous Perspective*. London: University of Nebraska Press.

Smith, L., 2006. *Uses of Heritage*. London: Routledge.

Tapsell, P., 2011. "Aroha mai: Whose museum?": The rise of indigenous ethics within museum contexts: A Maori-tribal perspective. In J. Marstine, ed. *The Routledge Companion to Museum Ethics. Redefining Ethics for the Twenty-First-Century Museum*. London: Routledge, pp. 85–111.

The Eleanor Luxton Historical Foundation, 2010. *Family—Norman Luxton*. [Online] The Eleanor Luxton Historical Foundation. Available at: http://www.luxtonfoundation.org/index.php?page=family/norman

Vergo, P., ed., 1989. *The New Museology*. London: Reaktion Books Ltd.

Vizenor, G., 1999. *Manifest Manners: Narratives on Postindian Survivance*. Lincoln: Nebraska.

Vizenor, G., 2007. *Literary Chance: Essays on Native American Survivance*. València: Universitat De València.

Wakeham, P., 2008. *Taxidermic Signs. Reconstructing Aboriginality*. Minneapolis: University of Minnesota Press.

Waterton, E. and Watson, S., eds., 2011. *Heritage and Community Engagement: Collaboration or Contestation?* London: Routledge.

Watson, S., 2007. Museum communities in theory and practice. In S. Watson, (ed.), *Museums and Their Communities*. London: Routledge, pp. 1–23.

Witcomb, A., 2003. *Re-Imagining the Museum: Beyond the Mausoleum*. London: Routledge.

1 Indigenous Peoples and International Museology

We've had systemic prejudice against First Nations in Canada since Canada began, although a lot of people don't admit it.

(Interview, Janes 2008)

In much engagement work in museums today, there seems to be little realization of what such contact actually entails, and how fraught with suppressed anger and emotion it can be.

(Lynch 2011:150)

For many Indigenous peoples museums can imbue strong emotional responses, from anger and sadness to joy, because ethnographic collections are connected with the traumas of colonial conquest and yet provide a direct link to pre-colonial life. The paradoxical duality of their roles makes museums key sites for post-colonial debate, as they embody colonial narratives whilst having the potential to decolonise the history of former colonial states. For Indigenous people museums can be viewed as culpable bodies of former colonial oppression who continue to keep cultural material beyond source community reach. Yet they are also invaluable resources as store houses of materials that are often vital to the survival and revival of cultural practices. Museums are also desirable platforms for Indigenous voice, presenting opportunities to re-examine the past and present.

Western museums and their practices arrived in Canada with colonialism. The occupation and conquest of Indigenous peoples by European colonial powers supplied museums in Europe with collections from around the globe. Methods of collection and display were used to help justify European aggression and naturalise their dominance over the Indigenous peoples they conquered, oppressed and killed. Consequently, modern collaboration between Indigenous communities and museums is frequently complicated by difficult colonial histories and strong emotions which make engagement a sensitive and complex process.

This chapter gives a brief overview of the international context and colonial history of museums and highlights some key Indigenous protests that

have shaped museum practice. In particular, examples are drawn from the English speaking former British colonies of Canada, America, New Zealand and Australia as the Indigenous people in these countries share similar experiences of being colonised and becoming culturally distinct minorities within their own lands. Although there are many differences between the peoples, their cultures and their countries, these nations tend to dominate the Anglophone literature on museums, new museology and Indigenous peoples, therefore it is useful to briefly explore this background to place current Albertan museum engagement with Blackfoot communities into its historical, political and geographical context.

CONTACT EXPERIENCE

As the 'New World' was 'discovered' and colonised, Europeans first impressions of Indigenous peoples were generally formed through the fragments brought back by explorers. Descriptions, artistic depictions, objects, human remains and even living people were collected to inform European audiences about 'new found worlds'. 'The earliest representations of Native Americans available to European publics were rare illustrated books about the "New World"' (Maurer 2000:15). Many of these first impressions permeated the collective imagination and persist to this day despite their colonial subtext and frequent inaccuracies. For example, in 1505 a German book *The People of the Islands Recently Discovered* showed images of 'Carib Indian men and women dressed in feathered headdresses' cooking a meal of human limbs (Maurer 2000:15–16). The uncivilized, exotic, feathered Indian became the iconic image that 'remained popular throughout the seventeenth and eighteenth centuries' (Maurer 2000:16–17). Even today feathered headdresses are erroneously used as an icon representative of all the diverse Indigenous communities of North America. Similarly the term 'Indian' is a misnomer that has perpetuated for more than five hundred years, based on a European navigational miscalculation. Since contact Indigenous peoples have had to fight European misconceptions and stereotypes that have sought to render them as less-than-human, savage, uncivilised and doomed to die out physically or at least culturally through assimilation.

Early paintings of the 'New World' were enhanced through the exhibition of living people transported to Europe for display. In 1551 a number of Indigenous Brazilians were brought to Rouen, France, to demonstrate their cultural practices for the French King Henri II (Maurer 2000:18). 'In 1577, Frobisher brought a group of Baffin Island Inuits to England to promote his voyages' and demonstrate their cultural traditions and life ways (Maurer 2000:19). Initial exports of Indigenous peoples to Europe often had tragic consequences as many died from European diseases or as a result of the long voyages they had to endure. Although some people came willingly, human display was often characterised by derogative and dehumanising

frames of display. Saartjie Baartman has been cited as a key example of the display of 'Others' as freaks and exotic, erotic curiosities (Wels 2004; Strother 1999; Abrahams 1998; Gilman 1985; Gould 1982). Known as the Hottentot Venus, she was a member of Khoisan peoples of South Africa, who at that time 'were considered by anthropologists to be the race closest to primate monkeys, together with Australian Aborigines' (Wels 2004:83). In 1810 Baartman was sold as a slave for display in London and France. After experiencing considerable mistreatment she died in 1815 at the age of 25 and was quickly 'collected' once more: anatomist George Cuvier examined, plaster casted and dissected her body, rendering her parts, bones and casts 'suitable' for museum collection, where she remained on display until 1980s, finally returning to her community 192 years after her death in 2002 (Wels 2004:83).

Following the colonial discourse of the day, collections were made to 'salvage' the remains of cultures 'doomed' to extinction. In North America 'the dominant view was that Indian cultures were in varying stages of decay, and museums had to rush to preserve evidence of pre-contact peoples' (Hill 2000:103). There was some substance to these claims as contact diseases had devastating effects with 'estimated post-contact population losses in the Americas as high as 85–90 percent' (Sundstrom 1997:306). Similarly in New Zealand, 'a prime motivation was to acquire the unique objects from what many Europeans believed was a dying race' the Māori (Hakiwai 2005:154).

Indigenous cultural material, sacred items and human remains were increasingly brought into public and private collections as both 'curio and exotica' and for scientific documentation. Such collection echoed and reinforced colonial power relations and narratives of ownership of formerly free and independent Indigenous peoples and lands. They helped to demonstrate Western superiority whilst justifying colonial practice by dehumanising colonised Indigenous peoples. 'Collecting, as a process of ordering and classification, was thus not only a means of salvaging the material traces of disappearing cultures, it was also used to confirm existing theories about social evolution' (Brown 2014:3). Thus museums were active participants in colonisation, both reflecting and building the colonial societies of their day. As Hutcheon articulates:

> The history of most European and North American ethnographic museum collections is one that cannot easily be separated from the specific history of imperialism. Not only were the objects collected often the spoils of colonial conquest (seen at the time as 'discovery' and 'exploration'), but their acquisition and retention have been legitimised by the institutionalization of an ideal (and an ideology) of apolitical, detached objectivity and a positivist commitment to science.
>
> (1994:206)

Items collected during this period are imbued with contention. Stolen, confiscated, unearthed, traded, gifted and bought, cultural material and human remains entered collections and were lost to their source communities. Simpson argues that 'to many Indigenous peoples, Western-style museums are laden with associations of colonialism, cultural repression, loss of heritage, and death' (2006:153).

The asymmetrical power relations imposed by colonialism prevented 'fair trade'. In New Zealand colonialism created a new trade in *moko mokai* (cured head of captured male enemy) and 'by 1830, hundreds of *moko mokai* had been internationally traded via Sydney, Australia, finding their way into major European and North America private collections and museums' (Tapsell 2005:156).

> The pre-1840 dark years of Māori inter-tribal musket warfare provided opportunity for kin adversaries not only to settle old scores, but also to debase the heads of their enemies as trade items with foreigners. The better they were tattooed, the greater the price they fetched—measured in muskets, powder, and shot—thus improving the opportunity to capitalise on one's enemies even further.
>
> (Tapsell 2005:156)

Franz Boas, often called the 'Father of American Anthropology' (Mithlo 2004:749), facilitated the movement of cultural and human material from Canadian First Nations communities to museums:

> Boas's second Northwest Coast visit in May 1888, funded by the Canadian government, had as its emphasis in physical anthropology—the collection of Native American skulls and skeletons, specifically from British Columbia . . . Boas paid $20.00 for a complete skeleton and $5.00 for a skull resulting in a collection of two hundred crania valued at $1,600.00. The collection was eventually accessioned at the Chicago Field Museum in 1894.
>
> (Mithlo 2004:749–750)

In America, Richard W. Hill, Sr. notes that in the past:

> Museums felt that if they discovered an Indian body in the ground, they could claim it for science. All objects made by ancient Indians were thought to belong to the archaeologists who discovered them.
>
> (Hill 2000:103)

The problematic colonial nature of early collecting has resulted in current situations where 'many museum curators find themselves entrusted with the care of material that evokes powerful emotional responses in their source or home communities' (Racette 2008:57).

FORMING NEW NATIONAL IDENTITIES

While relations between museums and Indigenous people were initially performed at a great distance with collectors acting as go-betweens, colonisation and settlement brought European and Indigenous cultures into increasing proximity making exoticizing and 'Othering' colonised people crucial to creating conceptual distance between the two.

> By the mid-nineteenth century, museums were used as educative and ideological tools that displayed Western culture as the triumphant culmination of all life forms on the planet, especially in its superiority to other human cultures, which were seen as less developed and hence inferior.
>
> (Gillam 2001:XV)

Dicks suggests that there is a continuum of difference between 'Us' and 'Other' that affect peoples' experience of heritage. Histories of other peoples and other cultures, she argues, are the furthest from self and are the 'Other' (Dicks 2003:127). The level of 'Otherness' is influenced by the distance between the two in terms of geography, culture and time. By locating Indigenous people as 'uncivilised' and from a pre-historic past, colonial discourse 'Othered' and distanced colonised people from new settlers in the land.

Tony Bennett notes that in the late 19th century Aboriginal Australians were located by archaeologists and evolutionists as 'evolutionary ground zero', from which all people developed and 'civilized' (2004:9). They were presented as the most distant 'Others' to Europeans, which helped Europeans' justify their colonisation.

> Australia came to be regarded as a place where extinct, or soon-to-be extinct, forms of life survived in the separated enclaves of Aboriginal reserves where the race was supposed to live out its last days. Yet this view of Australia as a 'living museum' lasted well into the twentieth century, and certainly beyond the period of 'let die' policies directed at softening the pillow of a dying race to the 'let live' programmes of assimilation in which the goal of biological elimination, however 'passively' pursued, was transformed into one of cultural and epidermal transformation.
>
> (Bennett 2004:155–6)

As the colonies started to form their own identities based on settler populations, attempts were made to present these as distinct from their European origins. Representation in museums was a key part of establishing and authorising new identities, narratives and founding myths.

The 'first' museum in North America was the Charleston Museum, a natural history collection established in 1770. In Canada a 'Lyceum of

Natural History and Fine Arts in the City of York' was proposed to the Upper Canada Assembly in 1833, and a provincial museum that would eventually become the Royal Ontario Museum was actually established in 1851.

(Kaye 2003:96)

Museums were a tool new nations could use to present and define their identity. 'National museums promote national histories to generate a sense of identification and patriotism within their population' (Mason 2007:95).

In many developing nations, collections and the institutions have been established to promote unity and a national consciousness, on the pattern of Western nation-state. Nowhere is this nationalist agenda more prominent than in Canada, a country that has formidable problems defining itself as a unified whole.

(Gillam 2001:XXII)

Despite new settler museums being built on traditional Indigenous territories, they continued to distance source communities from their cultural material by removing it from community to museum control for display or storage in new urban centres. These museums also continued to interpret Indigenous cultures through a Eurocentric lens for Western audiences, whilst colonial authorities suppressed living Indigenous cultural practices.

CULTURAL SUPPRESSION

As the colonial assumption that all Indigenous people were destined to extinction began to be proven false, colonial policy shifted to focus on eliminating 'uncivilized' Indigenous cultures through assimilation. In New Zealand, in 1880s there was a period of 'recolonisation' as policy shifted from '"smoothing the pillow" of a dying race' to 'rehabilitation and assimilation' (McCarthy 2007:39–40).

Assimilation policies had devastating effects on Indigenous communities and their traditional lifestyles. In Canada and America Indigenous people were placed on reserves and reservations and lost access to their traditional territories. Communities in Canada, America, Australia and New Zealand were shattered by the forceful removal of their children to residential schools, where they were required to abandon their traditional culture in favour of European customs, English language and Christianity. Residential schools prevented the traditional intergenerational transfer of knowledge and material within communities. Colonial laws forbade Indigenous cultural practices, including ceremonies, dances and clothing. These policies reduced Indigenous peoples' ability to maintain their culture, nor control its

representation. During this period of cultural oppression and poverty many items were collected for museums.

In Canada the government used laws such as the *Indian Act* (first enacted in the Canadian Constitution Act of 1867, then legislated in 1876) to oppress First Nations culture. The 1884 amendment to the *Indian Act* created Section 149 commonly known as the Potlatch Law which criminalised two Northwest Coast ceremonies the Potlatch and the Tamanawas: attendance and participation was punishable by a prison sentence of two to six months (Racette 2008:58). This amendment supplied collectors with confiscated cultural material. In 1921 the first arrests under the Act were made in Alert Bay, British Columbia.

> During that initial arrest and subsequent raids, masks, coppers and other valuable ceremonial items were confiscated and disappeared into private and public collections . . . Under this law, an enormous amount of cultural property was seized and sold.
>
> (Racette 2008:58)

Amendments to the *Indian Act* made it increasingly oppressive, banning the Sundance and other ceremonies in 1895 under section 114, and public appearances in traditional dress in 1914 (Smith 2014:96–97; Racette 2008:58). Deputy Superintendent of Indian Affairs from 1913–1932, Duncan Campbell Scott, 'secured successive pieces of legislation that culminated in the most oppressive period of First Nations history in Canada' (Racette 2008:58).

> The first half of the twentieth century was a time of extreme disempowerment and poverty. Many collectors visited Aboriginal communities during this time and found people willing to sell possessions that they might otherwise never have parted with.
>
> (Racette 2008:59)

As the perceived threat of Indigenous peoples to settlers reduced, and colonisation and assimilation were seen to be working, the stereotypes of 'wild savages' of the contact period were re-imagined into the idea of 'noble savages', and romanticised views of the pre-contact period became popular. In New Zealand, McCarthy notes that 'in the late nineteenth century, the same objects [that were rejected] received a more positive response from Pakeha [non *Māori*] viewers as the image of the noble savage displaced the ignoble one in the colonial culture of display' (2007:26).

The paradoxical celebration and oppression of Indigenous culture by colonial powers created a legacy that continues to influence relations between Indigenous peoples and museums today. Source communities often resent museums for collecting and thus removing important cultural and sacred material from their communities, which prevented certain cultural practices

from being maintained. Conversely, the survival of such material in museums has enabled suppressed cultural practices to be revived, such as some of the Blackfoot sacred bundle openings as Elder Pam Heavy Head explained: 'our Medicine Pipe didn't dance for 75 years because it ended up in the hands of collectors' (Interview Heavy Head 2008). As Hill notes 'culture is, indeed, more than objects, but for many Native American nations, there are certain objects that are essential to manifesting that culture' (2007:313).

Thus Indigenous communities often have complicated relationships with museums, because they are a source of anger and hope. David Penney (2000) captured this conflict in his description of responses to the 1992 exhibition *Art of the American Indian Frontier: The Collecting of Chandler-Pohrt* at the National Gallery of Art in Washington, D.C.:

> Many Native visitors to the galleries could not look at the collections without being reminded of what they had lost. Some supported the museum's efforts to approximate some kind of recovery. . . . Others, like the protesters, simply could not proceed beyond their anger.
> (Penney 2000:61)

The anger Indigenous people feel towards museums is often linked to ongoing inequalities in society. The traumas of the past continue to affect Indigenous peoples, and governments have shown some recognition of this through public statements of apology for elements of their colonial pasts, such as the residential school era in Canada and the stolen generations in Australia. Indigenous people still tend to be at the lowest socio-economic levels in society, be it in life expectancy, political representation, employment, disease, substance abuse, violence or just in the way the wider, non-Indigenous public perceives them. Indigenous people in Canada still remain largely segregated on reserves where the quality of life is considerably lower than the neighbouring non-Indigenous communities. Museums cannot resolve these inequalities, but they can help to address them through re-contextualising the history that informs current relations and decolonising the display of Indigenous peoples.

RESISTANCE, PROTEST AND AGENCY

Although colonised, Indigenous peoples have continually demonstrated their resistance, resilience and agency. Conal McCarthy's (2007) research has demonstrated the presence of Māori involvement in museums at many different levels from the moment museums began representing them. He argues their agency came from their control over source materials, knowledge and skills. Māori were called upon to carve items for exhibits, interpret customs and even perform as part of exhibitions.

In 1851 a new mode of exhibiting began in London at the Crystal Palace with the opening of the first world fair. These fairs gave the colonies the

chance to represent their own distinct identity and colonies often repre-
sented the Indigenous peoples and cultures within their territories as unique
and iconic elements of their new identity, whilst suppressing the cultures at
home.

> Native peoples of North America were featured in the Canadian section
> of the exposition. A guidebook described a selection of objects as being
> made by 'Canadian savages' and noted their contrast to products of
> English civilisation. These persistent colonialist attitudes influenced the
> presentation of Native Americans and their cultures, showing them to
> be of less value than their European counterparts.
>
> (Maurer 2000:21)

Despite the representation of First Nations cultures as lower in status
than European cultures, the involvement of living Indigenous peoples in
exhibitions provided an opportunity for them to voice their views and have
some control over the way they were represented on a world stage. McCar-
thy notes that: 'by participating in local and international fairs, Māori saw
themselves as partners in colonial development rather than as subjects of it'
(McCarthy 2007:38). However, 'when real *Māori* proved to be too much
of a handful or refused to live up to their ethnic stereotype, wax models
were found to be a much more malleable substitute, their mortuary pallor
signifying their fate in a much more acquiescent way' (McCarthy 2007:42).

In Canada, First Nations peoples resisted assimilation, continued cul-
tural practices, and publicly challenging colonial practices despite increasing
oppression and control through colonial legislation such as the *Indian Act*.
For example, when Boas visited the Northwest Coast in May 1888 to collect
human remains, 'the Cowichan people hired a lawyer to press claims against
Boas and his assistant for their activities and even secured a search warrant
for the bones' (Mithlo 2004:751). Although their claim was unsuccessful, it
demonstrates that despite biased power relations, the Cowichan people had
agency and used it to oppose the collection of their ancestors' remains. The
depiction of Indigenous people as passive victims of colonialism is a colo-
nial narrative. Power was not simply unidirectional, and Indigenous people
resisted in many different ways, some subtle, others bold.

First Nations, such as the Stoney Nakoda, found ways to maintain their
culture and ceremonies, both covertly and openly. Norman Luxton (founder
of the Buffalo Nations Luxton Museum) was one of the organizers of Banff
Indian Days, a week of First Nations festivities designed to attract tourists.

> His enterprises provided the Stoneys with cash for their craft items,
> and like the Calgary Stampede, with an officially sanctioned venue for
> ceremonies—as long as they conformed to feathered, beaded, dancing
> stereotypes—that had been proscribed by the government. . . . Despite
> their exploitation of Native peoples as spectacle, Wild West Shows,

Indian Days celebrations, and stampedes were small safe havens in a time of assimilation and a market for traditional crafts, ensuring the preservation of art and craft skills during periods of extreme economic and cultural hardship.

(Kaye 2003:106)

Early forms of self-representation often occurred within bigger colonial frames, such as the Calgary Stampede in Canada. From the first Stampede in 1912 local Treaty 7 First Nations peoples, including the Blackfoot, were encouraged to live within the grounds for ten days in an 'Indian Village' were they could represent themselves to the visiting public. Special permits were issued to allow the participants to leave the reserves. Although power relations were typically paternalistic and First Nations were treated as second-class compared to their white counterparts, the village became a tradition, which continues today, as it allowed families segregated on different reserves to gather together and practice their culture.

At the first Stampede in 1912 traditional Blackfoot life received attention and interest, while on the reserve traditional life was increasingly being suppressed, outlawed and ridiculed by the dominant society. Thus a complex paradoxical relationship developed between colonised and coloniser, as Canada wished to both claim the 'Native' as their own whilst working to eradicate Indigenous cultural identity.

While some ceremonies went 'underground' and others found safe havens hidden within public celebratory events, it was not until the 1950s and 60s that the balance of power began to shift to enable Indigenous cultures to come out of the colonial shadows.

In 1951 an amendment to the *Indian Act* in Canada ended the ban on First Nations ceremonies (Smith 2014:232) and in 1960 First Nations people were declared to be Canadian citizens, gaining the right to vote. By the late 1960s First Nations and Native American people were adding their voice to the civil rights movements and Indigenous resistance started to gain public attention. Beginning with the occupation of Alcatraz in 1969 and the emergence of the Indians of All Tribes, the American Indian Movement (AIM), and other pan-Indian political groups, a series of landmark events, including the Trail of Broken Treaties, the occupation of the Bureau of Indian Affairs in 1972, and the standoff at Wounded Knee in 1973, flung Indigenous issues into the public spotlight and 'shaped a pan-tribal political force' (Lawlor 2006:7). Protesters and activists such as AIM spoke out against the status quo and the unequal treatment of Native Americans. They raised issues over the treaties that had not been honoured, the poor socio-economic status of Indigenous peoples and the government's interference in their lives. They called for the right to self-determination, to control their own lives, culture and affairs.

'For most of the long history of Canada's internal colonisation of its Aboriginal peoples the power to determine how that history is recounted has been vested in a narrow stratum of the non-native population' (Phillips

2006:134). The new wave of Indigenous activism challenged this norm. 'In the latter decades of the twentieth century, Indigenous peoples around the world challenged the right of museums to tell their stories and to hold collections obtained from their ancestors' (Nicks 2003:19). These protests catalysed a new surge of Indigenous agency and resistance to traditional museums.

> Native interests . . . took institutional form with the creation of the American Indian Studies programmes in universities across the country and the establishment of what are still essential organs of trans-tribal Native legal and political life, the Native American Rights Fund, the Indian Law Resource Centre, and the National Congress of American Indians.
>
> (Lawlor 2006:7–8)

Political protests and concepts of self-determination began to influence Indigenous community relations with museums. In New Zealand, in the early 1980s, the Māori 'successfully challenged the "civilized" practice of placing dead on display, finally giving voice to the geographically isolated elders' (Tapsell 2005:153). The resolution of this conflict between museums and communities enabled a new relationship to develop. '*Te Māori* was born out of this era, and demonstrated a new way for museums to engage with its audiences, allowing the native voice to enter the exhibition space' (Tapsell 2005:153). In 1998 a new museum called Te Papa was opened after extensive consultation with *iwi* (Māori tribal groups) and sought to represent the bicultural and bilingual nature of New Zealand (Te Papa, 2008). Te Papa has been described as an 'ultimate expression' of new museology (McCarthy 2007:119).

Attempts to disrupt traditional grand narratives, national founding myths, and to decolonise museums have sparked controversy. In Australia, the National Museum of Australia suffered a backlash in the media when they presented colonial history which people found controversial (Casey 2007:292). 'The museum came under fire from the press for vilifying white Australians and presenting distorted views of modern Australian history' (Dean and Rider 2005:37). The government issued a *Review of Exhibitions and Programs* to 'investigate whether the Museum had fulfilled its obligations under the 1980 statute and whether 'the Government's vision . . . has been realised' (Dean and Rider 2005:38). This controversy highlights that state sponsored museums are expected to 'carry the authoritative stamp of . . . government' (Carnegie 2006:74). However, it also illustrates that museums can, as Bennett argues, change from *within* (Bennett 1995, 1998). This change was supported by the results of the *Review of Exhibitions and Programs* that actually 'congratulated the Museum for its displays on the first Australians' which had been the source of much of the controversy (Dean and Rider 2005:38).

In 1990 the American government responded to complaints and protests by Native Americans against the collection and display of their ancestors, and passed the *Native American Graves Protection and Repatriation Act* (NAGPRA) (Dubin 2001:22–23). The act requires American museums that receive federal funding to conduct inventories of their Native American collections and repatriate human remains, associated funerary objects, sacred objects and cultural patrimony to linear descendants or culturally affiliated tribes or organisations (NAGPRA 1990:169). The Act requires museums to consult with the Indigenous source communities throughout the process and has resulted in human remains and sacred objects being removed from public display and returned to their source communities. Statistics from October 2007 show that the act has enabled the 'accounting for 32,706 human remains' through museum inventories, which is the first step to enable these remains to be repatriated (National Park Service 2007:5). This was a crucial step in addressing community-museum relations as:

> Undoubtedly the most important of the abuses from the Native point of view is the desecration of Indian burials, the display of their skeletons in museum exhibits, and the storage of an estimated 300,000 to 600,000 bodies in museum archives. . . . No other ethnic group in the USA has been treated in this manner.
>
> (Blancke 1990:125)

In Canada, museum representation of First Nations reached a crisis point after there was protesting and a mass boycott of *The Spirit Sings* exhibition at the Glenbow museum in 1988 (McLoughlin 1999:3). Initially the protest focused on a specific Lubicon-Cree land claim issue with the exhibit sponsors Shell Oil (Herle 1994:39), but it quickly escalated into an international discussion of the role museums play in settler/Indigenous relations.

> The boycott did a great deal to raise awareness of the issues, and as a result of the conflict, the Assembly of First Nations (AFN) and the Canadian Museums Association (CMA) formed a task force with a mandate to 'develop an ethical framework and strategies for Aboriginal Nations to represent their history and culture in concert with cultural institutions'.
>
> (Report of the Royal Commission on
> Aboriginal Peoples 1996:554)

After years of discussion, meetings, and consultation with Indigenous communities and museums, AFN and CMA published the *Task Force Report on Museums and First Peoples* (1992a, 1992b).[1] It provided guidelines for museums working with First Nations communities and their cultural materials. 'The Task Force recommendations were based on the fundamental principle that First Peoples own or have moral claim to their heritage and therefore should participate equally in its preservation and presentation'

(Ames 2000:74). The report encouraged museums to involve Indigenous communities they sought to represent 'in the interpretation of their culture', and to improve 'access to museum collections' for Indigenous people, and to enable the 'repatriation of artefacts and human remains' (Carter 1994:221).

In 1992 the Canadian government made it a requirement for 'museums to provide letters of support from First Nations communities being represented when applying for government grants' (Phillips 2003:159) to help support the Task Force Report. However, Canada does not have a national law like NAGRPA, as it was decided by AFN and CMA that voluntary compliance would be more effective (AFN and CMA 1992a:4).

These changes have made important steps to improving museum relations with Indigenous communities, although they are not without problems. Sharing the power over and authorship of museums with communities is a challenge to museum staff's professional authority (Ames 2000:82) and as Harrison has pointed out 'there is still much anger in the native community towards museums, and one Task Force is not going to make it go away' (Harrison 1992:11). One problem with the Task Force Report is the balance of responsibility for change. As Doxtator argues: the report 'ascrib[ed] most of the responsibilities . . . to non-native museums' and gave aboriginal peoples a passive role in the changes (1996:21–22).

Although it was 'thought that voluntary compliance to recommendations mutually agreed upon by First Peoples and museum representatives would be more effective and less expensive than the legislative change brought about in the United States', 'the results so far . . . appear to be modest' (Ames, 2000:85). Ames attributes this to 'structural factors that inhibit change' within the museum culture and profession and the dependence of such initiatives on funding (2000:85–86). Although Carter demonstrated in her article in 1992 that many of the Task Force Report recommendations could be carried out through an investment of time rather than money (Carter 1992) funding is always a key issue for museums. Alison Brown notes that even today:

> . . . many First Nations people and museum staff in Canada would agree that more equitable working relationships, which may include the co-management of collections and better integrated indigenous concepts of collections care, are still a long way off and may not be possible or desirable. Not all First Nations are in a position to establish working relations with museums even if they want to.
>
> (Brown 2014: 8–9)

Despite the modest gains, the political disputes associated with the 1988 *Spirit Sings* exhibition changed the way Canadian museums viewed themselves. 'Suddenly, it seemed, we had become "political" institutions and it became necessary to open the doors to the people from whom our collections were derived' (Conaty 2006:254).

SELF-REPRESENTATION

As museums began to 'open their doors' to Indigenous communities to co-curate representation, communities were also increasingly representing themselves through their own means, such as community centres and heritage parks. Such self-representation is not new, but increasingly prolific. 'Contrary therefore to the assumption that national museums go hand-in-hand with states wishing to impose hegemonic cultural ideologies, museums can also be enlisted by non-state groups as a means of asserting themselves in opposition to dominant powers' (Mason 2007:95). Indigenous Nations within settler nations used museum-like-forms to challenge dominant national historical discourses.

> Many native museum-like facilities refuse to use the word museum in the name of their facility, and often their museum-like centres operate differently than museums have typically done . . . This refusal to use a word that visitors would readily understand represents a subtle protest, an act caused by aversion, directed at the institution known as museum.
>
> (Cooper 2008:155)

Community centres attempt to resist the hegemonic influence of Western museology, and maintain Indigenous processes and control. Smith has argued: 'the export of the Western European model of heritage management around the world has been identified as part of the processes of Western colonization, and an expression of Western cultural imperialism, that has tended to result in the alienation of local communities from their cultural heritage' (2006:279). Thus resistance is both politically and strategically necessary if a community wishes to keep control of their culture.

At the same time, communities have been taking up opportunities to work with mainstream museums that wish to democratise and pluralise their displays and include community voice in interpretation.

> Some Canadian museums have stepped away from authoritative practices and have tried to initiate policies, operations and programming that integrate both formal and substantial cohesion. This has been especially successful in attempts to feature First Nations' perspectives in the national narrative.
>
> (Ashley 2007:493)

The Canadian Museums of Civilization (CMC) opened the First Peoples Hall in 2003 after eleven years of collaboration. 'A sharing of management and curatorial power between aboriginal and CMC participants resulted in a unique exhibition that juxtaposes standard ethnographic treatment and First Nations' perspectives on living cultures' (Ashley 2007:493).

However this is not entirely new as Conaty highlights: 'working closely with First Nations was not a truly novel concept' in the late 1980s, as

many Canadian museums had already been working collaboratively 'most often . . . quietly with little publicity' (Conaty 2006:254, 255). Early leaders in the field of Indigenous engagement and collaboration include the Museum of Anthropology at the University of British Columbia; the Royal British Columbia Museum; the Prince of Wales Northern Heritage Centre in Yellowknife in the Northwest Territories; Head-Smashed-In Buffalo Jump Interpretive Centre in Southern Alberta and the Wanuskewin Heritage Centre, near Saskatoon, Saskatchewan (Conaty 2006:254).

West, Director of the National Museum of the American Indian (NMAI), proposed that 'if the museum community can make [a] cultural shift', to 'foster the systematic inclusion of diverse cultural elements in their interpretive process', then:

> Museums have the chance to do even more than become centres for the exchange of cultural ideas. They will have the potential to assume a role that ascends to an entirely new plane—they will become far more pivotal to the continuing evolution of culture, and genuine instruments of the cultural reconciliation the society so desperately needs.
>
> (West 2000:102)

Although, as Mithlo notes, 'many may question if the museum has the power or even the right to be positioned in the role of saviour to cultures interpreted as disempowered' (Mithlo 2004:751), as Ames argues:

> If they are to serve as important mechanisms for empowering local communities to define, recognise, and develop their own indigenous heritages, they should first consider a potential contradiction contained within this initiative: museums specialize in the representation of other peoples, while people have the sovereign right to represent themselves. Left unresolved, this contradiction could produce counterfeits of good intentions.
>
> (Ames 2006:171)

Indigenous challenges to museums have continued to spark change and development of new relationships between museums and Indigenous communities. These changes have been supported by wider change and international recognition of Indigenous rights.

> All of these activities occurred within the context of a broader social, political and economic activism which has led, at the international level, to recognition by the United Nations that indigenous people have the right to self-determination, and, in consequence, the right freely to determine their political status and to pursue their economic, social and cultural development.
>
> (Nicks 2003:19)

In 2007 the United Nations contributed to discourse on museum and Indigenous relations by adopting *The Declaration on the Rights of Indigenous Peoples*. It states that 'Indigenous peoples have the right to maintain, control, protect and develop their cultural heritage, traditional knowledge and traditional cultural expressions' and should receive government funding to do so (UNESCO 2006). Four nation states voted against the declaration: Canada, Australia, New Zealand and the United States.

Current relations between museums and Indigenous communities are shaped and informed by events that have occurred between them in the past. Past wrongs are slow to be forgotten, and continue to cause pain and anger in Indigenous communities. Improvements in relations have occurred as a result of increased Indigenous involvement and activism, and ideas of multiculturalism and multivocality, which have made mainstream society gradually more receptive to counter-narratives. Legislation, reports, declarations and protests have helped to change and improve relations. The difficulties that remain are partly the result of cross-cultural misunderstanding and a failure to communicate with and comprehend one another, but more often the result of a history of unequal colonial relations and exploitation that continues in the present. By working with communities, museums can help to develop new relations with communities that have the power to improve the present lives of Indigenous people by recognising past wrongs and enabling Indigenous self-determination over their culture and heritage. 'These relationships are the most important manifestations of the new curatorial praxis' (Peers and Brown 2007:531). However they are lined with contradictions, layered with competing historical narratives and create new discourses and challenges of their own.

NOTE

1. Hereafter referred to as the Task Force Report.

REFERENCES

Abrahams, Y., 1998. Images of Sara Bartman: sexuality, race and gender in early nineteenth-century Britain. In: R. Roach Pierson & N. Chaud-huri, eds. *Nation, Empire, Colony: Historicizing Gender and Race*. Indiana: Bloomington, pp. 220–236.
AFN (Assembly of First Nations) and CMA (Canadian Museums Association), 1992a. *Turning the Page: Forging New Partnerships between Museums and First Peoples*. Task Force Report on Museums and First Peoples. Ottawa: Carleton University.
AFN (Assembly of First Nations) and CMA (Canadian Museums Association), 1992b. Task Force Report on Museums and First Peoples. *Museum Anthropology*, 16(2) pp. 12–20.
Ames, M.M., 2000. Are changing representations of First Peoples challenging the curatorial prerogative? In W.R. West, ed. *The Changing Presentation of the*

American Indian: Museums and Native Cultures. Washington: Smithsonian Institution, pp. 73–88.

Ames, M.M., 2006. Counterfeit museology. *Museum Management and Curatorship*, 21 pp. 171–186.

Ashley, S., 2007. State authorities and the public sphere: ideas on the changing role of the museum as a Canadian social institution. In S. Watson, ed., *Museums and Their Communities*. London: Routledge, pp. 485–500.

Bennett, T., 1995. *The Birth of the Museum: History, Theory, Politics*. London: Routledge.

Bennett, T., 1998. *Culture: A Reformer's Science*. London: Routledge.

Bennett, T., 2004. *Pasts beyond Memory: Evolution, Museums, Colonialism*. London: Routledge.

Blancke, S. and Slow Turtle, C.J.P., 1990. The teaching of the past of the Native peoples of North America in US schools. In P.G. Stone and R. MacKenzie, eds. *The Excluded Past: Archaeology in Education*. London: Routledge, pp. 109–133.

Brown, A.K. 2014. *First Nations, Museums, Narrations: Stories of the 1929 Franklin Motor Expedition to the Canadian Prairies*. Vancouver: University of British Columbia Press.

Carnegie, E., 2006. 'It wasn't all bad': representations of working class cultures within social history museums and their impacts on audiences. *Museums and Society*, 4(2) pp. 69–83.

Carter, B., 1992. Let's act—not react: some suggestions for implementing the task force report in museums and First Peoples. *Alberta Museums Review*, 18(2) pp. 13–15.

Carter, J., 1994. Museums and indigenous peoples in Canada. In S. Pearce, ed. *Museums and the Appropriation of Culture*. London: The Athlone Press, pp. 213–226.

Casey, D., 2007. Museums as agents for social and political change. In S. Watson, ed. *Museums and their Communities*. London: Routledge, pp. 292–299.

Conaty, G.T., 2006. Glenbow Museum and First Nations: fifteen years of negotiating change. *Museum Management and Curatorship*, 21(3) pp. 254–256.

Cooper, K.C., 2008. *Spirited Encounters: American Indians Protest Museum Policies and Practices*. Plymouth: AltaMira Press.

Dean, D. and Rider, P. E., 2005. Museums, nation and political history in the Australian National Museum and the Canadian Museum of Civilization. *Museum and Society*, 3(1) pp. 35–50.

Dicks, B., 2003. *Culture on Display. The Production of Contemporary Visitability*. Maidenhead: Open University Press.

Doxtator, D., 1996. The implications of Canadian nationalism on Aboriginal cultural autonomy. In J. Davis, M. Segger and L. Irvine, eds. *Curatorship: Indigenous Perspectives in Post-Colonial Societies. Proceedings*. Hull and Calgary: Canadian Museum of Civilization with the Commonwealth Association of Museums and the University of Victoria, pp. 56–76.

Dubin, M., 2001. *Native America Collected: The Culture of an Art World*. Albuquerque: University of New Mexico Press.

Gillam, R., 2001. *Hall of Mirrors: Museums and the Canadian Public*. Banff: The Banff Centre Press.

Gilman, S., 1985. Black bodies, white bodies: toward an iconography of female sexuality in late nineteenth century art, medicine and literature. *Critical Inquiry*, 12(1) pp. 204–242.

Gould, S.J., 1982. The Hottentot Venus. *Natural History*, 10 pp. 20–24.

Hakiwai, A.T., 2005. The search for legitimacy: Museums in Aotearoa, New Zealand—a Māori viewpoint. In G. Corsane, ed. *Heritage, Museums and Galleries: An Introductory Reader*. London: Routledge, pp. 154–162.

Harrison, J.D., 1992. Turning the page: forging new partnerships between museums and First Peoples conference—personal reflections. *Alberta Museums Review*, 18(2) pp. 10–12.

Heavy Head, Pam. 18 Sept 2008. Interview. Fort Macleod.

Herle, A., 1994. Museums and First Peoples in Canada. *Journal of Museum Ethnography*, 6 pp. 39–66.

Hill, R.W. Sr., 2000. The Indian in the cabinet of curiosity. In W.R. West, ed. *The Changing Presentation of the American Indian: Museums and Native Cultures*. Washington: Smithsonian Institution, pp. 103–108.

Hutcheon, L., 1994. The post always rings twice: the postmodern and the postcolonial. *Textual Practice*, 8(2) pp. 205–238.

Janes, Robert (Bob). 14 Oct 2008. Interview.

Kaye, F.W., 2003. *Hiding the Audience: Viewing Arts & Arts Institutions on the Prairies*. Edmonton: University of Alberta Press.

Lawlor, M., 2006. *Public Native America: Tribal Self-Representations in Casinos, Museums, and Powwows*. London: Rutgers University Press.

Lynch, B.T., 2011. Collaboration, contestation, and creative conflict. On the efficacy of museum/community partnerships. In J. Marstine, ed. *The Routledge Companion to Museum Ethics. Redefining Ethics for the Twenty-First-Century Museum*. London: Routledge, pp. 146–163.

Mason, R., 2007. *Museums, Nations, Identities: Wales and its National Museums*. Cardiff: University of Wales Press.

Maurer, E.M., 2000. Presenting the American Indian: from Europe to America. In W.R. West, ed. *The Changing Presentation of the American Indian: Museums and Native Cultures*. Washington: Smithsonian Institution, pp. 15–28.

McCarthy, C., 2007. *Exhibiting Māori: A History of Colonial Cultures of Display*. Oxford: Berg & Te Papa Press.

McLoughlin, M., 1999. *Museums and the Representations of Native Canadians: Negotiating the Boarders of Culture*. London: Garland Publishing Inc.

Mithlo, N.M., 2004. "Red Man's Burden": the politics of inclusion in museum settings. *The American Indian Quarterly*, 28(3&4) pp. 743–763.

NAGPRA (Native American Graves Protection and Repatriation Act), 1990. (104 STAT. 3048 Public Law 101–601—Nov. 16 1990). Washington: U.S. Department of the Interior.

National Park Service, 2007. *National NAGPRA FY07 Final Report For the period October 1, 2006–September 30, 2007*. [Online] Available at: http://www.nps.gov/nagpra/documents/Reports/FY%2007%20Final%20Report%20final%20draft%20102207.pdf

Nicks, T., 2003. Introduction. In L. Peers and A.K. Brown, eds. *Museums and Source Communities: A Routledge Reader*. London: Routledge, pp. 19–27.

Peers, L. and Brown, A.K., 2007. Museums and source communities. In S. Watson, ed. *Museums and their Communities*. London: Routledge, pp. 519–537.

Penney, D.W., 2000. The poetics of museum representations: tropes of recent American Indian art exhibitions. In W.R. West, ed. *The Changing Presentation of the American Indian*. Seattle: University of Washington Press.

Phillips, R.B., 2003. Introduction: community collaboration in exhibitions: Towards a dialogic paradigm. In L. Peers and A.K. Brown, eds. *Museums and Source Communities: A Routledge Reader*. London: Routledge, pp. 155–170.

Phillips, R.B., 2006. Show times: de-celebrating the Canadian nation, de-colonising the Canadian museum, 1967–92. In A.E. Coombes, ed. *Rethinking Settler Colonialism: History and Memory in Australia, Canada, Aotearoa New Zealand and South Africa*. Manchester: Manchester University Press, pp. 121–139.

Racette, S.F., 2008. Confessions and reflections of an Indigenous research warrior. In A.K. Brown, ed. *Material Histories: Proceedings of a Workshop Held at Marischal Museum, University of Aberdeen, 26–27th April 2007*. Aberdeen: Marischal Museum, University of Aberdeen, pp. 57–67.

Report of the Royal Commission on Aboriginal Peoples. 1996. *Volume 3 Gathering Strength*. [Online] Available at: http://caid.ca/RRCAP3.6.pdf

Simpson, M.G., 2006. Revealing and concealing: museums, objects, and the transmission of knowledge in Aboriginal Australia. In J. Marstine, ed. *New Museum Theory and Practice. An Introduction.* Oxford: Blackwell Publishing, pp. 153–177.

Smith, L., 2006. *Uses of Heritage.* London: Routledge.

Smith, K. D., 2014. *Strange Visitors: Documents in Indigenous-Settler Relations in Canada from 1876.* Toronto: University of Toronto Press.

Strother, Z.S., 1999. Display of the body Hottentot. In B. Lindfors, ed. *Africans on Stage: Studies in Ethnological Show Business.* Indiana: Bloomington, pp. 1–16.

Sundstrom, L., 1997. Smallpox used them up: references to epidemic disease in Northern Plains winter counts, 1714–1920. *Ethnohistory*, 44(2) pp. 305–343.

Tapsell, P., 2005. Out of sight, out of mind: human remains at the Auckland Museum—*Te Papa Whakahiku.* In G.T. Conaty and R.R. Janes, eds. *Looking Reality in the Eye: Museums and Social Responsibility.* Calgary: University of Calgary, pp. 153–173.

Te Papa, 2008. *Museum of New Zealand Te Papa Tongarewa, Wellington, New Zealand—About Us.* [Online] Available at: http://www.tepapa.govt.nz/TePapa/English/AboutTePapa/AboutUs/

UNESCO, 2006. *United Nations Declaration on the Rights of Indigenous Peoples.* Geneva: UNESCO.

Wels, H., 2004. About romance and reality: popular European imagery in postcolonial tourism in Southern Africa. In C.M. Hall and H. Tucker, eds. *Tourism and Postcolonialism: Contested Discourses, Identities and Representations.* Oxon: Routledge, pp. 76–94.

West, W.R., 2000. Appendices: cultural rethink. In W.R. West, ed. *The Changing Presentation of the American Indian: Museums and Native Cultures.* Washington: Smithsonian Institution, pp. 99–102.

2 The Blackfoot Confederacy, Contact, Colonialism and Museums[1]

When the white man came they called us savages, we called them, our ancestors called them, crazy people. They didn't know our way of life.

(Kainai Elder Frank Weasel Head Interview 2008)

BLACKFOOT WAYS OF KNOWING

Traditional Blackfoot epistemology and ontology, or ways of knowing and being, are distinct from dominant Euro-Canadian culture. These differences, along with the history of colonialism, can help explain some of the challenges for museums working cross-culturally. This chapter will first introduce Blackfoot traditional culture, and then provide a brief historical overview of key contact and colonial events that have shaped Blackfoot/settler relations, which in turn influenced museums and Blackfoot collections.

'Blackfoot' is an English term used to refer to members of four Blackfoot Nations known as the Blackfoot Confederacy: Siksika, Kainai, Piikani and Blackfeet. Three Nations (Siksika, Kainai and Piikani) have reserves in southern Alberta,[2] Canada, whereas the Blackfeet Reservation is in northern Montana, America. The Blackfoot nations share a common Algonquian language of Blackfoot and the Blackfoot name for themselves is *Niitsitapi* meaning 'real people' and *Siksikaitsipoyi* meaning 'Blackfoot-speaking real people' (Bastien 2004:212). This name distinguished the people from the other three categories of persons that make up the traditional Blackfoot world: the *Sspommitapiiksi* (Above People) including the Sun, Moon, stars, planets and high-flying birds; the *Ksaahkommitapiiksi* (Earth People) including low-flying birds, plants and animals; and *Soyiitapiiksi* (Underwater People) such as fish, beaver and wetland animals (Lockensgard 2010:79; Blackfoot Gallery Committee 2001:9).

Traditional Blackfoot territory was vast extending from the North Saskatchewan River in Alberta, south roughly six hundred miles to the Yellowstone river in Montana, and from the eastern slopes of the Rocky Mountains eastwards for an average of around four hundred miles to a point beyond the Great Sand Hills in Saskatchewan (Blackfoot Gallery Committee 2001:4).

In Blackfoot this original territory is known as *Niitawahssin*, and the landscape of the territory is *Niitsisskowa* (Lockensgard 2010:16). The landscape and the land itself are intricately woven into traditional Blackfoot culture and identity.

The Blackfoot origin stories highlight the 'distinct relationship between the people, environment and geography, and the animal and plant world' (Bastien 2004:9). Many feature an important figure, a trickster called Old Man Napi. The Napi stories connect the people to historic events from time immemorial that occurred within the landscape and remind the Blackfoot to maintain a balanced life and not to break social rules or go to extremes.

> Napi, Old Man, always acted on impulse. He was rude, mean, and stingy. He often lied and played dirty tricks. He was always getting into trouble and suffering the consequences of his bad behaviour. And yet, he did not act out of malice. He merely overdid things and caused chaos as a result.
>
> (Glenbow Museum 2011)

The stories hold valuable information about social etiquette, the local environment and how to live in the Blackfoot territory. This knowledge enabled the Blackfoot to live sustainably and successfully in the harsh climate of the plains and mountains landscape (Glenbow Museum 2011). Traditional Blackfoot epistemology is based upon a respectful relationship with the environment, non-human inhabitants, and the land.

> Balance is recognized as the natural law of the cosmic universe, and respect is based on that law. . . . This law is acknowledged in the thought patterns and organizational behaviour of *Siksikaitsitapi*. The pipes and bundles form the societies that shape the organizational behaviour of the people. Balance is the mission of the *Siksikaitsitapi* culture, and through the organization of societies, balance is manifested in the values, norms, and roles of the people.
>
> (Bastien 2004:11)

Although not practiced by all members of the community, traditional Blackfoot culture continues today in a modern living form. 'The Blackfoot "traditions" themselves are the group of practices, and perspectives that inform those practices, which together comprise the larger cultural system of value' and they are fluid, 'rooted in narratives and yet adaptable to change circumstances' and 'lived by "real-world people"' (Lockensgard 2010:13–14). In traditional Blackfoot culture there is no separation between secular and spiritual life; the religion, history and culture are interconnected. 'In the system of value embraced by Blackfoot traditionalists, all beings are understood to have a degree of personhood and be able to share their skills and powers as persons with other beings, including humans' (Lockensgard 2010: 14). *Matapiiksi* is

the Blackfoot term for person, living beings, and 'all *matapiiksi* receive life from *Ihtsipaitapiyo'pa*' the 'source of our life' often referred to as 'creator', and the Sun *Naato'si* is 'the greatest manifestation of *Ihtsipaitapiyo'pa*' (Lockensgard 2010:77–78).

The concept of *matapiiksi* is perhaps the most important epistemological difference between Euro-Canadian and Blackfoot understandings of the world and humans' relation to it. An example often used by traditionalists to help explain the difference is the personhood of stones and rocks. While Euro-Canadians conceive stones to be inanimate, in Blackfoot traditions stones can have life, personality and power. *Napi and the Rolling Rock* is a traditional story in which *Okotoks*, Big Rock, not only communicates with Napi but chases him because Napi breaks traditional gifting etiquette. *Okotoks* is a large glacial erratic that lies just west of the modern town of Okotoks, split in half as the story describes, and is a sacred place for the Blackfoot. Similarly, *Iinnisskimms*[3] are buffalo calling stones and feature in the traditional stories and ceremonies as animate beings that can communicate with animals and humans to help them (Lockengard 2010:83). These stones are still gifted, worn and respected today as powerful animate beings.

Today, people who practice and are keepers of traditional Blackfoot knowledge, ceremonies and material culture are commonly known as traditionalists. Within the Blackfoot community there are important traditionalists known as Elders. The Elders, *Kaaahsinnooniksi*, are the custodians of the traditional knowledge and they teach it to the new generations through age-graded societies, ceremonies and cultural events (Bastien 2004:222). Elders have high standing in their communities as spiritual and cultural leaders; they earn their knowledge through traditional Blackfoot sacred societies and transfer ceremonies, passing on information from one generation to the next and enabling many of the pre-contact traditional customs to continue today.

Elders are often bundle holders or involved in caring for elements of tangible and intangible heritage connected to sacred ceremonies. Bundles are a common focus of Blackfoot repatriation requests to museums because in Blackfoot culture they are sacred, powerful living beings that are vital to traditional ceremonies and annual renewal. Bundles are at the centre of traditional Blackfoot ceremonial life and 'are intricately tied to a traditional "system of value"' (Lockensgard 2010:13). Each bundle is unique and has a particular origin and personality (Lokensgard 2010:57). Bundles are associated with different events and sacred societies and are opened at specific times of the year according to protocol. For example Thunder Medicine Pipe Bundles are opened during a ceremony after the first thunder in spring. As living beings, bundles are cared for as though they are children. Their carers are called bundle holders, or keepers, indicating that they are temporary custodians of these spiritual gifts from other beings, which must be circulated by using the power of the bundle to help others and by transferring the bundles to new keepers (Lockensgard 2010:76). Bundle holders have specific cultural rights gained through participation in Blackfoot sacred

societies and follow strict sacred protocols as the bundles are considered to be very powerful. Bundle keepers act as parents to the bundle, while previous bundle holders become grandparents and through this process generations of guardians protect and care for these sacred items.[4]

> Ceremonies are a way to make present, teach, and demonstrate through origin stories the life of the ancestors, the natural laws of the universe and relationships, the moral and ethical conduct of the people, and the essence and respectful approach to the alliances of the bundles. The legends and stories of these bundles and ceremonies are the connection to Siksikaitsitapi knowledge, customs, and rituals.
>
> (Bastien 2004:12)

Reciprocity, respect and balance are core values of traditional Blackfoot culture and are taught through the ceremonies along with Blackfoot history and culture. As the historians, traditional spiritualists, and cultural leaders, it is the Elders who are most often sought by museums as consultants on collections and as collaborators for co-created exhibits. In each of the case studies considered in this book, Elders (and in many cases the very same people) were engaged in the process of informing and shaping the museums and exhibitions.

CONTACT AND COLONIALISM

As Kainai Elder Frank Weasel Head states in the opening of this chapter: 'When the white man came they called us savages, we called them', our ancestors called them crazy people, they didn't know our way of life' (Weasel Head Interview 2008). The interaction between the different epistemologies of the Blackfoot and the colonising Europeans informed and misinformed much of the early contact and colonial period and still plays a role in modern cross-cultural misunderstandings.

In Blackfoot *Ksissta'pitapii* is a term used to refer to 'nothing people' or 'crazy people' who do not 'possess or aspire to the characteristics valued among the *Siksikaitsitapi*', also known as ghosts (Lockensgard 2010:80; Bastien, 2004:49–50). The first European explorers and settlers did not know Blackfoot customs, and today, as a result of colonialism, missionaries, the residential schools and social change, some Blackfoot community members have also lost their connection to, or moved away from, traditional culture to varying extents (Bastien 2004:49–50). Not all Blackfoot members speak the Blackfoot language and many follow other faiths such as Christianity and Mormonism. To help contextualise the research it is necessary to very briefly outline the history of Blackfoot/European relations as the colonial and postcolonial relationships between Blackfoot and settlers have left a lasting impression on modern relations.

The Blackfoot were one of the later groups to be contacted by Europeans in the territory now known as Canada, mainly due to their geographical location and the priorities of the colonising European powers. Prior to first contact with Europeans, the traditional 'dog days' era came to an end with the arrival of horses around 1730 (Bastien 2004:14; Conaty 1995:404). Despite the relatively recent arrival, the horse has become synonymous with 'Plains Indian' culture. Horses enabled the Blackfoot to travel further faster, carry more goods and hunt more easily which increased the unity and the strength of the Blackfoot Confederacy and, through warfare with other First Nations, gained the Blackfoot a fierce reputation (Bastien 2004:15, 18).

The first European explorers drawn to Blackfoot territory were English and French traders in search of furs and trade relationships. Hudson Bay Company (HBC) employee Henry Kelsey's 1690–1692 expedition into the plains marked the first European exploration of what is now known as Saskatchewan. Pierre Gaultier de Varennes, Sieur de La Vérendrye's 1731–1734 expedition also took him into Saskatchewan, but not as far at the Blackfoot. The first recorded contact between the Blackfoot and a European explorer was in 1754 when Anthony Henday, an Englishman working for the HBC, visited what is thought to have been a Blackfoot camp in an attempt to develop trade (Berry and Brink 2004:32). It was not until 1787 when HBC employee, David Thompson, wintered with a Piikani camp on the Bow River that a 'good description of early Blackfoot culture' was made by a European (Conaty 1995: 404). In 1792 Peter Fidler, of the HBC, travelled with a Piikani band from Edmonton to southwestern Alberta and back (Berry and Brink 2004:28). At this time 'early explorers estimated the Blackfoot population to be 30,000 to 40,000' (Bastien 2004:9 referencing McClintock 1910:5).

It was only in the 1800s that contact became more regular and sustained with furs being traded for 'tobacco, guns, steel knives and arrowheads, blankets, cloth and many ornaments' and liquor (Blackfoot Gallery Committee 2001:55). It is important to note that the fur trade period in Western Canada was predominantly a time during which Europeans adapted to work with Indigenous culture, taking on Indigenous survival techniques and following traditional protocols (Berry and Brink 2004:31). However, with contact and trade came diseases including smallpox, measles, whooping cough, tuberculosis and influenza (Blackfoot Gallery Committee 2001:59). 'In the Canadian northwest, epidemics of introduced contagious diseases swept through the region with regularity from the 1730s to the 1870s' (Daschuk 2013:XII). In 1837 smallpox claimed two thirds of the Blackfoot population (Farr 2001:145).

> Every fifteen to twenty years . . . a new epidemic spread through our people's camps. Each time, a half to three-quarters of our people died: infants, children, adults, our old people. Families were devastated. The knowledge of our ceremonial leaders and old people began to disappear.
> (Blackfoot Gallery Committee 2001:60)

The fur trade also altered the traditional balance in Blackfoot epistemology as the Blackfoot began to hunt not for subsistence, but for commercial gain. Bastien describes this as the beginning of the 'breach with the sacred' and emphasises that 'the demise of the *Iiniiwa* [buffalo] changed the overall *Siksikaitsitapi* relationship of alliances with all beings of the natural world' (2004:18).

A significant shift in power began with the impact of diseases and the declining buffalo herds, but the first formalised colonial control exerted over the Blackfoot came in the form of the 1855 Lame Bull Treaty. It was a peace treaty, not a land treaty, and it created a common buffalo hunting ground to 'be shared "in peace" by the Blackfoot tribes and what were termed the "Western Indians," those who had come from west of the Rocky Mountains', the 'Nez Perce, Yakima, Walla Walla, Cayuse, Kootenai, Spokane, and numerous Salish speakers, most prominently the Flatheads and the Pend d'Oreille' (Farr 2001:132). The treaty gave federal recognition to a 'buffalo commons' that had been negotiated between the First Nations groups through war, treaties and diplomacy, with the intention of ending warfare and raids between the groups and promoting peaceful coexistence (Farr 2001:132–133, 137, 139–140). However it encroached on what had been defined, in the absence of any Blackfoot members, as Blackfoot Territory in the 1851 Fort Laramie Treaty (Farr 2001:132–133, 137, 139–140). Article IV of the 1855 Treaty redefined the Blackfoot territory 'in which the Blackfeet would "exercise exclusive control"' as a diminished version of the territory set out in the 1851 treaty, but compensated the Blackfoot with a ten year guarantee of $20,000 annual government spend on goods and provisions for the Blackfoot Nation, plus $15,000 annually for farms, agricultural instruction, education and towards general efforts to civilize and Christianise the people (Farr 2001:146–147).

From the 1840s the decline of the Buffalo was a 'generalized prediction', and by 1850s the Blackfoot were noting the decreasing numbers of the Buffalo. In 1854 there were winter counts[5] depicting starvation, and the drought of 1855 raised concern among the signing partners of the Lame Bull Treaty (Farr 2001:144–145). By the late 1870s the buffalo had all but been eradicated due, not to traditional hunting, but to European demand for hides as industrial leather (Carter 2003:84; Scott Taylor 2011:3163).

> In the sixteenth century, North America contained 25–30 million buffalo; by the late 1880s less than 100 animals remained wild in the Great Plains states. While removing buffalo east of the Mississippi took settlers well over 100 years, the remaining 10 to 15 million were killed in a punctuated slaughter in a little over ten years.
>
> (Scott Taylor 2011:3163)

The 'disappearance' of the buffalo, as it is commonly described in the case study museums, had a dramatic effect on traditional Blackfoot life as the

buffalo were central to the culture as a resource for food, tools and clothing, and the migration of the buffalo was intertwined with the Blackfoot seasonal rounds and part of Blackfoot ceremonies. As Carter argues 'a high degree of independence remained possible [for the Blackfoot] as long as the buffalo were abundance, that is, until the late 1870s' (2003:84).

While America was making treaties with the Blackfoot, north of the 49th Parallel[6] the Blackfoot territory was part of what was called Rupert's land: 1.5 million square miles of land granted by royal decree of King Charles's II in 1670 to the ownership of the Hudson Bay Trading Company (HBC). HBC and its competitor, the North West Company (NWC), began trading with the Blackfoot on a regular basis in the late 1780s (Dempsey 2002:7). Along with disease, the decreasing numbers of buffalo, and changes to material culture, trade brought alcohol into Blackfoot territory. Prior to European contact alcohol had been unknown to the Blackfoot and it was named *Napiohke* or White Man's Water (Dempsey 2002:7–8).

While the HBC had originally not traded in alcohol, competition with the NWC encouraged the trade and 'by the time the Blackfoot trade was underway, [HBC] imports at that post were almost 8,000 gallons annually' (Dempsey 2020:7). Encouraging alcohol dependency was a strategy used by both trading companies and as such rum and brandy was often initially gifted to encourage addiction (Dempsey 2002:8). At first the trade in alcohol was restricted as the Blackfoot tended to only make twice-yearly visits to the trading posts in the spring and fall (Dempsey 2002:2, 9). With the amalgamation of HBC and NWC under the HBC in 1821 efforts were made to discontinue the trade in alcohol due to the expense and the stigma attached to its consequences (Dempsey 2002:9). However trade in alcohol continued between the HBC and the Blackfoot until 1862, due to the pressure to compete with American whiskey traders who established themselves in Blackfoot territory in 1831 (Dempsey 2002:10).

Between 1831–1880 the American whiskey trade became a major influence in Blackfoot territory and was a key factor in shifting power relations between the Blackfoot and incoming settlers. On 9th July 1834 a prohibition law was passed in America (Dempsey 2002:12), and in 1846 four agents of the American Fur Company (AFC) 'were each fined eight hundred dollars for bringing illegal alcohol into Indian Country' (Dempsey 2002:15). Huge profits of up to 400 percent could be made from the illicit trade and despite the prosecutions, the American Fur Company established Fort Benton in 1847 which 'became the main outlet for whiskey to the Blackfoot Indians for the next quarter of a century' (Dempsey 2002:14–15).

The Blackfoot communities were ravaged by the effects of, and deaths from, whiskey known as 'firewater' which was a concoction of 'alcohol, pepper, gunpowder and other toxins' such as 'vitriol, turpentine, strychnine, *cocculus indicus*, tobacco' (Blackfoot Gallery Committee 2001:60–61; Dempsey 2002:11–12). By the 1860s the situation worsened, with the withdrawal of the HBC from trade and the dissolution of the AFC, free traders entered the

market and in 1869 many extended their business into the relatively unregu-
lated British half of Blackfoot territory (Dempsey 2002:16, 39). Crowfoot
stated 'The whiskey brought among us by the Traders is fast killing us off
and we are powerless before the evil. [We are] totally unable to resist the
temptation to drink when brought in contact with the white man's water.
We also are unable to pitch anywhere that the Trader cannot follow us'
(Dempsey 1972:78). The dire consequences are illustrated in Frank Wilson's
1871 comment: 'The whiskey traders . . . told me they came here to make
money . . . Far from being an injury to the United States, they said they were
a great benefit as they keep the Indians poor, and kill directly or indirectly
more Indians of the most warlike tribe on the continent every year, at no
cost to the United States government, than the more regular army did in ten
years!' (Dempsey 2002:224).

In 1856 the discovery of gold in the Upper Missouri brought prospectors
into the area, further aggravating relations, which escalated into a series
of events commonly known as the 'Blackfoot war' 1865–1870 (Dempsey
2002:18; Blackfoot Gallery Committee 2001:63–64). This was a period of
unstable relations, tensions and suspicion as 'oral accounts relate how dur-
ing the 1860s and 1870s, Kainai people were frequently subjected to brutal
and traumatic attacks in which entire families were slaughtered, women
were raped, and camps were burned' (Rufus Goodstriker quoted in Brown
and Peers 2006:17).

Within the common hunting grounds tension continued between First
Nations groups and incoming settlers (Lokensgard 2010:116). One of the
most notorious conflicts began on 17 August 1869 when a Piikani man
named Pete Owl Child, son of Mountain Chief, killed his uncle Malcolm
Clark, a rancher living in Prickly Pear Canyon near Helena Montana in
retaliation for an insult (Lockensgard 2010:116; Dempsey 2002:36). While
the incident was a family quarrel, it ignited the conflict and a volunteer com-
pany was raised and armed to collect scalps for a bounty; the matter was then
passed to a U.S. Grand Jury who saw it as a declaration of war and turned to
the military for support (Dempsey 2002:36). Four companies of the Second
Cavalry were dispatched and early on the winters morning of 23 January
1870 Major Eugene Baker led an attack on the friendly Piikani Chief Heavy
Runner's camp, mistaking it for Mountain Chief's camp where Owl Child
was thought to be residing (Lokensgard 2010:116; Ewers, 1958:249–250).
The camp, which was suffering with smallpox, was sleeping when the attack
started; 173 people, mainly women and children and the elderly were mas-
sacred and over 100 women and children were captured and later turned out
into the bitter winter cold (Schultz 1962:304–305; Lokensgard 2010:116;
Ewers 1958:250; Dempsey 2002:49).

In Baker's reports he claimed he did not know he had the wrong camp;
but First Nations claim Heavy Runner walked towards the troops waving
his official papers and was shot dead (Dempsey 2002:49). Schultz's account
states that Baker was told that he had the wrong camp by his scout Joe Kipp

and Sharp notes that accusations were made that Baker was drunk at the time (Lockensgard 2010:117; Ewers 1958:250; Schultz 1962:303; Sharp 1955: 149). The massacre marked the end of the 'Blackfoot war' and is remembered and recounted today in the Blackfoot community (Blackfoot Gallery Committee 2001:63–64). It was an important moment where the power and willingness to decimate the Blackfoot population was made clear by the American government, and many survivors fled north to Canada (Sharp 1955:150–151). The same winter a smallpox epidemic killed over two thousand Blackfoot people (Dempsey 2002:60). These losses weakened the Blackfoot and shifted the balance of power towards the incoming settlers.

In 1869 Canada purchased Rupert's Land from the HBC, making Blackfoot territory a part of the newly formed North-West Territories and part of the new Dominion of Canada (Dempsey 2002:124). In October 1870 a proclamation outlawed the sale of alcohol, but it was not until March 1871 that the Canadian government received official reports of the whiskey traders (Dempsey 2002:124–125). In 1873 the Cypress Hills Massacre brought the situation to a head, when American wolfers (wolf hunters) attacked a peaceful Assiniboine camp of forty lodges, killing, mutilating and raping the inhabitants, in mistaken drunken vengeance for a supposed horse theft (Dempsey 2002:116–121). This violence in Canada's new territory prompted a chain of events that led to new legislation to create the North West Mounted Police[7] (NWMP) which was passed in parliament on 23rd May 1873. In the spring of 1874 over three hundred NWMP set out on a march westwards from Manitoba, by which time many of the whiskey traders had already abandoned their business (Dempsey 2002:148, 184).

The First encounter between the NWMP and the Blackfoot occurred in August 1874 at Fort Walsh; the NWMP then travelled west into the heart of Blackfoot territory and built a fort and settled at a place now known as Fort Macleod (Crowshoe and Manneschmidt 2002:76). At first the Blackfoot welcomed their presence and their efforts to suppress the whiskey trade, but the NWMP soon began enforcing laws on behalf of the Queen which restricted Blackfoot freedoms (Blackfoot Gallery Committee 2001:61; Dempsey 1972:80).

In 1875 fifteen Blackfoot Chiefs wrote 'a memorial to the Queen's government protesting the increasing invasion of their country by mixed-bloods and whites' and requesting a meeting with a commissioner to discuss the potential for treaty (Dempsey 1972:83–4). In September 1877 Treaty 7 was signed between the British Crown and Siksika, Kainai, Piikani, Tsuu T'ina and Stoney Nakoda at Blackfoot Crossing in Blackfoot territory. Treaty 7 stated that the government would provide reserves measured on a per capita basis of 'one square mile to each family of five persons', an annual payment of twenty-five dollars to each Chief, fifteen to each minor Chief or Councillor and five to 'every other Indian of whatever age', basic farming equipment and stock, ammunition rations, and the salary for teachers to instruct the children 'as to Her Government of Canada may seem advisable' (Treaty 7 1877). The

map below shows the reserves, depicted in dark grey, in relation to the traditional Blackfoot territory, shaded in lighter grey (Figure 2.1).

Unbeknown to the Blackfoot, the year before they signed Treaty 7 the Canadian government passed the *Indian Act* without First Nations consultation or notification. The 1876 *Indian Act* is one of the most influential laws controlling First Nations life in Canada and is still in place today. The Act made the First Nations wards of the state and gave the government control over all aspects of their lives. Treaty 7 allocated the Blackfoot three reserves in what was to become southern Alberta and within these boundaries the *Indian Act* empowered government appointed Indian Agents to hold

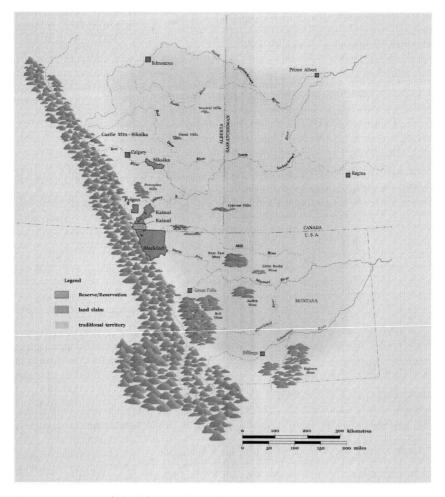

Figure 2.1 Map of Blackfoot traditional territory.
Courtesy of Glenbow Museum. ©Glenbow, Calgary, 2014.

'complete authority over the lives' of Blackfoot people (Blackfoot Gallery Committee 2001:68–69).

> Indian agents could limit or refuse to give out rations. In Canada, Indian agents issued passes that permitted people to leave the reserve for three days; any person caught off the reserve without a valid pass was sent to jail for thirty days. Indian agents issued permits to sell crops and livestock. They made sure the children went to school. Indian agents ran our council meetings and often selected the chiefs and members of council.
>
> (Blackfoot Gallery Committee 2001:69)

Under this new system of rule the Blackfoot were increasingly forced to depend upon government rations as their hunting and gathering was restricted by the pass system, by 1879 the buffalo had gone from their territory, and farming efforts met with mixed results. Rations were often poor quality, rotten, infected and on one occasion 'the meat was salted with lime' causing sickness and death (Blackfoot Gallery Committee 2001:71). 'In 1890 nearly one-quarter of Amsskáápipikani [Blackfeet] starved to death on Ghost Ridge' (Blackfoot Gallery Committee 2001:70).

The *Indian Act* also imposed one of the most culturally destructive institutions upon First Nations, the Residential School System.[8] Residential schools were established on the reserves across the country and First Nations children were forced to attend as part of a nationwide government effort to assimilate Indigenous children through Christian education. Blackfoot children were not allowed to practice their culture or speak their language in the schools (Miller 2004:246) and disobedience was at times severely punished (Milloy 1999:282). Some children went at a young age and remained in the schools till their late teens without visits home (Brown and Peers 2006:26).

> The purpose of residential schooling was to assimilate Aboriginal children into mainstream Canadian society by disconnecting them from their families and communities and severing all ties with languages, customs and beliefs. To this end, children in residential schools were taught shame and rejection for everything about their heritage, including their ancestors, their families and, especially, their spiritual traditions.
>
> (Chansonneuve 2005:5)

Schools were chronically underfunded, overcrowded and often unsanitary, making ill-health and neglect common (Brown and Peers 2006:27; Milloy 1999:98–99; TRC 2012, 30). Not only were children forced to live in poor conditions, they were given insufficient diets and overworked in an effort to make the schools self-sustaining (TRC 2012, 30; Milloy 1999:35, 121). Education in these schools was sub-standard and as 'late as 1950, according to an Indian Affairs study, over 40 per cent of the teaching staff

had no professional training' (LHF 2013). The schools were highly effective in breaking family bonds, preventing traditional processes of knowledge transfer, and undermining cultural identity and pride.

> Two primary objectives of the residential schools system were to remove and isolate children from the influence of their homes, families, traditions and cultures, and to assimilate them into the dominant culture. These objectives were based on the assumption Aboriginal cultures and spiritual beliefs were inferior and unequal. Indeed, some sought, as it was infamously said, 'to kill the Indian in the child'.
>
> (Parliament of Canada 2008)

'Sexual and physical abuse by staff and students was widespread' (Blackfoot Gallery Committee 2001:76). While 'the official records of the residential school system make little reference to incidents of [sexual] abuse', the Truth and Reconciliation Commission has found that sexual abuse was known about by authorities from the early days of the residential school era (TRC 2012:42; Onciul 2014a, 2014b). Indigenous resistance, protest and testimony about the schools was largely ignored until 1990 when the Grand Chief of the Assembly of Manitoba Chiefs, Phil Fontaine, spoke about his own experiences of sexual abuse at a residential school (TRC 2012: 41). With more recognition given to survivors, testimony of physical, mental and sexual abuse, malnutrition, 'forced eating of rotten food', corporal punishment, 'bondage and confinement', forced labour, disease, high death rates, electrocution and medical experimentation have been brought to public attention (LHF 2013).

The last federally run residential school closed in 1996 (Health Canada 2011). The residential school era has been described as a national crime by Bryce (1922) and Milloy (1999), as genocide by Churchill (2004) and as the Canadian Holocaust by the *Truth Commission into Genocide in Canada* (2001).

On Wednesday 11th June 2008 the Prime Minister of Canada, Stephen Harper, made a Statement of Apology to former students of Indian Residential Schools, on behalf of the Government of Canada. The apology came as part of the Indian Residential Schools Class Action Settlement Agreement which included a Common Experience Payment to former students (Service Canada 2011). A Truth and Reconciliation Commission (TRC) was launched in 2008 and is due to give its final report in June 2015. So far, the TRC has released two reports, a 2012 Interim Report and a 2012 document entitled: *They Came for the Children*. Both record harrowing details of institutionalised abuse, neglect and racism. The TRC has recorded thousands of survivors' testimony which will be made available through a National Research Centre on Indian Residential Schools. In 2013 new revelations of abuse came to light, including nutritional and medical experimentations (Mosby 2013; Porter 2013).

Generations of Aboriginal people today recall memories of trauma, neglect, shame, and poverty. Those traumatized by their experiences in the residential school have suffered pervasive loss: loss of identity, loss of family, loss of language, loss of culture.

(LHF 2013)

The effects of the residential school era continue to be felt in First Nations communities and families today, as abuse can create cycles of abuse, violence and trauma (TRC 2012:44; Elias et al 2012). The residential school system disrupted and broke children's ties with their families, language, culture and identity. Indigenous communities continue to work on rebuilding these today. The case studies explored in this book had to consider their role in representing this difficult history when working with the Elders, which will be considered in depth in chapter seven.

CHANGES TO THE *INDIAN ACT*

Alongside the physical changes to Blackfoot life, the *Indian Act* also defined who was legally considered 'Indian'. Only 'Registered Indians' had legal 'Status' (AANDC 2010) and could be entitled to treaty rights. This resulted in First Nations groups who did not sign treaty, or members of groups that did but were not originally recorded, being unacknowledged and disinherited from their cultural identity.

The legal definition of 'Status' and the restrictions placed on 'Status Indians' has changed over the years. In 1960 First Nations people in Canada gained the right to vote without forfeiting their Status. Originally women lost their Status if they married non-Status men. In June 1985 Parliament passed an amendment to the *Indian Act*, Bill C-31, to bring it in line with the *Canadian Charter of Rights and Freedoms* (AANDC 2010). The Bill had 'the specific intent of correcting more than 150 years of discrimination against First Nations women' as it 'removed discriminatory provisions, eliminated the links between marriage and Status, provided greater control of membership to individual bands, and defined two new categories of Status' (AANDC 2011c). 'With this amendment some 60,000 persons regained their lost Indian Status' and a separation was made between band membership and Indian Status: 'while the Department of Indian and Northern Affairs would continue to control Status, bands had complete control over their membership lists in accordance to their own rules' (AANDC 2011c).

On 31st January 2011 the Act was amended again with Bill C-3, as it was found to be unconstitutional by the Court of Appeal for British Columbia. The new bill 'will ensure that eligible grand-children of women who lost Status as a result of marrying non-Indian men will become entitled to registration (Indian Status). As a result of this legislation approximately 45,000 persons will become newly entitled to registration' (AANDC 2011b). Thus the Indian

Act has, over the years, directly affected the recognised population counts of First Nations and determined who can or cannot be part of that identified group.

In 1969 the Canadian Government, led by Prime Minister Pierre Trudeau, proposed the White Paper *Statement of the Government of Canada on Indian Policy* to dismantle the *Indian Act* and make First Nations equal status to all other Canadian Citizens. The proposal was met with strong opposition from First Nations leaders. Harold Cardinal, leader of the Indian Association of Alberta published a book called *The Unjust Society* in which he described the White Paper as 'a thinly disguised program of extermination through assimilation' (1969:1). In 1970 the Indian Association of Alberta rejected the White Paper in their document *Citizens Plus* (1970) which became known as the Red Paper (UBC 2009). Despite the colonial and patriarchal nature of the *Indian Act*, it does provide legal recognition of specific status and First Nations rights. First Nations leaders have pushed for greater self-determination and autonomy for First Nations, rather than equal Canadian status.

Today Indigenous people in Canada often describe themselves as living in two worlds. Many Blackfoot people maintain their traditional culture while living modern Canadian life styles. The late 1960s and 70s saw Native American political movements such as the American Indian Movement publically challenge the status quo in North America. A notion of pan-Indianism developed and encouraged a renewed sense of pride in being Indigenous and sparked cultural revival in many communities, including the Blackfoot Confederacy. Despite enduring terrible hardships, massacres, starvation, disease, the removal of their children, oppression and segregation, the Blackfoot and their culture survived colonisation and they continue to be a strong and proud people. Brown and Peers capture this in their comparison:

> Samek . . . cites a comment made by the Indian Agent in 1909 that his wards maintained 'a proud and imperious spirit which after 28 years of reservation life is still the dominant characteristic of the Bloods' (Samek 1987:134). Community members today frequently refer to their strong sense of cultural identity and their pride in being Kainai (Blackwater 15 August 2002).
>
> (Brown and Peers 2006:19)

Today Aboriginal people in Canada are the fastest-growing segment of the Canadian population (AANDC 2009a) and 'Alberta is privileged to be home to one of the largest, youngest and fastest-growing Aboriginal populations in Canada' (Government of Alberta 2011). The Blackfoot Nations are maintaining and reviving their cultural practices and teaching their language. They are also taking control of their education, law and order, governance, and creating economic development, working towards self-determination.[9]

THE BLACKFOOT AND MUSEUMS

Over the past two hundred years the Blackfoot have experienced dramatic changes to their way of life. Despite government and missionary efforts to terminate traditional practices, traditional Blackfoot culture is still maintained and is currently undergoing a revival described by some community members as a renaissance.

During the contact and colonial period museums developed their collections and 'salvaged' material culture threatened by the prediction that First Nations were doomed to die out or be assimilated in the pursuit of progress. Early explorers and traders collected some of the first Blackfoot cultural material that entered museums. In 1841 the Governor of the Hudson Bay Company, Sir George Simpson, collected five Blackfoot shirts that have been in the collection at Pitt Rivers Museum, Oxford UK since 1893 (Pitt Rivers n.d).

Museums also sponsored collecting expeditions, such as the 1929 Franklin Motor Expedition to Western Canada, sponsored by Cambridge University's Museum of Archaeology and Anthropology. 'At the time, First Nations people were subject to extremely invasive policies aimed at assimilation, which, in turn, stimulated an extensive program of ethnographic salvage' (Brown 2014:2).

Some items entered museum collections from removing grave goods left with the dead. Items taken obviously carry a difficult legacy, but even items in museum collections that were gifted, bought and exchanged are imbued with the inequalities of colonial exchange. Loans and repatriation of museum collections to source communities is one of the current methods of returning sacred items to community use, and can go some way towards building relationships and starting to make amends for items taken wrongfully or under duress. Alberta has made significant strides in repatriating Blackfoot material from private and public collections. Repatriation is an important issue in modern museology and was a key factor in some of the relationships between communities and museums analysed in this book.

While the Provincial Museum of Alberta is not a case study in this book it is important to briefly highlight their relationship with the Blackfoot, as they are a government run museum in Alberta that holds extensive collections of early Blackfoot material. First Nations have been a major part of the museum since its conception. On 6th December 1967, 'the Museum's opening day, visitors were introduced to three main floor galleries: Fur Trade, Native Peoples of Alberta, and early photographs of Aboriginal people taken by Ernest Brown and Harry Pollard' (RAM 2013). In 1990 the museum hosted a major feature exhibition project called the Scriver Blackfoot Collection and in 1997 it opened its new permanent gallery Syncrude Gallery of Aboriginal Culture.

The Scriver Collection is an interesting example of repatriation. On 13th October 1989 the Scriver Collection was repatriated from the private

ownership of Bob Scriver in America to the Provincial Museum of Alberta in Edmonton, Canada. The museum celebrated repatriation as it made the collection 'available to all people, and most of all to the Blackfoot themselves' (Stepney 1990:8). The collection had been amassed over two generations of the Scriver family (Stepney 1990:5).

> The artifacts contained in the Scriver Blackfoot Collection were brought by their native owners as gifts or for sale, to Thaddeus Scriver and later to Bob as well. Significantly, many of the items, particularly the ceremonial ones, were brought because their owners wanted the Scrivers to have the old pieces, as the ceremonies were no longer practiced. The powers were lost from the bundles, and they knew the Scrivers would preserve the material. Many of the Elders feared for the loss and destruction of the ceremonial items after they passed away and to ensure their preservation brought them to the Scrivers.
>
> (Stepney 1990:7–8)

When the 1895 Section 114 amendment to the *Indian Act* banned Okan, Sundance, Blackfoot ceremonies were forced underground until its repeal in Bill 79 in 1951 (Smith 2014:96; Deutschlander and Miller 2002:28). The ban combined with the poverty on the reserves, the work of missionaries to covert the Blackfoot to Christianity, and the removal of children from the community to the residential schools, disrupted traditional intergenerational knowledge and ceremonial transfer. As a result some material culture including sacred items were sold, traded or gifted for safe keeping to collectors and museums (Hungry Wolf et al. 1994:89; Farr 1993:4). Thaddeus Scriver 'often accepted the items from the impoverished Blackfoot as payment for groceries', as George Kipp explained 'when it's a choice between keeping a medicine bundle and feeding your kids, it's not much of a choice' (Johnsrude 2001:E3). Farr emphasises that some Blackfeet people 'entrusted [sacred items] to local people like Bob Scriver whose stewardship they felt comfortable with, whose care they trusted' (1993:4). Hungry Wolf has noted that sometimes sacred material was given up to museums because of a 'lack of young people willing to take on the required commitments' (1994:89).

The Scriver collection included over 1500 pieces of historic Blackfoot material from the late 1800s, and contained a 'vast array of ceremonial items' including 'Sun Dance necklaces, medicine pipes, beaver, natoas, horn society, and other bundles' (Stepney 1990:5). Bob Scriver, who later sold the collection to the Provincial Alberta Museum, grew up in Browning and 'was a close personal friend' of many Blackfoot traditional ceremonialists; he held traditional Blackfoot rights and was a keeper of the Little Dog Thunder Medicine Pipe (Stepney 1990:7). According to the *Edmonton Journal*:

> With the Blackfoot accepting him as one of their own, many felt betrayed when he sold his collection to the Provincial Museum. 'We always felt he would be returning these to the community,' says Chief Earl Old

Person, 71, who as a youth played tuba in Scriver's band. 'We even talked about it. . . . Then the next thing I heard, he had sold it to the museum. I don't know what happened'.

(Johnsrude 2001: E3)

The sale of the collection 'created a fire storm of criticism and controversy among Blackfeet on both sides of the United States-Canadian border' (Farr 1993:4). The purchase moved important sacred Blackfoot material from a semi-community setting in Blackfoot territory, Browning, Montana, to the restricted-access storage facilities of the government run museum in Edmonton, Alberta.

The museum's active collecting of sacred material was particularly controversial, as it occurred at a time when many museums, community members, academics and government officials were debating the merits and challenges of repatriating human remains, funerary objects, sacred objects and objects of cultural patrimony in America in the lead up to the *Native American Graves Protection and Repatriation Act* (NAGPRA) which was enacted in America on 16th November 1990.

Similarly in Canada the majority of museums were reconsidering their relationships with Indigenous communities in light of the controversy sparked by *The Spirit Sings* exhibition at Glenbow in 1988. While the Assembly of First Nations and the Canadian Museum Association were working together on a task force to 'develop an ethical framework and strategies for Aboriginal Nations to represent their history and culture in concert with cultural institutions' (Indian and Northern Affairs Canada 2007:1.1), the Provincial Museum of Alberta was actively collecting contentious material[10] in apparent opposition to efforts to return material to community control and use.

The museum had already experienced some trouble in its relationship with the Blackfoot and collections were under tight security in response to an incident when a bundle 'walked out' of the museum and returned home to the community without museum consent (Devine Interview 2014; McMartin 1991; BCBW 1997). The *Vancouver Sun* reported that in 1975 Adolf Hungry Wolf, a non-Blackfoot man who had married into the community, 'inspired a Blackfoot Elder named Many-Gray-Horses, to reclaim a sacred Longtime Medicine Pipe Bundle', that had been bought by the museum for $3,000 (McMartin 1991:F9). Adolf and his wife Beverly accompanied Many-Gray-Horses to the museum and 'Many-Gray-Horses walked in, and walked off with the bundle' returning it home to the community where it still resides (McMartin 1991:F9; BCBW 1997).

According to the *Edmonton Journal*, Bob Scriver decided to sell his collection to the Provincial Alberta Museum for $1.1 million U.S. (paid for by the Canadian Cultural Property Export Review Board) because 'he believed that if he gave the articles back to their original owners, tribe members would turn around and sell them' and donating them to the Montana Historical Society may have resulted in them being repatriated through NAGPRA (Johnsrude 2001:E3; Farr 1993:15). This is very contentious line of

argument that has been challenged by people such as Gerry Conaty. Nevertheless the argument about the fear for the safety of items in the community has been repeated in more recent requests to repatriate a sacred meteorite to the Cree (Walker 2003:B1). Glenbow Curator Gerry Conaty 'who has negotiated the repatriation of numerous sacred artifacts, says he's never heard of any one of them being stolen or sold. "These aren't normal things we're talking about," says Conaty. "People don't take these things on lightly"' (Walker, 2003:B1). Conaty was quoted as saying '"The people who take them back would be afraid of doing that [selling the bundles] because of the censure they would face from the tribe," he says. "If these are so vital to their history and traditions, we have to trust them to look after them properly."' (Johnsrude 2001:E3).

Efforts have been made to get the Scriver Collection repatriated back to the Blackfeet in Montana. The sale and the documentation of the sacred material in Bob Scriver's book *The Blackfeet: Artists of the Northern Plains* brought to light the location of the Theodore Last Star Thunder Medicine Pipe Bundle and the Home Gun Beaver Bundle that had previously been kept by members of George Kipp and Gordon Belcourt's family (Johnsrude 2001: E3). On Wednesday 20th June 1990 Belcourt, Kipp and thirty other members from the Blackfeet and Kainai Nations travelled to Edmonton to discuss the return of sacred bundles from the Provincial Museum (*The Globe and Mail* 1990; Johnsrude 2001:E3). During a smudge ceremony 'Kipp grabbed a bundle and tried to walk out of the museum before being stopped by security guards' (*The Globe and Mail* 1990; Johnsrude 2001: E3; Farr 1993:13). Philip Stepney, the museum director who originally negotiated the purchase of the collection, said 'no further negotiations were planned. "We agreed to meet with them in good faith and hear their concerns," he said. "Unfortunately they chose to act in a negative manner. This makes further negotiation difficult"' (*The Globe and Mail* 1990).

1990 was a particularly tense time, as it was the year of the Oka Crisis, NAGPRA and the ongoing work by AFN and CMA on the Turning the Page Report (1992a, 1992b). When the Provincial museum decided to redo their Indigenous Gallery in the early 1990s, it too ran into difficulties. The museum used a process of consultation to work with Aboriginal people. An Aboriginal Advisory Committee was appointed and included four Aboriginal people: Reg Crowshoe, Peter Ladouceur, Rita Marten and Russell Willier (Berry and Brink 2004:vi). 'Elders from twenty-two First Nations and Métis communities . . . visited the Gallery while work was underway and offered their insight and advice' along with community members who were interviewed by museum staff (Berry and Brink 2004:vi). This input helped to design the new 10,000 square foot *Syncrude Gallery of Aboriginal Culture* supported by Syncrude, now one of the largest oil sands companies in Alberta (Berry and Brink 2004:vi; Syncrude 2014). Despite the involvement of Aboriginal people, there was a high profile conflict in the gallery development centred on the employment of non-Indigenous artists, Zhong-Yang

and Zhong-Ru Huang, to paint some of the murals in the gallery (see Figures 2.2 and 2.3).

The same mural was also controversial in its depiction of a Blackfoot tepee camp arranged in a line, rather than a circle, following the account in Anthony Henday's journal entry from 1750 (see Figures 2.2 and 2.4). Interestingly the book published by the museum to accompany the exhibition acknowledged

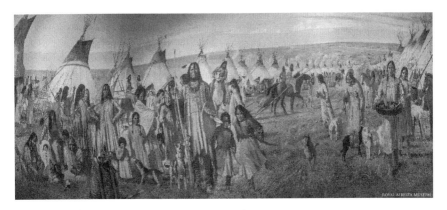

Figure 2.2 Mural from *Syncrude Gallery of Aboriginal Culture.*
Courtesy of the Royal Alberta Museum.

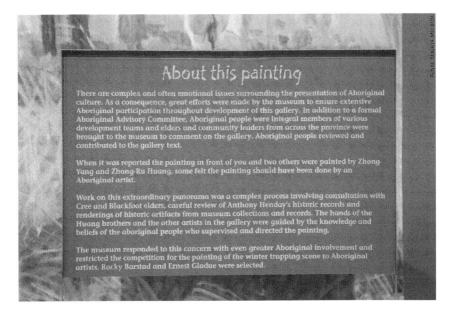

Figure 2.3 Text panel explaining the controversy in *Syncrude Gallery of Aboriginal Culture.*
Courtesy of the Royal Alberta Museum.

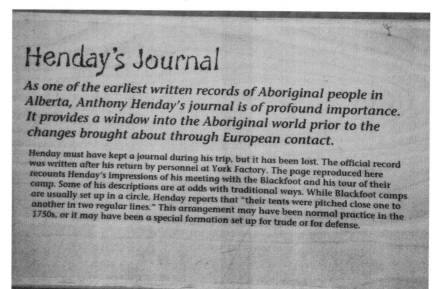

Henday's Journal

As one of the earliest written records of Aboriginal people in Alberta, Anthony Henday's journal is of profound importance. It provides a window into the Aboriginal world prior to the changes brought about through European contact.

Henday must have kept a journal during his trip, but it has been lost. The official record was written after his return by personnel at York Factory. The page reproduced here recounts Henday's impressions of his meeting with the Blackfoot and his tour of their camp. Some of his descriptions are at odds with traditional ways. While Blackfoot camps are usually set up in a circle, Henday reports that "their tents were pitched close one to another in two regular lines." This arrangement may have been normal practice in the 1750s, or it may have been a special formation set up for trade or for defense.

ROYAL ALBERTA MUSEUM

Figure 2.4 Text panel from the *Syncrude Gallery of Aboriginal Culture.*
Courtesy of the Royal Alberta Museum.

that interpreting Henday's journal was problematic as he recorded meeting the Archithinue, a Cree word for stranger, and not necessarily the Blackfoot (Berry and Brink 2004:32). The authors also explored the possibilities that Henday may have met the Sioux, who are recorded as making linear tipi arrangements, or 'alternatively, the two rows to which Henday referred may have been the inner and outer rings of a large camp circle' (Berry and Brink 2004:32). Despite the potential weaknesses of the source the museum exhibit continued to display the scene as Blackfoot, but highlighted the controversy around it in the text panels (Figures 2.3 and 2.4).

Despite these challenges, the Glenbow and the Provincial Museum worked with the Blackfoot to lobby the Provincial Government of Alberta and succeeded in passing the *First Nations Sacred Ceremonial Objects Repatriation Act* (FNSCORA) in May 2000 (Province of Alberta 2008). The act has enabled the repatriation of sacred items from the Provincial and Glenbow museums to Blackfoot communities in Canada. This was an extremely positive and significant step in Blackfoot/museum relations, as it enabled the repatriation of many sacred items crucial to maintaining and reviving Blackfoot traditional life and religion. The *Edmonton Journal* reported in 2001 that 'Alberta's Blackfoot tribes have had 251 sacred items returned by Calgary's Glenbow Museum under the province's *First Nations Sacred Ceremonial Objects Repatriation Act*, passed by the legislature last spring' (Johnsrude 2001: E3). The repatriation of the Scriver Collection to the Blackfeet in America falls outside this legislation, although it could be return to

the Blackfoot in Canada. Hugh Dempsey emphasised the potential for 'a reciprocal cross-border arrangement with the United States' as U.S. officials invited Alberta's Kainai Nation to seek repatriation of sacred material from collections in Chicago and Denver (Johnsrude 2001:E3).

In May 2005, the Provincial Museum was rebranded the Royal Alberta Museum (RAM). They are currently in the process of relocating to a new museum being built in downtown Edmonton. While there is not space within this book to explore the RAM and its relationship with the Blackfoot in depth, the discussion above highlights some of the important events that have influenced Blackfoot relationships with museums within and beyond Alberta.

Blackfoot Elders have been actively working on repatriating sacred material from museums in North America and around the world since the 1970s. They have successfully returned sacred material through FNSCORA and by building relationships with museums such as the Canadian Museum of Civilization who repatriated Blackfoot medicine bundles and sacred material (Stoffman 2000). Blackfoot Elders are increasingly travelling further afield to access their material culture stored in international museums.

Many Canadian museums are now responding to this task, but those in Europe, which contain a great deal of the earliest Aboriginal heritage items, also have a responsibility to end what Wayne Warry (2007) calls the denial of the colonial actions that sustain the social and economic disparities between mainstream society and Aboriginal people.

(Brown 2014:2)

In the UK positive work has been done through repatriation, collaborative research, exhibitions and loans. In 1999 an example of good practice was set by the Kelvingrove Museum in Glasgow when it returned a Ghost Dance Shirt to the Lakota Wounded Knee Survivors Association (see Glasgow City Council 2000; Simpson 1996:277–279). Research at the University of Aberdeen's Marischal Museum and the University of Oxford's Pitt Rivers Museum have led UK museum engagements with the Blackfoot community. In 2003 a Sacred Blackfoot Split Horn Headdress was repatriated from the Marischal Museum collection to the Kainai Nation (Curtis 2007:48–49). In 2010 a collaboration between the Pitt Rivers Museum in Oxford, the University of Aberdeen, the Galt Museum in Lethbridge and Glenbow Museum in Calgary allowed five Blackfoot Shirts collected in 1841 to visit Alberta to enable Blackfoot people to access and reconnect with them through exhibitions and handling sessions (Brown, Peers and Richardson 2012). The Royal Albert Memorial Museum in Exeter, UK, is now following in their footsteps and discussing the potential repatriation of Chief Crowfoot's regalia to the Blackfoot (Eccles 2014; Dempster 2014; Brown n.d.)

There is urgency to the need to repatriate sacred material, as the material is connected to living intangible culture and knowledge that is kept by Elders. With Elders aging and passing on, vital historical and cultural

knowledge can be lost if it is not transferred with the sacred material to new keepers within the younger generations. As such the efforts to repatriate sacred material is ongoing.

Contact and colonial history directly and indirectly informs the history of museum collections as well as the current relationships between museums and Indigenous communities. One of the key issues is that the inequalities built into colonial relations between settlers and Indigenous people are yet to be fully redressed. The *Indian Act*, while amended, remains on the legislative books and the Treaties still stand. Thousands of Blackfoot people continue to live on the reserves in comparative poverty to neighbouring Canadian towns. Statistically Indigenous people in Canada experience a quality of life far below mainstream Canadians on all measures of socioeconomic and health, apart from birth rate which is nearly four times that of Canadians.[11] Museums, as institutions born from the colonial era, have a complex and difficult legacy to contend with when working with communities and it is these relationships that will be the focus of the rest of the book.

NOTES

1. Some extracts in this chapter are reprinted by permission of Boydell & Brewer Ltd.
2. Alberta was first established in 1905.
3. Spelling from Lockensgard 2010:83.
4. For further details see Bastien 2004; Zedeño 2008; Lokensgard 2010; Conaty 2008.
5. A winter count is a traditional Blackfoot record of annual events recorded by a designated member of the group as a symbol on a buffalo hide. The Blackfoot man Bad Head or 'Father of Many Children' recorded 1854 in his winter count as 'Itaomitaohoyop', or 'when we ate dogs' (Dempsey 1965: 12; Farr 2001:144; Crowshoe and Manneschmidt 2002:10).
6. The 49th Parallel was set by the U.S. and Britain as the border in 1846.
7. The NWMP was renamed the Royal Canadian Mounted Police (RCMP) in 1920 (http://www.rcmp-grc.gc.ca/hist/index-eng.htm).
8. The Residential school system will be addressed in more depth in chapter 7.
9. 'On October 17, 2003, Canada, Alberta and the Blood officials signed an agreement-in-principle (AIP) on governance and child welfare' (AANDC 2011a; 2009b).
10. The purchase of the Doug Light collection quickly followed by the Scriver collection.
11. 'The Aboriginal population increased by 232,385 people, or 20.1% between 2006 and 2011, compared with 5.2% for the non-Aboriginal population' (Statistics Canada 2011:4).

REFERENCES

AANDC (Aboriginal Affairs and Northern Development Canada), 2009a. *Fact Sheet – Urban Aboriginal population in Canada*. [Online] AANDC. Available at: http://www.ainc-inac.gc.ca/ai/ofi/uas/fs/index-eng.asp

AANDC (Aboriginal Affairs and Northern Development Canada), 2009b. *Blood Tribe Governance and Child Welfare Agreement-in-Principle.* [Online] AANDC. Available at: http://www.ainc-inac.gc.ca/al/ldc/ccl/agr/sahtu/btg/btg-eng.asp

AANDC (Aboriginal Affairs and Northern Development Canada), 2010. *Indian Status.* [Online] AANDC. Available at: http://www.ainc-inac.gc.ca/eng/1100100032374

AANDC (Aboriginal Affairs and Northern Development Canada), 2011a. *General Briefing Note on Canada's Self–Government and Land Claims Policies and the Status of Negotiations January 2011.* [Online] AANDC. Available at: http://www.ainc-inac.gc.ca/al/ldc/ccl/pubs/gbn/gbn-eng.asp#s3a9

AANDC (Aboriginal Affairs and Northern Development Canada), 2011b. *Gender Equity in the Indian Registration Act.* [Online] AANDC. Available at: http://www.ainc-inac.gc.ca/eng/1308068336912

AANDC (Aboriginal Affairs and Northern Development Canada), 2011c. *A History of Indian and Northern Affairs Canada.* [Online] AANDC. Available at: http://www.ainc-inac.gc.ca/eng/1314977281262

Bastien, B., 2004. *Blackfoot ways of knowing: The Worldview of the Siksikaitsitapi.* Calgary: University of Calgary Press.

BCBW, 1997. *Adolf Hungry Wolf Interview.* [Online] ABC Bookworld. Available at: http://www.abcbookworld.com/view_author.php?id=2853

Bell C. and Paterson, R.K., 2009. Restructuring the relationship: Domestic repatriation and Canadian law reform. In C. Bell and R.K. Paterson, eds. *Protection of First Nations Cultural Heritage: Laws, Policy, and Reform.* Vancouver: UBC Press, pp. 15–77.

Berry, S. and Brink, J., 2004. *Aboriginal Cultures in Alberta: Five Hundred Generations.* Edmonton: The Provincial Museum of Alberta.

Blackfeet Enrolment Department, 2010. *Blackfeet Enrolment Department.* [Online] Available at: http://archive.today/8A1yf [Accessed 22 Feb 2015]

Blackfoot Gallery Committee, 2001. *Nitsitapiisinni: The Story of the Blackfoot People.* Toronto: Key Porter Books.

Brown, A.K., 2014. *First Nations, Museums, Narrations. Stories of the 1929 Franklin Motor Expedition to the Canadian Prairies.* Vancouver: UBC Press. [Online Sample Chapter] Available at: http://www.ubcpress.ca/books/pdf/chapters/2014/FirstNationsMuseumsNarrations.pdf

Brown, A.K., n.d. *Dr Alison Brown.* [Online] Available at: http://www.abdn.ac.uk/staffnet/profiles/alison.brown/

Brown, A.K. and Peers, L., 2006. *Pictures Bring Us Messages'/Sinaakssiiksi aohtsimaahpihkookiyaawa: Photographs and Histories from the Kainai Nation.* Toronto: University of Toronto Press.

Brown A.K., Peers L., and Richardson H., 2012. *Kaahsinnooniksi Ao'toksisawooyawa. Our Ancestors Have Come to Visit: Reconnections with Historic Blackfoot Shirts.* Oxford: Pitt Rivers Museum.

Bryce, P.H., 1922. *The Story of a National Crime.* Ottawa: James Hope & Sons, Limited. [Online] Available at: http://www.archive.org/stream/storyofnationalc00brycuoft/storyofnationalc00brycuoft_djvu.txt

Cardinal, H., 1969. *The Unjust Society.* Vancouver: Douglas & McIntyre.

Carter, S., 2003. *Aboriginal People and Colonizers of Western Canada to 1900.* Toronto: University of Toronto Press.

Chansonneuve, D., 2005. *Reclaiming Connections: Understanding Residential School Trauma among Aboriginal People.* Ottawa: Aboriginal Healing Foundation.

Churchill, W., 2004. *Kill the Indian, Save the Man: The Genocidal Impact of American Indian Residential Schools.* San Francisco: City Lights Books.

Conaty, G.T., 1995. Comments and reflections: economic models and Blackfoot ideology. *American Ethnologist,* 22(2) pp. 404–409.

Conaty, G.T., 2008. The effects of repatriation on the relationship between the Glenbow Museum and the Blackfoot people. *Museum Management and Curatorship*, 23(3) pp. 245–259.

Crowshoe, R. and Manneschmidt, S., 2002. *Akak'stiman: A Blackfoot Framework for Decision-Making and Mediation Processes*. Calgary: University of Calgary Press.

Curtis, N.G.W., 2007. Thinking about the right home: repatriation and the University of Aberdeen. In M. Gabriel and J. Dahl, eds. *UTIMUT: Past Heritage—Future Partnerships: Discussion on Repatriation in the 21st Century*. Copenhagen/ Nuuk: IWGIA/NKA, pp. 44–54.

Daschuk, J., 2013. *Clearing the Plains: Disease, Politics of Starvation, and the Loss of Aboriginal Life*. Regina: University of Regina Press.

Dempsey, H.A., 1965. *Blackfoot Winter Count*. Calgary: Glenbow-Alberta Institute.

Dempsey, H.A., 1972. *Crowfoot, Chief of the Blackfeet*. Norman: University of Oklahoma Press.

Dempsey, H.A., 2002. *Firewater: The Impact of the Whisky Trade on the Blackfoot Nation*. Fifth House Publishers.

Dempster, A., 2014. *Chief Crowfoot's Regalia to Return Home to Alberta*. [Online] CBC News. Available at: http://www.cbc.ca/news/canada/calgary/chief-crowfoot-s-regalia-to-return-home-to-alberta-1.2654211

Deutschlander, S. and Miller, L.J., 2003. Politicizing Aboriginal Cultural Tourism: The Discourse of Primitivism in the Tourist Encounter. *Canadian Review of Sociology/ Revue canadienne de sociologie* 40(1), pp. 27–44.

Devine, H. 2014 Interview. 12th Sept 2014. Skype.

Eccles, T. 2014 *Tony Eccles*. [Online] RAMM. Available at: http://www.rammu seum.org.uk/about-ramm/ramm-people/collections/tony-eccles

Elias, B., Mignone, J., Hall, M., Hong, S.P., Hart, L., and Sareen, J., 2012. Trauma and suicide behaviour histories among a Canadian indigenous population: An empirical exploration of the potential role of Canada's residential school system. *Social Science & Medicine*, 74(10) pp. 1560–1569.

Ewers, J.C., 1958. *The Blackfeet Raiders on the Northwestern Plains*. Norman: University of Oklahoma Press.

Farr, W.E., 1993. Troubled bundles, troubled Blackfeet: The travail of cultural and religious renewal. *Montana: The Magazine of Western History*, 43(4) pp. 2–17.

Farr, W.E., 2001. "When we were first paid" The Blackfoot Treaty, the Western Tribes, and the creation of the common hunting ground, 1855. *Great Plains Quarterly*, 4:1 pp.131–154.

Glasgow City Council, 2000. *Memorandum Submitted by Glasgow City Council*. [Online] Select Committee on Culture, Media and Sport. Available at: http://www.publications.parliament.uk/pa/cm199900/cmselect/cmcumeds/ 371/0051808.htm

Glenbow Museum, 2011. *Traditional Stories*. [Online] Glenbow Museum. Available at: http://www.glenbow.org/blackfoot/en/html/traditional_stories.htm#napi OldMan

Government of Alberta, 2011. *Alberta Aboriginal Relations*. [Online] Government of Alberta. Available at: http://www.aboriginal.alberta.ca/

Health Canada, 2011. *Indian Residential Schools*. [Online] Health Canada. Available at: http://www.hc-sc.gc.ca/fniah-spnia/services/indiresident/index-eng.php

Hungry Wolf, A., Scriver, M., Busch, E.T., Belcourt, G., Belcourt, C., Farr, W.E. and Lowman, A., 1994. Letters to the editor. *Montana: The Magazine of Western History*, 44(3) pp. 88–94.

Indian Association of Alberta, 1970. *Citizens Plus* ("The Red Paper"). Edmonton: Indian Association of Alberta.

Johnsrude, L., 2001. Bundles of contention: Blackfoot Lament: Montana Indians see the return of revered medicine bundles as a sacred quest. But cross-border snarls

and competing visions of cultural preservation keep the relics in Alberta's Provincial Museum. *Edmonton Journal* (Alberta), March 18, 2001 Sunday, Sunday Reader; p. E3.

LHF, 2013. *About Residential Schools*. [Online] Available at: http://www.legacyof hope.ca/about-residential-schools/conditions-mistreatment

Lokensgard, K.H., 2010. *Blackfoot Religion and the Consequences of Cultural Commoditization*. Farnham: Ashgate.

McClintock, W., 1910. *The Old North Trail: Life, Legends and Religion of the Blackfeet Indians*. London: Macmillan and Co.

McMartin, P., 1991. ADOLF HUNGRY WOLF; A German emigre struggles to revive British Columbia's Blackfoot Confederacy. *The Ottawa Citizen*, December 1, 1991, Sunday, NEWS; p. F9.

Miller, J.R., 2004. *Lethal Legacy: Current Native Controversies in Canada*. Toronto: McClelland & Stewart Ltd.

Milloy, J.S., 1999. *A National Crime: The Canadian Government and the Residential School System 1879 to 1986*. Winnipeg: University of Manitoba Press.

Mosby, I., 2013. Administering colonial science: nutrition research and human biomedical experimentation in Aboriginal communities and residential schools, 1942–52, *Histoire sociale/Social History*, 46(1) pp. 145–172.

Onciul, B. 2014a. Telling hard truths and the process of decolonising Indigenous representations in Canadian museums. In J. Kidd, S. Cairns, A. Drago, A. Ryall and M. Stearn, eds. *Challenging History in the Museum*. Farnham: Ashgate, pp. 33–46.

Onciul, B., 2014b. Revitalizing Blackfoot heritage and addressing residential school trauma. In I. Convery, G. Corsane and P. Davis, eds. *Displaced Heritage: Dealing with Disaster and Suffering*. New York: Boydell and Brewer.

Parliament of Canada, 2008. 39th Parliament, 2nd Session, Edited Hansard: Number 110, June 11. [Online] Available at: http://www.parl.gc.ca/HousePublications/Publication.aspx?DocId=3568890&Language=E&Mode=1&Parl=39&Ses=2

Pitt Rivers, n.d. *Pitt Rivers Museum Historic Blackfoot shirts to visit Canada, June 2009*. [Online] Available at: http://www.prm.ox.ac.uk/blackfoot.html

Porter, J., 2013. *Ear Experiments Done on Kids at Kenora Residential School*. [Online] CBC News. Available at: http://www.cbc.ca/news/canada/thunder-bay/story/2013/08/08/tby-documents-show-kenora-residential-school-ear-experiments.html

Province of Alberta, 2008. *First Nations Sacred Ceremonial Objects Repatriation Act. Revised Statutes of Alberta 2000 Chapter F-14*. [Online] Edmonton: Alberta Queen's Printer. Available at: http://www.qp.alberta.ca/documents/Acts/F14.pdf

RAM, 2013. *History of the Royal Alberta Museum*. [Online] Royal Alberta Museum. Available at: http://www.royalalbertamuseum.ca/visit/about/history.cfm

Report of the Royal Commission on Aboriginal Peoples, 1996. *Volume 3 Gathering Strength*. [Online] Available at: http://caid.ca/RRCAP3.6.pdf

Samek, H., 1987. *The Blackfoot Confederacy 1880–1920: A Comparative Study of Canadian and United States Indian Policy*. Albuquerque: University of New Mexico Press.

Schultz, J.W., 1962. *Blackfeet and Buffalo: Memories and Life among the Indians*. Norman: University of Oklahoma Press.

Scott Taylor, M., 2011. Buffalo Hunt: International Trade and the Virtual Extinction of the North American Bison. *American Economic Review*. American Economic Association, 101(7), pp. 3162–3195.

Sharp, P.F., 1955. *Whoop-up Country: The Canadian-American West, 1865–1885*. Minneapolis: Lund Press.

Simpson, M.G., 1996. *Making Representations: Museums in the Post-Colonial Era*. London: Routledge.

Smith, K.D., 2014. *Strange Visitors: Documents in Indigenous-Settler Relations in Canada from 1876*. Toronto: University of Toronto Press.

Statistics Canada, 2011. *Aboriginal Peoples in Canada: First Nations People, Métis and Inuit*. [Online] National Household Survey. Available at: http://www12.stat can.gc.ca/nhs-enm/2011/as-sa/99-011-x/99-011-x2011001-eng.pdf

Stepney, P.H.R., 1990. Bob Scriver: the man and the collection. In P.H.R. Stepney and D.J. Goa, eds. *The Scriver Blackfoot Collection: Repatriation of Canada's Heritage*. Edmonton: Provincial Museum of Alberta, pp. 5–11.

Stoffman, J., 2000. Native history preserved in British Museum. *The Toronto Star*. February 12, 2000, Saturday, Edition 1.

Syncrude, 2014 *Homepage*. [Online] Available at: http://www.syncrude.ca/

The Globe and Mail, 1990. Museum officials foil attempt to remove artifact sacred bundle neglected, Montana Blackfeet charges. *The Globe and Mail* (Canada), June 22, 1990 Friday.

TRC, 2012. *Truth and Reconciliation Commission of Canada: Interim Report*. [Online] TRCC, Winnipeg. Available at: http://www.trc.ca/websites/trcinstitution/index.php?p=580

Treaty 7, 1877. *Aboriginal Affairs and Northern Development Canada*. [Online] Available at: http://www.aadnc-aandc.gc.ca/eng/1100100028793/1100100028803

Truth Commission into Genocide in Canada, 2001. *Hidden from History: The Canadian Holocaust. The Untold Story of the Genocide of Aboriginal Peoples by Church and State in Canada*. [Online] Available at: http://canadiangenocide.nativeweb.org/genocide.pdf

UBC 2009 *The White Paper 1969*. [Online] Available at: http://indigenousfounda tions.arts.ubc.ca/home/government-policy/the-white-paper-1969.html

Walker, K., 2003. Cree want 'spiritual' meteorite returned. *Edmonton Journal* (Alberta), May 26, 2003 Monday, CITYPLUS; p. B1.

Warry, W., 2007. *Ending Denial: Understanding Aboriginal Issues*. Peterborough: Broadview Press.

Zedeño, M.N., 2008. Bundled worlds: the roles and interactions of complex objects from the North American Plains. *Journal of Archaeological Method and Theory*, 15(4) pp. 362–378.

3 Engagement Zones[1]

So I thought the only way I know we can make change and correct misconceptions, or at least provide truth to our people, was to start providing information. To start getting involved in publications, start getting involved in institutions, and start sharing this information. Otherwise we will continue to be told by mainstream this is what we are as people, instead of us saying what we are as people.

(Piikani Elder Allan Pard Interview 2008)

Developing a reflexive practice in museums would significantly help clarify the subtle nature of the power relationships and levels of participation on offer that are too often hidden within these transactions.

(Lynch 2011:147)

Traditional curator-led First Nations exhibits have, in recent years in Canada, undergone critical reconsideration. Collaborative engagements between museums and communities are becoming an expected norm, especially in ethnographic museums. The terms 'museums', 'community' and 'engagement' are popular shorthand for what are in reality complex networks or assemblages of people, materials and ideas. What engagement means in practice and to the participants is far more complex than it first appears. There are many models of engagement and many conceptions of museums and communities. This chapter will unpick the term 'engagement', explore current engagement theory and propose a new conceptualisation of engagement that could enable further decolonisation and Indigenisation of practice.

Current museology presents community engagement as a positive, mutually beneficial way to improve and democratise representation. However analysing participation in practice reveals that there are many forms of engagement, each with different advantages and challenges, none of which solve the problems associated with representing complex, multifaceted communities. Despite the positive assumptions, engagement has the potential to be both beneficial and detrimental. Whilst being a worthy pursuit, there are limits to what engagement can achieve within current museological practice and engagement does not automatically grant integrity or validity to

museum exhibits. Engagement has real consequences for the community and should only be entered into genuinely and with sufficient time and resources to honour community contributions.

The chapter proposes that when museums work with communities they create *engagement zones* (a reworking of James Clifford's (1997) museums as contact zones), which are conceptual, physical and temporal spaces in which participants interact in an unpredictable process of power negotiations. Engagement zones often produce results such as co-produced exhibits, museum programming, employment of community members, collection loans and/or repatriations, community inclusion on museum boards and changes to museum practice and ethos. These products can be seen as the tangible manifestations of power negotiations between the engagement zone participants, and the wider museums and communities they represent. What occurs in an engagement zone and what it produces depends upon the initial models of collaboration used, the participants involved, the way the process plays out in the engagement zone and the context in which it takes place.

THEORISING ENGAGEMENT

Community engagement has been highly theorized in development studies and more recently in museum and heritage fields. Increasingly, community engagement is becoming a common museological strategy for developing new exhibits. Popular in Western museums[2], community participation has been seen as a way to help counter traditional *authorised heritage discourse* (Smith 2006) and explore alternative narratives about the past. By sharing authorship with communities, many academics and museum professionals have claimed that museums can democratise and pluralise the histories they present. This can decentralise the traditional voice of museum expertise and enable counter-narratives to be heard through the representation of community voices in the museum (Peers and Brown 2003; Phillips 2003; Conaty 2003; Simpson 1996).

Despite its recent popularity, engagement is not a new phenomenon:

> Joallyn Archambault (2009) reminds us that at least since Franz Boas consulted with George Hunt and other Kwakiutl collaborators on their presentations at the 1893 World's Columbian Exhibition, Native American consultants have at least occasionally informed museum interpretation.
> (Hoerig 2010:65)

Perhaps surprisingly the term 'engagement' can conceal more than it reveals about the realities of collaborative practice. As Bernadette Lynch describes in her account of community participation at the Manchester Museum in 2007, power is a central but invisible force:

> In transactions between museums and participants, because of the challenges of different perspectives that such encounters will inevitably

generate, issues of power and coercion become central. Yet, such processes remain largely invisible to all concerned, frequently due to a lack of awareness about the ethics of these relations within the museum's public engagement work. There is therefore an imperative to make such processes visible, in order to illuminate the relational complexities within the messy and contradictory work of participation in museums.

(Lynch 2011:147)

The term 'engagement' is widely used to describe an array of relationships from placation and potential exploitation to so called 'empowerment' of communities. There are as many approaches to engagement as there are museums, communities and individuals to participate in them. Despite this, theorists have attempted to group engagement into categories based on the level of power sharing involved (Arnstein 1969; Farrington and Bebbington 1993; Pretty 1995; White 1996; Galla 1997).

A dated, and yet still relevant and frequently borrowed model is Sherry Arnstein's (1969) *Ladder of Participation*:

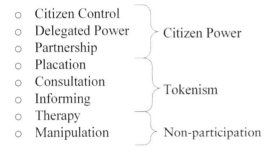

Developed from her work with neighbourhoods in urban planning and community development in 1960s America, Arnstein's model has proven useful to disciplines from social work to museology. Arnstein divides participation into three main categories: non-participation; tokenism; and citizen power. Using the ladder format enables ranking of each form with manipulation at the bottom and citizen control at the top.

Arnstein notes that each grouping is a simplification of participation in practice, yet useful because it helps show the power dynamics between groups.

The ladder juxtaposes powerless citizens with the powerful in order to highlight the fundamental divisions between them. In actuality, neither the have-nots nor the powerholders are homogeneous blocs. Each group encompasses a host of divergent points of view, significant cleavages, competing vested interests, and splintered subgroups. The justification for using such simplistic abstractions is that in most cases the have-nots really do perceive the powerful as a monolithic "system," and

powerholders actually do view the have-nots as a sea of "those people," with little comprehension of the class and caste differences among them.

(Arnstein 1969:219)

Amareswar Galla (1997:151) proposes another model in a similar vein, which focuses on heritage engagement. He describes three levels of interaction between museums and Indigenous peoples. His first mode is 'participation' which usually ends once sufficient information has been collected.

Heritage communication is a one-way process, where the external agency is empowered with the expertise and, with time, the indigenous community is disempowered of its authority on the relevant knowledge.

(Galla 1997:151)

Galla argues that it is 'a commonly practiced model that is familiar to most museums. It needs to be modified to be more participatory and less exploitative' (Galla 1997:151).

Galla terms his second mode of participation as 'strategic partnership' (1997:151). In this case 'the project is initiated either by the Indigenous community specialist or the external anthropologist' and both are co-workers on the project participating in shared decision making on the development, implementation and evaluation of the project (Galla 1997:151). Galla argues that this approach is 'mutually empowering, with heritage communication between and among all participants' (Galla 1997:152).

The third mode proposed by Galla is 'characterized by Indigenous community cultural action. The project is initiated by the community cultural specialists such as Elders and other keepers of the culture and activists working for community cultural development. Indigenous people control the cultural project and its developments. It provides a voice for Indigenous community cultural leadership and cultural reclamation' (Galla 1997:152). However, he notes that these centres are 'often inadequately resourced as they decentre the mainstream control of Indigenous peoples' heritage' (Galla 1997:152).

These two models complement one another and interestingly, my four case studies reflect four of the top categories on Arnstein's (1969) ladder and the three forms of Galla's model. Head-Smashed-In Buffalo Jump used consultation, ranked as fifth on Arnstein's ladder, but still in the category of tokenism, and the most common and basic form of participation in Galla's model. Glenbow used Galla's notion of strategic partnership initiated by the external museum expert, which features on Arnstein's third highest rung, as the lowest form of citizen power. Buffalo Nations Luxton Museum represents a form of delegated power on Arnstein's ladder as it is co-owned by community and non-community members and falls somewhere between Galla's partnership and community cultural action, suffering the effects of being 'inadequately resourced' that Galla notes as common to community centres (1997:152).

Blackfoot Crossing Historical Park is a community museum and is an example of citizen control at the top of Arnstein's ladder, and Indigenous

community cultural action in Galla's model. Blackfoot Crossing could also be considered an ecomuseum, a term first coined by the French museologist Hugues De Varine in 1971 (Davis 1999:59–60) and developed by Hugues De Varine (1978) and Georges Henri Rivière (1985). Blackfoot Crossing features many of the classic characteristics associated with ecomuseums; it is a community museum, interpretive centre and park which promotes the survival of local knowledge, culture, language and customs within, and in relation to, the local natural environment (Davis 1999; Corsane et al 2007a, 2007b). However this was not a term the community used, and as this study focused upon the self-representation of the community on their own terms the application of this concept was not pursued, although it may be a useful avenue for future studies.

Despite echoing the engagement models, the case studies do not completely reflect the hierarchy implied by their placement on Galla's model or Arnstein's ladder. Five factors can help account for this: first, the realities of engagement are much more untidy and fluid than any model or category can account for. Although engagement often starts out as a 'recipe' designed to achieve a specific outcome, through the process of engagement it can become more of a 'stone soup' (Ames 2001:207) where participants contribute on their own terms, rather than that of the institution, and create a collaborative but unpredictable outcome.

Secondly, during the process of engagement all the different kinds of participation listed in typologies such as Arnstein's may occur at different stages (Cornwall 2008:273–274) between different participants and outside bodies. Mapping Arnstein (1969), Pretty (1995), White (1996) and Galla's (1997) engagement theories against practice at the case studies (see Table 3.1) helps to give an indication of the spectrum of participation in any 'one' engagement, and highlights the changes in power sharing over the course of the process, and across different departments and activities. Thus it is not enough to ask if a museum engages, but to ask how, when, why, with what frequency and longevity, and to look at the forms and layers of engagement within an institution.

Thirdly, museums and communities do not enter into engagement with a predetermined or fixed amount of power. Power is always open to negotiation, theft, gifting and change, even in unequal power relations and 'invited spaces' (Fraser 1987, 1992, later used by Cornwall 2002; Miraftab 2004; Lynch 2011:147) of engagement in museums. In engagement, at any level on the rung, power can shift and move individual participants from positions of control, to manipulation or passive observation. Even the most powerful individual will experience moments of powerlessness, pressure and manipulation. The CEO of a museum is powerless to influence the outcome of a discussion held in an Indigenous language s/he cannot understand. A respected community Elder cannot influence museum practices which are enshrined in law. However, even the apparently powerless are able to resist and counter dominant power, because power must also be seen in relation to individual actor's agency, as Conal McCarthy (2007) explores in his analysis

of Indigenous Māori representation. In my research interviews, Kainai Elder Frank Weasel Head expressed this idea of agency and resistance through non-participation when deciding whether to work with a museum.

> I can sense it after the first day, if they are going to tell me what to do I'll sense it the first day and I'll walk out.
>
> (Interview, Weasel Head 2008)

Although a museum would traditionally be considered more powerful than an individual community member, Weasel Head illustrates the ability to resist and reclaim power through non-participation.

Power is not predetermined or innate, but it is situated within the context of the interaction. Thus despite the fluidity of power within engagement, there are structural inequalities that weight interactions between museums and Indigenous communities in Canada.

> In 2009, First Nation communities are still, on average, the most disadvantaged social/cultural group in Canada on a host of measures including income, unemployment, health, education, child welfare, housing and other forms of infrastructure.
>
> (Make First Nations Poverty History Expert Advisory Committee 2009:10)

In addition to societal inequalities, the location of museum/community meetings has an effect of power relations. Discussions held within the museum automatically favour the museum employees as they set the ground rules for interaction within their building. During Glenbow Museum's engagement with the Blackfoot community they noticed this bias and relocated meetings to Fort Macleod. By meeting with Elders away from the museum and the Blackfoot reserves, they found 'neutral ground' to try to minimise these inbuilt power imbalances.

Fourthly, there are influences beyond the *engagement zone* which limit what is made possible by engagement, such as logistics and institutional requirements (which are addressed in chapters five and six).

Fifthly and finally, the top rung of Arnstein's ladder 'citizen control' does not solve the problems of representation or relations between individuals within a community and an institution, such as a museum. Community control still requires methods of power sharing and consensus forming, because every individual cannot make all the decisions, and the whole community may not be engaged or even kept up to date. Some community members will be empowered at the top of the ladder and others will be involved in tokenistic ways or may not participate at all. The standard group binary approach of 'Us' and 'Them', museum and community, results in the models not addressing internal group power relations between individuals and over simplifies engagement in practice.

Table 3.1 Engagement theories mapped against practice at the case studies (created by Onciul).

		Theory to real-life comparison							
Theorists	Non-participation		Tokenism			Citizen power			
Arnstein 1969	Manipulation	Therapy	Informing	Consultation	Placation	Partnership	Delegated Power	Citizen control	
Models of participation Pretty 1995	Manipulative participation		Passive participation	Participation by consultation	Participation for material incentives	Functional participation	Interactive participation	Self-mobilization	
White 1996	Nominal				Instrumental	Representative	Transformative		
Galla 1997			Participation			Strategic Partnership		Community Cultural Action	
Case studies Head-Smashed-In	Provincial decisions		Gallery development			Interpretation			
Glenbow	General museum decisions			Aboriginal Board Native Liaison		Blackfoot gallery development Interpretation Community Gallery			
Buffalo Nations Luxton Museum	Exhibition		Shop staff	Board of Directors		Ownership			
Blackfoot Crossing	Wider community engagement			Gallery development				Ownership, development, staffing, running	

Thus there are a number of factors that effect the power relations within engagement, not just the model of participation used. Since current models and terminology do not fully encapsulate the complex realities of engagement in practice, I propose using the term *engagement zones* to conceptualise the space in which the unpredictable process of power sharing and negotiation plays out.

FROM CONTACT TO ENGAGEMENT

The engagement zone concept builds on James Clifford's (1997) use of Mary Pratt's (1992) concept of museums as contact zones. Pratt originally used the term to:

> . . . invoke the spatial and temporal copresence of subjects previously separated by geographic and historical disjunctures, and whose trajectories now intersect. By using the term "contact" I aim to foreground the interactive, improvisational dimensions of colonial encounters so easily ignored or suppressed by diffusionist accounts of conquest and domination. A 'contact' perspective emphasizes how subjects are constituted in and by their relations to each other. [It stresses] copresence, interaction, interlocking understandings and practices, often within radically asymmetrical relations of power.
>
> (Pratt 1992:6–7)

For Pratt the contact zone was 'the space of imperial encounters, the space in which peoples geographically and historically separated come into contact with each other and establish ongoing relations' (2008:8).

Clifford applied the term to museums, explaining that 'the organising structure of the museum-as-collection functions like Pratt's frontier' (1997:192–3). This idea has been influential in museum practice and theory and has inspired creations such as the Manchester Museum's 'Contact Zone' (Lynch 2011:153). Boast has argued that overtime the concept of the contact zone has been moulded to fit the aims of postmodern new museology (Boast 2011:59). Clifford's emphasis on the potential for agency in asymmetrical power relations has been a cause for optimism in collaborative work.

However, Tony Bennett (1998) critiqued the contact zone idea, viewing it as at odds with his own discourse on museums and governmentality.

> In place of the language of education, instruction and civic reform, Clifford envisages the museum as a place in which diverse communities might enter into exchange with one another, with museums playing the role of mediator, a facilitator of multiple dialogic exchanges governed by relations of uneven reciprocity, rather than acting as an agent in its own right in pursuit of its own civic or educative programmes.
>
> (Bennett 1998:211)

For Bennett, collections were not frontiers, but but objects to perform the work of government (1998:210). Viv Golding (2007a; 2007b; 2009) has suggested a route between these two discourses, presenting:

> . . . a view of the museum frontiers—a spacio-temporal site for acting in collaborate effort with other institutions, which provides a creative space for respectful dialogical exchange for promoting critical thought, for questioning taken-for-granted ideas in general and for challenging racist and sexist mindsets in particular . . . frontier museum work can progress lifelong learning, 'intercultural understanding' and what is known in the UK as community cohesion.
>
> (2009:2)

Golding shows that museums and their collections can function as places where diverse communities engage, with the museum as facilitator, whilst performing educative programmes that often meet government social objectives. Museums, Golding argues, 'can hold up a hope for challenging racist mindsets essentially through respectful dialogical exchange' which she terms 'feminist-hermeneutics' which draws on Fanon's (1993) concept of 'authentic communication' (2009:2).[3] Golding developed 'issue-based' active learning, to develop 'critical' thought in participants at these museum 'frontiers' (2007b:317). Golding argues that the museum:

> . . . has the potential to function as a 'frontier': a zone where learning is created, new identities are forged; new connections are made between disparate groups and their own histories (Philip 1992). In some cases, collections are shown to have a new and more positive power: to help disadvantaged groups, to raise self-esteem and even challenge racism by progressing learning.
>
> (2009:4)

Nevertheless, Robin Boast argues that only a 'partial portrait' of the contact zone perpetuates in many current discussions of engagement. He attempts to 'expose the dark underbelly' of the contact zone and, by doing so, the 'anatomy of the museum that seems to be persistently neo-colonial'. He puts forward that contact zones have been used continually by museums, by 'native science' and by 'governmentality of indigenous populations (Hemming and Rigney 2008)' as a neocolonial genre (Boast 2011:62).

> Part of this problem, of the traditional reappropriation of the contact zone as colonial contact zone, is due to the now ignored role of auto-ethnography as a fundamental neocolonial rhetorical genre and even an instrument of appropriation.
>
> (Boast 2011:62)

AUTOETHNOGRAPHY

In 1988 Indian theorist Gayatri Chakravorty Spivak raised the critical question: 'Can the subaltern speak?' (1988:271). Spivak explored the question by considering the place of women in India with consideration to the British abolition of widow sacrifice (1988:271). She criticised Foucault and Deleuze for rejecting speaking for others on the grounds that 'it assumes the oppressed can transparently represent their own true interests' (Alcoff 1991:22). She argued that subalterns cannot represent themselves authentically because their subservient position in society means that they can only speak in the terms of the dominant discourses (Spivak 1988:308).

Spivak argues that '"listening to", as opposed to speaking for, essentializes the oppressed as nonideologically constructed subjects' (Alcoff 1991:22). However Spivak recognises the dangers of speaking for others and settles on a 'speaking to' approach in which 'the intellectual neither abnegates his or her discursive role nor presumes an authenticity of the oppressed but still allows for the possibility that the oppressed will produce a "countersentence" that can then suggest a new historical narrative' (Alcoff 1991:23).

For museums engaging with communities, the power to speak is a key issue. Museums must grapple with the challenge of acknowledging their discursive role, avoiding essentializing 'Others', whilst concurrently recognising the potential limitations of peoples' abilities to speak for themselves and their potential to create new counter narratives. To do this requires critical reflexivity and careful communication between the museum staff and the community. Such engagement places heavy demands upon museum resources and staff members' skills.

Researching Māori in New Zealand, Conal McCarthy (2007) presents a different perspective on subaltern agency and their ability to speak. He argues although museums have only recently undertaken official consultation, Māori have had agency and sought to influence the way they are represented since Europeans began showing their material culture in museums. McCarthy considers different forms of power and influence, and explores agency throughout the history of Māori relations with museums. Spivak and McCarthy both make compelling arguments, as colonised people are both influenced by the dominant society within which they live, but also have the agency to resist, speak out, and contradict the dominant discourse, even if it is framed within the context of the times.

Mary Pratt (1991) describes this framed agency as 'autoethnography': a process 'in which people undertake to describe themselves in ways that engage with representations others have made of them' (1991:35). Indigenous people can critically engage with, and respond to, negative stereotypes and misrepresentations and rebut widely held misinformation.

> Autoethnographic works are often addressed to both metropolitan audiences and the speaker's own community. Their reception is thus highly

indeterminate . . . [as] it will read very differently to people in different positions in the contact zone . . . Such [works] often constitute a marginalized groups' point of entry into the dominant circuits of . . . culture.
(Pratt 1991:35)

Robin Boast argued that Pratt's example of autoethnography (Pratt 1991:38) is vital to understanding how the museum as contact zone functions (2011:61). It is this autoethnography that has mostly been forgotten in the more recent uses of Pratt and Clifford's contact zones despite both Clifford (1997:213) and Pratt's (1991:34) emphasis on its importance as 'one of the most significant, and most neo-colonial, aspects of all contact zones' (2011:61–62).

Boast notes Pratt's emphasis on autoethnographic texts as not being forms of self-representations, but a point of entry into dominant discourse (2011:62). This raises key issues for collaborative engagement based on contact zone models and ties into the debate on the limits of self-representation within a dominant cultural form such as the museum (which will be addressed in chapters five, six and seven).

Boast argues that Clifford provides a near perfect example of a functioning contact zone, however, he highlights that it is not the assumed relationship of 'equal reciprocity and mutual benefit' (2011:63). Boast explains that contact zones are 'asymmetric spaces of appropriation' and that despite best intentions, they 'remain sites were Others come to perform for us, not with us' (2011:63).

Boast critiques the contact zone as neo-colonialism, stating that the contact zone is a *clinical collaboration*, a *consultation* that is designed from the outset to appropriate the resources necessary for the academy and to be silent about those that are not *necessary*' (emphasis original, Boast 2011:66). Instead of decentring the museum he sees the contact zone as a site 'in and for the centre' (2011:67) and rather than addressing asymmetries, the museum as contact zone, 'is and continues to be used instrumentally as a means of masking far more fundamental asymmetries, appropriations, and biases' (2011:67). His solution is for museums to 'learn to let go of their resources, even at times of the objects, for the benefit and use of communities and agendas far beyond its knowledge and control' (2011:67).

While Boast raises interesting and valid points, he is talking about a certain kind of engagement: consultation, termed tokenism by Arnstein (1969); and his solution is another form of engagement: community control, viewed as the top of the engagement ladder (Arnstein 1969). This book will demonstrate some of Boast's points, as my research highlights inequalities in current engagement relationships; however my work will also illustrate the potential of engagement to create critical thought, raise self-esteem and challenge racism, as Golding (2007a, 2007b, 2009) has argued. I support the need for Western museums to release resources and return objects to community benefit and use (Boast 2011:67). However, I also think it is important

to recognise that community controlled museums are not necessarily a conclusion, but the beginning of new relations with their own challenges and dynamics that will require communities and any museum-like forms to continue to engage and deal with the asymmetries of power relations.

To return to Clifford and the notion of the contact zone, from the beginning Clifford acknowledged 'the limits of the contact perspective' (1997:193). Describing Portland Museum's consultation with Tlingit Elders about the museum's Rasmussen Collection, Clifford notes that 'some of what went on in Portland was certainly not primary contact zone work', among the Tlingit 'interclan work' occurred that was 'not directed to the museum and its cameras' (1997:193).

> It would be wrong to reduce the objects' traditional meanings, the deep feelings they still evoke, to 'contact' responses. If a mask recalls a grandfather or an old story, this must include feelings of loss and struggle; but it must also include access to powerful continuity and connection. To say that (given a destructive colonial experience) all indigenous memories must be affected by contact histories is not to say that such histories determine or exhaust them.
>
> (Clifford 1997:193)

ENGAGEMENT ZONES

I propose the use of the term *engagement zones* to incorporate what *contact zones* cannot: the inter-community work that occurs in cross-cultural engagement and is prominent in community controlled grass-root community developments, such as Blackfoot Crossing. The engagement zone includes the spectrum of engagement approaches from tokenism to community control and emphasises the agency of participants and potential for power fluctuations, despite common inequalities of power relations. It allows for consideration and exploration of culture and heritage prior to and beyond the experience of colonialism. The term enables internal community engagement and indigenisation of the process, distinct from contact work: thus the concept is different to, but compatible with contact zones. Contact zones can occur within engagement zones, and engagement zones produce outputs such as exhibits that often become public contact zones; but engagement zones can also occur without being contact zones, for example within inter-community engagements.

I originally modelled the engagement zone as it appears below (Figure 3.1) to show the input of individuals from the museum and community into the engagement zone and the output of potential products of engagement work such as: adaptation of curatorial practice; community participation or influence on policy and advisory boards; co-produced exhibits; co-produced programmes and the employment of community members, for example in

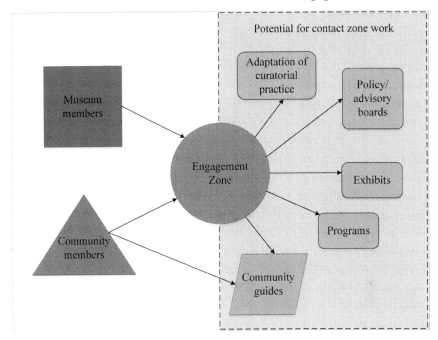

Figure 3.1 Engagement Zone diagram.
(Onciul 2013:84).

the role of guides. Whether cross-cultural or mono-cultural, the engagement zone (depicted above) is:

- a conceptual, physical and temporal space created through engagement;
- spontaneous or strategically planned;
- a location of power flux and negotiation;
- an unmapped and unpredictable terrain;
- semi-private semi-public space where 'on stage and off stage' (Shryock 2004) culture can be shared and discussed;
- a space in which knowledge can be temporarily and/or permanently interpreted and translated;
- a space in which insider/outsider boundaries blur;
- powerful, but fragile, unique and impermanent;
- a space that can be indigenised and created on its own culturally specific terms;
- a process that can produce tangible products of power sharing, such as exhibits, programming, new curatorial practice and ethos, knowledge creation and new relationships.

The additional models below (Figures 3.2 and 3.3) help to demonstrate how engagement zones can function in different scenarios; for example community

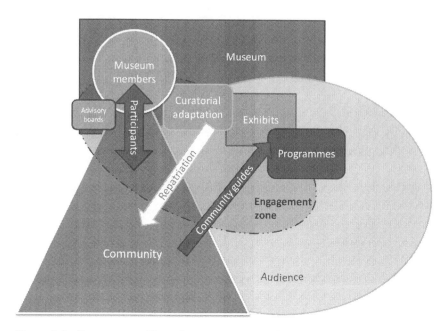

Figure 3.2 Engagement Zone in a non-community museum engaging with a community.

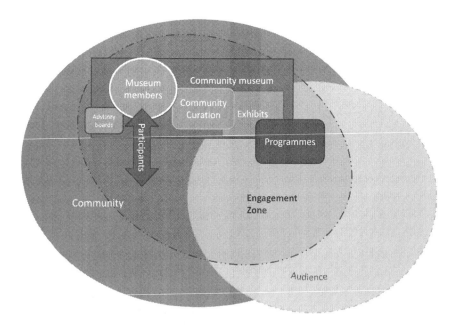

Figure 3.3 Engagement Zone in a community run museum.

and non-community museums. All illustrate that the individual participants in the engagement between the museum and community are at the heart of the engagement zone. These participants do not include the whole community, nor necessarily the whole museum. Nevertheless, the engagement zone also has a wider impact and influence beyond the participating individuals.

The repatriation arrow in the non-community museum diagram represents a catalyst and product of engagement and falls just beyond the edges of the engagement zone to emphasize that items returned to communities can be part of the engagement zone or return to private lives within the community. Similarly the arrow representing the community guides does not necessarily stem directly from the original engagement, but comes later, with people often sourced directly from the community who then enter the engagement zone.

The hard edges of the museum and exhibit boxes in Figure 3.2 emphasise that these spaces often follow more traditional rules, whereas the rounded edges of the community museum, curatorial adaptation, advisory board and programmes emphasise their adapted and potentially more flexible nature. The extent to which different elements of the museum and museum practice fall within the engagement zone depends upon the level of institutional engagement and the outside influences on processes and decisions, such as government funding and laws. Similarly the audience oval encompasses some of the museum, community and engagement zone, but goes beyond this to include visitors and tourists unrelated to the community, or visiting to view galleries unrelated to the engagement process.

Whichever way the idea is modelled in the diagrams, the emphasis is upon engagement zones as physical and conceptual spaces in which participants interact. They are created when individuals enter into engagement and close when those participants cease engaging. If participants change, so do the parameters of the zone and the interaction within it. It is a temporary, movable, flexible and living sphere of exchange that can be spontaneous or strategically planned. Engagement zones can occur on frontiers, within groups, and as a result of border crossings.

Engagement zones are 'in-between' spaces (Bhabha 1994:2), semi-private semi-public, where 'on stage and off stage' (Shryock 2004) culture can be shared and discussed. Knowledge can be interpreted and translated to enable understanding for those without the necessary cultural capital. If required, 'off stage' information may be disclosed to facilitate the process, although it is generally not intended to leave the engagement zone, nor for public dissemination in products such as exhibits.

Within the engagement zone power ebbs and flows, continually being claimed, negotiated and exchanged, not predetermined or static, but situated within the context of the interaction. Conflict, compromises and consensus can occur. Participants continually negotiate the rules of exchange, challenging and debating power and authority. Cultural concepts such as expertise, customary boundaries and hierarchies, come into question and negotiation, and can change individuals' roles and status within the zone. Boundaries

between insider and outsider blur, and temporary boundary crossing are enabled. Some participants described feelings of risk caused by stepping out of traditional roles and crossing boundaries in these zones, due to the fact that individual participants are often judged by the action of the engagement zone group, irrespective of internal power relations or individual contributions (discussed in detail in chapters eight and nine).

Despite the fluidity of power within engagement zones, as discussed there are real structural inequalities that weight interaction between museums and Indigenous communities. Museums generally hold the majority of the power as cultural authorities, but Indigenous communities still have power and agency to negotiate terms, particularly because they have the leverage of holding desperately sought after Indigenous knowledge that cannot be found beyond the private sphere of the community.

As spaces of power flux, engagement zones are an unmapped, unpredictable and inconsistent terrain, which has the capacity to produce unexpected outcomes. To borrow Lisa Chandler's expression, community engagement is a 'journey without maps' (2009:85), and what will be discovered, shared and changed along the way can only be known through doing and experiencing the process. If temporary changes are carried beyond the engagement zone and incorporated into each groups' practices, or the products they co-produce, the results can be transformative. However, these zones do not operate in isolation, but are influenced by the wider context in which they are situated (explored in chapters five and six).

Ruth Phillips (2011) proposes that Bruno Latour's Actor Network Theory can help to bring Western academics and museums closer to an understanding of Indigenous epistemology. Understanding and valuing the agency of human and non-human actors in networks helps embed museums into their wider social, political and historical contexts and enables connections to be made beyond the walls of the museum that explain the ongoing importance of representation and cross-cultural understanding to everyday lived experience of people in Canada, settler nations and beyond. Such networks are to some extent captured in the engagement zone, although they also go beyond it.

CONCLUSION

Engagement is more complex than the current models can illustrate because engagement is a living, organic, ever-changing process. The focus on community control as the best option in the models obscures the fact that community members still have to consult with their community which will not automatically empower all community members. Some of the complexities of engagement can be explored using the idea of engagement zones with permeable boundaries and a specific set of engagement rules, enabling power to be shared and negotiated. Each case study highlighted an important factor

that influences even the best intentions of community engagement. The next chapter will consider engagement theory in practice, particularly how engagement zones were initiated and negotiated at each case study, and the individuals who crossed boundaries to enter them.

Engaging with the Blackfoot communities required the case studies to consider questions of how to engage, who to work with, when, why and what for. It also raised issues around the levels of power sharing and the extent to which the case studies were willing or able to change. Communities are not discrete objects that can simply be collected, but a mass of ever changing living people, with their own issues, agendas and dynamics. As such, engagement requires negotiation as each participating community representative has their own expectations and requirements. The Blackfoot community in particular, is aware of their academic appeal as they have been studied and documented since Western contact and they have considerable experience in managing and negotiating these relationships. Consequently members of the community, particularly Ceremonialists and Elders with traditional knowledge, are often asked to participate in studies and are experienced in deciding who to work with and on what terms. It is within this context that the case studies developed engagement theory into practice.

NOTES

1. Extracts of this chapter have previously been published and are reprinted here with permission. © B. Onciul 2013 'Community Engagement, Curatorial Practice, and Museum Ethos in Alberta, Canada'. pp. 79–97 in *Museums and Communities: Curators, Collections and Collaboration* edited by V. Golding and W. Modest, and Bloomsbury Academic, an imprint of Bloomsbury Publishing Plc.
2. In Britain the government Department for Culture, Media and Sport publically endorsed the idea of democratising museums and enabling public participation (DCMS 2006:2). In Canada, Indigenous community engagement was advocated in 1992 by the Task Force on Museums and First Peoples report, *Turning the Page: Forging New Partnerships Between Museums and First Peoples* (AFN 1992a).
3. Although this book does not directly address issues of gender or feminist theory, these ideas are useful to understanding the Blackfoot community's goals to build pride and tackle racism identified in the research.

REFERENCES

AFN (Assembly of First Nations) and CMA (Canadian Museums Association), 1992a. *Turning the Page: Forging New Partnerships Between Museums and First Peoples. Task Force Report on Museums and First Peoples*. Ottawa: Carleton University.

Alcoff, L., 1991. The problem of speaking for others. *Cultural Critique*, Winter Issue pp. 5–32.

Ames, M.M., 2001. Why post-millennial museums will need fuzzy guerrillas. In: M. Bouquet, ed. *Academic Anthropology and the Museum: Back to the Future.* New York: Berghahn Books, pp. 200–211.

Arnstein, S.R., 1969. A ladder of citizen participation. *JAIP*, 35(4) pp. 216–224.

Bennett, T., 1998. *Culture: A Reformer's Science.* London: Routledge.

Bhabha, H.K., 1994. *The Location of Culture.* London: Routledge.

Boast, R., 2011. Neocolonial collaboration: museum as Contact Zone revisited. *Museum Anthropology,* 34(1) pp. 56–70.

Chandler, L., 2009. 'Journey without maps': unsettling curatorship in cross-cultural contexts. *Museum and Society,* 7(2) pp. 74–91.

Clifford, J., 1997. *Routes: Travel and Translation in the Late Twentieth Century.* London: Harvard University Press.

Conaty, G.T., 2003. Glenbow's Blackfoot Gallery: working towards co-existence. In L. Peers and A.K. Brown, ed. *Museums and Source Communities: A Routledge Reader.* London: Routledge, pp. 227–241.

Cornwall, A., 2002. Locating citizen participation. *IDS Bulletin,* 33(2) pp. 49–58.

Cornwall, A., 2008. Unpacking 'Participation': models, meanings and practices. *Community Development Journal,* 43(3) pp. 269–283.

Corsane, G., Davis, P., Elliot, S., Maggi, M., Murtas, D. and Rogers, S., 2007a. Ecomuseums evaluation in Piemonte and Liguria, Italy. *International Journal of Heritage Studies,* 13(2) pp. 101–116.

Corsane, G., Davis, P., Elliot, S., Maggi, M., Murtas, D. and Rogers, S., 2007b. Ecomuseum performance in Piemonte and Liguria, Italy: the significance of capital. *International Journal of Heritage Studies,* 13(3) pp. 224–239.

Davis, P., 1999. *Ecomuseums: A Sense of Place.* London: Leicester University Press.

DCMS, 2006. *Understanding the Future: Priorities for England's Museums.* London: UK Government.

De Varine, H., 1978. L'écomusée. *Gazette,* 11(2) pp. 29–40.

Fanon, F., 1993. *Black Skin, White Masks.* London: Pluto Press.

Farrington, J., Bebbington, A. with Wellard, K. Lewis, D.J., 1993. *Reluctant Partners: Non-governmental Organisations, the State and Sustainable Agricultural Development.* London: Routledge.

Fraser, N., 1987. Women, welfare, and the politics of need interpretation. *Hypatia: A Journal of Feminist Philosophy,* 2 pp. 103–21.

Fraser, N., 1992. Rethinking the public sphere: A contribution to the critique of actually existing democracy. In C. Calhoun, ed. *Habermas and the Public Sphere,* Cambridge, MA: MIT Press, pp. 109–142.

Galla, A., 1997. Indigenous peoples, museums, and ethics. In G. Edson, ed. *Museum Ethics.* London: Routledge, pp. 142–155.

Golding, V., 2007a. Inspiration Africa! Using tangible and intangible heritage to promote social inclusion amongst young people with disabilities. In. S. Watson, ed. *Museums and Their Communities.* London: Routledge, pp. 358–372.

Golding, V. 2007b. Learning at the museum frontiers. Democracy, identity and difference. In S.J. Knell and S. MacLeod, eds. *Museum Revolutions. How Museums Change and are Changed.* London: Routledge, pp. 315–329.

Golding, V., 2009. *Learning at the Museum Frontiers. Identity, Race and Power.* Surrey: Ashgate Publishing Limited.

Hemming, S. and Rigney D., 2008. Unsettling Sustainability: Ngarrindjeri Political Literacies, Strategies of Engagement and Transformation. Continuum 22(6) pp. 757–775.

Hoerig, K.A., 2010. From third person to first: A call for reciprocity among non-native and native museums. *Museum Anthropology,* 33(1) pp. 62–74.

Lynch, B.T., 2011. Collaboration, contestation, and creative conflict. On the efficacy of museum/community partnerships. In J. Marstine, ed. *The Routledge*

Companion to Museum Ethics. Redefining Ethics for the Twenty-First-Century Museum. London: Routledge, pp. 146–163.

Make First Nations Poverty History Expert Advisory Committee, 2009. *The State of the First Nations Economy and the Struggles to Make Poverty History.* [Online] Available at: http://abdc.bc.ca/uploads/file/09%20Harvest/State%20of%20the%20 First%20Nations%20Economy.pdf [Accessed March 2011].

McCarthy, C., 2007. *Exhibiting Māori: A History of Colonial Cultures of Display.* Oxford: Berg & Te Papa Press.

Miraftab, F., 2004. Invited and invented spaces of participation: neoliberal citizenship and feminists' expanded notion of politics. *Wagadu*, 1(Spring) pp. 1–7.

Onciul, B. 2013. Community engagement, curatorial practice, and museum ethos in Alberta, Canada. In V. Golding and W. Modest, eds. *Museums and Communities: Curators, Collections and Collaboration.* London: Bloomsbury, pp. 79–97.

Pard, Allen, 2008. 12 Nov 2008. Interview.

Peers, L. and Brown, A.K. ed., 2003. *Museums and Source Communities: A Routledge Reader.* London: Routledge.

Philip, M.N. 1992. *Frontiers: Selected Essays and Writings on Racism and Culture 1984–1992.* Toronto: The Mercury Press.

Phillips, R.B., 2003. Introduction: community collaboration in exhibitions: towards a dialogic paradigm. In L. Peers and A.K. Brown, eds. *Museums and Source Communities: A Routledge Reader.* London: Routledge, pp. 155–170.

Phillips, R.B., 2011. *Museum Pieces: Toward the Indigenization of Canadian Museums.* Montreal: McGill-Queen's University Press.

Pratt, M.L., 1991. Arts of the contact zone. *Profession* 91. New York: MLA, pp. 33–40.

Pratt, M.L., 1992. *Imperial Eyes: Travel Writing and Transculturation.* London: Routledge.

Pratt, M.L., 2008. *Imperial Eyes: Travel Writing and Transculturation.* 2nd ed. London: Routledge.

Pretty, J., 1995. Participatory learning for sustainable agriculture. *World Development*, 23(8) pp. 1247–1263.

Rivière, G. H., 1985. The ecomuseum - an evolutive definition. *Museum International*, 37(4) pp. 182–183.

Shryock, A., 2004. Other conscious/self aware: First thoughts on cultural intimacy and mass mediation. In A. Shryock, ed. *Off Stage On Stage: Intimacy and Ethnography in the Age of Public Culture.* Stanford: Stanford University Press, pp. 3–28.

Simpson, M.G., 1996. *Making Representations: Museums in the Post-Colonial Era.* London: Routledge.

Smith, L., 2006. *Uses of Heritage.* London: Routledge.

Spivak, G.C., 1988. Can the subaltern speak? In C. Nelson and L. Grossberg, eds. *Marxisim and the Interpretation of Culture.* Hampshire: Macmillan, pp. 271–313.

Weasel Head, Frank. 13 Nov 2008. Interview.

White, S.C., 1996. Depoliticising development: the uses and abuses of participation. *Development in Practice*, 6(1) pp. 6–15.

4　Transforming Theory into Practice

The last chapter set out the current theory on engagement and proposed *Engagement Zones* as a new module for indigenizing and decolonising engagement. To give that discussion tangibility it is useful to contextualise it in relation to the four southern Albertan case studies: Head-Smashed-In Buffalo Jump Interpretive Centre; Glenbow Museum; Buffalo Nations Luxton Museum and Blackfoot Crossing Historical Park. Each case study sought to work collaboratively with local Indigenous Blackfoot communities, in particular Blackfoot Elders and Ceremonialists, and three used the engagement to create co-authored exhibits on Blackfoot culture. However, each selected a different model of engagement at a different point in time for different reasons.

By exploring theory in practice the chapter illuminates the human connections that develop from real relationships between individuals that cannot be captured in theoretical models. Negotiation of the terms of engagement was unique to each case study as it depended upon the actors, the context and previous experiences of each party. This chapter will analyse the initiation and negotiation of each engagement to explore some of the complexities and uncertainties of engagement and the challenges of navigating the unmapped territory of engagement zones.

HEAD-SMASHED-IN BUFFALO JUMP
INTERPRETIVE CENTRE

The first of the case studies to embark on engagement was Head-Smashed-In in the early 1980s when it involved Piikani and Kainai Blackfoot Nations in the development of the interpretive centre for the archaeological buffalo kill site. At the time, the other case studies were still developing their ideas on community work (in the case of Glenbow) or developing the ideas about establishing a museum (in the case of Buffalo Nations Cultural Society and Blackfoot Crossing).

Head-Smashed-In is an important site to Blackfoot people as the buffalo jump provided a source of food for the winter for generations and was an

important processing and campsite. The jump is still seen and respected as sacred place by Blackfoot people, there are Blackfoot petroglyphs and a sacred vision quest site nearby which are still in use.

Pre-NAGPRA (1990) and pre-Task Force (1992), Head-Smashed-In's consultation with the Blackfoot was ahead of wider reform in Canadian museum/Indigenous relations, and the archaeologists were under no legal or professional obligation to engage. Interestingly the engagement was as a result of circumstance, more than ethos. The initial stages of development went ahead without any consideration for the local Blackfoot Nations, and in the beginning there was no plan to include them. The site was approved funding and status as a World Heritage Site before any Blackfoot communities had been asked their opinion on the development. However, the proximity to the Piikani Reserve and the community's connection with the site was influential on the archaeologists' decision to consult the community (Brink 2008:272–275).

> The Piikani put forward their ideas to include the Blackfoot oral histories in the interpretive centre. Their skills and knowledge made the involvement happen; it was not, by any means, a government initiative to involve them.
>
> (Interview, Brink 2006)

Jack Brink, currently the Curator of Archaeology at the Royal Alberta Museum, was an archaeologist on the Head-Smashed-In dig and was assigned the task of community consultation. Brink approached the neighbouring Piikani Nation first. The Piikani Band Council advised him to talk to the Elders and the Elders recommended Joe Crowshoe to be Brink's main consultant and assistant in the development of the interpretive centre. Crowshoe was an Elder and he conducted interviews and consulted with other Blackfoot Elders on Brink's behalf, gathering knowledge about the jump for the centre's interpretive exhibits.

The neighbouring Kainai Nation also wished to be consulted as they considered themselves stakeholders in the Jump as it was used by them and also part of their heritage. Regional Manager Ian Clarke explained that after initial consultation the Piikani community were not convinced about the development of the centre, so Brink and Crowshoe approached the Kainai nation:

> It is interesting that it was the Blood's [Kainai's] acceptance of [the concept] that allowed us then to go back to the Peigan [Piikani] with the information that Mr. Crowshoe and the Bloods were in favour of going ahead, and on that basis they changed their position. I expect they didn't want to be left out of the process if it was going to go ahead anyway. So since we had the Blood's blessing, and there is probably more rivalry among those bands than a lot of people understand, it seemed that

Mr. Crowshoe, the Peigan, used the Blood band's interest to draw the Peigan back in again.

(Interview, Clarke 2008)

Clarke's account of the purposeful manipulation of community rivalry may account for ongoing challenges Head-Smashed-In faces today, as issues continue around the balance of Kainai and Piikani perspectives and employment. Further still, the late involvement of Kainai restricted their ability to shape the project and the Siksika and Aamsskáápipikani were not consulted at all. As Clarke states, Head-Smashed-In would have gone ahead without Piikani support, thus the building blocks of community involvement began with vast asymmetries.

Although relations were not equal, Joe Crowshoe was able to negotiate his terms of engagement and what would and would not be shown within the exhibit. However, not all of the community was comfortable with the decisions he made on their behalf (Interview, Anonymous 2008). The decision to create replica sacred bundles and a painted Buffalo Skull for exhibition continue to be a point of contention at Head-Smashed-In today because they represent sacred ceremonial items which are traditionally not for public display. Crowshoe and Brink negotiated what would be included in the interpretation and Brink notes his influence on the inclusion of the controversial replicas:

I did push them a bit on having something in that building about aboriginal religion. I was the guy that introduced replicas. I suppose that's my Western culture coming through my bias, well better to educate [the visitors] than keep them in the dark. I didn't grow up in a culture where you hide things because they're sacred or ceremonial.

(Interview, Brink 2006)

For the Blackfoot, bundles are extremely sacred. Protocol requires that they only be handled or kept by Elders with ceremonial rights and knowledge, gained through years of participation in age graded sacred societies. Crowshoe had the cultural rights to work with bundles, but as a result some community members felt that this meant he could not make a replica. The argument being that either a person does not have the rights to work with bundles and therefore could not produce a replica as they would lack the knowledge; or they do have the rights, but then they would make a real and active bundle. Thus the 'replica' status of the bundles is in question, and many community members feel that real bundles have no place being on display as they are believed to be powerful and restricted sacred items (Interview, Provost 2006). In a similar example, Blackfoot Kainai protocol prevented a replica being made or photographs taken of a sacred Headdress repatriated in 2003 from the University of Aberdeen Marischal Museum collection to the Kainai (Curtis 2007:48–49).

Although Crowshoe negotiated his participation, the majority of the decision making power and authority remained with Head-Smashed-In

non-Blackfoot staff. Brink wrote all the text panel copy for the interpretive boards in consultation with Crowshoe and the Blackfoot interpretive guides still use an interpretive matrix developed by non-community members in consultation with the community, as the then Site Manager explained:

> Ultimately the matrix was written by professional people from the ministry. In other words our scientists, our heritage people, our historians dealt with the Elders and the discussion; and they pulled all the amalgamated material together and laid it out, with a consensus that it represented the themes and discussions that had taken place. It wasn't signed off, but it essentially had the agreement of all parties.
>
> (Interview, Site Manager 2006)

This quote highlights a value judgement on the Blackfoot knowledge compared to 'the professional people from the ministry', and emphasises that although Blackfoot Elders were consulted they did not have the final say. This highlights one of the problems of consultation: community consultants are often held accountable for decisions that were not necessarily within their control (discussed at length in chapters eight and nine). Upper-management positions at Head-Smashed-In have always been non-Blackfoot and the storyline and films continue to be scripted by non-Blackfoot staff with Blackfoot input.

As a government run interpretive centre, Head-Smashed-In is often associated with ongoing conflicts between First Nations and Canadian government. Such negative connotations can overshadow the community input. As a result some community members often think of it as a Western, government institution and not a necessarily a place of Blackfoot community voice. Joe Crowshoe's son, Reg Crowshoe (Piikani Chief at the time of interview) said:

> The provincial museum, Head-Smashed-In, and so on, those governments come from a Western perspective, museum concepts that are Western models. So when we look at the museums and Head-Smashed-In, they are really developed from a Western development initiative.
>
> (Interview, Crowshoe 2008)

Head-Smashed-In used consultation, which is ranked as tokenism on Arnstein's (1969) *Ladder of Participation*. This could account for some of the negative feelings towards the centre within the community. However, in the 1980s it was still a progressive step in museum/community relations at the time (see Slater 2006 for more discussion on the original development of Head-Smashed-In).

In 2007 Head-Smashed-In began redevelopment of their multimedia presentations and created a small new exhibit on contemporary Blackfoot life. This action was taken in response to the need to renew the worn-out dated films, and in response to Blackfoot community members and interpretive staff

recommendations. The need for the creation of an exhibit to interpret modern Blackfoot life was emphasised by Blackfoot employees such as the late Lorraine Good Striker. The interpreters wanted a way to address tourists' curiosity in their modern day lives (Interview, Good Striker 2006). Even though the Blackfoot staff requested and supported the development, the process was initiated by upper-management and was a top-down process with input via consultation from community representatives (Interview, Brink 2008).

Thus despite the significant changes in museology and engagement practice since the early 1980s, Head-Smashed-In repeated their original approach to engagement and used consultation. The process involved consulting with internal Blackfoot staff and a group of four Elders from the community: Joe Spotted Bull; Margret Plain Eagle; Rosie Day Rider; and Wilfred Yellow Horn. Jim Martin, the Head-Smashed-In Education Specialist and in-house Film Project Manager at the time of interview, noted that 'we tried to have two men two women, two Piikani, two Kainai to have equal representation' (Interview, Martin 2008). Similar to the original development, Head-Smashed-In relied on one primary external consultant for the film.

> Wilfred Yellow Horn was really our main contact after the initial meeting with Elders. We had a couple of meetings with Elders, three or four, where we brought them together here at the Jump [Head-Smashed-In] and we walked them through the script and then we asked their opinions and asked for their commentary. And we would do all of this orally, we would read through it with them and take notes and then revise the script and then get back to them. We went through two or three revisions like that and Wilfred was our main contact that we would go back to and ask: 'is this right now?'.
>
> (Interview, Martin 2008)

Consultation with the Elders was used primarily to gain approval of the partially developed product. Rather than being asked to initiate ideas, the Elders were there to comment on ideas developed by the non-Blackfoot film company and the non-Blackfoot Head-Smashed-In staff.

Similarly the Blackfoot Head-Smashed-In staff were consulted to gain information and approval, but were not included in the main development team. Elder and former Head of Interpretation, Lorraine Good Striker was the main internal consultant on both the film and exhibition. She was relied upon heavily by the non-Blackfoot team to review the film and exhibits; however she was diagnosed with terminal cancer and passed away before the completion of the projects.

> What I know for a fact was she was lying there on her death bed within an hour or two of dying and she was reading through something for one of our projects we were working on. They were bringing her stuff, she was saying 'no no, I'm going to do it, I'm going to do it.' She was

incredibly weak and riddled with drugs, but she literally read till almost the last minute she was breathing.

(Interview, Brink 2008)

Her dedication to the project was noted in the *Alberta Sweetgrass* news:

The day before she died, Lorraine Good Striker was going over notes and making suggestions to improve the accuracy of a film to be shot at Head-Smashed-In Buffalo Jump Interpretive Centre in southern Alberta. 'She was dealing with little details of the script, making comments right until her last breath,' said centre manager Terry Malone, who oversaw her work as head of the interpretation department over the last seven years. 'It was a personal obligation of hers to ensure her culture was represented as truthfully as possible,' he added.

(Meili 2007)

This illustrates both Good Striker's passion and commitment, and Head-Smashed-In's overreliance on a few Blackfoot individuals to represent a whole community and history.

The major focus of the redevelopment was on the feature film which is shown in the centre's theatre at the start of every tour. The film aims to enable the visitor to experience a buffalo hunt. Based on the original film which was developed in the 1980s, the new film was intended to update the original with better graphics and special effects, and to correct some problems the community had identified in the original, namely the depiction of women with bare shoulders which was highlighted as inaccurate and culturally inappropriate by Blackfoot Elders.

The original film was 20 years old and many parts of the original film were actually missing. The one that people were seeing on DVD had been cobbled together from remaining bits and pieces of a number of 35mm film prints. Certain scenes were still quite good, like the scene of the Inniskim ceremony and certain shots of outside, but there were a lot of slides filling in. It was more like a multi-media piece; it had a lot of weak points, so it was felt that the centre needed to have a new showcase film.

(Interview, Martin 2008)

The need for a new film had been in discussion for many years, but was only initiated when funds became available providing the feature film with a $400,000 budget. The film was created by Myth Merchants, a non-Blackfoot film company, and the Director Brian Murphy wrote the first draft of the script. The script was worked on by Head-Smashed-In's former archaeologist, Jack Brink (who had developed the original interpretive centre and its interpretation with the assistance of Elder Joe Crowshoe). The Elders and Blackfoot employees were consulted on the script only after its original

development. Thus the project was not an exercise in empowering the community to represent themselves, but a method to try to ensure accuracy and community approval before finalising and publically exhibiting the film.

> Any details in the script or in the shooting we would go to Wilfred and he would consult with other Elders if he felt he needed to.
>
> (Interview, Martin 2008)

The centre has two other audio-visual presentations embedded in the exhibits. The first is on the history of the return of the buffalo from near extinction, and the second is about the archaeology of the site and features the original archaeologists including the exhibit developer and archaeologist Jack Brink. They were both updated, but as their focus was not Blackfoot culture they did not under-go such a rigours consultation process:

> The other films were fairly straight forward. We had scripts that were reviewed in-house here by our Blackfoot staff and any kind of content that related to Blackfoot culture was reviewed generally by Quinton [Crowshoe] and to some extent Trevor [Kiitokii], but Quinton was my main contact here and if he had things he wasn't sure about he would take it to speak with Elders.
>
> (Interview, Martin 2008)

Head-Smashed-In relied on the Elders they consulted with and their own Blackfoot staff members to go out and consult with others in the community on behalf of the centre to bring wider knowledge and approval into the process. Although it is not formalised in the process, this is a vital role Elders and employees play as go-betweens between the museum and the community.

Despite the awareness of the need for these individuals to consult with the wider Blackfoot community, time was limited and some staff members felt the process was hindered by a lack of sufficient time to engage properly. Head-Smashed-In had to meet government set budgeting and development timelines despite staff members recognising that they were not culturally appropriate, as Jim Martin explained:

> I felt we had some fairly good representation from Elders from the beginning; however we needed more time because the Elders did not feel they had enough time to ponder. They like to take it home and think on it for maybe weeks, maybe months. In this case we needed them to get back to us within days. That was very stressful for them and for us. So looking at projects like this in the future, my biggest recommendation would be to find a way to allow more time because the Elders do not react to reviews like a script committee, they can't just take it home as homework. They need to really think about it for a while and they might go and talk with other Elders, and they may start looking into

the oral history and talking with people who have certain memories and that can take a long time.

(Interview, Martin 2008)

Thus in the time between the original development of Head-Smashed-In and re-development of its films and some exhibits, little changed in the approach to community involvement. The main engagement occurred between the non-Blackfoot film company and Head-Smashed-In's upper non-Blackfoot management, with Blackfoot participants invited into the predominantly white engagement zone as and when information and approval was required. The centre continues to approach engagement from Arnstein's level of tokenism, despite the institutionalisation of Blackfoot Elders involvement and the employment of Blackfoot staff.

Some Elders who had not been included in the consultation had strong feelings about the level of community participation and the accuracy of the representation at Head-Smashed-In.

... here [Head-Smashed-In] they didn't do enough consultation, so there is still work that needs to be done, proper consultation.

(Interview, Pard 2008)

Pard put forward that even the Jump's name was incorrect:

I would name it right. It is not Head-Smashed-In, it is called the Ancient Jump. So, total failure to consult appropriately way back then. What happened, they just went to the wrong people and people must have got the wrong information. Somewhere something fell between the cracks.

(Interview, Pard 2008)

Consequently, despite leading the field in community involvement in the 1980s, Head-Smashed-In is not always viewed positively by the wider Blackfoot community or seen as a place that presents a Blackfoot perspective.

And now even with Head-Smashed-In, they have got a bunch of these younger people there that have a Pan-Am view of all the stuff they talk about, it is from the books, but the historical parts are not from a Blackfoot perspective.

(Interview, Potts 2008)

Head-Smashed-In reflects Galla's model of consultation where participation is initiated by a non-Native specialist with the role of the Indigenous people restricted to that of 'informants' (Galla 1997:151). Head-Smashed-In highlights issues concerning the over-reliance on individual consultants and the potential for consultants to be tarred with decisions they did not necessarily have complete control over (discussed in chapters eight and

nine). Importantly it helps to illustrate that the use of community members as 'informants', who do not have a significant amount of decision making power, results in a hollow relationship that is readily identified by the community and can potentially worsen rather than improve relations between museum and community.

However, the situation is more complex than it first appears because Head-Smashed-In is still seen as a Blackfoot place, despite the form of consultation, because it has institutionalised Blackfoot involvement through the sole employment of Blackfoot people as guides and interpreters. Head-Smashed-In also maintains close relations with a small number of Elders who come into provide guide training and act as advisors. The wider community is also regularly involved through craft and dance days and the annual Elders Christmas dinner (these contradictions will be discussed further in chapter six).

Thus the relationship between Head-Smashed-In and the Blackfoot community is complex and the centre itself has a multifaceted identity being both government and Blackfoot. These identities overlap but are not fully integrated. There is a Blackfoot Head-Smashed-In and a government Head-Smashed-In side-by-side in communication but not one of the same, because they hold different roles and levels of power.

GLENBOW MUSEUM

In contrast, Glenbow (Figure 4.1) has a relatively positive relationship with, and reputation in, the Blackfoot community (despite being the venue for the controversial *Spirit Sings* exhibition in 1988). Glenbow's Ethnology team approached community engagement as an exercise in partnership building, and developed a relationship over many years slowly negotiating the levels of power sharing and boundaries.

The development of Glenbow's relationship with the Blackfoot Nations was made possible by Glenbow staff's willingness to reconsider traditional approaches to museology and take into account Blackfoot cultural protocol, adapting and to some extent indigenising practice.

Beginning with the loan of sacred materials from the collection to community Elders for use in ceremonies, the relationship developed into tangible forms. Individuals from each group began crossing boundaries to participate in the other's world. Glenbow's Ethnology team began attending Blackfoot ceremonies and community events and in doing so started to gain a greater understanding of the significance of the intangible heritage to the tangible material culture.

In 1998 A Memorandum of Understanding was signed between Glenbow and the Kainai Mookaakin Society to formalise a working relationship between the museum and community.

Key among the 17 points of the M.O.U. is Glenbow's commitment to include Kainai in our process of collecting, researching, programming,

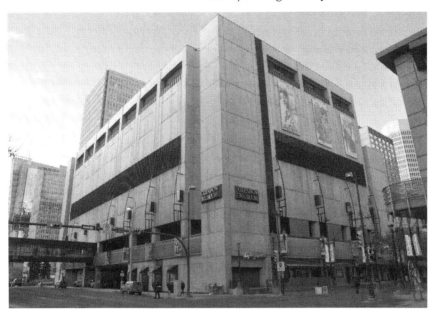

Figure 4.1 Glenbow Museum.
(Photo by Onciul 2010). Printed with permission of the Glenbow Museum. ©Glenbow, Calgary, 2014.

and exhibiting Kainai or Blackfoot culture. The Kainai, for their part, acknowledged that final responsibility rests with Glenbow. Glenbow also agreed to assist Kainai in their efforts to repatriate sacred material from other institutions and to undertake a long-term initiative to permanently transfer spiritually sacred objects held by Glenbow to Kainai. In return, Mookaakin members agreed to provide their knowledge and expertise in assisting the museum in our development of exhibits and programs.

(Conaty 2008:252)

These steps facilitated the establishment of a working partnership with community Elders and the co-creation of a Blackfoot Gallery entitled *Nitsitapiisinni: Our Way of Life*, 'one of the first permanent galleries in Canada to be built using a fully collaborative approach' (Krmpotich and Anderson 2005:279).

In 1998 we invited 17 Blackfoot people to work with us in developing an exhibit that would reflect their culture and history as they know it. These individuals are ceremonial leaders and teachers and, according to Blackfoot practices, have the right to speak about the traditional ways.

(Conaty 2003:231)

The Blackfoot-Glenbow engagement zone began modestly and in a loose form years before the development of a Blackfoot gallery became a

possibility. Glenbow Curator Gerry Conaty with support from Glenbow's then CEO, Bob Janes, began establishing relations with individual Blackfoot Elders to build and improve relations between the two groups.

> When I came here Hugh [Dempsey, the former Assistant Director of Glenbow] had arranged the loan of the first Medicine Pipe Bundle. And the focus, at first, was on returning sacred material. That was because there was NAGPRA, it was starting to be thought about, repatriation was in everybody's mind. And we had things that people wanted, and so we started saying well, okay, we will lend things out because our Board of Governors was not ready to let them go. The government sure wasn't ready to let them go. And as we worked towards that, I got to know more and more people.
>
> (Interview, Conaty 2008)

By taking steps towards repatriation, Glenbow showed the Blackfoot community that they were changing their approach to museology and were interested in engaging in more reciprocal arrangements with Elders, rather than simply seeking to collect cultural material and knowledge from the community. Committed to their objective, Glenbow, and its then CEO, Bob Janes, took steps to help change the repatriation law in Alberta, which eventually led to the Blackfoot specific *First Nations Sacred Ceremonial Objects Repatriation Act* (2000), and the *First Nations Sacred Ceremonial Objects Amendment Act* (Province of Alberta 2008) (see Bell 2007 and Conaty and Janes 1997 for further discussion).

Glenbow supported Blackfoot claims for repatriation from other museums both nationally and internationally. This helped established a power-sharing partnership relationship.

> Glenbow, over time, because we began returning more and more bundles on loan, and began to get into disputes with some of the provincial government people, who disagreed with our approach. I think the Blackfoot people began to see us as sort of a friend and a supporter. This all cumulated in 1998 with the signing of a formal Memorandum of Understanding with the Mookaakin Society from Kainai which stated that we would support their efforts to repatriate and we would involve them in these efforts. In return, they would become involved in advising us in the care and interpretation of material from Kainai, Siksika, and Piikani. When we decided to redo our First Nations gallery, we went back to them and said "we have this agreement with you and would you like to help us?" By that time I knew a good many people, and knew who would work well together. So we put together the team we ended up with, well we began to put that together, but it grew and changed over time. . . . But they were the group we put together to work on the Blackfoot gallery.
>
> (Interview, Conaty 2007)

By developing relations slowly over time, Conaty showed the community his personal commitment and the museum's commitment to partnership and power sharing. This helped to overcome negative feelings the community held towards museums.

> Anytime on the Blood [Kainai] Tribe, you start talking about a museum, it is a dirty word, because of what they have done in the past. And it took a little bit, for a while it took a little bit to accept Gerry [Conaty] because he was from a museum, to accept Beth [Carter] and Irene [Kerr]. It took a little bit. But when they showed a genuine interest and their help to return those objects, our sacred material, for the tribe, then people start changing. So it took a little bit. It wasn't an overnight, and even with the team, yeah they agreed to come, they'll come, but it wasn't an overnight, took two, three times, and finally everybody got to feeling at ease, you know, there was always that question: what are they going to use it for? But when they kept coming in and saying no, it is your display, it is your story, you tell it your way. So then it started.
>
> (Interview, Weasel Head 2008)

Glenbow's Ethnology team successfully established enough trust in the community to enable individual Elders to feel they could negotiate their participation and build a partnership with the museum to develop the gallery (see the caption of the gallery poster in Figure 4.2). The process of negotiation can be seen throughout the minutes from the Blackfoot Gallery meetings at Glenbow. In the first meeting Elder Frank Weasel Head negotiated the terms by which the participants would be referred to:

> **Frank** feels that the term advisory limits their roles, and indicates that they don't have much input. He likes the term team—we all participate on an equal footing—there is full participation by everyone.
>
> (Glenbow 1998:3)

At the third meeting Elder Jerry Potts asked what they would gain in exchange for their participation and Glenbow Curator Gerry Conaty responded:

> JERRY: Coming to the First Nations to request assistance for this project. Is Glenbow willing to assist, as part of the project, in repatriation of stuff back from such places as Mexico, the Vatican, East Germany? We would like to look at the possibilities of a big repatriation project down the road.
>
> GERRY: I have been talking to people, working with Mookaakin, and we can certainly help.
>
> (Glenbow 1999b:2)

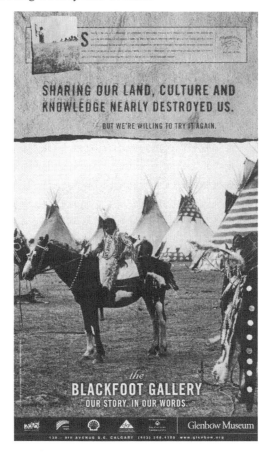

Figure 4.2 Poster for Glenbow's Blackfoot Gallery.
Courtesy of the Glenbow Museum. ©Glenbow, Calgary, 2014.

Working relationships grew through sharing, trust and humour, and turned into personal friendships. Frank Weasel Head recalls how his relationship with Gerry developed:

> [It] was built through repatriation, through our ceremonies in the '90s, mid '90s through to late '90s and it just kept going on. We became friends and he is still my friend, lifelong friend. He's come to visit us at our house. I've travelled with him.
>
> (Interview, Weasel Head 2008)

Conaty's close working relationship with the Kainai Nation was reflected in the makeup of the Blackfoot Gallery team. The Kainai were the largest groups out of the four Nations represented. The team's makeup

changed over the course of the four year project as individuals balanced other commitments, but the final Blackfoot community team named in the gallery was comprised of thirteen Glenbow staff members, eight Kainai, four Siksika, four Piikani, three Blackfeet. The Kainai represented just over 42% of the community membership of the group, but only 25% of the team as a whole, as the Glenbow staff made up over 40% of the group. The Blackfeet were least represented. Despite the small number of Piikani members on the team, the individuals were heavily involved. It was generally felt amongst the team members and the museum that it was the Siksika Nation who were least represented because the individual members on the team changed and were not always available for every meeting.

> With our group the only ones that kind of changed throughout the whole term was Siksika, start with so and so, then others come in with so and so, but we worked together.
>
> (Interview, Weasel Head 2008)

Before work began on the gallery the Elders negotiated the terms of the partnership with the museum. Kainai Elder, Frank Weasel Head explained: 'we always had to have final say; that was the deal' (Interview 2008). The team was almost 60% Blackfoot, giving the Blackfoot the majority of the partnership and helping to reinforce the idea that the exhibit was Blackfoot led and from a Blackfoot, rather than Glenbow, perspective. Piikani Elder Allan Pard recounted the negotiations:

> I told you about how White people were publishing and talking about our culture with their own opinions, their own conclusions. And I told Glenbow, no way was this going to happen, if they wanted our involvement it had to be done jointly, in partnership, it had to be co-operative and that it would be our story, not Glenbow's story.
>
> (Interview, Pard 2008)

Allan Pard recalled his past experiences and observations of museum consultation and the influence this had on his approach to working with Glenbow:

> Here [at Head-Smashed-In] they didn't do enough consultation, so there is still work that needs to be done, proper consultation. I went to the new interpretive centre at Writing-on-Stone, the people down there just consulted with the Blood people. They didn't know enough to consult with other Blackfoot communities. So that was the first thing first with Glenbow we ensured, hey you don't just consult one Blackfoot Tribe, consult with all the Blackfoot Tribes.
>
> (Interview, Pard 2008)

This meant working with the three Canadian Blackfoot Nations and the American Blackfeet Nation in Montana, which added an international dimension to the *Nitsitapiisinni* Exhibit. Glenbow participant and Kainai Elder, Frank Weasel Head explained the makeup of the team:

> So we got the team up there and some of the members, they said well if we are going to, right at the very first meeting, if we are going to do a true Blackfoot gallery we got to invite our brothers and sisters from the Montana Blackfoot, Amsskáápipikani, the southern Blackfoot. That's how we first started our meetings and it worked very well. Glenbow staff, they changed a little bit, different people, but the main people that were always there were Gerry Conaty, Beth Carter and Irene Kerr. Although the CEO met a couple of times with us, Bob Janes, he left it to his people but he supported it one hundred percent.
>
> (Interview, Weasel Head 2008)

The Blackfeet team members were added after the initial meeting and were handpicked by the team.

> When we added the team from the southern Blackfoot the group almost selected individuals, because they were not part of the original. Right after the first meeting and we said well who can, and Glenbow wanted to know, who can we invite? So the group start coming up with names and we settled on names and they phoned and they got those people involved.
>
> (Interview, Weasel Head 2008)

Participant and Piikani Elder Jerry Potts explained that it was easy to work with Glenbow because they were willing to let the Elders tell their own story.

> Glenbow's approach on that gallery is hey, we've got money here to tell a story from the Blackfoot people, we want to tell the story the way the Blackfoot people are telling it, not from a Euro, archaeological, Western concept or anything. We want to tell your story. So that made it very easy to work with.
>
> (Interview, Potts 2008)

Frank Weasel Head supported this view:

> Glenbow expressed the desire right from the start that they wanted this story to come from us. So we told our story from the way we saw it, from the way we felt and from the way we knew about it. So it was our story and Glenbow provided the technical aspect, because I don't know how to put together an exhibit. So they provided, and I felt very

comfortable in the way that Glenbow put it together and in Glenbow because they would say it is yours, it is your gallery. You tell us what to do and they would do it.

(Interview, Weasel Head 2008)

Glenbow's partnership approach went beyond the Task Force guidelines (AFN 1992a, 1992b) and was time consuming, taking almost four years, and expensive costing $1.915 million, but created a working relationship that satisfied both parties.

And yes we had difficulties, I'm not going to say we didn't, but the experience I got from there, and I think Glenbow's experience that they got from there, was how we worked together. That was very important. The cooperation between the two groups and Glenbow really made us feel that way, so we in turn, after that, we made sure we made them feel a part of it, a part of the story, part of it, that they were on the team. We were one. That race and language did not divide us up.

(Interview, Weasel Head 2008)

Thus partnership, ranked as the lowest form of citizen power on Arnstein's ladder, appears to have enabled successful engagement between the museum and community. Former CEO Robert Janes explained the process as a combination of actions and words that accumulated into an effective partnership:

I suppose partnership is a bit of a formal word because it was only strictly defined as a partnership when we did the Memorandum of Understanding (MOU) with Mookaakin. The partnership also took various other forms: Glenbow's Native Advisory Committee, my getting a Blackfoot name, going to ceremonies, having a First Nations person on the board, developing the Blackfoot exhibit, and organizing and implementing the repatriation—the largest unconditional return of sacred objects in the history of Canada. It was effective in the sense that both partners listened to each other and evolved and changed and in the process did tangible things that benefited both parties. Both parties invested in the work and both parties gained from it, which I think is an ideal partnership.

(Interview, Janes 2008)

However, once the gallery opened the engagement zone changed shape as the group disbanded and returned to their normal lives and other Blackfoot people joined the museum to interpret the gallery. Managing long term engagement relationships and how new people are integrated into old engagement models will be explored further in chapters eight and nine.

Nicks has noted that '[t]he first reaction of museums to challenges from Indigenous communities has often been fear that mainstream museums

would lose the right to hold or exhibit Indigenous materials' (2003:23). Glenbow is an example of how sharing power and repatriating cultural material can enhance Indigenous community representation and museum/ community relations, and should not be feared.

BUFFALO NATIONS LUXTON MUSEUM

While Head-Smashed-In and Glenbow appear to reflect the hierarchy of Arnstein's (1969) *Ladder of Participation*, Buffalo Nations Luxton Museum (Figure 4.3) presents an intriguing anomaly in engagement theory. Since 1992 the museum has been in the ownership of the Buffalo Nations Cultural Society, which has a mixed board of Indigenous peoples and non-Indigenous Canadians, and represents several Indigenous groups including the Cree nations, members of the Blackfoot Confederacy (Siksika, Piikani, and Kainai), the Tsuu T'ina, Nakoda and Métis (Mason 2009:356). However the displays have remained almost unchanged since the 1950s when it was run by the original proprietor Norman Luxton (detailed in the introduction). Thus an anomaly appears to occur between Arnstein's model which would describe this as delegated power under the grouping of citizen's control and the reality of the power exercised by the group.

Galla's third model helps to shed light on the situation (Galla 1997:152). Although the museum at first appears to fit Galla's model of community

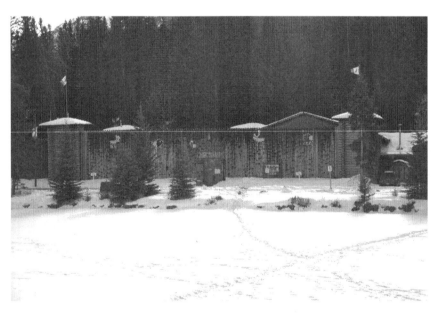

Figure 4.3 Buffalo Nations Luxton Museum.
(Photo by Onciul 2010). Printed with permission of the Buffalo Nations Luxton Museum.

control, not all of the necessary aspects are in place. Firstly, the community does control the project, but they did not initiate it. The museum was established in 1952 by local entrepreneur, Norman Luxton with the help of his friend Eric Harvie who two years later founded the Glenbow Museum. 'To a large extent the Luxton Museum served as a trial run for what would become the Glenbow-Alberta Institute' (Kaye 2003:116).

The museum was designed to resemble a fort and house Luxton's collection of taxidermy animals and First Nations artifacts. On Luxton's death in 1962, the Glenbow-Alberta Institute took over operation of the Luxton Museum. However as a satellite operation the museum became untenable in the early 1990s and being unable to finance either the continued operation of the museum or its closure, Glenbow opted to sell the museum (Interview, Brewster 2008). Keen to develop relations and engage with First Nations communities, Glenbow offered the museum to First Nations in the locality (Interview, Conaty 2008).Yet interest was not expressed by the local reserve communities, so in March 1992 the museum was sold to the Buffalo Nations Cultural Society for the nominal amount of one dollar (Interview, Conaty 2008). Pete Brewster, former Executive Director of Buffalo Nations Luxton Museum, explained what happened:

By '91 the Alberta Government was in fairly deep debt and were cutting back significantly on funding for cultural groups and the Glenbow in particular had been hit fairly hard and they said that in light of the cut backs in funding they were going to close down the Luxton Museum in Banff and focus on what they were doing in Calgary. And they were going to close the museum and just leave everything. Well, Parks put some restrictions on that. It was going to cost a lot of money. They were either going to have to tear down the building or fix it up, and fixing up the building was their main concern, the amount of money was more than they felt they could justify. So they put the building up, they put the facility up and said if somebody wanted to take it over to put in an application and a number of groups did and the group that was selected by Glenbow to take it over was Buffalo Nations Cultural Society. There were lots of negotiations that went on, and in March of '92 the society took over the museum. And we'd gone out and raised some money to do that and from March of '92 to the present it has been operated by the Society.

(Interview, Brewster 2008)

Thus the museum was well established by the time the Buffalo Nations Cultural Society became involved. Interestingly, Frances Kaye argues that although Norman Luxton and Eric Harvie were 'basically assimilationist' (2003:113) and their relations with First Nations were paternalistic, they moved away from older models of interpretation:

In their ongoing association with local Indians [sic], the Luxton and Glenbow were in the forefront of anthropological museums, most

of which remained in the 'Ishi' mode, preserving Native people as specimens.

(Kaye 2003:113)

Under the new ownership of the Buffalo Nations Cultural Society, the museum was renamed Buffalo Nations Luxton Museum, but the majority of the collections remain on loan from the Glenbow and are displayed in the same fashion as they were in the 1950s. From the beginning the poor labelling and interpretation of the museum collection was criticised. In 1953 George Browne briefly worked as Art Director of Luxton museum and recommended the museum incorporated more descriptive labels (Kaye 2003:108). 'Despite Harvie's approval of Browne's suggestions, they were apparently not carried out, for in January 1957 University of Alberta biology professor William Rowan' also recommended better labelling (Kaye 2003:109). Rowan commented that 'visitors should learn that particular instances, like the configuration for harnessing sled dogs, were particular to one culture and should not be generalized to "all Indians"' (Kaye 2003:110).

The Buffalo Nations Cultural Society set up another charitable society to run the museum called the Luxton Museum Society (although the membership of each overlaps) (Interview, Brewster 2008). The Buffalo Nations Cultural Society hoped that the museum would give them the opportunity to build-up a track record to enable them to go on to develop other initiatives such as a cultural park or a University of Nature which were the original goals of the society (Interview, Brewster 2008). However, as Galla notes as a common problem, the museum is inadequately resourced (Galla 1997:152). The shortage of funds meant that the society struggled to maintain the building, which made significant investment in exhibit redevelopment unfeasible.

Interestingly, despite being part-owned by the community, there has been little community engagement beyond board membership and even this has often been somewhat tokenistic. The community board members have little direct contact with the museum and tend to act more as figure heads than active participants.

At the time it was taken over the president of both societies was Leo Young Man, he was Blackfoot and the vice president was Reverend Arthur Ayoungman, also Blackfoot. After Leo died Harold Healy from the Blood became the president. Arthur and Nora Ayoungman were both on the board and until Arthur's death. Nora stayed on the board but she's not been terribly active and we've been trying to get some other involvement from the Blackfoot and talking to a couple of her relatives, but at this point nothing has happened. Now three years ago Harold wanted to retire because he was getting on. He's stayed on the board, but he's retired as President. Joe Yellow Horn, the son of Tom Yellow

Horn, is the current president and has been for the last few years. He's from Peigan. Tony Starlight was on the board and stepped down this past summer too to take over and run the museum. When I retired in 2005 we'd hired one of our former staff members to run the facility and she decided to leave last year, so it had been run by a committee from the board from that time till Tony became involved.

(Interview, Brewster 2008)

As Brewster explains, the community representation of the board has changed over the years and generally only a few individuals represent the many communities whose artifacts are on display in the museum. This is due in part to the location of the museum, far from the reserves, and the lack of resources to bring people in. The lack of resources also meant that redevelopment was unlikely to be possible even if or when community members did recommend changes. The most active members have tended to be locally based Canadians like Pete Brewster who acted as Executive Director for the museum from 1992 to 2005 and, although now retired, still has a semi-active role.

Thus this museum contravenes Arnstein's model as it should be on the second top rung of citizen power, as a form of delegated power, however a lack of resources prevent it from empowering the community. Instead the Buffalo Nations Cultural Society maintains an outdated exhibition. The society defends the museum as an artefact in itself, however they acknowledge the main issue is funding and that this prevents any real development or changes to the museum (Interview, Bedford 2008).

Buffalo Nations Luxton Museum is not highly visited by First Nations communities, partly due to its location in Banff, but also because it is also not widely known about, nor considered a community museum within the Blackfoot communities. I asked Manager Tony Starlight why current First Nations visitation was low:

Probably because they don't know we are there. Even a lot of Banff and Canmore residents have told me I've lived here all my life and I've never been inside that museum. It's because it is an Indian museum.

(Interview, Starlight 2008)

Piikani Elder, Jerry Potts, has worked with many museums including Glenbow, but dismissed Buffalo Nations Luxton Museum saying:

I was in touch with them but they are mainly a, it's just a beads and feathers exhibit, there's nothing, it is mainly set up to appeal to tourists.

(Interview, Potts 2008)

There does not seem to be wider Blackfoot community recognition of ownership of the museum, despite a succession of Blackfoot presidents. This

may be partly due to the fact that the Buffalo Nations Cultural Society represents many First Nations and has stronger relations with some nations than others. The local Tsuu T'ina (Sarcee) and Nakoda (Stoney) nations, provide employees, including the manager at the time of interviewing, Tsuu T'ina Elder Tony Starlight, and a number of board members. The society has links to the Indian Village at the annual Stampede in Calgary, and it is within the mixed community represented there that the museum is more widely known. Particularly as the former Buffalo Nations Luxton Museum President Harold Healy is a long time participant and tipi owner at the Stampede Indian Village.

The lack of change since coming under Indigenous ownership can be accounted for not only as a result of lack of finances, but also differing institutional motivations (see chapter six). Thus, not only was there a lack of resources to enable the museum to engage with Indigenous communities, but there was also a lack of motivation, as the actual aim of the project was to develop a new Indigenous tourist experience separate from the museum. Potentially, if the Native Village goal is realised, then wider engagement with the community would occur.

Thus although Buffalo Nations Luxton Museum appears to be citizen controlled (Arnstein 1969) it did not empower the community because it lacked the resources to actually do anything other than open its doors to the public. Consequently the museum appears as an anomaly presenting outdated exhibits under the banner of community control. Power appeared to be there when in fact it was not, and engagement was tokenistic because there were no resources to enable changes to be made. This case study highlights the importance of institutional ethos and the impact of resources upon engagement (discussed in chapter six).

BLACKFOOT CROSSING HISTORICAL PARK

In comparison, Blackfoot Crossing Historical Park (Figure 4.4) is a good example of Arnstein and Galla's top model of engagement, as it is initiated and controlled by the community.

> Our direction is dictated by our own people and by our Board members, and they get the feedback from the community and that's where we take our direction from. There's no Government agenda, no Federal agenda, or Provincial agenda. It's fantastic we are kind of free from those ties.
> (Interview, Breaker 2008)

Nevertheless, Blackfoot Crossing still faces challenges common to any kind of representation as it has to engage with the wider Siksika community, and negotiate and balance Blackfoot and Western practices of heritage management.

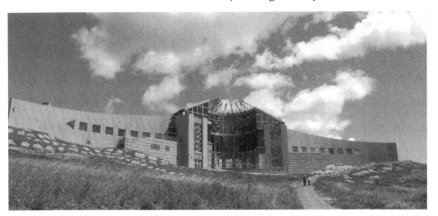

Figure 4.4 Blackfoot Crossing.
(Photo by Onciul 2007). Printed with permission of Blackfoot Crossing Historical Park.

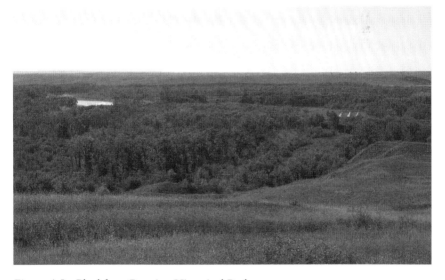

Figure 4.5 Blackfoot Crossing Historical Park.
(Photo by Onciul 2007). Printed with permission of Blackfoot Crossing Historical Park.

Like Head-Smashed-In, Blackfoot Crossing is situated within a significant heritage landscape (see Figure 4.5).

> There was a lot of respect for this area because of the history that lies within this area, the Treaty, battles, and different ceremonial areas and so on. And I think that underlying all of this, Siksika members knew this was a special place and it was protected as such.
>
> (Interview, Royal 2008)

To develop such a significant site took many years of negotiations and planning with local people and the Siksika Band Council. Director of Blackfoot Crossing, Jack Royal explained the development:

> 1977 was when the ball really started rolling. We had had a re-enactment of the signing of Treaty number 7 because it was the 100th commemoration of the signing. And at that point in time it was noticed that there was a lot of interest within people or from people that visited the area. There were thousands of people that attended that weekend and from then on the leadership of the day, along with the Elders set out to look for something to commemorate this area, besides just a monument, to have some sort of facility that would pay homage to this area.
>
> (Interview, Royal 2008)

Over the years the project developed and stalled with successive Siksika Band Councils and changes in community priorities and funding. The project developed in a piecemeal fashion as funding became available. 'There was never really any one specific set of resources that we had to work with, it was kind of the resources of the day and that is why it took so long' (Interview, Royal 2008). At different points different community members and government departments were involved, each contributing their ideas.

> The project moved between different departments within the Siksika Government, at one point it was under a Tourism Department, and then it was under a Community Services Department and then it was moved to another legal entity, a separate legal entity: Siksika Resource Development Limited and then I got a hold of it under my department at the time, which was Major Projects and Council Initiatives and that is where it really got rolling.
>
> (Interview, Royal 2008)

With funding being sporadic, aspects of development occurred and then were shelved. To keep costs down, when more funding became available old reports were dusted off rather then re-issued. Consequently Blackfoot Crossing grew in a piecemeal style over generations.

A number of Elders were engaged at an early stage in the development to consider what kind of centre they wanted to create. These Elders worked with a non-Blackfoot architect Ron Goodfellow (who worked on the project for 22 years) and together designs were drawn up for the building. The Elders proposed the integration of Blackfoot concepts and symbols into the fabric of the building and the finished product is layered with meanings that can be interpreted through the architecture. Funding and delays resulted in a long time gap between the design and creation of the centre and many of the Elders never saw their ideas come to fruition.

When the project gained momentum again the community members were left with a dilemma. The plans that had been developed with the Elders were no-longer in-date as the project had evolved. However, it was felt to be important to honour these Elders and to respect the previous consultation, so the original plans were used to develop the building as it stands today. Unfortunately the concept of the role and function of the building had changed, as had technology and museology. As a result, the building is not ideally fit for purpose as the exhibit and archive area lacks the required environmental controls needed for modern museum standards and the archive is too small to house all of the communities' documents (discussed further in chapter six).

Thus long term deep community engagement also has its problems, as the more people and time involved, the more complex and confusing the project can become. Whose input should be valued and used is an ongoing question during engagement, and it is important for museums to plan for the possibility of community participants passing away during engagement and consider how their input will be used in the long term.

An exhibit storyline had not been part of the original development of the building, so as the centre was constructed a new team was created to develop the exhibits. The engagement zone was created by the Siksika government team developing the centre, many of whom later became the museum staff, and they invited Siksika Elders to guide the direction and content of the gallery. Where local services were not available non-Siksika contractors were brought in such as the design team (Terry Gunvordahl and Irene Kerr) who were chosen for their previous work on Glenbow's *Nitsitapiisinni* Gallery. Assistant Curator Michelle CrowChief explained how they engaged with the Elders, stating at the outset: 'I know we couldn't do it without them, I know that!' (Interview 2008).

I think there were seven or ten Elders. We then went out and talked to the Elders and asked them if they could assist us. And just a handful would come in and say oh well we will help you out. But we had to do this project within two years; when people can do it for 10, 15 years to just design the exhibit. But it was, we were trying our hardest and we are still working through it right now, and there is still a lot to be done.
(Interview, CrowChief 2008)

What we did was we went to the Elders, they have Elders meetings out here and we told them what we were all about, what we would like to do, and just certain people would get up and say stuff. And we basically got two of the main people in. They have a board, and one of the main board members of the Elders turned around and told us: 'well, I'll help along with some others, I will look for other people who will be good for this'. So we managed to get them to come to our meetings, but I think it was mainly

Irvine [Scalplock]'s decision along with some of the other members here too, to decide who is going to be good to help out with this. 'Okay, well this person knows this much, this is what they can contribute to this . . .' See the people that we invited they have always worked in the cultural area. They all knew, they brought in their expertise. Like they knew about the coal mining days or they knew about the signing of the Treaty, or they've worked a lot with Elders who would talk about the ancestry. . . .[They] would help with our storyline to develop it more, because they knew exactly what they were talking about. They were speaking on behalf of the community because they had all that knowledge, they worked in that field.

(Interview, CrowChief 2008)

Thus despite being a community museum they still used engagement to bring together expertise and knowledge from the wider community by engaging staff, Elders and specialist contractors. The Elders acted as consultants and advisors, and had the power of veto. Some became museum employees, and many regularly visit the museum to contribute information or to find out information from the museum, collections or archives.

Even though Blackfoot Crossing is community controlled some community members are not involved. There are simply too many people in the Siksika Nation for them all to have a say in the development and direction of the museum. As such the idea of citizens' control is misleading. Only a few people in the Siksika community have influence over the museum, and the museum still has to consult and engage with the community.

Obviously we can't tell our whole story in one little display downstairs. There are so many aspects, so many different things that we could communicate, that we can't possible do it in one sitting.

(Interview, Royal 2008)

Everybody had an input on what they'd like to see and what they wanted in there. But it had to go with the story as well, you know. We're not going to put snowshoes in there if it's not even anything to do with snowshoes. It has to go in with the stories, like the animals, the transportation, the language, certain things you could use to specifically identify something.

(Interview, CrowChief 2008)

An important finding in the research was the feeling amongst some staff at Blackfoot Crossing that they did not have a good relationship with their community. Darren Pietrobono, Blackfoot Crossing's VP of Finance, stressed:

A relationship of trust needs to be developed to show that we are, that our goals and objectives meet their understanding of what we are trying

to accomplish here. And so I believe that is the next step that needs to be done here with the community, is to build their trust that we are going in the right direction. Because we are getting, I believe we are getting a lot of different conflicts of where we are heading. Some people believe we are representing our gift shop in the wrong fashion, maybe even our exhibit downstairs. But I think there needs to be more synergy, where there is a co-relationship working with them, so that we can all develop a direction for Blackfoot Crossing, so that they feel involved with the facility and it is not just a money making venture.

(Interview, Pietrobono 2008)

Pietrobono felt that they 'need input from the community at large and not from outside representation, but from them' (Pietrobono Interview 2008). He felt there was misunderstanding within the community as to the function of the museum and there was a lack of feeling of ownership, despite it being an entirely grassroots community development. He noted the lack of Siksika visitation: 'that would be excellent evidence to making that claim that they don't have the ownership here, because they are not, their numbers are not showing up here' (Interview, Pietrobono 2008). Bev Wright, VP of Programming and Development at Blackfoot Crossing echoed this view:

I would like to see a lot more community inside instead of just tourists. Don't get me wrong, I love the tourists too and we need the revenue, but it's, it's the community's place and the community's not there as much as they should be I feel.

(Interview, Wright 2008)

As did VP of Marketing & Public Relations at Blackfoot Crossing, Shane Breaker:

. . . there are some critics of the [Blackfoot Crossing] centre who really don't see the centre as representing the Siksika Blackfoot culture. Again, you will always have critics in a community where you are trying to represent them, they see that representation as skewed or not as representative. We will always have those critics but the numbers are few.

(Interview, Breaker 2008)

These comments illustrate the fact that engagement and community empowerment is not simply achieved through community control. Community museums still have to engage with their community and can still experience criticisms of tokenism and non-participation. Thus Arnstein and Galla's models need to be expanded to explore the complexities of community control. Blackfoot Crossing also illustrates that the difficulties of engagement are not simply cross-cultural, but also inter-cultural, because the issue boils down to who has the power to have their voice heard.

CONCLUSION

Each case study highlighted that engagement is more complicated that current models account for, and that community control needs to be considered more carefully as it does not automatically empower all community members but requires models of inter-community engagement.

Head-Smashed-In showed that even institutionalised engagement in the form of consultation and community employment does not necessarily integrate community with museum if power is not shared. Glenbow illustrates that power sharing in the form of partnership is a resource heavy and time consuming process, which needs to be maintained even after the exhibit opens. Buffalo Nations Luxton Museum demonstrates that resources are crucial to enable engagement to have any practical outcome. Blackfoot Crossing Historical Park highlights that community control does not automatically result in community empowerment or engagement. This chapter has created an overview of engagement theory in practice at the case studies. In doing so it has introduced many issues that will now be explored in depth in the following chapters.

REFERENCES

AFN (Assembly of First Nations) and CMA (Canadian Museums Association), 1992a. *Turning the Page: Forging New Partnerships between Museums and First Peoples. Task Force Report on Museums and First Peoples.* Ottawa: Carleton University.
AFN (Assembly of First Nations) and CMA (Canadian Museums Association), 1992b. Task force report on museums and First Peoples. *Museum Anthropology*, 16(2) pp. 12–20.
Anonymous. 2008. Interview.
Arnstein, S.R., 1969. A ladder of citizen participation. *JAIP*, 35(4) pp. 216–224.
Bedford, Judy. Interview 26 Sept 2008. University of Calgary.
Bell, C.E., 2007. That was then, this is now. Canadian law and policy on First Nations material culture. In M. Gabriel and J. Dahl, eds. *UTIMUT: Past Heritage—Future Partnerships: Discussion on Repatriation in the 21st Century.* Copenhagen/ Nuuk: IWGIA/NKA, pp. 154–167.
Breaker, Shane. 16 Oct 2008. Interview. BCHP.
Brewster, Pete. 14 Oct 2008. Interview. Canmore.
Brink, Jack. 19 July 2006. Interview. RAM.
Brink, Jack. 26 Sept 2008. Interview. Calgary.
Brink, J.W., 2008. *Imagining Head-Smashed-In: Aboriginal Buffalo Hunting on the Northern Plains.* Athabasca, Alberta: Athabasca University Press.
Clarke, Ian. 12 Nov 2008. Interview. HSIBJ.
Conaty, Gerald. 26 Sept 2007. Interview. Glenbow.
Conaty, Gerald. 20 Nov 2008. Interview. Glenbow.
Conaty, G.T., 2003. Glenbow's Blackfoot Gallery: working towards co-existence. In L. Peers and A.K. Brown, eds. *Museums and Source Communities: A Routledge Reader.* New York: Routledge, pp. 227–241.
Conaty, G.T., 2008. The effects of repatriation on the relationship between the Glenbow Museum and the Blackfoot people. *Museum Management and Curatorship*, 23(3) pp. 245–259.

Conaty, G.T. and Janes, R.R., 1997. Issues of repatriation: a Canadian view. *European Review of Native American Studies*, 11(2) pp. 31–37.

CrowChief, Michelle. 2 Sept 2008. Interview. BCHP.

Crowshoe, Reg. 19 Aug 2008. Interview. Calgary.

Curtis, N.G.W., 2007. Thinking about the right home: repatriation and the University of Aberdeen. In M. Gabriel and J. Dahl, eds. *UTIMUT: Past Heritage—Future Partnerships: Discussion on Repatriation in the 21st Century*. Copenhagen/Nuuk: IWGIA/NKA, pp. 44–54.

Galla, A., 1997. Indigenous peoples, museums, and ethics. In G. Edson, ed. *Museum Ethics*. London: Routledge, pp. 142–155.

Glenbow, 27 Nov 1998. *Blackfoot Exhibit Team Meeting*. [Minutes] Unlisted. Calgary: Glenbow Archives.

Glenbow, 4 Feb 1999b. *Blackfoot Exhibit Team Meeting*. [Minutes] Unlisted. Calgary: Glenbow Archives.

Good Striker, Lorraine. 25 July 2006. Interview. HSIBJ.

Janes, Robert (Bob). 14 Oct 2008. Interview. Canmore.

Kaye, F.W., 2003. *Hiding the Audience: Viewing Arts & Arts Institutions on the Prairies*. Edmonton: University of Alberta Press.

Krmpotich, C. and Anderson, D., 2005. Collaborative exhibitions and visitor reactions: The case of Nitsitapiisinni: our way of life. *Curator*, 48(4) pp. 377–405.

Martin, James (Jim). 24 Sept 2008. Interview. HSIBJ.

Mason, C.W., 2009. The Buffalo Nations/Luxton Museum: Tourism, Regional Forces and Problematizing Cultural Representations of Aboriginal Peoples in Banff, Canada. International Journal of Heritage Studies, 15(4), pp. 355–373.

Meili, D., 2007. Good Striker's passion for life will always be remembered. *Alberta Sweetgrass*, 1 Sept.

NAGPRA (Native American Graves Protection and Repatriation Act) 1990. (104 STAT. 3048 Public Law 101–601—Nov. 16 1990), Washington: U.S. Department of the Interior.

Nicks, T., 2003. Introduction. In L. Peers and A.K. Brown, eds. *Museums and Source Communities: A Routledge reader*. London: Routledge, pp. 19–27.

Pard, Allan. 12 Nov 2008. Interview. HSIBJ.

Pietrobono, Darren. 16 Oct 2008. Interview. BCHP.

Potts, Jerry. 10 Oct 2008. Interview. Fort Macleod.

Province of Alberta, 2008. *First Nations Sacred Ceremonial Objects Repatriation Act. Revised Statutes of Alberta 2000 Chapter F-14*. Edmonton: Alberta Queen's Printer. [Online] Available at: http://www.qp.alberta.ca/documents/Acts/F14.pdf

Provost, Angie. Interview 2006. Head-Smashed-In.

Royal, Jack, 25 Aug 2008. Interview. BCHP.

Site Manager. 24 July 2006. Interview. HSIBJ.

Slater, B.A., 2006. *Blackfoot Consultation and Head-Smashed-In Buffalo Jump Interpretive Centre*. Unpublished M.A. thesis. Newcastle: University of Newcastle.

Starlight, Anthony (Tony). 17 Oct 2008. Interview. Calgary.

Weasel Head, Frank. 13 Nov 2008. Interview. Calgary.

Wright, Beverly (Bev). 4 Sept 2008. Interview. Calgary.

5 Indigenising Museology and the Limits to Change

> *Museums, themselves a cultural artefact, are an institutional invention of the colonizing culture. That they may not be ideal for a First Nations 'museum' should not surprise us.*
>
> (Ross and Crowshoe 1996:253)

> *This asymmetry is built, literally and figuratively, into our institutions (Chakrabarty 1992; Shelton 2001). They are determined by our funding regimes, by our proscribed professional practices, and in museums, by the very roles that we fulfil—collecting, documenting, and displaying. . . . Good intentions have little force against the power of this institutional assemblage.*
>
> (Boast 2011:66–67)

Change is a common goal when museums engage with communities. Engagement is used as a way to bring community ideas and voices into the museum, to tell hidden histories, present new perspectives and to share cultural knowledge. In the process the museum must adapt to accommodate this influx; however the extent to which such institutions are willing and able to change is the crux of what can be made possible through engagement.

Arnstein's (1969) *Ladder of Participation* model proposes that increasing community control improves participation, with the top model on her ladder being citizen control. At surface level my case studies appear to reflect four of the top rungs of Arnstein's ladder. Following this logic one could assume that those with greater community participation would have undergone greater change, moving away from traditional museum models to include indigenised practice and other ways of working. What constitutes change can vary. Change can be temporary, used strategically to gain ground in the engagement zone. It can be shallow and aesthetic to give an illusion of more substantial shifts. Change can be deep, changing the ethos and culture of the institution, and lasting, creating new practices that continue after participants leave.

To begin, the chapter will assess why and in what ways Blackfoot engagement may change museological practice and ethos by comparing Blackfoot

cultural heritage management with Western approaches. Drawing on Brady's (2009) analysis of the National Museums of the American Indian (NMAI), the chapter will consider the residual practices that remain even when deep change is attempted. It will analyse the influence of practical and socio-political factors on the case studies which can define the limits of engagement and cause indigenisation to be embraced or resisted by the institutions. The chapter will also consider the way museums as a cultural form frame Indigenous voice.

INDIGENISING ETHOS AND PRACTICE

As Julie Cruikshank states 'museums and anthropology are undeniably part of a Western philosophical tradition' (1992:6). This idea is echoed by Christina Kreps who argues 'Western museology is rooted in the assumption that the museum idea and museological behaviour are distinctly Western and modern cultural phenomena' (2005:1). However she points out that 'many cultures keep objects of special value and have created complex structures or spaces for the objects' safekeeping as well as technologies for their curation and preservation' (Kreps 2005:1). This is true of the Blackfoot, as Piikani Chief Reg Crowshoe asserts:

> In our culture we have those disciplines and institutions and belief systems. We have our own principles of what we call museums, how we preserve. We have those disciplines and institutions. But when the Western museum developed their guidelines they never consulted with First Nations to say do you have any such models?
>
> (Interview, Crowshoe 2008)

The consideration and incorporation of Indigenous ways of working are important to the process of engagement, but also to the survival of cultural heritage itself, as Kreps explains:

> The hegemony of Western museology and approaches to heritage preservation has contributed to two phenomena that pose a threat to indigenous curation: 1) the global spread and reproduction of Western-oriented models, and 2) the reliance on expert-driven, top-down, professionalized/standardized museum training and development. Both of these forces can inadvertently undermine indigenous curatorial practices and paradoxically the preservation of people's cultural heritage.
>
> (2005:4)

By working with Blackfoot Elders the case studies brought in individuals who hold expertise in 'Indigenous curation'[1] (Kreps 2005:3). Blackfoot Elders, like Western museum professionals, follow complex and intricate practices and procedures which determine the way they manage cultural

heritage and materials. Like their Western counterparts, they undergo extensive training with their respective educational authorities and are valued by their own communities as having particular knowledge and expertise that enable them to care for material culture and cultural knowledge on behalf of the wider community. While museum and heritage professionals tend to have professional training and university education, Blackfoot Elders train through apprenticeships in age-graded sacred societies and study and participate for many years before earning the right to become a keeper of an item, song, dance, story, or ceremony, which they maintain and pass on according to strict cultural protocol. Once they transfer an item to new keepers they become grandparents of that particular piece of tangible or intangible culture. When the item or knowledge is transferred again they become great grandparents, and so on, creating a living lineage of people invested in caring for and maintaining that element of cultural heritage. Elders continue this learning process throughout their lives and refer questions to the most knowledgeable member of the community, even if they have training in that particular aspect of knowledge or practice. Many of my interviewees described Elders as having the equivalent of a PhD (or higher) in Blackfoot knowledge.

Blackfoot heritage management has enabled the Blackfoot people to maintain their tangible and intangible culture and heritage since time immemorial, before and without written accounts. Although it is difficult to date the longevity of cultural practices, it is clear that archaeological sites dating back over six thousand years (such as Head-Smashed-In Buffalo Jump) remain important to Blackfoot culture. At the turn of the last century early anthropologists like Clark Wissler, Leslie Spier (Tovias 2010:276) and photographer Walter McClintock (McClintock 1910:125) witnessed sacred Blackfoot cultural practices such as Okan (Sundance) that continue today (despite government attempts to ban the practice[2] and the collection of sacred bundles by museums and private collectors). Thus it should come as little surprise that when engaging with museums Blackfoot Elders feel suitably qualified to question Western practices and suggest repatriation of cultural items or the adoption of Blackfoot protocols for the caring of Blackfoot materials held in museum collections.

There are considerable differences between Blackfoot and Western epistemologies that influence each group's cultural approach to heritage management. Four key areas of conflict are the differences between Blackfoot and Western conceptions of:

1. Sacred objects: living beings vs. inanimate objects
2. Time: cyclical vs. linear
3. Reasons for acting: spiritualism vs. scientific rationale
4. Access: restricted sacred knowledge vs. freedom of information

These four issues (amongst many others) are topics for negotiation in engagement zones as museums and communities have to find common

ground to enable co-operation and to develop museological practices that meet both Blackfoot cultural and museum professional standards and expectations.

The traditional Blackfoot belief that sacred items are living[3] and require care similar to that of a baby, is the opposite of the traditional museum view of objects as inanimate, suitable for conservation techniques ranging from poisons to freezing, and storage and display practices that minimise exposure to light, air and human contact. Consequently museums have been associated with death and dormancy by many Indigenous communities whose living cultural materials have been collected and treated in this way by museums.

With the increasing participation of Indigenous communities in museums, changes to these practices have begun to occur. In 1998 the National Museums of the American Indian (NMAI) acknowledged that 'current standard museum treatments such as plastic bags, freezing, and low-oxygen atmospheres may be inappropriate for certain objects because they might "suffocate" a living entity', and began 'investigating traditional Native American fumigation techniques such as regular smudging and the use of certain aromatic botanical substances in sachets' (Rosoff 1998:38). Similarly the American National Museum of Natural History (NMNH) adapted practice in response to Hopi protocol: 'the Hopi tradition stresses that Katsina friends are living, breathing entities. As such, they should not be covered in plastic nor is it appropriate to house them in airtight containers' (Flynn and Hull-Walski 2001:34).

Not only do the Blackfoot have a different view of the life-force of their cultural material, they connect with their historic material as part of the present on-going lived experience as a result of their conceptualisation of time as cyclical rather than linear. Conaty explains: 'when First Nations people view artifacts at Glenbow they see their own memories' (2008:255). Conaty describes the important role sacred bundles play in Blackfoot cyclical history:

It is a history which is cyclical and which is renewed in an ancient seasonal ceremonial cycle. As bundles play an integral role in these ceremonies, they are key elements in defining the history of Niitsitapi. Bundles which are not celebrated each year, such as those in museum collections, represent a break in the communication line; a break in the history of Niitsitapi, and a break in the spiritual and ecological balance of the Niitsitapi world.

(Conaty 2008:248)

While Western museum professionals may consider an item as coming from the distant past and disconnected from contemporary culture by temporal distance along the linear line of time, Blackfoot Elders consider these items as part of their present and future. '*Niitsitapi* epistemologies represent knowledge from an ever-present time. It is experienced in the moment,

which is infinite and all-encompassing' (Bastien 2004:105). Kainai Elder Narcisse Blood explained the concept:

> Because we kept our language, we kept our ceremonies, yesterday is today. When you go to these ceremonies, history is occurring today. That is the Blackfoot paradigm, the pedagogy of learning, yesterday is today because those messages have carried on. Which is quite different from a very Western linear way of thinking that the past is way there and can never happen again. Whereas for us it happens over and over again.
>
> (Interview, Blood 2007)

Using historical items in ceremonies is normal practice in traditional Blackfoot society as this helps to connect yesterday to today and tomorrow, and maintains culture for future generations. Such practice stands in direct opposition to Western museological beliefs that objects must not be touched or used, but instead preserved for future generations. This highlights one of the key differences in emphasis, with museums tending to focus on preserving tangible material culture and the Blackfoot taking a more holistic approach that also incorporates maintaining intangible knowledge and practice.

Such differences forced the case studies working with Blackfoot Elders to reconsider the reasoning and beliefs behind their curatorial practice. Western museology has developed conservation practices based on technological and scientific innovations to maintain the tangible structure of an object. In comparison, Blackfoot follow cultural protocols based on their spiritual practice to maintain both the tangible and intangible culture and heritage that together maintain their history and perpetuate their living culture.

Access and restriction to knowledge and material culture are key areas of conflict between Western and Blackfoot epistemologies. While traditional Western museums generally restrict direct access to handle objects, they are institutions based on notions of education, learning and freedom of information. This can be problematic when engaging with communities such as the Blackfoot who have distinct areas of their culture that are not for public dissemination, but instead are 'off stage' private practices (Shryock 2004). These are generally the sacred aspects of their culture, such as ceremonies, sacred items and Okan. But as George Horse Capture (Gros Ventre) Deputy Assistant Director of Cultural Resources for NMAI, explained to Kate Morris of the Repatriation Foundation in 1994:

> Sacredness in the Indian world is like the early morning dew, it falls over everything. Nothing is exempt, everything is sacred. But there are degrees of sacredness, places where the dew only lightly touched, and others where the dew heavily coated. These are the areas of intense sacredness, of power.
>
> (Morris 1994:1,3)

He adds that when deciding what is acceptable to show within a museum: 'the bottom line is that we have to go back to our communities for these answers, to the Elders. We are going to have to deal with them. If they say we can't show it, we can't show it' (Morris 1994:3). This echoes Blackfoot beliefs that 'everything in our world is sacred' (Blackfoot Gallery Committee 2001:33), and Elders should have the final say on whether something can be shown based on their knowledge and expertise.

However this can be problematic, as Flynn and Hull-Walski analysed at the American NMNH where restricting access to collections contradicted freedom of information, and religion and discrimination laws: 'because it is a public institution receiving federal funding, it is precluded from discriminating or supporting any particular religious point of view' (2001:35). The anthropology department found a way around the problem by developing: 'a method to accommodate the wishes of the cultural and religious groups who request restricted access while avoiding a violation of the law. In instances where groups advised the Museum of a cultural restriction on access to certain objects, we labelled the storage units with that information, thereby allowing those who wish to obey the restriction the opportunity to do so' (Flynn and Hull-Walski 2001:35). Whether this was considered sufficient by the source communities is unclear. Deciding who can and cannot have access to collections and information is a difficult area for engaged museums. Flynn and Hull-Walski argue that although adaptations can be complicated and not always feasible, it 'is possible if executed in a sensitive yet methodical manner' and 'if all parties are flexible and alternative options are considered' (2001:39, 33).

Museums can benefit from sharing and adapting to non-Western cultural curatorial practice, as Kreps explains: 'Indigenous museum models and curatorial practices have much to contribute to our understanding of museological behaviour cross-culturally, or rather, of how people in varying cultural contexts perceive, value, care for, and preserve cultural resources' (2003:146). Engaging with communities and adapting museum practice in response, demonstrates the museum's willingness to share power and respect cultural practices, which can in turn help to strengthen relations between museums and the communities they represent. Simpson argues that: 'through the incorporation of Indigenous concepts of cultural heritage, curation, and preservation, the idea of the museum is evolving to accommodate the needs of diverse cultural groups, both as audiences for museums and as presenters of culture and custodians of tangible and intangible heritage' (2006:173). Lissant Bolton notes that even in 1978 the Indigenous Australian delegates at the UNESCO regional seminar in Adelaide were arguing for 'the important role that owners and leaders of particular cultural traditions can have in giving life to existing collections of lifeless objects (Edward and Stewart 1980:13)' (2003:44). Understanding and following cultural protocol can help museums become places that support living Indigenous cultural practice, rather than store houses for disused relics considered 'dead' or 'dormant' by their source communities.

NATURALISED, RESIDUAL PRACTICE AND THE LOGISTICAL AND PHILOSOPHICAL LIMITS TO CHANGE

When considering the engagement of Blackfoot Elders in museums there is clearly a need for the differences between cultural practices to be discussed and negotiated, and common ground to be found, from which new museum practices can develop and potentially be institutionalised. This process is often discussed as though it is a boundless exercise: the greater the community control, the greater the horizon of possibilities. But in reality engagement zones function within the limits of the institutions in which they occur, and museums function within the norms of the societies in which they are located. As such there are very real limits to what can be made possible through engagement, which are generally left out of discussions about engagement. Jack Brink, reflecting on his own experience of being encouraged to do 'blue sky thinking' which eventually resulted in no change at all, highlighted that obscuring the parameters of engagement can be detrimental to morale and relations:

It kills the morale in the place, because we have been told to dream as big as you can dream and then told well actually there is nothing. And I think we are doing that with Native people a lot when we say, we want you to guide us, we want your advice, and there are no limits to it. I think it is unfair and I think it is unfair to them because then you have to go back to them and say, well we didn't do that, we didn't do it because there were actually parameters but we didn't tell you about them.

(Interview, Brink 2008)

Even when deep change is attempted by institutions, such as the National Museum of the American Indian's (NMAI) endeavour to be a 'museum different' (Rand 2009:130), parameters and residual practices can remain (Brady 2009). As Jacki Rand states 'resistant strains of tradition and naturalized processes . . . have evaded even the NMAI's "Museum Different" solution' (2009:130). Miranda Brady carefully critiqued the ways in which, despite its efforts to be 'a solution to troubled museological approaches to communication', the NMAI embedded old ideas into new practice and even created new problems (2009:134, 147). Brady identified five main residual practices in the NMAI's 'Museum Different':

1. Object orientated museology: maintaining and preserving collections (2009:144–5)
2. 'Voyeuristic treatment and commodification of Native culture by the majority' (2009:137) for a 'mostly non-Native audience', with the location of the museum far from 'constituent' communities (2009:136)
3. Failure to consider the impact of framing on self-representation (2009:137)

4. Use of the collective (and inaccurate) term 'Indian' for disparate cultural groups (2009:146)
5. 'Use of expressionless mannequins and dioramas'[4] (2009:145)

Brady (2009) also identified two new problems that engagement created at NMAI:

1. Politics of funding (2009:147)
2. Naturalisation of the need for a museum (2009:148)

Although specific to the NMAI, Brady's critique is useful to consider when examining the Albertan case studies, as they too have residual practices and naturalised assumptions that underlie, and to some extent determine, what is made possible through engagement.

The case studies, like all museums and heritage sites, are restricted by the resources available to them and the logistics of heritage and museum work. Engagement is a resource heavy practice that requires time, money, space and personnel. Funding is always an issue in the heritage sector and there are real limits to what museums can afford to do, both in terms of the processes of engagement and the products. As chapter four highlighted, getting funding for the process of engagement is difficult. 'There are several funding agencies that will support assistance from consultants; there are few that will help pay for an Elder's help and these endowments are much more limited' (Conaty 2006:256). Museums also tend to have set budgets for exhibits, which limit what is possible to achieve through engagement, for example Piikani Elder Allan Pard recalls:

> I think we had a real good opportunity to do a tremendous job, but what I didn't like about Glenbow, was Glenbow just wanted to use their artifacts. I wanted to use Blackfoot artifacts, not Glenbow artifacts but Blackfoot artifacts. I wanted to borrow the best pieces.
>
> (Interview, Pard 2008)

Pard recalled the beautiful Blackfoot material he saw on display in the 1988 *Spirit Sings* exhibition at Glenbow, which were borrowed from collections around the world. He was disappointed that they were not able to access these items for permanent display at Glenbow (Interview, Pard 2008). With Blackfoot items scattered across the globe in private and public collections it would be near impossible for Glenbow to raise the funds to buy these pieces for their collection, and loaning material is a temporary solution that comes with considerable costs and often complex requirements.

Blackfoot Crossing encountered similar issues when pursuing Siksika material for their collection, as Jamie Komarnicki reported in the *Calgary Herald*:

> Museum officials say scores of displaced artifacts potentially worth millions of dollars remain out of reach. . . . Royal said . . . "the Nation

can't afford to buy everything back." . . . Acquiring items through usual museum channels . . . comes at a staggering cost. Last winter, a Siksika buckskin shirt adorned with horsehair, beads and weasel tails went up for sale at New York's swank Sotheby's auction house. It sold for $1.1 million to a private collector, Royal said. The matching leggings went for $800,000. The museum's tight budget—funded about 70 to 80 per cent by the Siksika Nation—doesn't stack up with the big spenders.

(Komarnicki 2009)

In the same article Alfred Young Man comments: 'I think it's a perfect example of how powerless First Nations people are in all this' (Komarnicki 2009). As Young Man notes, power is not just about participation, but also having the resources to achieve your goals.

Funding is closely connected to time limits: deadlines are set by funding bodies, and longer projects tend to cost more. Engagement is a time consuming process, lengthened by the traditional Blackfoot approach of taking the time to do things right, rather than to meet specific timescales. 'It takes time and money to travel and stay in communities, and this travel is vital if relationships are to develop' (Conaty 2008:256). Glenbow took four years to develop *Nitsitapiisinni*, but their relations began back in 1990 with the first loan of Blackfoot material to the community (Conaty 2008:250). Blackfoot Crossing took considerably longer to develop, it began in the 1970s, with momentum building after the commemoration of Treaty 7 in 1977, with the community developed centre opening in 2007.

A further logistical limit to engagement is the abundance and quality of the resource of people. Both the museum and community need to have skilled individuals with knowledge and understanding of their own culture, strong communication and interpersonal skills, an openness and willingness to consider different ways of thinking and working, and time, passion and energy to dedicate to the project. Engagement depends upon the individuals involved as it is they who make up the engagement zone, not the notion of a museum or a community. These people must have the necessary time and resources to participate, which requires them to be one of the following: financially independent; supported by their respective groups; or financed through the engagement process.

When developing co-produced exhibits there are logistical limits to self-representation, in terms of gallery space and the collections available, and how community voice is framed by the other exhibits and the museum building itself. Brady notes that at the NMAI 'it was seen as self-representation without consideration of the ways in which working within such a [national] venue might frame American Indian issues or delimit the potential for deep critical engagement with past and continuing government policy' (Brady, 2009:137).

FRAMING COMMUNITY VOICE

One of the key, and often under analysed, limits on engagement is the physical museum itself. The medium of the museum influences how communities present their perspectives and the extent to which exhibits function as agents of decolonisation.

Elizabeth Bird's (2003) research on Native American developed television shows found that the participants created a show that 'fit the confines of the television genre and its commercial form' despite their critique of the genre (Brady 2009:146). Miranda Brady (2009) draws on this example to argue that a similar phenomenon occurred in the community developed exhibits at the National Museum of the American Indian (NMAI).

> One explanation for the persistence of the dioramas in the NMAI and other residual practices is that while community curators were given the opportunity to self-present, their understanding of such self-presentation comes from the traditional museum form with which they are accustomed. In such museums, the diorama is standard. . . . Similarly, despite the collaboration and inclusion employed by the NMAI, we must ask what really changes when American Indian people themselves are working within the confines of the cultural form.
>
> (Brady 2009:145–146)

This echoes the discussions of autoethnography in chapter three. When considering the case studies, Blackfoot messages of survival and revival are made tangible through the creation of exhibits. But these exhibits have to fit physically within the museums that housed them, and theoretically within the museums' overall message and professional standards (see chapters four and six for further discussion). Consequently Blackfoot voice is framed by the museum, its building, architecture and galleries.

Visitors' first impressions are formed on entry to the case studies and influenced by the architecture of the buildings. Head-Smashed-In and Glenbow are concealed within structures: Head-Smashed-In within a cliff face; Glenbow within a high-rise city convention centre. As such their content is hidden until entering. In comparison, Buffalo Nations Luxton Museum is housed in a building that resembles a trading fort. The historic design of the building conveys a message that the exhibits inside are about the past, and limits the museum's ability to locate living First Nations peoples in the present. In stark contrast, Blackfoot Crossing's building is an artistic show piece on a monumental scale, infused with Blackfoot iconography, and vibrant with Siksika life. It firmly places the Siksika in the here and now. Director Jack Royal explains:

> Some people ask me 'why should I go to Blackfoot Crossing Historical Park when I can go to downtown Glenbow museum and look at the

Blackfoot exhibit?' and what I tell them is: 'well the difference is you are going to get the real experience here'. We are not in some little downtown building, surrounded by high rises where you have got filtered information that is run by the government with non-Native employees telling you about me. You know when you come here it is living history. It is where everything happened. It is by the people. By and where the people still continue to live. And you are going to get the true story. And that is the biggest difference.

(Interview, Royal 2008)

Once inside the case studies, the visitor's understanding of the exhibits is influenced by the way in which the material and intangible culture has been made tangible and how the information is presented. Everything from objects, cases, displays, text panels, labels, photos, audio-visuals, colours, lighting, sounds, temperature, vistas and furnishings, to the gallery routing combine to create a tapestry through which the narrative can be read. Mazel and Ritchie argue that 'museums give physical expression to particular ideas. Whether audio-visual, artefactual or textual, all presentations are ideologically loaded' (Mazel and Ritchie 1994:226). They go on to explain that:

... there are a host of other subliminal messages communicated by museums that have a critical effect on the way that interpretations presented in museums are understood by the public. These are, for example:

1. The authority with which museum knowledge is presented;
2. The manner in which objects are ordered and constructed into displays; and
3. Display techniques, particularly the boundaries reinforced by glass cases.

(1994:235)

Exhibits are complex texts that are layered with meaning and can tell multiple, potentially contrary, stories. One of the key framing devices is the use of voice—who is speaking to the visitor. Knowing the author is very important to the message because, as Alcoff explained, the location of the speaker has an 'epistemically significant impact on that speaker's claims' (1991:6–7). Blackfoot protocol shows direct recognition of this in their tradition of stating who they are, their family and their Elders, before making comment, so that listeners can review their right to speak, their sources of knowledge, and their potential for bias.

At Head-Smashed-In the exhibits are predominantly narrated by an authorised Western scientific voice, reflecting the status of the real-life author of the text panels: the Royal Alberta Museum Curator and Archaeologist Jack Brink. In the exhibit, Blackfoot voices appear in a temporary and ephemeral

way as words made of light projected on to rocks around the exhibit. They fade and strengthen depending on the sunlight filtering into the exhibit and if you inspect them too closely they disappear as the visitor blocks the beam from the light projector (Figure 5.1). Projected on to uneven rock surfaces the words blur and bleed making reading them difficult (Figure 5.2). Overall this implies to visitors that Western archaeologists have the facts which are presented in an authoritative and permanent way, whereas the Blackfoot have stories which are ethereal and evanescent.

However, the narrative is complicated by the presence of Blackfoot guides who give tours from a Blackfoot perspective and at times counter and challenge the information presented in the main text panels. For example, guides will present alternative Blackfoot cultural explanations for scientific accounts, such as the movement of the glacial erratics, and highlight inaccuracies in Western depictions of the buffalo hunt.

At Glenbow, despite the primary audience being non-Blackfoot (Glenbow 1999:1), the exhibit team made a conscious decision to use first person narrative and Blackfoot terms to emphasise to visitors that the exhibit comes from a Blackfoot perspective. The opening text panel of the exhibit states 'in order to understand who we are, it is first necessary to understand how we see the world around us' (*Nitsitapiisinni* gallery, *Our World* text panel 2008). This clearly grounds the exhibit in the Blackfoot narrative and gives Blackfoot voice museum authority. Community voice can literally be heard in the exhibit through the audio-visual presentations. Visitors have the

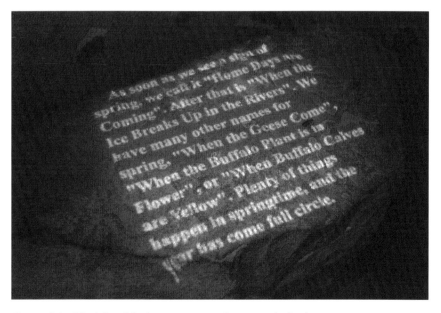

Figure 5.1 Blackfoot Napi story projected onto rock displays.
Courtesy of Head-Smashed-In Buffalo Jump World Heritage Site.

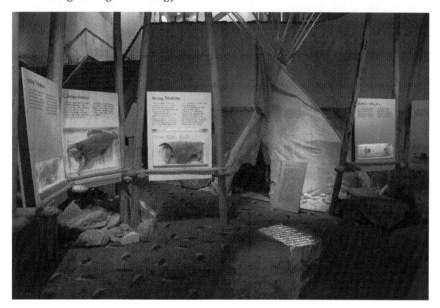

Figure 5.2 Head-Smashed-In *Napi's People* exhibit.
Courtesy of Head-Smashed-In Buffalo Jump World Heritage Site.

opportunity to listen to Elders' pre-recorded stories in Blackfoot or English via phones placed around the gallery and on the films, in addition Blackfoot guides provide tours of the exhibit in both Blackfoot and English.

Despite the prominence and emphasis of the gallery being a Blackfoot story, Krmpotich and Anderson's research indicates audiences did not always receive this message. Krmpotich and Anderson conducted 62 face-to-face, semi-structured interviews over a four-day period with visitors to the Blackfoot Gallery (Krmpotich and Anderson 2005).

> An exploratory evaluation of visitors' responses was undertaken to investigate how effectively *Nitsitapiisinni* is communicating the four primary messages that embodied the essence of collaboration and aboriginal authorship and to determine the scope of messages visitors interpreted in the gallery. Exploratory approaches seek to determine the multiple impacts an exhibition may have, whether or not those impacts correspond with the goals expressed by the curator, exhibition team, or museum.
>
> (2005:386–7)

They found that:

> Visitors rarely recognized the extent of the collaboration, and thus rarely equated *Nitsitapiisinni* with concepts of self-representation or

self-determination. However, other messages were successfully communicated to museum visitors, namely the impact of colonialism, the efforts to revitalize Blackfoot culture, and the importance of Blackfoot spirituality.

(Krmpotich and Anderson 2005:377)

As Bird (2003) and Brady (2009) highlight, people tend to recreate what they know and analyse new situations by using frames of reference based on prior knowledge.[5] It appears that visitors may read exhibits based on past experiences or assumptions about museums, i.e. museum exhibits are curator led, despite abundant evidence to the contrary.

Blackfoot Crossing also presents a Blackfoot narrative, from a specifically Siksika perspective. Their opening text panel greets the visitor in Siksika Blackfoot and English '*Oki Ka'nai'tapi'wa, Aipi'ma. Welcome, All Visitors*'. The text panels use a combination of third person narrative describing Siksika and first person stories, accounts and perspectives. With a large local Siksika audience, it is unsurprising that the interpretation features Blackfoot language in Siksika dialect more prominently that the other case studies. Exhibit designer Irene Kerr noted that the primary audience was the local community, although the centre also seeks to attract tourists and off-reserve visitors.

We knew in the back of our minds that this obviously would have to make money as an interpretive centre, we knew all that, but at the same time we really had to bear in mind that it was for the community; probably a tougher audience than just about anybody.

(Interview, Kerr 2008)

The centre repeatedly emphasises its Siksika perspective and like the other case studies, the message is reinforced by the Siksika staff members and interpretive guides. However, to-date, there are no visitor studies on how this message is received by visitors to Blackfoot Crossing.

Besides the direct use of language, Blackfoot messages can be conveyed through the inclusion of concepts, symbols (as discussed in chapter seven) and ways of understanding. However, making Blackfoot intangible culture tangible within a Western style of museological interpretation is particularly challenging as it requires translating cultural concepts that may have no equivalent translation in the other cultures' epistemology or language. A key example is translating between Western linear time and Blackfoot cyclical time concepts. In the Blackfoot Exhibit Team Meeting minutes the following discussion is recorded:

REG [CrowShoe] . . . this is an oral tradition, language, and culture. The old timers were trying to relay this idea. If these ideas are taught in the Western perspective, they reflect a linear world view. How can we pre-

sent what the old timers really meant it to be? Timelines and storylines take away from this. We need to consider how our young people will relate to this exhibit.

GERRY [Conaty] commented that we need to get the two systems to work together.

(Glenbow 1998:2)

At Glenbow the gallery routing and layout was utilised to attempt to bridge the conceptual differences. The gallery is laid out in a predominantly chronological linear order but physically comes full circle in the routing, representing both linear and cyclical world views. Allan Pard explained that it was a conscious decision to present their culture in Western terms of reference to help non-community members understand the history: 'we tailored it for you White people. Yes, it was linear thinking there. That's because we were trying to get this message across and teaching you guys' (Interview, Pard 2008).

The gallery routing influences the messages an exhibit conveys, as the route determines the ordering of the narrative. Western linear time is based on the idea of moving forward, with the past behind and the future ahead. Inbuilt into this concept is the idea of progress. During the colonial period 'progress' was a term for conquest, 'civilization' and assimilation. As such the use of chronology can be read to imply a Western perspective and even a value judgement on Indigenous culture. Consequently the *Nitsitapiisinni* exhibit at Glenbow purposefully disrupts the chronology at different points emphasising cultural continuity by showing living modern-day versions of traditional events such as dancing and drumming and by using videos of Elders discussing traditional ways that are still in practice. This helps to enforce the message of survival and revival.

In comparison, Head-Smashed-In uses a set route from the top to the bottom of the interpretive centre which encourages visitors to follow a path that presents the information in linear chronological order. Head-Smashed-In frames their interpretation in the past by directing visitors to watch an orientation film at the beginning of their visit. Recently redeveloped, the film is set 1000 years ago and depicts a Blackfoot buffalo jump hunt. The actors are all local Blackfoot people and the dialogue is in Blackfoot with English subtitles. This firmly locates the interpretation in the pre-historic period, with the only reference to living Blackfoot culture being presented in a small side exhibit and by the presence of Blackfoot staff.

In direct contrast, Blackfoot Crossing directs visitors to watch an orientation film about the strength and vibrancy of current Siksika life, firmly placing the culture in the present. The film emphasises how Siksika blend traditional culture with modern living by showing cultural continuity and intergenerational knowledge sharing, alongside modern developments such as industry and community schools on the reserve. Consequently, visitors begin their visit with the knowledge that this is not an ancient forgotten culture; it is a way of life that continues today. This challenges colonial myths

about dying races, assimilated cultures, and notions that 'Indians [sic]' are either 'backwards' and/or 'failures' because they 'couldn't get with the program' (Smith 2009:52) which still abound in the public imagination.

To reinforce this message Blackfoot Crossing also breaks away from the chronological linear model of interpretation. The gallery creates a circular notion of time through free routing enabling visitors to weave through the exhibits, moving in and around the displays in circular patterns. Although some text panels and exhibits refer to certain eras, others are timeless combining the modern with tradition. The gallery allows visitors to view the exhibits in any order they choose, avoiding the concept of progression through time (see Figure 5.3).

These examples show that museums can be adapted to take on different cultural concepts and convey them physically through the building structure and layout. Thus the very fabric of the museum can begin to be decolonised and adapted, even indigenised, to include other cultural forms and concepts.

In addition to these practical and logistical limitations there are also socio-political limits to what can be made possible through engagement. As Mazel and Ritchie state: 'in the museum context, ideology is reflected not only in the displays but in all spheres of the institution' (1994:226).

The socio-political limits can be grouped under four headings:

1. Ethos, culture and direction of the institution (museum or heritage site)
2. Professional standards of museology and heritage
3. Political climate in which the institution works and engagement develops
4. Expectations of visitors who come to see the products of engagement zone work

Figure 5.3 Free routing in Blackfoot Crossing's Gallery.
Preliminary sketches by Exhibition Planning and Design for Blackfoot Crossing Historical Park.

These socio-political and logistical limitations will be explored in the analysis of each case study in the next chapter. For the moment it is worth noting that the physical, practical and logistical limits and residual practices of the museum as a cultural form that frames self-representation help to account for some of the reasons why engagement theory models are generally not reflected in practice, and why community members often still have grievances with museums even after apparently successful engagement.

NOTES

1. Christina Kreps uses the expression "Indigenous curation," as 'shorthand for non-Western models of museums, curatorial methods, and concepts of cultural heritage preservation' (2005:3).
2. 'In 1895, Section 114, an amendment to the *Indian Act*, prohibited certain aspects of Sun Dance ceremony (e.g., body piercing). Since 1951, Bill 79 has revoked any restriction pertaining to "mutilations of flesh"' (Deutschlander and Miller 2002:28).
3. For further discussion on the living nature of sacred Blackfoot bundles and repatriation see Todd 2003, Zedeño 2008, Lokensgard 2010, Conaty forthcoming.
4. Dioramas and mannequins are discussed in detail in chapter eight.
5. This is known as constructivism in learning theory.

REFERENCES

Alcoff, L., 1991. The problem of speaking for others. *Cultural Critique*, Winter Issue pp. 5–32.
Arnstein, S.R., 1969. A ladder of citizen participation. *JAIP*, 35(4) pp. 216–224.
Bastien, B., 2004. *Blackfoot Ways of Knowing: The Worldview of the Siksikaitsitapi*. Calgary: University of Calgary Press.
Bird, S.E., 2003. *The Audience in Everyday Life: Living in a Media World*. New York: Routledge.
Blackfoot Gallery Committee, 2001. *Nitsitapiisinni: The Story of the Blackfoot People*. Toronto: Key Porter Books.
Blood, N. 12 Sept 2007. Interview. Calgary.
Boast, R., 2011. Neocolonial collaboration: museum as contact zone revisited. *Museum Anthropology*, 34(1) pp. 56–70.
Bolton, L., 2003. The object in view: Aborigines, Melanesians, and museums. In L. Peers and A.K. Brown, eds. *Museums and Source Communities. A Routledge Reader*. London: Routledge, pp. 42–54.
Brady, M.J., 2009. A dialogic response to the problematized past: the National Museum of the American Indian. In S. Sleeper-Smith, ed. *Contesting Knowledge: Museums and Indigenous Perspective*. London: University of Nebraska Press, pp. 133–155.
Brink, Jack. 26 Sept 2008. Interview. Calgary.
Chakrabarty, D., 1992. Postcoloniality and the artifice of history: who speaks for the "Indian" pasts? *Representations*, 37(1) pp. 1–26.
Conaty, G.T., 2006. Glenbow Museum and First Nations: Fifteen years of negotiating change. *Museum Management and Curatorship*, 21(3) pp. 254–256.

Conaty, G.T., 2008. The effects of repatriation on the relationship between the Glenbow Museum and the Blackfoot people. *Museum Management and Curatorship*, 23(3) pp. 245–259.

Conaty, G.T. ed., forthcoming. *"We Are Coming Home!": Repatriation and the Restoration of Blackfoot Cultural Confidence*. Athabasca: AU Press.

Crowshoe, Reg. 19 Aug 2008. Interview. Calgary.

Cruikshank, J., 1992. Oral tradition and material culture. Multiplying meanings of "words" and "things". *Anthropology Today*, 8(3) pp. 5–9.

Deutschlander, S. and Miller, L.J., 2003. Politicizing aboriginal cultural tourism: the discourse of primitivism in the tourist encounter. *Canadian Review of Sociology/ Revue canadienne de sociologie* 40(1) pp. 27–44.

Flynn, G.A. and Hull-Walski, D., 2001. Merging traditional Indigenous curation methods with modern museum standards of care. *Museum Anthropology*, 25(1) pp. 31–40.

Glenbow, 27 Nov 1998. *Blackfoot Exhibit Team Meeting*. [Minutes] Unlisted. Calgary: Glenbow Archives.

Glenbow, 23 Feb 1999. *Blackfoot Exhibit Team Meeting*. [Minutes] Unlisted. Calgary: Glenbow Archives.

Kerr, Irene. 20 Aug 2008. Interview. BCHP.

Komarnicki, J., 2009. Displaced Blackfoot artefacts remain out of reach. *Calgary Herald*, 08 Feb. [Online] Available at: http://www.elginism.com/similar-cases/retrieving-blackfoot-artefacts/20090208/1707/

Kreps, C., 2005. Indigenous curation as intangible cultural heritage: thoughts on the relevance of the 2003 UNESCO Convention. *Theorising Cultural Heritage*, 1(2) pp.1–8.

Kreps, C.F., 2003. *Liberating Culture. Cross-cultural Perspectives on Museums, Curation and Heritage Preservation*. London: Routledge.

Krmpotich, C. and Anderson, D., 2005. Collaborative exhibitions and visitor reactions: the case of Nitsitapiisinni: Our Way of Life. *Curator*, 48(4) pp. 377–405.

Lokensgard, K.H., 2010. *Blackfoot Religion and the Consequences of Cultural Commoditization*. Farnham: Ashgate.

Mazel, A. and Ritchie, G., 1994. Museums and their messages: the display of the pre- and early colonial past in the museums of South Africa, Botswana and Zimbabwe. In P.G. Stone and B.L. Molyneaux, eds. *The Presented Past. Heritage, Museums and Education*. London: Routledge, pp. 225–236.

McClintock, W., 1910. *The Old North Trail: Life, Legends and Religion of the Blackfeet Indians*. London: Macmillan and Co.

Morris, K., 1994. Consultation: an ongoing process. An interview with George Horse Capture. *American Indian Ritual Object Repatriation Foundation News & Notes*, 1(2) pp.1, 3. [Online] Available at: http://www.repatriationfoundation.org/pdf/newsnotes/fall_winter1994.pdf

Pard, Allan. 12 Nov 2008. Interview. HSIBJ.

Rand, J.T., 2009. Curatorial practices: voices, values, languages, and traditions. In S. Sleeper-Smith, ed. *Contesting Knowledge: Museums and Indigenous Perspective*. London: University of Nebraska Press, pp. 129–132.

Rosoff, N.B., 1998. Integrating Native views into museum procedures: hope and practice at the National Museum of the American Indian. *Museum Anthropology*, 22(1) pp. 33–42.

Ross, M. and Crowshoe, R., 1996. Shadows and sacred geography: First Nations history-making from an Alberta perspective. In G. Kavanagh, ed. *Making Histories in Museums*. London: Leicester University Press, pp. 240–256.

Royal, Jack. 25 Aug 2008. Interview. BCHP.

Shelton, A. 2001. Museums in an age of cultural hybridity. *Folk*, 43 pp. 221–249.

Shryock, A., 2004. Other conscious/self aware: First thoughts on cultural intimacy and mass mediation. In A. Shryock, ed. *Off Stage On Stage: Intimacy and Ethnography in the Age of Public Culture*. Stanford: Stanford University Press, pp. 3–28.

Simpson, M.G., 2006. Revealing and concealing: museums, objects, and the transmission of knowledge in Aboriginal Australia. In J. Marstine, ed. *New Museum Theory and Practice. An Introduction*. Oxford: Blackwell Publishing, pp. 153–177.

Smith, P.C., 2009. *Everything You Know about Indians Is Wrong*. London: University of Minnesota Press.

Todd, L.S., 2003. *Repatriation and the Blackfoot people. Excerpts from Kainayssini Imanistaisiwa: The People Go On* [Film] [Online]. Available from: http://wn.com/Museums_and_the_Blackfoot_People

Tovias, B., 2010. Navigating the cultural encounter. Blackfoot religious resistance in Canada (c. 1870–1930). In A.D. Moses, ed. *Empire, Colony Genocide. Conquest, Occupation, and Subaltern Resistance in World History*. Oxford: Berghahn Books, pp. 271–295.

Zedeño, M.N., 2008. Bundled worlds: the roles and interactions of complex objects from the North American Plains. *Journal of Archaeological Method and Theory*, 15(4) pp. 362–378.

6 Institutionalising Relations

Laura Peers and Alison Brown . . . suggest that collaborative rela-tionships established between museums and source communities are contingent on three things: the nature of the source community; the political relationship between the source community and the museum; and the geographical proximity of museums to these communities (2003: 3). . . . I add another factor to these three: the unique culture of the individual museum.

(Harrison 2005:195)

When we talk about museum practices, they are a lot more flexible than the museum beliefs of curation and preservation . . . if they are flexible to change those practices, then they are flexible to interpret those practices into our practices, so we can build middle ground.

(Interview, Crowshoe 2008)

This chapter will put the discussion about the challenges and limits to change in the last chapter into the real-life contexts of the case studies. All of the case studies have been influenced by Blackfoot approaches to cultural heri-tage management as a result of their engagement with the community and specifically Elders. In different ways and to differing extents each case study found a 'middle ground' from which to build new museological practices, and over the course of engagement, institutionalised aspects of the rela-tionship to greater and lesser extents. However, each case study has had to negotiate very real practical and socio-political limitations which will now be explored in detail to tease out the naturalised assumptions and practices that problematize institutionalising indigenisation.

HEAD-SMASHED-IN BUFFALO JUMP
INTERPRETIVE CENTRE

Head-Smashed-In interpretive centre was developed with community con-sultation from the Piikani and Kainai Blackfoot Nations. On Arnstein's model (1969) this is ranked as tokenism, however by the time the centre

opened the notion of Blackfoot involvement had been institutionalised in the form of the storyline and the employment of Blackfoot interpretive guides. In practice, Head-Smashed-In used participatory methods that spanned the engagement spectrum at different points in the process and adapted its practice to accommodate some Blackfoot protocol. However there are clear limits to what has been made possible through engagement at Head-Smashed-In mainly based around the issues of institutional ethos and time limitations.

As an interpretive centre Head-Smashed-In does not have a dedicated curator. All of the collections are on display and items were chosen for their durability or replicated as the centre is not an environmentally controlled space. Nevertheless, non-Blackfoot management have learnt about Blackfoot protocol and heritage management through consultation with Elders and employment of community members, and have sought to incorporate elements of it into practice. In an attempt to respect the sacred nature of the Buffalo jump and some of the items that are on display, like the painted buffalo skull and two replica bundles, a space has been created where smudging[1] and prayer can take place without disturbance or fire alarms being triggered. Although an archaeological site and Government of Alberta Institution, Head-Smashed-In facilitates an annual renewal ceremony for a sacred skull on display which includes allowing the skull to be handled by appropriate Elders. The interpretive centre has also acknowledged cultural restrictions about photographing sacred items and have, from time to time, requested visitors do not photograph the sacred skull.

However, these adaptations have not been practiced consistently and Head-Smashed-In has not always acted on the advice of the community. Despite acknowledging the photographic restrictions on sacred objects, images of the sacred skull are frequently used in marketing and educational material and even merchandise, which has been a cause for controversy amongst the Blackfoot. The annual renewal ceremony has had periods of dormancy when the skull has not been renewed and the amount of prayer and smudging at Head-Smashed-In fluctuated depending on the spirituality and traditional authority of the people employed at, and involved with, Head-Smashed-In at the time. The limited nature of these adaptations can be seen to relate to, and reflect, the level of power sharing between the centre and the community. As Arnstein's model indicates, consultation favours the consulters over the consulted. And yet Head-Smashed-In has institutionalised Blackfoot interpretive guides as the only cultural group allowed to do interpretation and they regularly involve community Elders in the in-house training of guides and host events just for the Elders such as an annual Christmas meal. Brink explained that the position of Head of Interpretation at Head-Smashed-In has such specific criteria that it is restricted not just to Blackfoot people, but specifically to people with knowledge equivalent to an Elder:

What we've created is almost a situation where now we have to hire Elders to get what we want, you know. To hire somebody under-fifty

would be really difficult given the criteria of what we've set out we want those staff to do. Like one of the hiring criteria is to speak Blackfoot.

(Interview, Brink 2008)

This mismatch between institutionalising Blackfoot participation and not following community advice can be traced back to the origins of the centre and a double thinking that has been maintained throughout its life. At its inception the Head-Smashed-In Interpretive Centre was an idea envisioned by a group of non-Blackfoot archaeologists who had been working on excavations at the site. Community involvement became a part of the process only after the site had received World Heritage designation and funding for an interpretive centre had been secured. Not involving the community from the very beginning has remained a key issue for the Blackfoot communities, and was exacerbated by the way community rivalries were manipulated to gain approval for the development of the centre (explained in chapter four).

Although the Blackfoot were consulted, the non-Blackfoot staff controlled the development and operation of the site. Nevertheless, there were times when Head-Smashed-In followed Blackfoot protocol despite non-Blackfoot staff members' doubts and the bureaucratic challenges, as Brink recalls in Lorretta Sarah Todd's (2003) film *Kainayssini Imanistaisiwa: The People Go On*:

I'm your average white guy in the sense that I'm not steeped in the ceremonial world of Blackfoot people, but I had my own experience with this . . . just when we opened, literally within the first two weeks we had two tourists die here, both dropped dead of a heart attack . . . it was pretty traumatic. We were all deeply affected by this, but the Blackfoot staff; to me it's like, well geez that's pretty bad luck . . . but they said this is not luck, there's something wrong. And they said we have to close this building down and do these cleansing ceremonies and it is going to be all day and we need everybody here. And that's not easy to do in a government building. This is a facility that's advertised to the public, it is open every day and there are signs all over the highway. To just shut it the doors and say sorry no-one's coming in today, you have to go way up into Edmonton Government and get permission for that. Well they just insisted, and that's what we did. A lot of offerings were made, special people were brought in for that ceremony and we had smudging and face painting and we went all through the building with these offerings cleaning the spirits out. And of course I'm there as a young man not really understanding all of it, but taking part in it, and that was twenty years ago and no-one's died since, so, you tell me.

(Brink Interview in Todd 2003)

Julia Harrison argues that 'as each source community is seen to have its own character, something which in anthropological terms could be glossed

under the notion of cultural traditions, practices, or simply its way of being in the world, so do institutions such as museums' (2005:197). At Head-Smashed-In they have two different layers to their character: there are the community members who are employed in interpretation who encourage the involvement of community and Elders; and then there are the management who are characteristically non-Blackfoot and have tended to view the centre as primarily an archaeological site, which the Blackfoot people and their history supplement and enrich. As Brink explains 'it is a UNESCO World Heritage Site because of the incredible story of that [Buffalo] jump and not because Blackfoot people work there' (Interview, Brink 2008). He explains that:

> It is my perception that the Jump has evolved dramatically in the last 20 years. And one of the major revolutions is the story of the Jump has become more the story of the people. It has become more and more of a cultural centre for the Blackfoot, rather than a celebration or story about the buffalo jump. And I think that's controversial. There are some people who don't agree with that trend, and there are others who I think who favour it and maybe like to see more of it. I am one of the people who feels that the jump has gone too far as a Blackfoot centre and needs to go back to being more as a story about the buffalo jump, and it just so happens that the Blackfoot people ran the jump.
>
> (Interview, Brink 2008)

Referring to the new exhibit on the Blackfoot, Brink goes on to say:

> [The Blackfoot] can say this is who we are, this is our people and this is our buffalo jump. I think [visitors] should hear that story, it's important. But I also do think that we're losing our focus, which I find it regrettable because I think the jump is such a compelling story in and of itself that we have the potential to hold people in the palm of our hands when they walk in the door.
>
> (Interview, Brink 2008)

This view is further illustrated by the then Site Manager's explanation on why they involved the Blackfoot:

> Well very much because A) there is a dead culture here, well a series of dead cultures, that are prehistoric, but there happens to be a living culture immediately within the area, and the Blackfoot although they are recent arrivals, have been here for four, five hundred years. So yes they used the site. It is important to them. It was part of their territory. Were the original people 6–7000 years ago connected to the Blackfoot culture? Well the assumption of the scientists is no. There were other tribes

that predate the Blackfoot tribes in this region. Could they be associated with any one of those tribes? Possibly, but we can't confirm that.

(Interview, Site Manager 2006)

The view that the Blackfoot are 'recent arrivals' is controversial and stands in direct opposition to Blackfoot oral history that records that they have been in Alberta since time immemorial, as Kainai Elder Narcisse Blood noted:

> Blackfoot have always been there. It is difficult for me to reconcile that you are going to make some conclusions or theories based on the base of [arrowhead] points in archaeology and say that these are Clovis people, these are Sandia people, they have all these phases and cultural groups that are based on an artefact. Because the technology changes it is very dangerous to say that they weren't Blackfoot. That just doesn't make sense. Then who were they?
>
> (Interview, Blood 2007)

Head-Smashed-In Blackfoot Interpreter and Archaeologist, Stan Knowlton, accounts for the differences in the arrowhead points found at the buffalo jump not as different ethnic groups, but as hunting adaptations made to accommodate the reducing cliff drop, due to the increasing level of buffalo bones building up at the base of the jump through its thousands of years of use (Interview, Knowlton 2008). However, this is not the official interpretation presented at Head-Smashed-In. Thus despite the embedded community involvement at Head-Smashed-In there is still a strong notion of Western science verses Blackfoot knowledge, which many of the Blackfoot archaeologists who have been employed at the centre over the years have tried to bridge.

It is important to note that recent Western research is increasingly providing scientific support for the Blackfoot accounts of the past, such as those mentioned above. A discovery of human remains in Montana dating from the Clovis period, 13,000 to 12,600 years ago, has been identified through DNA testing as belonging to a 'population directly ancestral to many contemporary Native Americans' (Rasmussen et al 2013:225). This is a direct scientific challenge to the idea put forward by Head-Smashed-In's Site Manager in 2006, that the Blackfoot were 'recent arrivals' of 'four, five hundred years' and to the commonly held notion that Clovis people were unconnected to modern day First Nations. Similarly a recent study on Arctic peoples has shown that 'Paleo-Eskimo technological innovations and changes through time, as evident from the archaeological record, seem to have occurred solely by movement of ideas within a single resident population. This suggests that cultural similarities and differences are not solid proxies for population movements and migrations into new and dramatically different environments, as is often assumed' (Raghavan et al 2014:1020). This

echo's Knowlton's argument that technological innovation was a response to changing circumstances rather than evidence of different ethnic groups using the jump. Such findings hint at the depth and wealth of Indigenous knowledge that has until very recently been almost entirely overlooked.

Winnel Branche has argued that museums 'presently enjoy positions of superiority and can therefore graciously afford to accommodate "the other"' but questions how much museums are really prepared to give up (1996:120). 'The true test will come when we ask ourselves if we are ready to have our Indigenous brothers and sisters giving the orders, not taking them—making the decisions and being the directors, not just the side-show "live" craft persons' (Branche 1996:121). At Head-Smashed-In, community employment has not equalised the Blackfoot/non-Blackfoot power relations because upper-management are not community members. Some, but not all, Blackfoot protocol is observed, and Blackfoot employees are expected to toe-the-line of the institutional message and practice. The Site Manager at the time explained how he has adopted Blackfoot witnessing as an important part of his job, and always took the time to be present for discussions between staff and community members at the centre (Interview 2006). However he added 'this is a government operated site and you are given three chances' if an employee does not meet the expected standards they lose their job even if they try to make amends following traditional Blackfoot protocol (Interview, Site Manager 2006). Thus from its development Head-Smashed-In made adaptations and institutionalised aspects of community involvement and protocol that in the 1980s was ahead of its time. However it has not stayed ahead of the changes in museology. The extent of indigenization has not satisfied the expectations of all of the community, nor have changes been institutionalised with consistency.

In 2007 Head-Smashed-In redeveloped their films with Blackfoot input. As discussed in chapter four, it is surprising that Head-Smashed-In chose a similar engagement approach of consulting a small group of Piikani and Kainai Elders on a script that was already written by non-Blackfoot staff members and consultants. Head-Smashed-In limited the engagement process to the government set timelines despite staff members' recognition that they were not culturally appropriate as they did not allow enough time for the Elders to reflect and consult within their communities. Thus over the twenty years (1987–2007) Head-Smashed-In had been operating, little had changed in the institutional ethos or practice of involving the community, despite the changes in museology and Head-Smashed-In's institutionalisation of community employment and Elder consultation.

The lack of change can be partly accounted for as a result of it being a government institution, primarily developed to interpret archaeology to a non-Native international tourist audience, rather than being community run or focused. However, this means that despite Head-Smashed-In's institutionalisation of Blackfoot involvement and employment, many community members continue to see Head-Smashed-In as a commodification of their

culture by a government institution (the consequences of this will be discussed in chapter nine). Thus what is made possible through engagement at Head-Smashed-In is limited by the lack of power sharing, the limited time allocated to such work, and the internal divisions in institutional culture. Confusion over the identity, purpose, message and ownership of the Buffalo Jump continues to prevent productive co-working that meets the expectations of the institution and the community.

GLENBOW MUSEUM

It would be reasonable to assume that since Glenbow used a partnership model of engagement, ranked as the lowest form of citizen power on Arnstein's model, it would have had greater success at meeting community expectations and made greater strides in indigenising curatorial methods.

Like Head-Smashed-In, Glenbow made changes to their facility to allow space for prayers and smudging. But unlike Head-Smashed-In, Glenbow holds large collections on display and in storage and chose to adapt its curatorial practice further to accommodate Blackfoot protocols which the Ethnology team learnt through participation in Blackfoot society and by working with Elders. Partnership, collaboration and adaptation helped to build a strong and respectful relationship between the Ethnology Curators and Blackfoot Elders. This relationship was formalised in 1998 with the signing of a Memorandum of Understanding (MOU) with the Kainai Mookaakin Society designed to 'facilitate a cooperative working relationship' (Mookaakin and Glenbow 1998:3).

This relationship enabled the repatriation of sacred bundles and the participation of museum employees in cultural and ceremonial events. This led on to the development of the *Nitsitapiisinni* permanent gallery, temporary community exhibits, Blackfoot employment at Glenbow, cultural programming, and curatorial adaptation. Former CEO Robert Janes explained the learning process of working together to adapt practice:

> We had to learn from the Blackfoot first and they had to learn that we had certain structures, processes and requirements, as well. We had a standard conservation practice of putting loaned objects in a freezer so that they would not contaminate the rest of Glenbow's collection when they came back from a loan. But then we found out that the Blackfoot view these bundles as living children. We had a choice. We could continue to uphold the museum's conservation standards. Or, with our growing awareness and our evolving respect for Blackfoot traditions, we actually listened to the Blackfoot ceremonialists and no longer put the bundles in freezers. [We] just kept them in a separate holding room.
>
> (Interview, Janes 2008)

Following Blackfoot protocol Glenbow removed sacred items from display and either repatriated them or kept them in separate designated areas in storage, restricted from general access with clear labelling to avoid unintentional exposure. The Senior Curator at the time, Gerry Conaty, had participated with Blackfoot ceremonial life since the 1990s and had a deep appreciation for the sacred nature of items in the collection and encouraged staff members to respect the power Blackfoot people believe they hold. Conaty worked hard to keep the storage areas quiet and respectful. As Conaty explained:

> I became friends with the Weasel Moccasin family and began to understand the significance of the holy bundles to people; not to a foreign culture. They, in turn, began to see me as an individual who was beginning to understand and respect their culture and their holy bundles. They now asked that I fulfil some obligations to their culture: I was encouraged to prepare a daily smudge for the bundle while it resided at Glenbow; I was expected at various ceremonies; and I was requested more and more often to lend religious objects. These requests were made in light of my understanding of their culture, my tendency to agree to such loans and to champion the loans within the museum bureaucracy in conjunction with Janes' support of these efforts. As I developed similar personal relationships with other Kainai and Piikani, I moved beyond being seen as the representative of a faceless institution. This, in turn, personalized Glenbow and it became regarded less as a custodian of objects and more as a steward of living things.
>
> (Conaty 2008:251)

The Ethnology team followed traditional Blackfoot practice and restricted women from accessing the sacred storage areas during their menstrual cycle or when pregnant, which required staff members to significantly adapt their work schedules to accommodate these protocols. Glenbow has also applied Blackfoot protocol to their archive and restricted public access to sensitive Blackfoot material. In Australia such restrictions have become commonplace, as Bolton describes: 'no museum in Australia now displays or allows research access to Aboriginal human remains or secret or restricted material, and significant numbers of objects in both categories have been returned to their traditional owners' (2003:46). This practice is not yet normalised in North America (Flynn and Hull-Walski 2001) and there can be resistance to such changes.

Not only did Glenbow change the way it managed its existing collections, it also adapted its collecting strategy. The Ethnology team collect modern cultural material that emphasises contemporary concerns and Blackfoot culture in the modern world. Curator Beth Carter accessioned an exemplary piece of Blackfoot dance regalia—a beaded hide hair piece in the shape of a *Nike* tick, the emblem of the modern sports brand. Glenbow has also opened up

its collection to Blackfoot visitors allowing object handling in response to Blackfoot traditions of using items to maintain the tie between the tangible object and the intangible knowledge it relates to. Items have been loaned and repatriated to the community to be used in ceremonies and cultural practices. Some community members come to the museum to see their ancestor's possessions and to reconnect with and renew culture, for example by studying traditional items of dress held in storage to inspire the creation of new regalia for cultural events (Interview, Carter 2008). Co-operation between the museum and community helps to maintain and renew both tangible and intangible Blackfoot culture. In turn, knowledge sharing across the network of engaged people has improved both the museum and the community's understanding of Blackfoot culture (Conaty 2008:255).

A key to the success of this relationship was the Ethnology team's commitment and willingness to accommodate Blackfoot approaches, including taking the time the community needed to do the project right even though this was expensive and bureaucratically challenging. Kainai Elder Frank Weasel Head explained: 'from our first initial meeting it took us three and a half years to complete. It was a drawn out process, but the Blackfoot team felt very comfortable' (Interview, Weasel Head 2008). He went on to say 'sure it took a long time, but then Gerry and then Beth and Irene and whoever else came in with the Glenbow, they start realising, ah, this is their way. Sure it might take longer but we'll get a better product' (Interview, Weasel Head 2008). The Ethnology team at Glenbow successfully indigenised curatorial practice and institutionalised community engagement in their department that 'in many ways, meet First Nations' criteria rather than museum standards' (Conaty 2008:256).

The Ethnology team's willingness to commit personal time and energy to the development of community relations facilitated its success, but ironically, it was one of its weaknesses because the change brought about by engagement primarily affected the Ethnology Department, leaving the rest of the institution relatively unchanged; perhaps understandably, given its diverse subject areas and collection in Native North America, community history, art, mineralogy, military and world cultures. The institutionalisation of Blackfoot protocol has therefore occurred in Glenbow not on an institutional level, but on a departmental and personal level within the Ethnology team.

While the Ethnology department, with the support of CEO Robert Janes and his successor Mike Robinson, adapted to Blackfoot ways of working:

Other parts of the museum were not so open to change. The registration department, other curatorial areas, and the board of governors were all hesitant to engage in repatriation. There was a fear that the objects would find their way to the marketplace and Glenbow would be accused of neglecting its fiduciary responsibility. . . . Although we were moving toward a new philosophy, our bureaucracy had not yet begun to change.

(Conaty 2008:251)

Conaty recognised that 'in 1990, this was a radical approach for a museum to take and we often felt isolated from other institutions and from colleagues within Glenbow who felt that we should not abdicate our traditional role as the arbiter of knowledge' (2008:256). The formalising of power sharing through the MOU caused unease among some staff who 'were concerned that the museum was relinquishing its responsibility to manage our collections and our ability to exercise our intellectual freedom when developing exhibits and programs' (Conaty 2008:252). These concerns occurred despite the MOU clearly stating 'that final responsibility rests with Glenbow' (Conaty 2008:252). Similarly Janes recalled that:

> Some of the staff were looking askance—wondering if we were going to give away everything? . . . who are these people who get to make you change all these traditional museum practices? . . . I think there was a certain amount of cynicism and, as a result, we established the Native Advisory Group (with the ironic acronym of NAG), to share concerns, questions and assumptions. I think that went a long way toward diffusing the concerns about our relationship with the Blackfoot throughout the organisation. But you can appreciate in a place like Glenbow, with all of the specialist positions, that there were a lot of people who didn't care at all, or didn't have the time, energy or interest to get involved. You could talk to a lot of staff at Glenbow during that time who never had anything to do with the Blackfoot. I don't think that really matters as long as there are enough staff participating, and there is sufficiently strong leadership to keep the relationship moving in the right direction.
>
> (Interview, Janes 2008)

Attempts to indigenise curatorial practices often come up against resistance. Flynn notes that in America: 'the incorporation of traditional care methods into standard museum storage and handling practices has been controversial. Conservators, with good reason, have been concerned that traditional care methods could compromise standard museum care, affecting the stability of an object or an entire collection' (Flynn 2001:2).

> The sub-text is that in order for those things to go on, the authority and responsibility have to be devolved throughout the organization, but you also have to have a museum director who is interested in doing this kind of work, or it isn't going to happen. Without support at the top, money won't be allocated and staff won't be allowed to go to the reserves to spend time at the ceremonies. At the same time, you have to have the staff who are equally committed.
>
> (Interview, Janes 2008)

At the time of interviewing a new director had been appointed to Glenbow, Jeff Spalding, to lead Glenbow in a new direction, that of Arts Renewal. This

directly threatened the space and resources available to maintain engagement with the Blackfoot community. Conaty found ways to adapt, such as providing Blackfoot cultural awareness programming for social services like the police (Interview, Conaty 2008).

Since conducting the interviews the Ethnology team has undergone many changes, with the Technicians moving on to new jobs, Curator Beth Carter moving to another museum, and Senior Curator and Director of the Indigenous Studies Institute at Glenbow, Gerry Conaty, sadly passing away in the summer of 2013. The extent to which the practices and ethos developed in the original Ethnology team has been embedded and passed on is yet to be seen. As the original team members leave the museum practices may change, and certainly new relationships will have to be built between those individuals and members of the Blackfoot community. As Piikani Elder Jerry Potts notes, a new member of staff would:

> . . . have some pretty big shoes to fill there. All the guys that know what is going on, that have developed this positive relationship with Gerry, none of them are going to go banging on the door to say hey, here is me, here is what I can do, here is what I can offer. None of them will do that. It is a trust friendship, like a bond.
>
> (Interview, Potts 2008)

Kainai Elder Frank Weasel Head said: 'I hope if, when they do leave, that Gerry, Beth and the Blackfoot team have created an environment that future CEOs, or future staff members, can carry on the work that was done' (Interview, Weasel Head 2008). However former CEO Janes had concerns about the extent to which engagement had been institutionalised at Glenbow:

> I wouldn't be optimistic. Although Gerry Conaty, Beth Carter and I attended ceremonies, there was still an organizational vacuum . . . how are you going to build in the continuity and commitment? You would hope that the Board of Governors would be sensible enough to realise that Glenbow's work with First Nations has actually made it internationally renowned.
>
> (Interview, Janes 2008)

In summary Glenbow's engagement with members of the Blackfoot community radically changed the way members of the Ethnology team approached the care and display of their collections. It brought community voice and people into the museum and it gave the museum international recognition. However it did not change the museum as a whole, nor did it institutionalise practice in a way that would guarantee the future of the relationship with the Blackfoot beyond the employment of certain members of

Glenbow's Ethnology staff. The engagement also did little to disrupt the naturalised practices Brady (2009) identified at NMAI. Although it has repatriated sacred items, the museum remains object orientated (Brady 2009:144), with the MOU clearly stating it would: 'balance Blood Tribe access to spiritually sacred materials, cultural objects and relevant data, while respecting the concerns of the Glenbow Museum regarding the care, maintenance and preservation of the Glenbow Museum's collection' (Mookaakin and Glenbow 1998:3–4). Further still, Shell Oil Company supported the co-created *Nitsitapiisinni* gallery by funding admissions for First Nations peoples for two years and a Blackfoot Gallery programmer for three months (Conaty 2003:238), despite the controversy caused by Shell funding the original 1988 *Spirit Sings* exhibition. The *Nitsitapiisinni* gallery is still orientated towards a predominantly non-Blackfoot audience and as an inner-city Calgary museum Glenbow frames Blackfoot community voice within a non-community frame, naturalising the need for the museum, which is in Brady's words perhaps an 'unfortunate compromise' (Brady 147:2009).

BUFFALO NATIONS LUXTON MUSEUM

Following the logic of Arnstein's *Ladder of Participation* (1969), one might expect a community owned museum such as Buffalo Nations Luxton Museum to have integrated 'Indigenous curation' (Kreps 2005:3) into their daily practice and institutional ethos. However, Buffalo Nations Luxton Museum is strikingly unchanged by its transfer in ownership from Glenbow to the Buffalo Nations Cultural Society, despite this occurring over two decades ago in 1992. Four factors can help to account for this: a lack of financial resources; pressure to meet professional standards; visitor expectations and arguably political pressure.

The continuity at Buffalo Nations Luxton Museum since its opening is directly related to the unavailability of funds and resources to make change at the museum. Former Executive Director (1992–2005) and local Canadian Entrepreneur, Pete Brewster, explained that: 'it was operating at a modest surplus from the time it was taken over till, basically till 9/11 and from 9/11 it's been a real problem. It's been a little bit up and down, made a bit of money some years, most years it's been down' (Interview, Brewster 2008). Finances were so restricted that the museum structure itself was beginning to fall into disrepair. 'There are major problems with the roof and leakage and because it was built out of logs, there's some deterioration there that is going to require repair very shortly' (Interview, Bedford 2008).

> The main concern since then has been to try and get the facility in a decent shape and the big problem of course, trying to raise money, that's been the big, big stumbling block from the beginning. A lot of the work that needed to be done never has been done. During the 1990s we'd

spent well over a quarter of a million dollars on work on the building, getting it shored up. But the roof still needs a lot of work and that's been an area of concern for a few years now, a major concern. We do have some leaks in the roof.

(Interview, Brewster 2008)

Because of the condition of the building, the Glenbow actually took back [items] to store in the museum in Calgary, so that certain artifacts could not be ruined. I think it was all out of care for the artifacts that they took several back. But I do know that they are willing to loan again certain artifacts to the Luxton. One of the problems that the Luxton has building-wise too, is the four furnaces, no environmental controls, which can be very problematic for some artifacts. So everybody has to keep up standards and keep a careful watch. And so the Glenbow is wonderful, they come and check out the collection. I believe they come once a year to make sure things are okay. And if there is a problem, for example insects in cloth, they take them back and clean them and bring it back.

(Interview, Bedford 2008)

With the fabric of the museum disintegrating it was little surprise that all efforts were focused upon fund raising. 'In the meantime we have been getting some additional donations, artefacts and things: we've had a fairly large contribution of Stoney material that came in 2006' (Interview, Brewster 2008) but these collections were vulnerable to damage given the condition of the building. At the time of interviewing the global financial crisis threatened the museum's future.

Perhaps surprisingly, the efforts that have been made to change curatorial practice at the museum have been focused on meeting Western museological standards. One of the museum's goals was to get the museum up to Alberta Museums Association standards (AMA:2010) (based on ICOM international standards 2007), to enable them to be officially designated as a museum, which would then give them access to more funding opportunities. However, the board also recognised the need to conduct culturally sensitive conservation as Judy Bedford notes:

[For] First Nations there is no such thing as an artefact. If you make it an artefact it's dead. I mean, simply in First Nations culture it has its own life and so therefore the life, you don't take that away, it can be in air and within their culture there are ways to renew them and restore them and it may very be in certain cases that its brand new, brought in through ceremony. So I think some curators are beginning to understand that there are different ways of conservation.

(Interview, Bedford 2008)

However, despite being community owned, curatorial practice is currently moving towards Western mainstream professional standards to meet funding requirements.

Visitors are a key source of revenue for the museum, whose main audience are international tourists who are drawn to the picturesque mountain town of Banff. They have few community visitors partly as a result of the distance of the museum from any of the First Nation communities (Interview, Starlight 2008). Starlight was working with the Tsuu T'ina Nation to encourage visitation, but notes that many First Nations probably do not know about the museum (Interview, 2008). Thus the museum was, at the time, focusing on meeting its core audience's needs and Starlight was working on providing multi-lingual interpretation, namely in French and German, to meet the needs of their international tourist market (Interview, Starlight 2008). However this work was vulnerable to the power of finances as the museum only had a director and two members of staff who ran the gift shop and did admissions, and Starlight noted at the time of interview 'I'm not too sure whether they can renew my contract' (Starlight Interview 2008).

Buffalo Nations Luxton Museum is a clear example of the power of economic resources, but change is also prevented by visitors' expectations. The museum finds that tourists enjoy the way the museum currently represents Plains peoples as Starlight explains, visitors 'always tell us, this is better than Glenbow, better than the Museum of the American Indian down States' (Interview, Starlight 2008). Nancy Mithlo argues, 'the economic need to garner support from a largely non-native audience often clearly results in a censoring of purpose or a muting of important narratives' (Mithlo 2006).

Members of the Buffalo Nations Cultural Society have begun to think of the museum as an historical artefact in itself and may choose not to change it even if funds became available. As Judy Bedford explains: 'the building in my view is actually a heritage resource that should be preserved' (Interview, Bedford 2008). This different approach can be partially explained by the history of the Buffalo Nations Cultural Society with the museum:

> The background to the Buffalo Nations Cultural Society was a group that really started from the Calgary Stampede Indian Committee and largely as a result of a tour by Walking Buffalo from the Stoneys in 1958. In a period of four months he visited four different continents, talked to over a million people. When he came back he began talking to various members of the Indian Committee about establishing a University of Nature on the banks of the Kananaskis River.
>
> (Interview, Brewster 2008)

Walking Buffalo, also known as Tatanga Mani in Stoney Nakoda, and as George McLean in English, was born in 1871 and 'as a child attended the signing of Treaty 7' in 1877 (Whyte 2011). After Walking Buffalo passed away in 1967 the people he influenced at Stampede 'started talking about

trying to revive the dream of Walking Buffalo and start a facility' (Interview, Brewster 2008). The idea was to develop:

> . . . native villages with all the various tribal groups represented and at first they were talking about local, and then they were talking about the rest of North America and South America and eventually they were talking about Native groups of all the world. But when they started talking to the Alberta Government about getting some land for the facility they were asked to scale things back. So they started talking about how to do something on a local level and, they weren't getting anywhere because they were individuals, they were not representing their tribe as such, so there was no entity with which the government could deal. So they said set up the society so we can deal with you. So that eventually led to the establishment of the Buffalo Nations Cultural Society which was formalised in '89, and then the response from Kananaskis Country was well we can't really deal with you because you don't have any kind of a track record [laughs], as a group.
>
> (Interview, Brewster 2008)

When the Glenbow decided to sell the Luxton Museum the society saw this as an opportunity to establish their track record: 'now, because they still wanted to try and get a cultural park or a University of Nature going they decided that they should set up a separate organisation to run the museum, but they would work in concert. So the museum is owned by the Buffalo Nations Cultural Society, but the Luxton Museum Society was set up to operate the facility' (Interview, Brewster 2008). Since 1992 Buffalo Nations Luxton Museum has been run by the society to establish themselves in order to pursue their goal of developing a Native Village. Thus the institutional ethos at Buffalo Nations Luxton Museum was focused on fund raising to maintain the museum with the goal of developing their future project. In short, the museum was a means to an end, rather than an end in itself.

It is possible that there are also political limitations to change at Buffalo Nations Luxton Museum, as Courtney Mason argues: 'if the Buffalo Nations Luxton Museum directors choose to overtly deconstruct ethnocentric stereotypes of 'Aboriginality', or offer politically charged representations of Aboriginal peoples, for example focusing on land claims or repatriation issues, the museum's directors may risk alienation of local politicians and the business community' in Banff (Mason 2009:366). Alienation could damage the museum's financial potential, and given the limited resources, could be disastrous for the museum.

Thus Buffalo Nations Luxton Museum stands as something of an anomaly on Arnstein's (1969) *Ladder of Participation*, and illustrates the power of practical, institutional and socio-political factors on what is made possible through community engagement. Citizen control can only really be effective when a museum is in a position to act, has resources to support their plans, and most importantly wants to change.

BLACKFOOT CROSSING HISTORICAL PARK

Blackfoot Crossing presents an interesting contrast to the other case studies. As a community developed collection-holding museum, interpretive centre and park rolled into one, it ranks as Citizen Control at the top model on Arnstein's ladder (1969). Blackfoot Crossing has taken a uniquely Siksika approach to heritage management. It has indigenised practice and unsettled residual practices, such as those identified at NMAI by Brady (2009). Blackfoot Crossing has also attempted to limit outside influence on the way they interpret and run the centre. A key factor has been keeping control of the funding as Director Jack Royal explains:

> The uniqueness about BCHP is that we are not governed by any funding agreements or by the government. We are not trying to interpret somebody else's culture. This is our own culture we are talking about. We are taking about ourselves. So we are the experts on ourselves. And we are not constrained by policies of how and when, and terminology, and mediums that you should be using. And all these different things that other institutions, government institutions primarily, are limited by. So to me, that is the message that: yeah you can go anywhere else, but if you want the real story and the real experience come to BCHP.
>
> (Interview, Royal 2008)

Royal is wary of the effect of external demands on the centre and aims to minimise these practical and socio-political influences, to keep control in the community's hands and present the community's view of themselves without pressure to adapt to Western protocol. The feeling that outside influences limit Blackfoot self-representation is also expressed by Piikani Chief Crowshoe, who explained:

> As a First Nations we would say in order to do anything, to show any of our culture we have to fall within this Western mechanism of guidelines. And once you do that you have automatically sold you soul to the devil, you have fallen, maybe what we might say you have recreated culture, so that is not really historical, it is modern. And recreation of culture, I think is, has been a danger all along, when you fall within Western guidelines and principles.
>
> (Interview, Crowshoe 2008)

Despite Blackfoot Crossing's efforts to indigenise and control their centre, they are not immune to the influence of practical and socio-political factors, as they must operate within the wider fields of the museum community and Albertan, and Canadian politics.

From the beginning BCHP took a community approach and developed slowly over three decades of community participation, experiencing periods

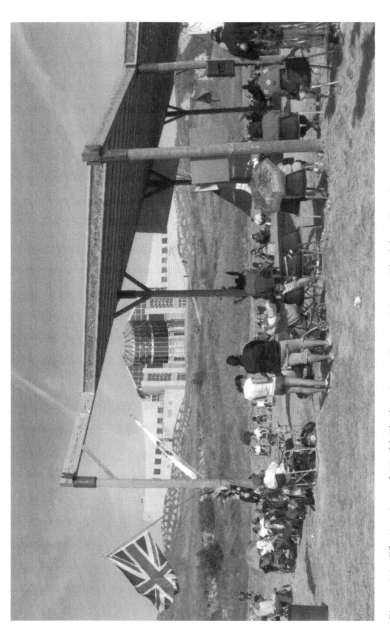

Figure 6.1 The 1st *Annual World Chicken Dance* Competition at Blackfoot Crossing. (Photo by Onciul 2008). Printed with permission of Blackfoot Crossing Historical Park.

of activity and stagnation as priorities shifted and changed on the reserve. Over the course of the development ideas changed about the use of the building. Originally seen as an interpretive centre rather than a museum, the building was not designed with the necessary environmental controls in the gallery space to take care of the artefacts to Western museum standards (Interview, CrowChief 2008). As Bev Wright, VP of Programming and Development explained:

> We were given this building, and they were like 'K: run it. First of all its not really anything, like it's not up to museum standards in terms of the gallery, so we can't really do full museum stuff. The only thing that is environmentally controlled is the storage, so we can get stuff and store it. . . . The archives wasn't environmentally controlled and that whole one side of the archives is windows which is a no-no, right. So we found that we were given this really, really nice building, you know 30 million dollar building, that was impractical for what people wanted to use it for, and so in hindsight, and Jack says this as well, he's like "if we had the project from the beginning we would know like: okay what do we want to use it for? Find out what you want to use it for first, before you build it." Because it had so many heads, there are so many ideas patched into this one building, so, anyway. It is too late for that now, so we've got to figure out a way to run it, which is what we are trying to do right now.
>
> (Interview, Wright 2008)

It is reasonable to ask why Blackfoot Crossing wishes to follow Western museum standards, considering the Blackfoot have maintained their culture and heritage for thousands of years. Why not follow traditional practice alone? The answer can be found in the museum's history and the wider context in which Blackfoot Crossing operates. Before Blackfoot Crossing, Siksika had a museum in the old residential school building, run by Irvine Scalplock and Michelle CrowChief who became Blackfoot Crossing's Curator and Assistant Curator. Both were trained in museology and worked hard to meet museum standards. CrowChief explained how they cared for their objects: 'we had temperature control, like what light wattage and all that stuff, you know the RH factor and all that. We made sure everything was taken care of but it was old, dusty and [laughs], but we tried our hardest to do it as much as we could there' (Interview, CrowChief 2008).

Like Buffalo Nations Luxton Museum, Blackfoot Crossing must meet the Alberta Museums Association requirements to be formally recognised as a museum (AMA 2010). This is important if Blackfoot Crossing wishes to be considered for collection loans and repatriation of Siksika material from other museums. The lack of environmental standards in the main exhibit area is a problem and Blackfoot Crossing was turned down as a venue for the exhibit *Our grandfathers have come to visit: Kaahsinooniksi*

Aotoksisaawooya by the Pitt Rivers Museum, Oxford (Pitt Rivers 2009). Thus, interestingly the apparently naturalised need for a museum on the Siksika Reserve is actually a result of wider professional standards that are required to enable the community to receive repatriated or loaned cultural material. Consequently Blackfoot Crossing has hybridised its curatorial practice, blending Blackfoot protocol with Western standards.

Curatorial practice at Blackfoot Crossing is based on Blackfoot traditions balanced with Western curatorial standards. The Curators at Blackfoot Crossing are Blackfoot Elders, trained in Western museology and Blackfoot traditions. They hold the rights to handle and keep sacred objects and knowledge, granted through their participation in sacred societies. Assistant Curator Michelle CrowChief described her society membership: 'I belong to the Buffalo Women's Society and the Horn Society and I help out with the Sundance. So I have an understanding of what is going on in here' (Interview, CrowChief 2008).

> When we first moved here I was told by our spiritual leaders: 'well maybe you should prepare the place first. Do a ceremony in here.' So we had all the society members come in here and put up a Big Smoke and we did the traditional ceremonies, in order for this place to be, you know, broken into, so that it's able to have those artefacts come here, that is why they have that Elders room. We have our meetings with all societies in there and we have some ceremonies in here too.
>
> (Interview, CrowChief 2008)

CrowChief was able to deal with the sacred items as she explains:

> I'm one of the society members; I have the rights to move them over. You know I went through the proper procedures bringing them here and I knew exactly what I was going to do, but [the Elders] kind of assisted me: 'this should happen, that should happen', you know. So basically I have done exactly what everybody was expecting for the sacred materials to come here, and they are here and this building is alive.
>
> (Interview, CrowChief 2008)

Blackfoot Crossing keeps sacred items in a separate storage area, cared for following traditional protocol.

> They've got their own area: the back room. Only certain people can go back there. There is just me and my co-worker Irvine, the only two that can actually go back there. Not everybody has access. It is only designated for certain people, and when the society members come in, they're able to come in and visit something that nobody else can visit. Yeah, so they are pretty happy.
>
> (Interview, CrowChief 2008)

Photography is not allowed within the gallery and the Curators are conscious of maintaining low noise levels within the museum to avoid disturbing the living sacred beings they house in storage. This responsibility is taken seriously to the extent that they have attempted to restrict visitor numbers to the centre through methods that have caused some upset in the community as Wright explained:

> There are four or five days throughout the year when it's free admission for community members and that was a board decision because they wanted to use the admission as a form of crowd control because otherwise, you know, it would become the next rec. centre or something like that and that's what they didn't want because there is sacred stuff in there, they didn't want people to use it just as a place to go hang out. So that was their position. I think a lot of the community, and again I don't know, I'm not a community member,[2] but I think they're a little put off by the fact that they are charged admission, even though when they do go to admissions they're typically not charged.
>
> (Interview, Wright 2008)

Wright noted that although there was 'kind of a backlash in terms of the admission . . . I think it is starting to calm down now and people just realise that "oh, okay, we can still go"' (Interview, Wright 2008). While respecting the sacred items is vital to Blackfoot Crossing, it is also vital for them to have community support and involvement. Many of the staff expressed the need for the centre to get the community more involved and make sure it is seen and used as a cultural centre not just an economic venture (as discussed in chapter four).

The centre opened in 2007 and I conducted research interviews with staff in 2008, so at the time the centre was still developing its plans and programmes. Nevertheless, it was clear that Blackfoot Crossing was keen to provide a service to their community and had begun to critically consider and unsettle residual practices such as those identified by Brady (2009) at NMAI. Moving away from Western object-fetishisms, they aimed to maintain both tangible and intangible culture. Blackfoot Crossing was built by and for the community and they aim to support and enrich Siksika culture and community. Blackfoot Crossing encourages their community to utilise the collection and archives to access and keep cultural items and information:

> We even have, sort of, our own internal repatriation. We have a lot of our members who come and bring artefacts or items, heirlooms, cultural heirlooms . . . they know it is going to be safe, it is going to be stored and they won't have to worry about it.
>
> (Interview, Royal 2008)

While maintaining the tangible material the Curators support the maintenance and revival of cultural knowledge. Assistant Curator Michelle

CrowChief supports members with research, enabling the community to connect with their past and maintain and practice their culture:

> I take care of the artefacts, I assist you and if you want information on certain things I'll be there to answer your questions and help you out. [If] they want to learn about their family history, their tipi designs . . . phone me up and I'll help you out and I'll research that information and give it to you . . . so they're learning a lot of stuff.
>
> (Interview, CrowChief 2008)

Blackfoot Crossing is actively developing its archives and Colleen Sitting Eagle (at the time of interviewing) was establishing a monthly meeting with Elders to interview them and begin 'oral tradition archiving'.

Whilst maintaining cultural material and knowledge Blackfoot Crossing also supports cultural practice. They host ceremonies and provide a dedicated space for Elders to use within the building. Blackfoot Crossing has invested in reviving Siksika language, 'it is a huge undertaking' explains Royal, 'our language is in a critical stage, just like most First Nations, unfortunately, so we have realized that time is of the essence, so that is why that is one of our priorities, because we need to do it now' (Interview, Royal 2008).

> We have developed a language programme, sort of a Siksika dictionary. We have got a language kit where we have hard copies, and we have developed a CD that you can follow along and teach yourself. We also have these little instruments that they call Phraselators, a handheld device where we have, I think, 600 words and it will translate for you English to Siksika and vice versa. So we are utilising some of that technology. We actually got special permission from the US government to use it to preserve our language. So we are looking at utilising those in some of the classes we are planning. We are hoping to take the programmes and have them installed in your PC, so that people can do it online or at home.
>
> (Interview, Royal 2008)

The Phraselators are also used as interactives within the museum that encourage visitors to listen to Blackfoot words, then record themselves repeating the word and listen to it to encourage the proper pronunciation and use of the local language.

Royal goes on to add that: 'the other thing is we are trying to designate Siksika language days throughout the year where we encourage people to speak nothing but Siksika. And we are developing a pilot project internally that I am going to be using with my staff' (Interview, Royal 2008). Alongside the language they also aim to revitalise the practice of traditional naming:

> There are a lot of our young people that do not have a Siksika name, they have an English name, and that is what they use legally, but traditionally

we were all given Siksika names as children. Sometimes when you were older you were given a new name, an adult name. We are undertaking this initiative where we are going to try to ensure that all members have an Indian name or a Siksika name.

(Interview, Royal 2008)

Blackfoot Crossing is encouraging other traditional practices through their cultural programming and community days. The 22nd September commemorates the day Treaty 7 was signed in 1877 in the valley by Blackfoot Crossing. Blackfoot Crossing Historical Park celebrates it as *Siksika Day* and hosts events for the community admission free. In 2008 Blackfoot Crossing began hosting an *Annual World Chicken Dance* Championship, to bring together First Nations dancers to celebrate the Blackfoot origins of a dance that has become popular across the pan-Indian powwows of North America (see Figure 6.1).

In addition to hosting large community events, Blackfoot Crossing was, at the time of interview, developing cultural programming that will offer community members a chance to perform and learn about traditional skills such as drumming, dancing, singing, traditional cooking, and skills such as tipi building and hide tanning. Visitors to Blackfoot Crossing will also benefit from this intergenerational learning, as Wright explains: 'because that is part of the whole cultural continuity, right. You are going to have an old person teaching a young person how to do it, why not have some tourists involved in that too?' (Interview, Wright 2008).

Blackfoot Crossing also offers community support and development through mentoring programmes, programmes for community groups with disabilities (Interview, Wright and Sitting Eagle 2008), and through education as Director Jack Royal articulates:

We have our resource library here, and that is primarily focused on the Siksika or Blackfoot history. We have schools, our local schools that come through all the time. We are working with the University of Calgary, we are partnering on, right now it is limited to an archaeological dig, but the long term plans are to partner on other areas and we are currently setting that up. And maybe eventually acting as a satellite for the University of Calgary, and eventually becoming our own learning institution.

(Interview, Royal 2008)

Blackfoot Crossing is in a unique position to offer indigenised community programming because it is based within the community on the reserve, i.e. in situ. So although they are limited to the extent to which they can indigenise curatorial practice and still be recognised as a museum, they are successfully indigenising their programming to help sustain their intangible heritage.

Blackfoot Crossing was created for the community, as well as tourists, and by providing for the community it prevents itself from simply being a

commodification of Blackfoot culture for a non-Native audience. For the Siksika community to have their own museum that they control gives status and recognition to their representation of their history and culture. Blackfoot Crossing provides a way for the community to shape how others see them, and control access to Siksika cultural knowledge and material. Darren Pietrobono believes it will benefit the community's view of itself too: 'I think having a building like this will help identify with the people where they come from, with an accurate history that they can explore and analyse. Something tangible is what this place gives, as a reference point for them' (Interview, 2008). As Barbara Kirshenblatt-Gimblett states, 'claims to the past lay the foundation for present and future claims. Having . . . institutions to bolster these claims, is fundamental to the politics of culture' (1998:65).

CONCLUSION

The four case studies illustrate that although each took a different approach to engagement, the amount of change created and level to which the relationship was institutionalised was not only influenced by the power dynamics within the engagement zone, but by practical and cultural factors beyond its control. Greater community empowerment did not necessarily result in greater change or institutionalisation. Despite its problems, Head-Smashed-In institutionalised Blackfoot participation on a greater level than Glenbow or Buffalo Nations Luxton Museum. However, Glenbow's Ethnology team incorporated Blackfoot ways of working more effectively than either Head-Smashed-In or Buffalo Nations Luxton Museum. Buffalo Nations Luxton Museum indicated that without sufficient resources the apparent level of community control is near to meaningless. And Blackfoot Crossing illustrated that even citizen control (Arnstein 1969) does not result in total community control, because the museum has to function within the limits of time and money, and within the context of the heritage and museum profession, the socio-politics of their location and to some extent meet the needs and expectations of their visitors and stakeholders. In short, they must operate within the context and power relations of their time. Thus, currently restrictions remain in place that dictate how far a museum can indigenise without stepping outside the professional community of practice.

These limitations help account for some of the reasons why engagement theory models are not always reflected in practice and why community members often still have gripes with museums even after apparently successful engagement. Michael Ames notes that 'because museums as we know them are essentially white European inventions designed to serve the interests of mainstream or non-Aboriginal segments of society . . . the value of that environment is not self-evident to most First Peoples, nor is the museum's internal organizational culture entirely compatible with Aboriginal sentiments' (2000:77). Changing museums as we know them is a goal of engagement and

although not always successful, each engagement brings about new practices and ideas that begin the process of greater change. As McMullen expresses: 'as anthropology has become post-colonial, so have many museum endeavours, but museums' often ponderous institutional infrastructures have been slower to change than individual researchers' (McMullen 2008:54).

> Institutional culture [is] . . . not something to be revolutionized over a short-time period; any fundamental change will likely be much more incremental, implicitly consensual, and sporadic, rather than directed. Fundamental to this is the recognition that in most cases core values will change only very slowly over extended periods of time.
>
> (Harrison 2005:198)

Perhaps with time and the process of learning from participating in engagement, these contexts will allow for greater indigenisation of practice than is currently possible, or perhaps new ways of thinking and working will emerge. For the moment, engagement practices could benefit from more open and honest acknowledgements of the very real restrictions placed on participation that limit what can be made possible through engagement. Knowing the boundaries of engagement will help museums and communities find ways to go beyond them with greater success.

NOTES

1. Blackfoot people use smudging, (the burning of sweet grass, sage, tobacco or sweet pine) to spiritually cleanse people and objects.
2. Beverly Wright, Vice President of Programming and Development, is Cree and at the time of interview was the only non-Blackfoot member of staff at Blackfoot Crossing Historical Park.

REFERENCES

Alberta Museums Association (AMA), 2010. *Recognized Museum Program.* [Online] AMA. Available at: http://www.museums.ab.ca/what-we-do/recognized-museum-program.aspx

Ames, M.M., 2000. Are changing representations of First Peoples challenging the curatorial prerogative? In W.R. West, ed. *The Changing Presentation of the American Indian: Museums and Native Cultures.* Washington: Smithsonian Institution, pp. 73–88.

Arnstein, S.R., 1969. A ladder of citizen participation. *JAIP*, 35(4) pp. 216–224.

Bedford, Judy. 26 Sept 2008. Interview. University of Calgary.

Blood, N. 12 Sept 2007. Interview. Calgary.

Bolton, L., 2003. The object in view: Aborigines, Melanesians, and museums. In L. Peers and A.K. Brown, eds. *Museums and Source Communities. A Routledge Reader.* London: Routledge, pp. 42–54.

Brady, M.J., 2009. A dialogic response to the problematized past: The National Museum of the American Indian. In S. Sleeper-Smith, ed. *Contesting Knowledge: Museums and Indigenous Perspective.* London: University of Nebraska Press, pp. 133–155.

Branche, W., 1996. Indigenes in charge: are museums ready? In J. Davis, M. Segger and L. Irvine, eds. *Curatorship: Indigenous Perspectives in Post-Colonial Societies. Proceedings.* Hull and Calgary: Canadian Museum of Civilization with the Commonwealth Association of Museums and the University of Victoria, pp. 119–131.

Brewster, Pete. 14 Oct 2008. Interview. Canmore.

Brink, Jack. 26 Sept 2008. Interview. Calgary.

Carter, Beth. 28 Aug 2008. Interview. Glenbow.

Conaty, G.T., 2008. The effects of repatriation on the relationship between the Glenbow Museum and the Blackfoot people. *Museum Management and Curatorship*, 23(3) pp. 245–259.

Conaty, G.T., 2003. Glenbow's Blackfoot Gallery: Working towards co-existence. In L. Peers and A.K. Brown, ed. *Museums and Source Communities: A Routledge Reader.* London: Routledge, pp. 227–241.

CrowChief, Michelle. 2 Sept 2008. Interview. BCHP.

Crowshoe, Reg. 19 Aug 2008. Interview. Calgary.

Flynn, G.A., 2001. *Merging Traditional Indigenous Curation Methods with Modern Museum Standards of Care.* [Online]. Edited by D. Hull-Walski. Paper submitted for Marie Malaro Award Competition Museum Studies Program, The George Washington University March 29, 2001. Available at: https://www.research gate.net/publication/249427121_Merging_Traditional_Indigenous_Curation_ Methods_with_Modern_Museum_Standards_of_Care

Harrison, J., 2005. Shaping collaboration: considering institutional culture. *Museum Management and Curatorship*, 20(3) pp. 195–212.

Janes, Robert (Bob). 14 Oct 2008. Interview. Canmore.

Kirshenblatt-Gimblett, B., 1998. *Destination Culture: Tourism, Museums, and Heritage.* London: University of California Press.

Knowlton, Stan. 16 Sept 2008. Interview. HSIBJ.

Kreps, C., 2005. Indigenous curation as intangible cultural heritage: Thoughts on the relevance of the 2003 UNESCO Convention. *Theorising Cultural Heritage*, 1(2) pp. 1–8.

Mason, C.W., 2009. The Buffalo Nations/Luxton Museum: tourism, regional forces and problematising cultural representations of Aboriginal Peoples in Banff, Canada. *International Journal of Heritage Studies*, 15(4) pp. 355–373.

McMullen, A., 2008. The currency of consultation and collaboration. *Museum Anthropology Review*, 2(2) pp. 54–87.

Mithlo, N.M., 2006. *American Indians and museums: the love/hate relationship at thirty. In Museums and Native Knowledges.* [Online] Arizona State University. Available at: http://nancymariemithlo.com/American_Indians_and_Museums

Mookaakin Cultural and Heritage Society and Glenbow-Alberta Institute, 6 March 1998. *Memorandum of Understanding.* [Unpublished] Calgary: Glenbow Museum.

Peers L. and A.K. Brown, eds., 2003. *Museums and Source Communities: A Routledge Reader.* London: Routledge.

Pietrobono, Darren. 16 Oct 2008. Interview. BCHP.

Pitt Rivers Museum, 2009. *Pitt Rivers Museum Historic Blackfoot shirts to visit Canada.* [Press Release][Online] Pitt Rivers Museum. Available at: http://www. prm.ox.ac.uk/pdf/PRMBlackfootShirtsPressRelease.pdf

Potts, Jerry, 2008. Interview (10 Oct 2008). Fort Macleod.

Raghavan, M. et al. 2014. 'The genetic prehistory of the New World Arctic'. *Science* 29 August 2014. 345:6200 pp.1020–1029. [Online] Available at: http://www. sciencemag.org/content/345/6200/1255832.full.pdf

Rasmussen, M. et al., 2013. The genome of a Late Pleistocene human from a Clovis burial site in western Montana. *Nature*, 506 pp. 225–229. [Online] Available at: http://www.nature.com/nature/journal/v506/n7487/full/nature13025.html

Royal, Jack. 25 Aug 2008. Interview. BCHP.

Site Manager. 24 July 2006. Interview. HSIBJ.

Starlight, Anthony (Tony). 17 Oct 2008. Interview. Calgary.

Todd, L.S., 2003. *Repatriation and the Blackfoot people. Excerpts from Kainayssini Imanistaisiwa: The People Go On.* [Film] [Online]. Available at: http://wn.com/ Museums_and_the_Blackfoot_People

Weasel Head, Frank. 13 Nov 2008. Interview. Calgary.

Whyte Museum, 2011. *Chief Walking Buffalo.* [Online] Whyte Museum Blog. 21st May 2011. Available at: http://whytemuseum.blogspot.com/2011/05/chief-walk ing-buffalo.html

Wright, Beverly (Bev). 4 Sept 2008. Interview. Calgary.

7 Decolonising Representation[1]

The stories of the continent must be told. A vacuum is impossible, and humans demand an explanation. So far, the only one that exists is the Big Movie [grand narrative]. It says with perfect consistency that we are extinct, we were never here anyway, that it is our fault because we couldn't get with the program. It says we are noble, are savage, and noble savages. There's another narrative waiting to be written.

(Smith 2009:52)

The issue seems not really to be one of representation and whether, or how, the addition of multiple voices reduces bias . . . The issue, instead, is really one of authority and control.

(Kahn 2000:72)

At the case studies, Blackfoot engagement enabled community members to present their perspectives, challenge misinformation and present hidden histories within the museums. One of the key ways this dialogue was made tangible and public was through the creation of exhibits. This chapter considers the extent to which Blackfoot culture is strategically represented (Spivak 1990), the limits of what can be said and heard within exhibits and how these messages are communicated on different levels through different forms, including via the fabric of the museum itself.

Blackfoot self-representation at the case studies is complex and the exhibits are layered with meaning, aimed to achieve multiple goals. Nevertheless, the ability for Blackfoot voice[2] to be heard within the museum is limited by the audience's ability to understand what is said. When presenting to non-community members, Blackfoot self-representations have to negotiate with colonial constructs that remain in the public imagination about who 'Others' are. Even within community settings self-representation must navigate colonial stereotypes, imbued through assimilation policies, Hollywood and popular culture that still have some influence over identity and historical consciousness. In this sense exhibits, or at least elements of them, can be seen as autoethnographic responses to dominant societal representations (Pratt 1991:35; Boast 2011; see chapter three).

By reframing Blackfoot identity and challenging colonial narratives the Blackfoot aim to decolonise the way they are viewed. This chapter considers the decolonizing potential of 'truth telling' (a term first used by Wilson and Yellow Bird 2005:7, and applied to museums by Lonetree 2009) and analyses the extent to which difficult colonial history is explicitly addressed in the exhibits. The chapter also takes into account the challenges of discussing sensitive memories and the notion of 'on stage and off stage' (Shryock 2004) sharing.

How much to share was a key issue for Elders, who chose to withhold some information on the grounds that exhibits were not the right place to present them. Four reasons help to account for this and will be addressed in this chapter. Firstly, sacred information is not for public dissemination according to Blackfoot cultural protocol. Secondly, the Elders wanted to improve non-Blackfoot understanding and recognition of Blackfoot culture by attracting and engaging Canadian and international audiences. This influenced how the trauma and devastation of colonisation was recounted in the exhibits, taking into consideration a perceived potential to repel or disengage visitors if displays evoked overwhelming feelings of guilt or responsibility. Thirdly, the Elders wanted to present a public Blackfoot identity their youth could be proud of, to support positive self-identification and the continuation of cultural practices. Finally, traumatic topics such as the residential school era hold very sensitive personal memories that can be hard to share and not necessarily suitable for permanent public display in museum exhibits.

The chapter argues that the exhibits employ, what Mary Lawlor terms 'displayed withholding' (2006:5) to share limited aspects of sensitive and sacred culture, whilst emphasising that there is more to the story than what is being presented. The chapter explores how 'displayed withholding' enables layers of meaning to be presented to 'select witnesses' (Lawlor 2006:5) within the exhibits.

STRATEGIC ESSENTIALISM ON THE PUBLIC STAGE

Representation tends to essentialise to simplify a vast array of information into a manageable and legible group of key elements. Essentialising can be a strategic and political act to achieve a specific goal, or a by-product of the logistical inability to tell the 'whole story'. Spivak introduced the idea of strategic essentialism and argued that 'it is not possible to be non-essentialist . . . the subject is always centred' (1990:109).

> . . . since it is not possible not to be an essentialist, one can self-consciously use this irreducible moment of essentialism as part of one's strategy. This can be used as part of a "good" strategy as well as a "bad" strategy and this can be used self-consciously as well as unself-consciously . . . no *Vertretung*, representation—can take place without essentialism.
>
> (1990:109)

If essentialism is a given, then it can be useful to use it consciously and strategically to achieve certain goals. It can be a useful tool for groups who are marginalised to gain an entry point into dominant discourse, as one united voice is stronger and louder than many disparate voices. For example, Indigenous groups often initially fight for the right to have their side of colonial history heard. Once they have secured a united voice, other subgroups within that society may voice alternative histories within that larger narrative, such as gender specific experiences or the experiences of minorities within that group. Essentialism is closely linked to authenticity. While considering the notion of authenticity and how it can be conceptualised as a relational and subjective notion, James Clifford notes that 'if authenticity is relational, there can be no essence except as a political, cultural invention, a local tactic' (1988:12). When a group essentialises its identity, even for tactical reasons, it risks drawing boundaries around authenticity that exclude people within its own community. The greatest threat essentialisation poses is to fossilise a living culture into a static position and prevent normal cultural development and change.

Even if communities are not actively using essentialism as a tactic (Spivak 1990), by selecting aspects of their identity for museum display they demarcate the elements they view as essential and freeze them in static form in an exhibit. Thus communities face difficult decisions when considering how to represent themselves, as the selections they make may end up defining who they are and who they can be. Representing living heritage in a coherent way within a static setting is not easy. Susan Ashley argues that 'the fluidity of the substantial sphere of participation, interaction and contestation is essential to respond to and overcome that fixation' (2007:492).

Although each of the case studies presents different aspects of Blackfoot culture in different ways, there are similarities in the messages they convey. Within Head-Smashed-In's new exhibit, Glenbow's *Nitsitapiisinni*, and Blackfoot Crossing's gallery, a common message can be heard: We were here before the Europeans from time immemorial, we survived colonisation, our culture is revitalizing and we are still very much alive and culturally distinct from mainstream Canadians. It is a political message of differentiation to outsiders and an empowering message of pride and strength to community members.

In Mary Lawlor's research, she highlights that: 'in the processes of displaying tribal experiences and identities in terms of distinct, unassimilated cultures, tribal public institutions often resort to modes of thought and expression that would be somewhat disparagingly termed "essentialist" in Western academic discourse' (2006:4). However, Lawlor argues that:

> Essentialism lends cultural stability where instability threatens and demarcates a place for the community at issue to stand, so to speak, in the process of negotiating with more powerful others. The presence of essentialist cultural claims in tourist venues where non-Native audiences meet the tribe can also function, somewhat paradoxically perhaps,

to attract consumerist desire to the exotic and to the distinctly 'other.' Such attraction can work to the economic advantage of the tribe and, together with the expressions of distinct cultural heritage, can also have the effect of furthering social recognition and respect in the broader public sphere beyond the reservation.

(Lawlor 2006:4)

At the case studies essentialism was a tool that Elders consciously used to demarcate Blackfoot culture. The aim was not to prohibit the continual and vital process of cultural change but to protect cultural distinctiveness from forced assimilation or appropriation. It marks their history as their own, and places them as both keepers and owners of the 'true' and 'authentic' knowledge and cultural practices. At Blackfoot Crossing Director Jack Royal emphasises this point in his statement:

If there is a single message, I think it is that [visitors] are getting true history from our perspective, through our eyes, through our language, through our own terms, our own definitions, our own experience. And not only that, that it is unique because it is living history and you are actually getting not only the true perspective, but also the living perspective of the history by the people that were involved, at the place where it happened, and the events that took place, that are still going.

(Interview, Royal 2008)

The Elders on the Glenbow *Nitsitapiisinni* team discussed ideas of essentialism and constructivism when considering what tradition is. Kainai Elder Frank Weasel Head is recorded as saying:

What is tradition? Traditions change according to the times. 150 years ago, we had to wear buckskin. Now our traditions are a cowboy hat (his dad was never without one), shirts, jeans, sunglasses, and home-made tweezers to pull hairs off chin to stay awake at the Big Smoke [ceremony]. What is tradition? Being a Blood Indian comes from the heart as to who you are.

(Glenbow 1998:4)

This quote highlights the validity of cultural adaptation whilst essentialising and internalising Blackfoot identity as something that 'comes from the heart'. At the second Blackfoot Gallery meeting Elder Pat Provost emphasised that 'it's not about how we have changed, but how we have survived' (Glenbow 1999a:3).

Cultural distinctiveness is a political and legal necessity for Blackfoot cultural survival in modern Canada, because colonial era laws, such as the *Indian Act* and Treaty 7, remain active and control rights based on race and cultural distinctiveness. Blackfoot identity comes under racial legislation.

Tom King, referring to the *Indian Act* prior to the C-3 amendment (see chapter two), noted that although:

> . . . the French in Quebec . . . occupy much the same position in Canada as Native people do there has been no legislative effort to distinguish between French and non-French. No French Act . . . the French can go on creating more French no matter whom they marry. All they have to do is maintain their language and culture, and they will never lose status, while Indians can disappear even with their languages and cultures intact.
>
> (King 2003:149)

The institutionalisation of 'racial status' requires First Nations to use binary definitions of 'us and them' to maintain their rights and to begin to reclaim power. Yet this is a delicate business as Lawlor warns:

> The problem arises with the binary relations on which essentialism rests: a view of the world as constituted by us and them . . . This method of self-identification centres on positioning oneself in opposition to others is, of course, the seed of much that is most dangerous in the present global scene.
>
> (2006:13)

Nevertheless, this seems to be the current situation in North America, where rights are defined by race and presenting an essentialised, united front to Indigenous culture is vital to current and future claims. As Kirshenblatt-Gimblett highlights:

> Claims to the past lay the foundation for present and future claims. Having a past, a history, a 'folklore' of your own, and institutions to bolster these claims, is fundamental to the politics of culture: the possession of a national folklore, particularly as legitimated by a national museum and troupe, is cited as a mark of being civilized.
>
> (1998:65)

Evidence for her claim can be seen in Sandra Crazybull's description of the Blackfoot exhibit at Glenbow: 'it is a personal story, it isn't a scholarly story, it is our story *and it is in a museum*' (Interview, Crazybull 2008, my emphasis). Her comment 'and it is in a museum' highlights the power of legitimisation museums can provide. Similarly, Brian Daniels' analysis of tribal attempts to gain Federal recognition through cultural self-representation in the Klamath River region, California, emphasises the political, legal and social value of publically presenting an essentialised cultural identity.

> Culture, as set out by these legal criteria, becomes the practical means for advancing political claims about citizenship and its entitlement rights in the multicultural democracy of the United States.
>
> (Daniels 2009:294–295)

The heritage institutions he researched appeared to be 'engaged in incipient ethnonationalism. By seeking to transform their communities into what they want them to be, these tribes specify the boundaries of their polity, the content of their own cultures, and the grounds of their future sovereignty claims' (Daniels 2009:299).

> What became apparent to the tribes throughout the Klamath River area was the political power of cultural documentation. Culture could define communities; it could provide a legal framework for protecting sacred lands; it could offer a justification for the persevering and organizing politics . . . The rise of tribal museums, libraries, and archives in the Klamath River is linked to the needs of the tribal communities to create and to control outward representations of their culture.
>
> (Daniels 2009:288)

Heritage institutions such as museums were used as places to publically show culture as 'pronounced, fixed and visible' and helped to demonstrate 'continued existence', one of the criteria for federal recognition (Daniels 2009:290,294). As Daniels explains:

> The homogenous narratives required by nation-states are upended by indigenous heritage institutions that use the same means of collection and documentation as their nationalist predecessors. In this way, the nationalist enterprise is being complicated by the very ways that were originally devised to sustain it.
>
> (Daniels 2009:301)

In the Blackfoot community Mrs. Margret Bad Boy, a Siksika Elder, is recognised as having been an 'invaluable resources in Siksika land claims research' as a result of her knowledge of Blackfoot traditions and history gained through her membership in many sacred societies (Blackfoot Gallery Committee 2001:22).

Strategically essentialised representation (Spivak 1990) in public museum exhibits can not only promote legal causes, such as land claims, but also unite fractured groups. The Elders who worked on the *Nitsitapiisinni* Gallery at Glenbow discussed the importance of unity (recorded in note form):

- Language and beliefs are the same with some differences. If differences in stories exist then we should revise stories with everyone's input. Don't want separation in points of view.
- Government ploys to split the Blackfoot peoples.
- If there are differences then we should just present one story based on Elders.
- . . . Blood, Siksika, and Peigan have differences in dialect, etc. But we don't argue—we bring it together (Glenbow 1999b:6).

Presenting a united story was, for the Elders, both a strategy and a Blackfoot cultural approach base on the importance of consensus. At Glenbow issues and differences were debated amongst the Elders, often in Blackfoot. This emphasises the importance of inter-cultural engagement zone work discussed in chapter three. By speaking in Blackfoot the Elders excluded non-Blackfoot team members until consensus was reached, and presented a single narrative rather than a multi-vocality of competing community perspectives. A similar strategy was noted by Jennifer Shannon in her analysis of the National Museum of the American Indian, where 'through the process of community curating, Native voice was produced by committee and resulted in a unified, authoritative voice in each exhibit' (2009:233). Interestingly this means that rather than a 'shift from monologue to dialogue' as Bennett (1998:211) describes Clifford's (1997) 'contact zones', engagement can actually result in the presentation of a different kind of monologue, formed through consensus.

Presenting strategically essentialised self-representation formed through consensus is important to the community because it creates a place from which to speak (Spivak 1990). It establishes Blackfoot as an official culture in the national narrative and creates a secure platform from which other Blackfoot stories can be told. As Hall states 'the margins could not speak up without first grounding themselves somewhere' (1997a:185). This is particularly important for Blackfoot communities that were divided by colonisation, missionaries and the residential school system. However Hall highlights that essentialism holds risks:

> Do those on the margins have to be trapped in the place from which they began to speak? Will the identities on the margins become another exclusive set of local identities? My answer to that is probably, but not necessarily so.
>
> (Hall 1997a:185)

It is possible for essentialism to be conscientiously used as a temporary strategy to achieve specific goals. It is possible and probable that once the Blackfoot gain equal power and rights in Canadian society and their culture and history is protected and respected, sub-narratives of Blackfoot culture may come forth and disrupt the strategically essentialised identity. This has begun to happen in the temporary exhibition spaces in Blackfoot Crossing and Glenbow, such as Glenbow's Community Gallery exhibit *Situation Rez: Kainai Students Take Action with Art* (December 1, 2007 to December 2008) which discussed the difficult topic of AIDS on the reserve and the history of introduced diseases. These more daring and diverse presentations open up dialogue on Blackfoot identity, presenting sub-narratives alongside the more essentialised permanent displays.

TELLING 'HARD TRUTHS' AND DECOLONISATION

The ability of exhibits to influence public perception makes them powerful tools for societal change (Mazel and Ritchie 1994:226). In Krmpotich and Anderson's description of Glenbow's *Nitsitapiisinni* gallery they note:

> The testimonies from community team members assert that self-representation and self-determination are more than concepts to be thought about intellectually. *Nitsitapiisinni* activates these concepts by inviting the Blackfoot to record their history, to teach their own youth, to improve relations between Blackfoot and non-Blackfoot, and to *emphasize their right to live as a distinct culture.*
>
> (2005:399 my emphasis)

Battiste and Henderson argue that 'reclaiming and revitalizing Indigenous heritage and knowledge is a vital part of any process of decolonisation, as is reclaiming land, language, and nationhood' (2000:13). However, how to decolonise representation remains a topic of debate.

Waziyatawin Wilson argues that there is a need for public recognition and acknowledgement of the wrongs done to Indigenous peoples through colonisation to enable decolonisation. She states that 'the colonizers must also take responsibility for and own the injustices that they have helped directly or indirectly perpetrate' (Wilson 2005:193). She highlights the 2001 *Truth Commission into Genocide in Canada* which released a report entitled *Hidden from History: The Canadian Holocaust*, 'which documents the crimes perpetrated against the Indigenous Peoples of Canada, such as murder, torture, and forced sterilization' (Wilson 2005:200). Wilson argues that public recognition is acutely needed given the current status of colonial amnesia and denial:

> While policies of genocide, ethnic cleansing, and ethnocide have been perpetrated against us and our lands, and resources have been threatened decade after decade, century after century, not only are we taught that we are to blame, we are taught that we should just get over it.
>
> (2005:190)

To right past wrongs and end the ongoing victimisation of Indigenous peoples, she argues that 'the truths of these experiences need to be publically disclosed, the carriers of this suffering need a validating and supportive forum in which to tell their stories' (Wilson 2005:191).While Wilson proposes that truth commissions could act as such forums, Amy Lonetree recommends that museums should contribute to this process:

> As we look to the future, I believe it is critical that museums support Indigenous communities in our efforts towards decolonization, through

privileging Indigenous voice and perspective, through challenging stereotypical representations of Native people that were produced in the past, and by serving as educational forums for our own communities and the general public. Furthermore, the hard truths of our history need to be conveyed, both for the good of our communities and the general public, to a nation that has wilfully sought to silence our versions of the past. We need to tell these hard truths of colonization—explicitly and specifically—in our twenty-first-century museums.

(2009:334)

She terms this a 'truth telling and healing process' (Lonetree 2009:334). However, Miranda Brady notes that decolonising national narratives is not straight forward. Drawing on *The Way of the People: National Museum of the American Indian EMP, Progress Report Executive Summary*, she argues that the desired audience influenced how difficult histories were addressed at the National Museum of the American Indian (NMAI).

The NMAI's planning documents indicate that, while the museum will be serving Native people indirectly as 'constituents,' the vast majority of the 'audience' for the Mall Museum will be non-Native. Several scholars have expressed concern about the abstract treatment of polemical issues within the NMAI, like genocide and repatriation; and its planning documents indicate that NMAI was well aware of its audience when determining the 'tone' of the museum.

(Brady 2009:136–137)

This raises questions as to who museums are for and how they should deal with different audiences. Each case study had to navigate these contentious topics with their stakeholders, the community participants, staff, funding bodies and audience. At Glenbow, Head-Smashed-In and Blackfoot Crossing the debate circled about what to display and how much should be shared. I will analyse three key areas of difficult history addressed in the exhibits: 1. colonisation; 2. stereotyping; and 3. the residential school era.

REPRESENTING COLONIALISM

Colonisation and its aftermath marked a dramatic change in Blackfoot life. The signing of Treaty 7 just 137 years ago is within recent living memory for Blackfoot peoples. Whilst extremely significant, it is a recent event in the long history of the Blackfoot peoples. Each of the case studies discuss colonisation to varying extents within the exhibits, the exception being Buffalo Nations Luxton Museum where the exhibits have not been significantly redeveloped since the 1950s. Interestingly, despite avoiding discussion of colonialism, Jackson Wesley, who ran the gift shop and ticket sales

at Buffalo Nations Luxton Museum, recalled: 'some white people, especially the older ones, they come out to me and they hug me and they say "I'm so sorry" and they kind of apologise . . . I told them it's in the past; look ahead' (Interview, Wesley 2008). In Wesley's account, visitors could see the impact of colonisation simply by comparing the historic exhibits to their knowledge of current First Nations, however the lack of direct discussion or representation of modern First Nations life means that visitors have to work on prior knowledge, and do not hear the community's perspective.

At Head-Smashed-In the discussion of colonisation mainly focuses on the direct affect it had on the buffalo and the buffalo jump. The exhibit on the fourth level (see Figure 7.1) entitled *Cultures in Contact* focuses upon the colonial greed for buffalo hides and sports hunting that 'recklessly wasted the buffalo' leaving carcasses to rot on the plains (Head-Smashed-In text panel 2008). Within two years of signing Treaty 7 'the buffalo had been all but eradicated from Canada' (Head-Smashed-In text panel 2008). It is worth noting that the exhibit tells a 'hard truth' about contact and colonialism that is often skimmed over. In comparison, the Glenbow *Nitsitapiisinni* Gallery states that 'by 1879, the buffalo had disappeared' (Glenbow text panel 'The End of the Buffalo Days' 2008). The simplicity of the Glenbow statement hides the cause of the effect, removing responsibility for the action.

While the gallery at Head-Smashed-In tells a 'hard truth' about the impact of colonialism on the buffalo, it only briefly considers the social and cultural

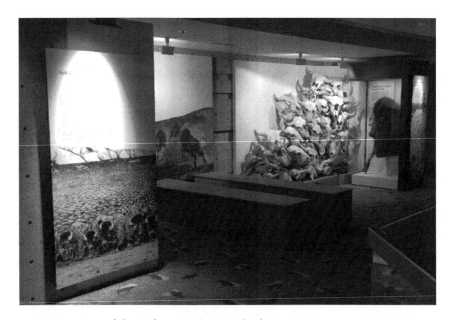

Figure 7.1 Part of the *Cultures in Contact* display.
Courtesy of Head-Smashed-In Buffalo Jump World Heritage Site.

impact of colonisation on the Blackfoot people. This vast and difficult topic is only hinted at by a display on trade goods and a small case displaying a copy of the Treaty. Aside from the live interpretation by Blackfoot guides, the only account of the devastation is a winter count that recorded each year from 1764 to 1879 with a pictograph, some of these symbols represent events such as smallpox epidemics and starvation, but only a few are interpreted for non-Blackfoot visitors (Figure 7.2).

Following the chronological order of the gallery, one would expect the final floor exhibits to focus on Blackfoot life after contact, but instead the main exhibit focuses on the archaeological process of excavating the site and 'uncovering' the buffalo jump. This leap to modern day science gives the impression that the Blackfoot people, or at least their culture, died with the buffalo and needs to be dug up to be known. The only striking evidence to the contrary is the presence of Blackfoot guides. The Blackfoot staff found that this absence in the historic record at the interpretive centre resulted in tourists asking questions to try to fill in the gap.

> So our job here as interpreters is to get it across to the visitors what our lives were all about in the past, right up to the present time. Some people still assume we live in tipis, some assume that we have uneducated people that live in communities here. But you have to carry across that you can actually live two worlds, myself, I was raised very traditionally, but

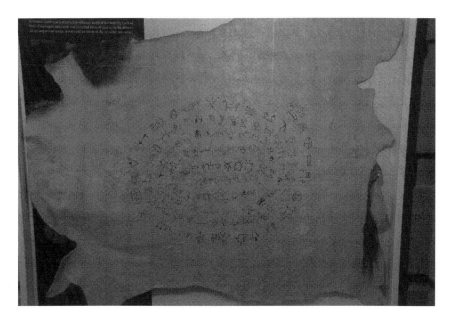

Figure 7.2 Winter Count.
Courtesy of Head-Smashed-In Buffalo Jump World Heritage Site.

I come here to work and I come out of those traditional ways in some way, but my spirituality is always with me.

(Interview, Good Striker 2006)

To alleviate this situation a display was added to the exhibit in 2007 to address current Blackfoot life and answer some of the basic visitor questions. The small exhibit informs visitors that the Blackfoot people still live on the reserves nearby and maintain their culture, but it does not address the sensitive and controversial subjects of the colonial and postcolonial period. When questioned on this the Site Manager, Regional Manager and Archaeologist Jack Brink all said that the interpretive centre was not the place to discuss politics. Yet, by not discussing these issues they were making a strong political statement; one which could account for some of the turbulent relations between Head-Smashed-In and the local Blackfoot community.

What is particularly interesting, and perhaps most surprising, is that some of the Blackfoot Elders who worked with Glenbow and Blackfoot Crossing appeared to share Head-Smashed-In managements' belief that museums are not the place for politics. Clifford Crane Bear recalls that many aspects of the colonial period were not addressed in these exhibits.

We didn't really talk much about the starving years; we didn't talk really much about the politics of that. We talked a little bit about the small-pox: the second one killed two thirds of our people; the first one almost killed us off; the third one, around 1869 that's when we almost died off. 1880s when the buffalo disappear and we came in here [Siksika Reserve], 750 of us from 10,000. We are up to 6,000 now, but tell me if there are any more true-blood Blackfoots? I doubt it. Well our Elders said that we weren't there to talk about politics. We will explain it just a little. There are other places for that. We don't want to be always saying to the Euro-Canadian every time they come in, take their noses and rub it in them and saying this is what you did to us. Maybe not you, but your ancestors did this to us. No, there are other places for that. If you want to hear about that then I will talk about that, I will talk about the starving years, I will talk about the people that lived here, how they lived, how they died, the discrimination and the residential school, how they beat us. All that I can talk about, but like I said there is a place and time for that.

(Interview, Crane Bear 2008)

The power behind Crane Bear's words when he hinted at the 'hard truths' that could be told show their enduring potency, the anger and hurt that remains within the community and the individuals who have endured these historical wrongs and their ongoing legacy, traumas that remain largely unaddressed.

The reasoning behind these omissions is highlighted by Glenbow Curator, Beth Carter, who explained the Elder's decision not to focus on the period of colonisation in the *Nitsitapiisinni* Gallery.

In terms of the sensitive issues that are historical, they wanted to very clearly show those as only a blip in time, in their 10,000 years history. So really in the last 100 years they've had a lot of problems, but they have been around for 10,000 years, so it is really only that tiny bit at the end. They wanted people to understand the beauty and the depth and the greater significance of Blackfoot culture and not just focus on the historical controversies. They did want to celebrate the really good things about Blackfoot culture. You have to remember that the Blackfoot team members came to Glenbow and worked with us specifically to speak to their own youth. [That] was the reason they were willing to work with us.

(Interview, Carter 2008)

Blackfoot Gallery Committee members told me in interviews that there was a desire to avoid reinforcing negative stereotypes, and instead present Blackfoot identity as something young Blackfoot people could feel proud of. Building pride is a key to decolonisation and overcoming feelings of shame that colonial policies, missionaries, and residential schools tried to make Indigenous people feel about their cultural heritage and religions. In the early discussions about the *Nitsitapiisinni* Gallery the meeting notes show that there was discussion about the importance of representing the 'negative era' and how much to share:

FRANK: It's hard to leave out the bad times such as residential schools.
PAT: We don't want to focus too much on the negative era. Look at the past and the present. Look at the positive side—how did we survive through that era? The young people need to look at the positive—the positive energy that brought us through that era.

(Glenbow 1999a:3).

These quotes from the Curator and community members at Glenbow illustrate that they did not want to 'tell these hard truths of colonization—explicitly and specifically' like Lonetree recommends (2009:334). Not because they wanted to hide them or because they doubted the importance of making this difficult history known, but because they wanted to create something that would build community pride. Lonetree recognises the difficulty of performing 'truth telling' stating:

I greatly respect [a community's] willingness to speak of what we as Indigenous people know but are somewhat reluctant to talk about within a museum context. All too often our concern of coming across as if we are subscribing to the language of victimization, or perhaps the more

legitimate concern that this information could potentially reinforce stereotypes, prevents us from speaking the hard truths about our present social problems and connecting those issues to the colonization process.

(2009:332)

Glenbow presents the trauma and legacy of colonial history in limited ways, to make it known but not the focus of the exhibit. As Alison Brown notes, in the *Nitsitapiisinni* Gallery:

Efforts have been made to avoid dwelling on the bleaker experiences of this time period, though by no means are they glossed over; direct quotations from community team members which criticize colonial policies of assimilation and their legacies are sharp reminders of the human costs involved. Instead, the focus in these sections is geared towards the strategies Blackfoot people have developed to maintain and assert their cultural identity in spite of oppression.

(Brown 2002:72)

While the focus on 'hard truths' in the textual interpretation may be limited, Glenbow's *Nitsitapiisinni* gallery does attempt to convey a sense of the emotional and physiological impact of colonisation through the gallery experience. As the visitor moves from the sunny open plains area interpreting traditional life toward the contact period the exhibit begins to narrow and darken creating a sense of unease. As the interpretation moves from trade to the North West Mounted Police, Treaty, the end of the buffalo and disease the gallery becomes increasingly dark and claustrophobic. A sense of temperature change is stimulated by the presence of artificial snow and the exhibit reaches is dramatic climax by routing the visitor through a small door into a dark reserve house (see Figure 7.3).

After passing through the small dark cabin the visitor emerges into a brightly lit institutional style hallway representing the residential school. The walls are lined with photos of early life on the reserves and text panels discuss farming, ranching, Indian Agents and rations. The hallway is traversed by another corridor which at one end shows solemn black and white images of children in the residential school as though they are just in the next room. Looking in the other direction the mirror image corridor shows colourful pictures of Old Sun Community College on Siksika Reserve, which is a modern community reuse of the old residential school (Figure 7.4). This provides a sense of hope and as the exhibit proceeds the gallery lightens and widens into a final circular space entitled *We are Taking Control* which focus on modern Blackfoot life and features positive video interviews on the future of the Blackfoot culture.

The layout is effective, creating an initial experience of freedom and space in the pre-contact era, moving through the restrictive dark colonial era, back out into the somewhat open space representing today. Exhibit Designer Irene Kerr and Curator Gerry Conaty explained the thinking behind the design.

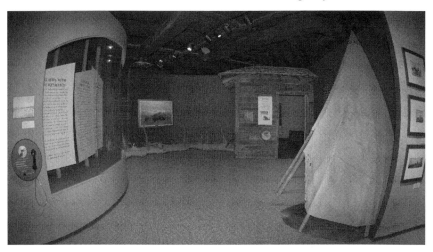

Figure 7.3 *Nitsitapiisinni* gallery narrows during discussion of the colonial period.
(Photo by Onciul 2009). Printed with permission of the Glenbow Museum. ©Glenbow, Calgary, 2014.

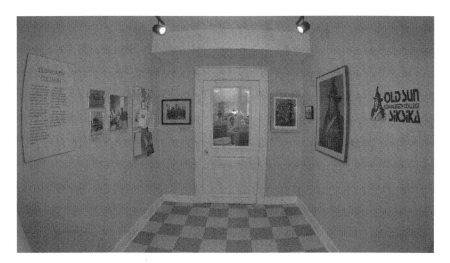

Figure 7.4 *Nitsitapiisinni* display of the reclaimed residential school.
(Photo by Onciul 2009). Printed with permission of the Glenbow Museum. ©Glenbow, Calgary, 2014.

The way it works at Glenbow, when you get to post-treaty, is every-thing gets smaller and more confined. Where the residential house is, we wanted to have cold air pumped in there and they wouldn't let us, so to make up for that we put a snow scene in.

(Interview, Kerr 2008)

I think what works well is the closed-in area, with the coming of the Europeans. The way that the gallery space starts closing in. When you point that out, people understand it.

(Interview, Conaty 2008)

The gallery design helps to achieve the Elders' aim to address the difficult history of colonialism, but focus on the positive story of survival and cultural pride. In the final display the participating Elders each have a photo and statement about their intentions for the gallery. A common aim was to correct misinformation and share traditional knowledge with the younger generations of Blackfoot to rebuild pride.

Of the four case studies, Blackfoot Crossing tackles the impact of colonisation with the most frankness and 'truth telling' (Lonetree 2009:334). The purposeful destruction of Blackfoot culture and people through colonisation is stated in the text panels of the exhibit and the legacy of these traumas, particularly the on-going prejudice and misunderstanding about First Nations communities within Canadian society, is directly addressed. The *Napikwan* text panel states:

[Explorers and missionaries] were the beginning of their future problems. They brought with them unfamiliar disease and other sickness the people could not control. During their attempts to kill off the culture, the buffalo once again came to the rescue by standing between the people and the aggressors. The buffalo paid a heavy price by being killed almost to the point of extinction. The massacre of so many buffalo was evidence of the white people's determination to achieve their intentions. Sadness came over the land and its people who were fed by the buffalo when all that was left of them was bleached bones everywhere. Whiskey traders appeared in the land and laced their whiskey with tobacco juice to sell to the people. The Blackfoot way of life, however partially destroyed, rose again as the buffalo and they carried on with what remnants of their past they could pick up again. They were herded onto reservations almost resembling the fate of the Buffalo in their pastures of today.

(Blackfoot Crossing *Napikwan* text panel 2008)

In the same text panel an 1877 *Sessional Paper* is quoted:

It would appear that the Blackfoot, who some ten or twelve years ago numbered upwards of ten thousand souls and were then remarkable as a warlike and haughty nation, have within the last decade of years been greatly demoralized and reduced by more than one-half their number— partly in consequence of the poisoned fire-water introduced into the territory by American traders, partly by the terrible scourge of the Red-man, small-pox.

(Blackfoot Crossing *Napikwan* text panel 2008)

In a text panel on *Indian Agents* it is stated that 'the agents abused the system, for even though rations were supposed to be distributed fairly to those who worked, children often died of starvation from the meagre rations' (Blackfoot Crossing text panel 2008). This open treatment of the decimation of Blackfoot life by colonisation is an example of what Lonetree terms 'truth telling' (2009:334). However, the gallery does not dwell on the negative history, but emphasises the survival and continuation of vibrant living Blackfoot culture. It presents a positive message of current day cultural strength, but in doing so it underplays current difficulties Blackfoot people face on and off the reserves.

All of the permanent exhibits[3] at the case studies shy away from directly discussing the current problems in Blackfoot society[4] despite the direct connections between current conditions and colonialism. The desire to create positive self-representations is a common and natural tendency. Elizabeth Carnegie's research on community representation in Scotland has parallels with the Blackfoot self-representation as the community there too performed what Carnegie terms 'stigma management' (2006:73). Although strategic censoring of history does not perform the direct 'truth telling' Lonetree encourages, it does enable the presentation of a positive image that can build community pride, which is a crucial first step in decolonising Blackfoot identity from within and outside the community.

Pride building required challenging stereotypes about the Blackfoot that still circulate in the Canadian public imagination. Professor Thomas King captures a snapshot of the stereotyping and racism First Nations people experience in Canada when he asks his readers:

> What is it about us you don't like? Maybe the answer to the question is simply that you don't think we deserve the things we have. You don't think we've worked for them. You don't think we've earned them. You think that all we did was to sign our names to some prehistoric treaty, and ever since, we've been living in a semi-uncomfortable welfare state of trust land and periodic benefits. Maybe you believe we're lazy/drunk/belligerent/stupid. Unable to look after our own affairs. Maybe you think all we want to do is conjure up the past and crawl into it. People used to think these things, you know, and they used to say them out loud. Now they don't. Now they just think them.
>
> (2003:147)

Tsuu T'ina Elder Tony Starlight noted that many First Nations people are judged on the homeless people seen in urban centres:

> It is a big world out there and most of them only have stereotypes of what a First Nations people should look like. And then when they go to the big city, Calgary, Edmonton, the only Indians they see are the ones downtown who are drinking, you know, who are poor and that is a poor representation of what most of us pride ourselves to be.
>
> (Interview, Starlight 2008)

Pete Standing Alone also expressed concerns about how people view the Blackfoot: 'We need to change stereotypes—many people still think [we] live in tipis and run around naked, or in buckskins. US thinks Canada is all Inuit and Indians' (Glenbow 1998:4). Creating an accurate and positive image was a goal at Glenbow, as Curator Beth Carter explained: 'there has been so much racism and negative stereotypes that bombard these young people and they need to have things they can be very proud of, and things that they can hope for the future. And have a message that gives them hope for where their life can go' (Interview, Carter 2008). Former Glenbow interpreter, Clifford Crane Bear emphasised this point: 'the first thing we were doing, and we accomplished, was that people walked out of there with heads up in the air, especially the Blackfoot people, and they were very, very, very proud' (Interview, Crane Bear 2008).

The desire to build pride was also a goal at Blackfoot Crossing, as Director Jack Royal describes: '[here] you are going to get the perspective of where we've been, where we are and where we want to go. And hopefully eliminate a lot of the stereotypes that are out there' (Interview, Royal 2008). Blackfoot Crossing's VP of Marketing & Public Relations, Shane Breaker, explained 'our audience is the immediate public in the area and there have been years and years of prejudice within those communities against the Native population in the area' (Interview, Breaker 2008).

> A lot of the views Albertans have of Native people have been instilled over generations since the '40s to the '60s. So, there's a lot of misinformation of how Native people live, how they are, so this facility, hopefully can help that and explain the history and actually talk to a Blackfoot person, because a lot of them just don't bother. That's our goal. Be able to walk away and say they're more educated about the Blackfoot people, more educated about First Nations people in general and just have a great experience here [at Blackfoot Crossing].
>
> (Interview, Breaker 2008)

Blackfoot Crossing directly addresses the problem of stereotyping within mainstream Albertan culture in the exhibit *Eurocentric Misconceptions* (Figure 7.5). The display combines a text panel that quotes archival newspaper articles about 'savages' with a video exploring current misconceptions within the general populous of Calgary.

Blackfoot Crossing's willingness to speak out and challenge visitors makes it more avant-garde than its fellow museums. Director Jack Royal argues that the freedom to speak openly on these subjects comes as a result of being self-funded, developed and run by the community, and therefore not required to toe any official government line (Interview, Royal 2008). For this reason, Blackfoot Crossing seeks to avoid reliance on government financial support as they feel that this could compromise their ability to, as they say, speak the truth about their history (Interview, Royal 2008).

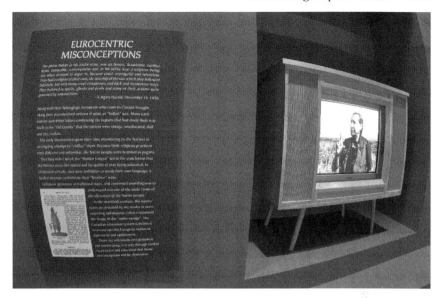

Figure 7.5 Eurocentric Misconceptions exhibit at Blackfoot Crossing.
(Photo by Onciul 2009). Printed with permission of Blackfoot Crossing Historical Park.

CHILDHOOD MEMORIES AND THE RESIDENTIAL SCHOOL ERA

One of the most sensitive topics for representation was the Residential School Era (1831–1996). After the devastating period of colonisation Blackfoot people continued to suffer under Canadian rule. The stolen generations of the residential schools era are a particularly painful part of Canadian and Blackfoot history. On 11th June 2008 the Canadian government made a formal apology to the residential school survivors. Many of whom suffered emotional, physical and sexual abuse as children at the hands of church and government employees. Blackfoot Crossing Director, Jack Royal, explained that residential schools were part of a hidden history:

> The whole reservation system, the whole residential school experience, those things aren't communicated because it was like a black eye on Canadian history. So because of that there was ignorance because it wasn't mentioned. . . . You still see the effects of that. Some people have these outrageous stereotypes of First Nations people.
>
> (Interview, Royal 2008)

At Glenbow and Blackfoot Crossing the exhibits aimed to correct and inform people about the period. Glenbow's on-line *Nitsitapiisinni*

Gallery teacher toolkit explains the damage the schools did to Blackfoot society:

> Sexual and physical abuse by staff and students was widespread. The children were helpless. They learned institutional behaviour—how to bully the young and weak. They learned to treat each other with contempt and violence. Residential schools created many dysfunctional people with low self-esteem, and these people in turn created a dysfunctional society. This process has been going on for five or six generations. It will take a long time to heal.
>
> (Glenbow 2011)

In an interview with Piikani Chief Reg Crowshoe he felt that museums were a place to discuss this difficult history.

> Whatever was done wrong has to be mitigated. I think museums can help with regards to mitigation and negotiation by, with supporting material and information. I think the deal with those kinds of monsters that present themselves as sensitive. . . . I think they can shed more light on it, than staying back and making it more mysterious.
>
> (Interview, Crowshoe 2008)

However, discussing these topics was a challenging and emotional process for the community Elders engaged in the development of the exhibits as many of them had attended residential schools in their childhood. As Kainai Elder Rosie Day Rider recalled:

> It was so stressful when I went to residential school. I cannot speak my language and I get hurt. It especially breaks my love, and it is very heart breaking. I do any miracle to get home to be with my parents. It is an entirely different feeling, just like in jail. But my dad is going to go to jail if I don't go. It was terrible rules. The government gave the permission to those teachers and principals, the advice to hit us and pull our hair, ears, and banging my face on the table. [She bangs her fist on the table]. See that's how. Sometimes we just get a bleeding nose by doing that. And then you get punished: scrubbing, time standing, and all kinds.
>
> (Interview, Day Rider 2008)

Rosie Day Rider's account provides a momentary glimpse into how powerful and current these memories are for survivors.

Kainai Elder Frank Weasel Head recounted the long discussions about if and how to represent the residential school era in the Glenbow exhibit:

> The residential school took us maybe five, six, seven meetings. It took us a long time because it was a hard subject. One person didn't even want

to discuss it. Although she didn't go, but her parents and other relatives went through it. And it took a while for her husband to calm her down, you know, and say no, we have to tell the story, we have to let people know what happened to us . . . if everything there in those several meetings was said, put on display on the residential school they would have covered the third floor. That would have been the only exhibit.

(Interview, Weasel Head 2008)

The exhibit is a small part of the gallery (Figure 7.6) and only the text panel suggests the trauma these schools caused their students (Figure 7.7). The negative history appears to be balanced by the display opposite of Siksika's Old Sun Community College, reiterating the positive message of survival (Figure 7.4). However, what remains unmentioned is the terrible history of Old Sun Residential School, a place notorious for the high death toll of students. Thus there is a sense of 'displayed withholding' that will be more readily understood by Blackfoot community members than passing tourists.

At Blackfoot Crossing the residential school experience is represented in the *Survival Tipi* exhibit (Figure 7.8). The design team created a three-dimensional collage of buildings to represent the hard times of the Residential School System, life on the reserves, the influence of Christianity, and labouring on the farms and down the mines. The exhibit uses audio-visual footage

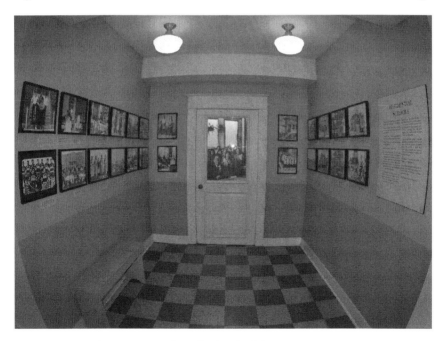

Figure 7.6 Nitsitapiisinni residential school exhibit.
(Photo by Onciul 2009). Printed with permission of the Glenbow Museum. ©Glenbow, Calgary, 2014.

RESIDENTIAL SCHOOLS

Schools were supposed to give our people the skills to live among the newcomers.

Instead, schools destroyed our family structure, our sense of belonging and our identity.

Schools tried to make us ashamed of our traditional teachings and practices.

Schools told us that our grandparents were heathens.

Schools almost destroyed us.

In both Canada and the United States, the governments contracted religious organizations to educate our people. The government and church groups believed that in order to educate us they needed to destroy our community support, discredit our traditional beliefs and eliminate our language.

To accomplish this, they confined our children to residential schools for ten or eleven months each year. Some children were sent half-way across the country for up to ten years.

Boys and girls were physically separated. They did not learn how to respect one another. Without parents and grandparents there was no opportunity to learn parenting skills, love, and respect. The lessons of Makoiyi (the wolves) were forgotten.

Physical and sexual abuse by staff and students was common. We learned how to bully the younger and weaker ones. We learned to treat each other with contempt and violence. Institutional behaviour replaced our traditional values.

This process has now been going on for five or six generations.

Even though the last residential school closed in the 1960s, the results of this process are still affecting us, many generations later.

The healing will take a long time.

Figure 7.7 Text panel in *Nitsitapiisinni*.
(Photo by Onciul 2009). Printed with permission of the Glenbow Museum. ©Glenbow, Calgary, 2014.

of current Elders who lived through the period telling their stories about their experience as children. The films emphasise that the trauma, which has been described as cultural genocide (Churchill 2004), is within living memory on the reserve. In the national apology by the government, M.P. Duceppe made special mention of one school: Siksika's Old Sun Residential School:

Nearly 150,000 people have waited their whole lives for this day of truth and reconciliation; 90,000 of them are still with us. These 90,000

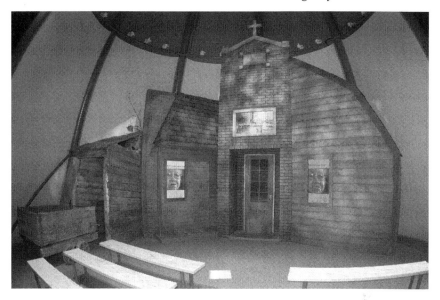

Figure 7.8 Survival Tipi at Blackfoot Crossing.
(Photo by Onciul 2009). Printed with permission of Blackfoot Crossing Historical Park.

are true survivors. Over 100 years ago, the Bryce report revealed that the mortality rate in residential schools was close to 25%. In the Old Sun's residential school in Alberta, the death rate was as high as 47%. That is why I consider these former students to be survivors.

(Duceppe 2008)

Siksika's Old Sun Residential School repeatedly appeared in government reports stating the unsanitary and poor conditions of the school and ill health of the children (Milloy 1999). Bryce condemned the school in 1907 and Cobett's survey of the schools in 1920 and 1922 'found that little had changed' (Milloy 1999:98).

Such conditions had left their indelible and mortal mark on the children who Corbett found to be 'below par in health and appearance.' Seventy percent of them were infected. They had 'enlarged lymphatic glands, many with scrofulous sores requiring prompt medical attention.' . . . But it was the discovery that sixty percent of the children had 'scabies or itch . . . in an aggravated form' that most upset Corbett, for this was unnecessary and a sign of gross neglect.

(Milloy 1999:99)

Even by 1957 the situation was dire, as the visiting medical doctor was recorded as saying 'The children are dirty. The building is dirty, dingy and is actually going backwards rather than forwards' quoted in Milloy (1999:263).

When the videos were made for the exhibit at Blackfoot Crossing it raised difficult memories for Elders and there was debate about how much they should share. Exhibit designer, Irene Kerr, was concerned that although Elders consented to share their experiences for the audio-visuals, she feared that they may not have fully understood how the material would be used and that it would be on permanent public display (Interview, Kerr 2008). Consequently she decided to edit the material:

> I mean there was a lot of stuff I wouldn't let [the film company] use in the final product. Especially the one about the residential school; we had some footage there that I just said we just can't [use]—we have to draw the line somewhere. But the Elders saw the videos, they approved them all.
>
> (Interview, Kerr 2008)

This highlights the dilemma between 'truth telling' (Lonetree 2009:334) and 'opening old sores' as Colleen Sitting Eagle explained:

> We decided to leave the negatives out, just like with the residential school. We weren't going to show, like it goes back to that pretty picture, we want to show that: the real life, but not the real-real life. So that's what we wanted to portray . . . What one of the Elders said was why open an old sore? People can read about it elsewhere and if they want verification they can find it, they can personally talk to somebody, but we're not going to open an old, because it's also hurting to them, hurting to their families, and they don't want to show that . . . keep a balance in what you want to tell, but more on the positive side, because people have always, are, labelling our stereotype. They have already finished stereotyping us, they've already finished labelling us, so why give them some more? So why confirm their allegations of what we are? Like we've had a few tourists that have had some racist comments and even the little kids, but when they come back from that gallery downstairs, you know, they're different. The little kid that thought that we're Hollywood Indians didn't see that anymore. They came up out of there and they'd got the real story. They went in there with a fairytale image of us, but came out with reality. So they have a different concept to what they labelled us as.
>
> (Interview, Sitting Eagle 2008a)

The concern about sharing but not hurting the community is echoed by interpreter Laura Sitting Eagle:

> That area is still touchy for the elderly. They say, well why did you put that in there? Again I have to explain that it comes from the Elders. It's part of our history. They want our kids to know. And they would ask,

well okay. The Elders are on that video, they don't really go into exactly their experience, you know, whether they went through abuse or all that experience. How come they don't? Well I tell them we're pretty private people, they're private. It's just to let them know they did go through that.

(Interview, Sitting Eagle 2008b)

Assistant Curator Michelle CrowChief explained the decision:

We tried not to make it a biased point. We did it so that we'll touch base on it but not sit there and 'well this is what they did to us, this is bad'. We just kind of touched it and just kind of steered away from it. If they wanted to learn more, you know that is where the archives are; and they can do their own research in there on that topic.

(Interview, CrowChief 2008)

Describing the Glenbow exhibit Piikani Elder Jerry Potts made a similar comment: 'I think the idea was that if you can show enough, then if somebody's interested there is enough there to kind of make them want to look deeper' (Interview, Potts 2008).

The Elders who worked with Glenbow and Blackfoot Crossing decided to share, but only so much. For these Elders, the exhibits were not the right forums for the explicit and specific discussion of the 'hard truths of colonization' as recommended by Lonetree (2009:334). However, as Colleen Sitting Eagle notes, what they do share appears to have the potential to transform visitors' views of Blackfoot people. What has been shared and the efforts made to present a positive image of the community to engender cultural pride is, I would argue, also crucial to countering the enduring legacies of the residential schools which taught the Blackfoot to be ashamed of their culture and identity.

'DISPLAYED WITHHOLDING'

The Elders' decision to share only so much about sensitive aspects of their culture was repeated in their decisions about what aspects of sacred culture to share. However, the decision was made for very different reasons.

In Blackfoot culture sacred and spiritual life is restricted and not culturally appropriate for public exhibition. The more sacred an item, event, song, dance, ceremony, or story, the more it is restricted. Sacred information is passed on gradually through participation in Blackfoot sacred societies. Once a person is transferred sacred information they too are bound by the same secrecy and required to continue the process of traditional teaching. Elders describe this process as their equivalent to Western universities, with Elders earning a level of knowledge and skill exceeding that of a Western PhD.

Similarities can be seen in the way Moira Simpson describes Australian Aboriginal cultures: 'traditional knowledge is strictly controlled and access

restricted. The more sacred and significant an object, image, or story, the more it is shrouded in secrecy' (2006:155). Simpson identifies this as the crux of the cross-cultural dilemma of representing such cultures in museums because:

> . . . in contrast, academic enquiry, public display, and the dissemination of knowledge are integral elements of conventional Western museum functions. In a Western museum, the more important an object, the more prominently it is displayed; it may be designated and promoted as a star item or masterpiece, a 'must-see' for museum visitors.
>
> (Simpson 2006:155)

Whether and how to represent restricted sacred information was a common focus of long and complex discussion during the development of the case study exhibits and continues to be a hot topic for staff and visitors (as discussed in chapters six and eight). The challenge was to find a way to share enough information to enable visitors to understand Blackfoot spiritual life, without crossing the boundaries of Blackfoot protocol. To accomplish this was a complex task, as there is no separation between the secular and the sacred in Blackfoot culture, all traditional Blackfoot life is built upon Blackfoot theology, although some elements are more sacred than others. As a result, the Elders had to decide where to draw the line, what to share and what to keep hidden.

> There are some things that are public things and there are some things that are very private, just like ceremonies, you don't see that stuff unless you are invited or you can't handle or touch unless you have transferred rights. So that is what we kind of got in order to protect that, we didn't want to get into any of that. So Glenbow had a lot of public kind of stuff to put in there.
>
> (Interview, Potts 2008)

In the Blackfoot Exhibit Team Meeting minutes the Elders expressed the need to only share the public information:

> Stay away from religion, spirituality, ceremonies. We can mention these but not elaborate. Talk about it as part of everyday life . . . part of culture—not a religion. . . . It's alright to mention societies, and the social aspects of Okan, especially the fourth day which is public.
>
> (Glenbow 1999b:6)

Interviews with the Elders who developed the exhibit reinforced this idea and illustrate the complexity and turmoil over what should and should not be shown:

> It was really frustrating because both sides didn't know, and still some of our people were reluctant to share information, I kept saying listen it is not for us, it is for our children, it is for our future that we share this

information. If we are a people we have got to have a culture, got to have a history. We don't know our history, we don't know our culture, who are we as a people?

(Interview, Pard 2008)

It was about telling the truth and there was a fine line between telling what is ceremony and what is a way of life.

(Interview, Heavy Head 2008)

At the outset of the first Blackfoot Exhibit Team Meeting at Glenbow, Curator Gerry Conaty said: 'the First Nations members of our team should not feel pressured to talk about things that are private and not for general knowledge' (Glenbow 1998:1). This was an important recognition of the parameters of the engagement zone and respect for Blackfoot protocol.

Blackfoot Crossing Director Jack Royal notes that the experience of colonialism has further limited what the community is willing to share:

It is not a written rule, we didn't all get in one room and agree lets only tell so much [laughs]. It is just kind of an underlying understanding, you know. And I grew up like that. It was because of this whole European experience. The whole relationship that evolved through history, that the trust, I guess, is not there.

(Interview, Royal 2008)

Lorraine Good Striker explained: 'we try to hang on to the spiritual part of our culture because it is the one last thing that hasn't been taken away from us is our spirituality' (Interview, 2006).

What is not spoken about is not openly discussed, so for community outsiders such as Western museum curators it can be hard for them to know what they do not know. Within the engagement zone this information was sometimes disclosed, and at Glenbow a key strategy was to invite Glenbow staff to attend Blackfoot ceremonies to witness some of the restricted elements of their culture first-hand. This involved trusting and sharing information that enabled participants to cross boundaries and gain temporary insider access. However, even in these 'invited spaces' (Fraser 1987) access was limited by the cultural capital required to comprehend the information that was presented through the ceremonies. These private elements of Blackfoot culture were not included in the public displays. Instead the exhibits present 'displayed withholding' (Lawlor 2006).

'Displayed withholding' is 'the point where the performance or display says, "There is more, but we choose not to show you" . . . the gesture points towards a dimension of being and knowing that cannot or will not be shared with visitors' (Lawlor 2006:62). For Glenbow Curator Beth Carter limited sharing was a positive first step in Blackfoot self-representation:

Because they recognise they can't share the intense spiritual teachings that you would if you actually came and started to sit with the Elders,

you would get much more in-depth. But they saw it as a first step to an authentic story about their past: the important stories, the relationship to the world around them, the philosophies, the guiding principles of who the Blackfoot people are.

(Interview, Carter 2008)

At Glenbow and Blackfoot Crossing 'displayed withholding' can be seen through the Blackfoot iconography and language in the exhibits which speaks exclusively to cultural insiders with the cultural capital to unlock these meanings. Culturally encoded messages are held before the visitor, but out of reach; shown but not explained.

This presence of the visibly invisible and the audibly inaudible, . . . has a great deal to do with the effective evocation of a specific tribal difference, of a discourse that is not shared which provides gravity to the lived idea of identity in difference.

(Lawlor 2006:5)

It also reminds non-Blackfoot visitors of their 'place' within the exhibit. The community, despite being in an unequal power relationship with dominant society, publicly asserts their power to define themselves and their 'Others', using the displays to mark the boundaries between 'Us' and 'Them', reversing the colonial lens.

At Blackfoot Crossing the iconography was built into the building (Figures 7.9, 7.10), as architect Ron Goodfellow explained: 'the building became a metaphor of Blackfoot culture, it was a teaching tool' (Interview, Goodfellow 2008). This enables the centre to share information with their community audience without tourists and outsiders gaining access to it. Nevertheless, Blackfoot Crossing consultant Linda Many Guns notes that debates still occurred over the representation of sacred symbols at the centre:

I mean it was, great debates about whether or not they could put the Motokik [sacred society] symbols up there. So what was there and what wasn't, part of that was a very keen discussion about what you display in that way and what you don't.

(Interview, Many Guns 2008)

Goodfellow explains that these concerns were quelled when the community saw that the building kept the sacred meanings off stage, displaying the symbols but not openly interpreting them, a form of 'displayed withholding' (Lawlor 2006).

Even when we started to build it, there were people who were upset that we were actually showing [sacred symbols]. But they realised after they

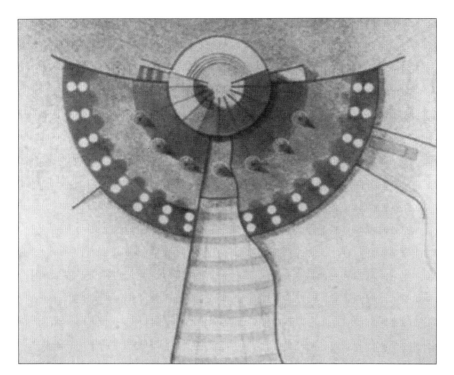

Figure 7.9 Drawing of Blackfoot Crossing from above shows the tipi cover design (Blackfoot Crossing display 2007).
Printed with permission of Blackfoot Crossing Historical Park.

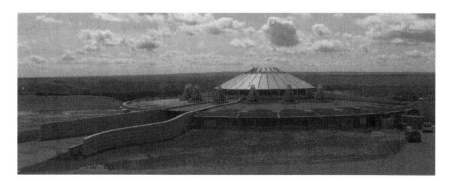

Figure 7.10 Blackfoot Crossing building features a buffalo run entrance, the seven tipis of the seven sacred societies and the Sundance lodge in the centre.
(Photo by Onciul 2007). Printed with permission of Blackfoot Crossing Historical Park.

saw it that it was actually a very respectful design. And the average tourist would not likely understand hardly any of the more sacred elements of the design. They might not even [understand] the symbolism of the roof: which represents a tipi cover laid out on the ground for painting the vision that came to its owner while fasting. The centre piece of the roof structure represents the Sundance lodge, and it is surrounded by seven tipi skylights which represent the seven societies. So the design process integrated a whole lot of very subtle elements of their culture into the building form. There is almost nothing you could point out that doesn't have a cultural or environmental contextual reason for why it was done.

(Interview, Goodfellow 2008)

The Glenbow and Blackfoot Crossing exhibits were created for Blackfoot communities to use and so within these galleries selective sharing occurs through the use of strategies to speak to 'select witnesses' (Lawlor 2006:5). For example the use of Blackfoot language and iconography speak to community members who can interpret them. Thus, while the exhibits outwardly perform autoethnography (Pratt 1991:35; Boast 2011; see chapter three), they also speak on different terms to cultural insiders via culturally encoded means. Layers of meaning simultaneously allow insiders to access deeper knowledge, while presenting a simplified introduction to Blackfoot culture for outsiders. As Goodfellow explained:

If you know what you are looking for there is a lot of [meaning embedded in Blackfoot Crossing]. For instance, these doors represent feathers. Anywhere you stand in that building a knowledgeable person can sit and describe what this or that means, right down to the wood panelling on the walls; which was done in different sized layers to represent the sedimentary stratum seen along the river banks.

(Interview, Goodfellow 2008)

Through this process the exhibits carefully control what Blackfoot knowledge is shared with whom. For those who have Blackfoot cultural capital, listening to what is not said in the gallery communicates strong messages about respect for the restricted nature of sacred Blackfoot culture.

'Displayed withholding' sends a message to visitors that Blackfoot culture is deep and complex, it continues today and is exclusive to community insiders. It draws a line between insider and outsider and what is and is not to be shared. Lawlor draws on Doris Sommer's description of being on the receiving end of 'displayed withholding':

Sommer writes, 'We are not so much outsiders as marginals, not excluded but kept at arm's length.' 'Kept at arm's length' is a useful image of the distancing effect that displayed withholding creates. The

phrase suggests that secrecy is maintained not by mounting a barricade but simply by performing a gesture, by keeping at bay that which is unavoidably near.

(Lawlor 2006:62)

Despite being engaged with the museum and willing to enter into public dialogues with mainstream narratives, 'displayed withholding' (Lawlor 2006:5) fences off what is not 'for sale' and differentiates between 'on stage and off stage' (Shryock 2004) culture and controls the insider/outsider border.

In practice 'displayed withholding' at Glenbow meant that the *Nitsita-piisinni* Gallery introduces Blackfoot spirituality and traditional Napi creation stories, but the more sensitive aspects of sacred culture are presented in limited ways or excluded. For example the Elders wished to include the most sacred event in the Blackfoot calendar, Okan (Sundance), but in a way that honoured its private and 'off stage' nature. This presented a challenge as Okan cannot be photographed, sketched or recorded in anyway. Elders sanctioned the use of archive photographs of Okan taken at a great distance from the ceremony. Interpretation was provided through an audio-visual display in which the Elders spoke about how Okan was almost lost when it was banned by the Canadian Government, and then revived by the community and how, once again, it plays an important role in Blackfoot life.[5] To emphasise the restricted nature of this information the gallery routing is physically restricted, forcing the visitor to enter through a small triangular doorway into an enclosed circular space that represents Okan (Figure 7.11).

At Blackfoot Crossing information on the sacred aspects of Blackfoot life is also presented in a small enclosed circular space with two narrow entrances/exits (Figure 7.12). They also used archive photos and audio-visual discussions of the importance of Okan. These similarities can be partly accounted for by the fact both exhibits were created by Terry Gunvordahl and Irene Kerr's *Exhibitio* Design Company. But unlike Glenbow, Blackfoot Crossing also included objects relating to the ceremonies. The Curators are both Elders and have the rights to handle sacred material, and they worked with Elders to decide what was appropriate for display and what should be kept in storage away from the public gaze (see chapter six).

As we developed [Blackfoot Crossing] further and further, there was a lot of internal debate about whether they should, or should not be telling the Whiteman or non-Siksika people about their culture. This was, had always been, internalised; "this is ours; not theirs". But they finally decided this was the only way, because the ancient societies were disappearing, and because their young kids were doing what all young kids do, listening to MTV and experimenting with sex, drugs and alcohol. And so there was great concern amongst the Elders, that theirs might be the last generation that had any of the Blackfoot traditional knowledge (Interview, Goodfellow 2008).

Figure 7.11 Okan exhibit at Glenbow Museum.
(Photo by Onciul 2008). Printed with permission of the Glenbow Museum. ©Glenbow, Calgary, 2014.

Figure 7.12 The design sketch for the Societies display space at Blackfoot Crossing Historical Park.
Preliminary sketches by Exhibition Planning and Design for Blackfoot Crossing Historical Park.

At the same time Blackfoot Crossing was careful not to cross the line of protocol, as Michelle CrowChief explained:

Even the Societies, you don't really talk about them, but you mention them. They are a big part of our culture, but we are not going to sit there and talk about that all the time. It is there, but it's not really what this whole centre is about.

(Interview, CrowChief 2008)

Blackfoot Crossing carefully balances acknowledging ceremony with protecting restricted information. They are the only museum out of the four case studies that does not allow photography within the exhibit. I was granted special permission to take photos of every display except for the one that addressed Okan. This restriction helps to prevent uncontrolled dissemination and misuse or misappropriation of sacred Blackfoot culture.

While techniques like 'displayed withholding' can enable strategic sharing within the exhibit, it is important to bear in mind that the messages presented are still framed within the larger context of the museum that houses them and the specifics of the museum as a cultural form.

CONCLUSION

Exhibits function as 'a public skin, a public face, for non-Indian audiences' (Lawlor 2006:5), while enabling community visitors to connect with the narrative in different ways through Blackfoot language, iconography, images and concepts. However Blackfoot voice is both framed through the cultural form of the exhibit and mediated by the need to communicate cross-culturally. Consequently Blackfoot self-representation at the case studies produced exhibits layered with meaning that speak to different audiences and strategically control cultural sharing through 'displayed withholding' (Lawlor 2006:5).

Within the exhibits the Blackfoot strategically use essentialism (Spivak 1990:109) to create a space from which the community can speak as one, to counter dominant narratives made about them. The exhibits present a public mono-narrative of Blackfoot culture, concealing 'off stage' the plurality and diversity of Blackfoot culture and peoples. Used as tools for strategic public communication, the exhibits do not represent the reality of the community per se, but present an image and narrative that has the potential to make change, develop cultural pride and potentially help decolonise relations. The exhibits position Blackfoot people on the political and historical map and support efforts to improve Blackfoot rights, cultural pride and even land claims. Once this public platform is secured other sub-narratives may then be presented.

While the case study exhibits each help with the process of decolonisation by countering Eurocentric grand narratives, they are not solely focused

upon telling 'hard truths of colonization' (Lonetree 2009:334). Instead they balance 'truth telling' with cultural sensitivity to restricted sacred culture, personal memory of traumatic history, and potential audience sensibilities. The Elders wanted to make the exhibit audiences aware of the difficult history of colonialism, but emphasise the long history of the Blackfoot peoples, their survival, and current day cultural revival, to create a positive image that can build community cohesion and self-esteem, key factors that will help the long term process of decolonisation.

NOTES

1. Excerpted by permission of the Publishers from 'Telling Hard Truths and the Process of Decolonising Indigenous Representations in Canadian Museums', in *Challenging History in the Museum* eds. Jenny Kidd, Sam Cairns, Alex Drago, Amy Ryall and Miranda Stearn (Farnham: Ashgate, 2014), pp. 33–46. Copyright © 2014. Some extracts in this chapter have been reprinted by permission of Boydell & Brewer Ltd.
2. See introduction for discussion on why voice rather than voices is used here.
3. Glenbow addressed some of these issues in their temporary community gallery with their 2008 exhibit *Situation Rez* which addressed the high levels of HIV on the reserves.
4. Such as drug and alcohol addictions, gangs, domestic abuse, high rates of suicide, corruption, low life-expectancy, poor housing, and high levels of diabetes, tuberculosis and other diseases.
5. See Tovias 2010:287–288 for details on Blackfoot response to the prohibition of Okan.

REFERENCES

Ashley, S., 2007. State Authorities and the public sphere: ideas on the changing role of the museum as a Canadian social institution. In S. Watson, ed. *Museums and Their Communities*. London: Routledge, pp. 485–500.

Battiste, M. and Youngblood Henderson, J. (Sa'ke'j), 2000. *Protecting Indigenous Knowledge and Heritage: A Global Challenge*. Saskatoon: Purich Publishing Ltd.

Bennett, T., 1998. *Culture: A Reformer's Science*. London: Routledge.

Blackfoot Gallery Committee, 2001. *Nitsitapiisinni: The Story of the Blackfoot People*. Toronto: Key Porter Books.

Boast, R., 2011. Neocolonial collaboration: museum as contact zone revisited. *Museum Anthropology*, 34(1) pp. 56–70.

Brady, M.J., 2009. A dialogic response to the problematized past: the National Museum of the American Indian. In S. Sleeper-Smith, ed. *Contesting Knowledge: Museums and Indigenous Perspective*. London: University of Nebraska Press, pp. 133–155.

Breaker, Shane. 16 Oct 2008. Interview. BCHP.

Brown, A.K., 2002. Nitsitapiisinni: Our Way of Life The Blackfoot Gallery, Glenbow Museum Calgary, Alberta, Canada. *Museum Anthropology* 25(2), pp. 69–75.

Carnegie, E., 2006. 'It wasn't all bad': representations of working class cultures within social history museums and their impacts on audiences. *Museums and Society*, 4(2) pp. 69–83.

Carter, Beth. 2008. Interview. Glenbow.
Churchill, W., 2004. *Kill the Indian, Save the Man: The Genocidal Impact of American Indian Residential Schools.* San Francisco: City Lights Books.
Clifford, J., 1988. *The Predicament of Culture: Twentieth-Century Ethnography, Literature, and Art.* Cambridge, MA.: Harvard University Press.
Clifford, J., 1997. *Routes: Travel and Translation in the Late Twentieth Century.* London: Harvard University Press.
Conaty, Gerald. 20 Nov 2008. Interview. Glenbow.
Crane Bear, Clifford. 8 Oct 2008. Interview. Siksika Reserve.
Crazybull, Sandra. 23 Sept 2008. Interview. Glenbow.
CrowChief, Michelle. 2 Sept 2008. Interview. BCHP.
Crowshoe, Reg. 19 Aug 2008. Interview. Calgary.
Daniels, B.I., 2009. Reimagining tribal sovereignty through tribal history. Museums, libraries, and achieves in the Klamath River region. In S. Sleeper-Smith, ed. *Contesting Knowledge Museums and Indigenous Perspectives.* London: University of Nebraska Press, pp. 283–302.
Day Rider, Rosie. 25 Nov 2008. Interview. Kainai Reserve.
Duceppe, G., 2008. *Statement by Ministers.* [Online] Parliament of Canada. Available at: http://www2.parl.gc.ca/HousePublications/Publication.aspx?DocId=356 8890&Language=E&Mode=1&Parl=39&Ses=2
Fraser, N., 1987. Women, welfare, and the politics of need interpretation. *Hypatia: A Journal of Feminist Philosophy*, 2 pp. 103–21.
Glenbow, 27 Nov 1998. *Blackfoot Exhibit Team Meeting.* [Minutes] Unlisted. Calgary: Glenbow Archives.
Glenbow, 15 January 1999a. *Blackfoot Exhibit Team Meeting.* [Minutes] Unlisted. Calgary: Glenbow Archives.
Glenbow, 4 Feb 1999b. *Blackfoot Exhibit Team Meeting.* [Minutes] Unlisted. Calgary: Glenbow Archives.
Glenbow Museum, 2011. *'Reserves and Residential Schools' Nitsitapiisinni Gallery Teacher Toolkit.* [Online] Calgary: Glenbow Museum Available at: http://www.glenbow.org/blackfoot/teacher_toolkit/english/culture/reserves.htm
Goodfellow, Ron. 18 Nov 2008. Interview. Calgary.
Good Striker, Lorraine. 25 July 2006. Interview. HSIBJ.
Hall, S., 1997a. The local and the global: globalization and ethnicity. In A. McClintock, A. Mufti, & E. Shohat, eds. *Dangerous Liaisons. Gender, Nation, & Postcolonial Perspectives.* Minneapolis: University of Minnesota Press, pp. 173–187.
Heavy Head, Pam. 18 Sept 2008. Interview. Fort Macleod.
Kahn, M., 2000. Not really Pacific voices: politics of representation in collaborative museum exhibits. *Museum Anthropology*, 24(1) pp. 57–74.
Kerr, Irene. 20 Aug 2008. Interview. BCHP.
King, T., 2003. *The Truth about Stories. A Native Narrative.* Toronto: House of Anansi Press.
Kirshenblatt-Gimblett, B., 1998. *Destination Culture: Tourism, Museums, and Heritage.* London: University of California Press.
Krmpotich, C. and Anderson, D., 2005. Collaborative exhibitions and visitor reactions: the case of Nitsitapiisinni: Our Way of Life. *Curator*, 48(4) pp. 377–405.
Lawlor, M., 2006. *Public Native America: Tribal Self-Representations in Casinos, Museums, and Powwows.* London: Rutgers University Press.
Lonetree, A., 2009. Museums as sites of decolonisation. Truth telling in national and tribal museums. In S. Sleeper-Smith, ed. *Contesting Knowledge. Museums and Indigenous Perspectives.* London: University of Nebraska Press, pp. 322–337.
Many Guns, Linda. 2 Dec 2008. Interview. Calgary.
Mazel, A. and Ritchie, G., 1994. Museums and their messages: the display of the pre- and early colonial past in the museums of South Africa, Botswana and Zimbabwe.

In P.G. Stone and B.L. Molyneaux, eds. *The Presented Past. Heritage, Museums and Education*. London: Routledge, pp. 225–236.

Milloy, J.S., 1999. *A National Crime: The Canadian Government and the Residential School System 1879 to 1986*. Winnipeg: University of Manitoba Press.

Pard, Allan. 12 Nov 2008. Interview. HSIBJ.

Potts, Jerry. 10 Oct 2008. Interview. Fort Macleod.

Pratt, M.L., 1991. Arts of the contact zone. *Profession 91*, New York: MLA, pp. 33–40.

Royal, Jack. 25 Aug 2008. Interview. BCHP.

Shannon, J., 2009. The construction of native voice at the National Museum of the American Indian. In S. Sleeper-Smith, ed. *Contested Knowledge. Museums and Indigenous Perspectives*. London: University of Nebraska Press, pp. 218–247.

Shryock, A., 2004. Other conscious/self aware: first thoughts on cultural intimacy and mass mediation. In A. Shryock, ed. *Off Stage On Stage: Intimacy and Ethnography in the Age of Public Culture*. Stanford: Stanford University Press, pp. 3–28.

Simpson, M.G., 2006. Revealing and concealing: museums, objects, and the transmission of knowledge in Aboriginal Australia. In J. Marstine, ed. *New Museum Theory and Practice. An Introduction*. Oxford: Blackwell Publishing, pp. 153–177.

Sitting Eagle, Colleen. 4 Sept 2008a. Interview. Calgary.

Sitting Eagle, Laura. 16 Oct 2008b. Interview. BCHP.

Smith, P.C., 2009. *Everything You Know about Indians Is Wrong*. London: University of Minnesota Press.

Spivak, G.C., 1990. *Post-colonial Critic: Interviews, Strategies, Dialogues*. London: Routledge.

Starlight, Anthony (Tony). 17 Oct 2008. Interview. Calgary.

Tovias, B., 2010. Navigating the Cultural Encounter. Blackfoot Religious Resistance in Canada (c. 1870-1930). In A.D. Moses, ed., *Empire, Colony Genocide. Conquest, Occupation, and Subaltern Resistance in World History*. Oxford: Berghahn Books, pp. 271–295.

Truth Commission into Genocide in Canada, 2001. *Hidden from History: The Canadian Holocaust*. Truth Commission into Genocide in Canada [Online] Available at: http://canadiangenocide.nativeweb.org/genocide.pdf

Weasel Head, Frank. 13 Nov 2008. Interview. Calgary.

Wesley, Jackson. 21 Oct 2008. Interview. Buffalo Nation Luxton Museum.

Wilson, W.A., 2005. Relieving our suffering: Indigenous decolonisation and a United States Truth Commission. In W.A. Wilson and M. Yellow Bird, eds. *For Indigenous Eyes Only: A Decolonizing Handbook*. Santa Fe: School of American Research Press, pp. 189–205.

Wilson, W.A. and Yellow Bird, M., 2005. Beginning decolonisation. In W.A. Wilson and M. Yellow Bird, eds., *For Indigenous Eyes Only: A Decolonizing Handbook*. Santa Fe: School of American Research Press, pp. 1–7.

8 Community on Display

The Indian floor staff have become objects, and it is safe to assume all of them knew this would happen when they signed on.

(Smith 2009:99–100)

In the process of creating museum exhibits, images, footage, names and wax mannequins of community members are collected, installed and placed on display. In addition, living community guides often accompany community voice into exhibits. Such inclusion creates an image of Blackfoot ownership

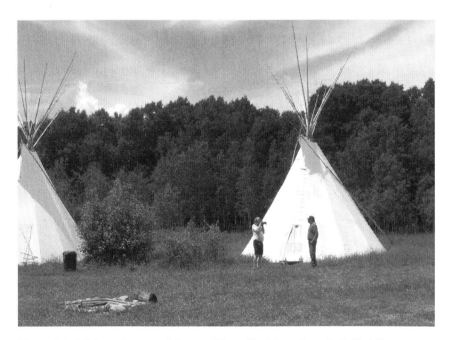

Figure 8.1 Visitor photographing a guide at Blackfoot Crossing's Tipi Camp. (Photo by Onciul 2008). Printed with permission of Blackfoot Crossing Historical Park.

and publically acknowledges the contributions of the individuals involved, whilst maintaining community presence in the museum through the employment of Blackfoot interpretive guides. However, in doing so, there is a risk that community members may become part of the spectacle of the exhibit, placed on display for visitors to view, potentially continuing a long history of human display of 'exotic Others'. In addition, the individuals embedded in the display become the 'public face' of the exhibit and are both credited with the display and held accountable for it, even if they did not have (complete) control over its creation.

Consequently, engagement can be challenging and risky for participants as their insider-outsider status complicates their relationship with both the museum and their own community. By exploring the potential for the apparently empowered to become exhibited, the chapter aims to illustrate the complicated nature of representing communities.

EXHIBITING HUMANS

Community interpretive guides tie into a long history of exhibiting Indigenous people that intertwines with the history of museums, exhibitions and colonialism. From first contact, Indigenous people were taken as prisoners and as guests to Europe to be exhibited as finds from the 'new world'. Indigenous people entered expos, freak shows and museums. The earliest display of people as 'living rarities' occurred in 1501 'when live Eskimos were exhibited in Bristol' (Kirshenblatt-Gimblett 1998:41). One of the most famous North American exhibitions of a living person began in August 1911 when the University of California anthropologists Alfred Kroeber and Thomas T. Waterman 'collected' a starving man, 'whose family and cultural group, the Yahi Indians, were murdered as part of the genocide that characterized the influx of Western settlers to California' (Scheper-Hughes 2004:66). As the last surviving member of the Yahi people they named him 'Ishi' meaning 'man' in Yana (Rockafellar 2010).

> After Ishi's 'rescue' by Kroeber, he lived out his final years (1911–1915) as a salaried assistant janitor, key informant, and 'living specimen' at the Museum of Anthropology at the University of California.
>
> (Scheper-Hughes 2004:63)

Scheper-Hughes notes that Ishi experienced what would now be recognised as clinical symptoms of post-traumatic stress disorder:

> Yet despite Ishi's physical and psychological vulnerability and his fear of crowds, Kroeber allowed Ishi to perform as a living exhibit at the Museum of Anthropology and at the San Francisco Panama-Pacific Trade Exhibition.
>
> (2004:64)

In March 1916 Ishi died from tuberculosis and despite his requests to be cremated intact, his brain was collected 'for science' through autopsy and shipped to the Smithsonian (Scheper-Hughes 2004:64–63). Eighty-four years later, Ishi's remains were finally repatriated to his descendants on 10 August 2000 (Repatriation Office 2011). Ishi was a museum employee, but he was also part of the display and the collection, in theory free to leave, but without a place to go. Thomas King captures this paradox:

> The people at the museum were inordinately fond of pointing out that Ishi was, in fact, free to return to the mountains and the lava fields of Northern California if he chose to do so. You can go home any time you wish, they told him. Which must have made him laugh and cry at the same time. For there was no home. No family. Not anymore. Ishi hadn't come out of the mountains because he had seen an advertisement in the employment section of a newspaper. "Help wanted. Museum curiosity. Apply in person." He had come to that slaughterhouse to escape the killings and the loneliness, and he would stay at the museum until his own death because he had nowhere else to go.
>
> (King 2003:65)

Ishi was both an educator and a curiosity, respected and objectified, simultaneously freed and imprisoned. The spectacle of being on display has been addressed by Barbara Kirshenblatt-Gimblett who notes that:

> The inherently performative nature of live specimens veers exhibits of them strongly in the direction of spectacle, blurring still further the line between morbid curiosity and scientific interests . . . circus and zoological garden, theatre and living ethnographic display . . . cultural performance and staged re-creation.
>
> (Kirshenblatt-Gimblett 1998:34)

She distinguishes between *in context* and *in-situ* displays, arguing that 'at their most mimetic, in situ installations include live persons, preferably actual representations of the cultures on display' (1998:20). Although Kirshenblatt-Gimblett's work and the descriptions of Ishi refer specifically to early nineteenth century America and Britain, these histories are remembered by Indigenous communities and influence current Indigenous relations with museums. When discussing colonialism and the reserve system the Elders who worked with Glenbow said 'we felt like a zoo society' (Glenbow 1999a:7). Blackfoot culture has been stereotyped and headdresses, buffalos, and tipis have become symbols used to represent all North American 'Plains Indians'.

Today Blackfoot guides interpret their culture as paid museum and heritage site employees. Through their work guides can gain public standing as representatives of their community, gain skills, experience and income, and

maintain Blackfoot voice in the exhibits. They are employed for their skills, knowledge and talent, but because this knowledge is generally restricted to Blackfoot members their employment is also tied to their Blackfoot identity. This is where potential for problems occurs, because the history of exhibiting people as subjects creates the potential for Blackfoot guides to be viewed as objects, rather than living representatives and interpreters of their culture. Like Ishi they are respected as knowledgeable, yet risk being objectified as examples of their culture. This problem is exacerbated by visitors who have never seen 'real living Indians' before, arriving with Disneyfied Hollywood notions. In this sense museums, such as the case studies, walk a fine line between empowering communities through continued employment and participation, and displaying Blackfoot guides as spectacle, playing into a long history of exhibiting human 'Others', albeit on new terms and from a more empowered position.

THE ROLE OF COMMUNITY GUIDES

> Well, you know, I think all museums, especially if they have Indian exhibits or materials there; they should have some sort of a First Nations Indian staff on hand.
>
> (Interview Weasel Head 2008)

Employing community guides to interpret community-produced exhibits is considered a positive policy that benefits the museum and the community. The Canadian *Task Force Report on Museums and First Peoples* stated that 'there is agreement that increased involvement of First Peoples in museum work is essential in order to improve the representation and interpretation of First Peoples' histories and cultures in museums' (AFN 1992b:15). The museum gains knowledgeable staff members who bring 'authenticity' to the exhibit though their cultural identity, experience and knowledge. Community guides can draw on personal experiences when discussing Blackfoot life and culture, and act as a link to the community, providing visitors with a 'contact' experience (often tourists' and Canadians' first meeting with a Blackfoot person). Their presence also helps to maintain, at least aesthetically, the connections between the Blackfoot community and the museum or heritage site.

For the community, guiding is an opportunity for employment, a way to maintain Blackfoot presence and voice in the museum, and helps to ensure the exhibit is interpreted by someone with insider cultural knowledge and lived experience of community life. At first glance it appears to be a win-win situation. However, interviews with guides at the case studies indicates that in practice it can be a challenging experience, sometimes highly rewarding, but at times causing real difficulties for the individuals involved.

Three of the case studies exclusively employ Blackfoot guides to interpret the Blackfoot exhibits. Buffalo Nations Luxton Museum is the exception,

as it employs a mix of First Nations and non-Native staff. Frances Kaye's (2003) research on the founders of the Glenbow and Luxton museums reveals that prior to its change in ownership the Luxton Museum did propose community employment. 'In 1958 and 1960 Clifford Wilson, the new Director of the Glenbow Foundation, provided another series of memos on the organization of the Luxton Museum' (Kaye 2003:110). He recommended hiring a First Nations person as Assistant Curator:

> It seems to me that if we could get some Indian who has mingled with white men a lot, can speak well and knows a good deal of Plains Indians, it would add an attractive note to the operations of the museum. This might be a somewhat radical departure and Mr Luxton might prefer to employ a white man who knows what he is talking about, but I think the visitors would get a great kick out of having an Indian there, even though he were not in costume.
>
> (Kaye 2003:111)

Although this never came to fruition, the quote is intriguing in its revelation. While it presents an inferior view of First Nations peoples and emphasises the spectacle of employing them for the entertainment of visitors, the suggestion of making the person Assistant Curator would have placed an Indigenous person in the 1960s in a position higher than either Glenbow or Head-Smashed-In does today.

Community run Blackfoot Crossing is unsurprisingly the case study that most comprehensively employs Blackfoot staff. All staff members are Siksika Blackfoot, with the exception of one Cree employee.[1] Consequently all interpretive guides are local community members. At Head-Smashed-In and Glenbow, Blackfoot interpretation was a condition negotiated for during the community engagement process. All the interpretive staff at Head-Smashed-In must have Blackfoot cultural knowledge and speak Blackfoot, which in practice restricts employment to Blackfoot community members (see chapter six). At Glenbow, an agreement was made to have Blackfoot staff interpret the co-produced Blackfoot Gallery *Nitsitapiisinni*.

> There was an agreement in place I believe for over fourteen years, where the Glenbow would have a member of the Blackfoot Confederacy deliver Blackfoot Gallery tours and that the only exceptions would be Dr. Gerry Conaty, but he is adopted into some of the Nations and he has a wealth of knowledge. He has his Indian name. So it's, you know, and it's not him volunteering to Sandra, it's when I haven't been available, Sandra hasn't been available, he has been asked to do that.
>
> (Interview, Wolfleg 2008)

However, such policy is open to criticism. The policy of restricting interpretation to First Nations people in the National Museum of the American

Indian (NMAI) has been questioned by Larry Zimmerman, who argues that non-Native interpreters can provide authentic information too:

> In museums focused on Native Americans, staff members must abandon colonial and stereotypic views about Native Americans. They also must challenge notions commonly held by Indians and non-Indians that only Indians can provide authentic information about Indians.
>
> (2010:33)

Zimmerman frames his commentary in the preliminary footnote of his paper, acknowledging that he has chosen not to follow the recommendations of the reviews of his article; stating:

> I certainly do know that there is a complex history relating to the very idea of "Indian" and the relationship of Indians to museums, both too long to tell in an op-ed piece. Simply put, I am concerned about the self-perceptions of Indians and non-Indians and their views of each other within Native American-focused museums that complicate—if not mystify—notions of authenticity and truth.
>
> (2010:35)

Zimmerman raises a key issue about ethnicity and authenticity. Neither skin colour nor birth endows people with innate knowledge or cultural insight. A person can speak about any topic, but for their words to be recognised as a valid source of information they must be accredited in some way. Who defines the credentials is the nub. In politics an elected member has a mandate: the authority granted by a constituency to act as its representative. In cultural terms it is not always possible or suitable to find elected representatives with clearly granted mandates to speak. In Blackfoot communities, there are two potential groups—the elected chief and council and the Elders. Blackfoot government has the mandate to speak on current issues; but the Elders, although unelected, are recognised as authorities on heritage and traditional knowledge. Elders have to earn their rights through the sacred societies and their position is dependent upon others' recognition of their knowledge. Within the community, people will refer others to appropriate Elders for information, thus Elders are authorised to speak through their community members' recognition of their knowledge, their membership of societies and their earned cultural rights.

For a person to have what they say taken seriously, they need to be recognised as having the appropriate knowledge, particularly by those whom the individual seeks to speak about or on the behalf of. This is true in any society or profession, and is the reason people gain qualifications and build résumés, to prove their authority on a subject or practice. In Blackfoot society it is normal protocol for a speaker to state the location from which they speak before starting. As such they will name themselves, their family members,

and Elders who have informed their knowledge. This allows others to judge the validity of what they say in the context of their cited references.

The authority to speak can appear to be based on race because there are relatively few non-Blackfoot people who have the gained the knowledge and rights to speak on behalf of the community. The community is relatively closed and the traditional knowledge transfer process takes many years of dedicated participation. Gerry Conaty was not Blackfoot, but he could cite the Blackfoot Elders who he learnt from, the Blackfoot societies he was involved with, his honorary status as a Chief, and his authority on the subject. As such he was recognised by the Blackfoot as validated to speak about, and in certain circumstances for, the aspects of Blackfoot culture he knew about.

Of course, it is possible for museums and communities to reduce these complexities to a simple matter of racial identity, and when this happens there is a potential for community members to be employed on the basis of cultural membership rather than knowledge (which is a criticism some Elders have levelled at Head-Smashed-In). But there are also times when younger community members are employed for their dynamic interpretation skills, and then offered support to supplement their knowledge (which is one of the approaches taken at Head-Smashed-In). As cultural insiders, community members have access to Elders and other authorised sources of information that non-community members would find harder to reach.

Les Goforth emphasises the logic of employing community guides in terms of honouring Indigenous community contributions and knowledge:

> First Nation involvement has to cover all areas of activity from construction, art, design, administrative, management, consultants and Elder Spiritual advisors. It would be nothing more than a mockery if when completed, the museum hired staff with little or no knowledge of the meanings and purpose of the displays.
>
> (Goforth 1993:16)

The Blackfoot community has reacted negatively when someone who is not recognised or authorised by the community to speak, attempts to speak about or for the community, or shares information that is restricted. This is not because of the persons' race or community ties. Instead the reasoning is threefold. Firstly some Blackfoot information is restricted and requires cultural rights to access, and is not for public dissemination. Secondly, non-authorised representatives may present erroneous information, which could potentially harm the community, disrupt oral histories and damage future rights claims. Thirdly, the Blackfoot community has experienced generations of exploitation at the hands of colonial authorities and is acutely sensitive to potential for further cultural exploitation such as non-community members profiting from community knowledge. Consequently, there is often a desire to maintain control over what some see as one of the last resources they have—their knowledge. In this way an exclusive Blackfoot employment

policy can be seen as a form of positive discrimination to help to return economic benefits and some control to communities.

A number of these issues are raised in the Site Manager's explanation for Blackfoot employment at Head-Smashed-In:

> It wasn't a major mental leap for the Government of Alberta to look at it in terms of why shouldn't we employ Blackfoot here? Why shouldn't we have them interpret Native culture as Native people? It is colourful, it's certainly more representative, or, accurate is perhaps the wrong term, it is certainly more of an experience for the visitor to be here and see people who are very specifically related to this locality. We employ Native people in a positive way, not in menial jobs, but in real responsible jobs that pay good wages.
>
> (Interview, Site Manager 2006)

Interestingly some of the language of spectacle that could be seen in the Luxton Museum's 1958 and 1960 memos discussed earlier is echoed here through the use of terms such as 'colourful' and 'more of an experience for the visitor'. This emphasises the underlying complexity of the potential for guides to be seen as part of the exhibit they are interpreting.

Traditionally Blackfoot history is maintained orally, through storytelling and guides can draw on this tradition and present oral accounts of their history to visitors, supplementing and enriching the fixed displays. At Head-Smashed-In they bring in Kainai and Piikani Elders to provide oral history sessions during the guide training. Jim Martin explained the value of guides learning from Elders like Rosie Day Rider:

> Rosie again was asked to participate because she also knows a lot about the early days of the jump and has stories from her grandmother who was told by her grandmother of actual accounts of the jump. So there is an unbroken oral history that Rosie carries.
>
> (Interview, Martin 2008).

Community guides also bring their own knowledge and expertise to the job. At Head-Smashed-In they have employed Elders like Blair First Rider and Lorraine Good Striker to work in interpretation, drawing on their deep cultural knowledge and Blackfoot language. Lorraine explained the importance of having Blackfoot guides:

> I think with this place it makes it a unique site because it has its own people telling the stories of our culture, whereas it is not going to sound natural if it is non-Natives and other cultures being the interpreters. The visitors want to hear it from the people who are the Blackfoot . . . Some of the interpreters come here with no knowledge of their culture, but we train them. Some come here with their own stories from their

Grandmothers and Grandfathers which makes it even better, because they are including the information given to them by their family members implementing them right into their tours. We share stories here and that is what makes the place come alive.

(Interview, Good Striker 2006).

Siegrid Deutschlander and Leslie J. Miller's examination of First Nations guides' interactions with non-Native tourists at cultural sites and events in Southern Alberta emphasised that Blackfoot identity was an important part of the role of interpreters. They concluded that the cross-cultural interaction is a political encounter which helps improve non-Native views of Indigenous culture and counters dominant colonial narratives that persist in modern Western society.

> In short, these sites have made openings for new ways of thinking about matters that were formerly taken for granted. History or tradition becomes political when visitors are provoked to challenge its facticity; the politicizing moment comes when visitors recognize that there are histories instead of History, and that the ways we represent a past or a people have real consequences for our lives.
>
> (Deutschlander and Miller 2003:42)

In my research there was a general consensus amongst the interviewees that community employment and interpretation was a positive step in improving Blackfoot representation and control. Blackfoot guides add to the static displays developed by the community by providing:

1. a connection to the community
2. community perspectives
3. personal stories
4. a way to continue the tradition of presenting history orally
5. a chance to interact with visitors and challenge and change stereotypes
6. drama of live interpretation
7. a real 'contact' experience.

Nevertheless, these last three points raise issues about the complicated realities of guiding, and raises questions about whether it is really empowering or whether guides are exhibited through the process.

THE SPECTACLE OF LIVE INTERPRETATION

> Within the North American imagination, Native people have always been an exotic, erotic, terrifying presence.
>
> (King 2003:79)

Blackfoot guides have a dual role in the museum, they are empowered to speak about their communities, but they are also symbols of themselves, performing 'Blackfootness' for the visiting audiences (see Figure 8.1). Interpretation is a form of performance and as such falls into the spectacle of display. As part of the 'show', they are a draw for tourists who can make 'contact' with 'real living Indians', as 'exotic Others', within the safety of the culturally familiar museum. Even at the NMAI, purpose built to change and empower Indigenous representation, they cannot escape the problem of exhibiting guides. Associate NMAI Curator Paul Chaat Smith frankly states:

> The Indian floor staff have become objects, and it is safe to assume all of them knew this would happen when they signed on. They are the first living Indians many visitors have ever "seen," although Washington is home to thousands of Indians.
>
> (Smith 2009:99–100)

Blackfoot guides act as 'points of contact' within the museum as 'contact zone' (Clifford 1997). Laura Peers observes that Native employment at historical reconstruction sites creates 'first encounters' between tourists and Native interpreters (2007). From conversations with visitors to one of her case studies Peers notes that 'many visitors admitted that it was the first time they had ever spoken with a Native person' (2007:145).

As 'objects of encounter' Blackfoot guides may be interpreted by tourists as part of the museum exhibit and experience. Paradoxically this reinforces the stereotypes of Indigenous people as curiosities to be viewed, whilst simultaneously empowering community members to challenges such stereotypes. The encounters are often used by guides to promote their culture and history to international audiences. However, many guides spend a substantial amount of their time countering racist stereotypes and misunderstandings about their people.

> Native interpreters have an agenda of their own which involves educating non-Native people about the important historical roles and human dignity of Native people . . . Marie Brunelle, a former interpreter . . . expressed this goal by saying, 'If we can reach just one person, teach one person that we are real human beings, then it's all worth it'.
>
> (Peers 2007:171)

This quote illustrates the level of racism some guides have to face in their daily encounters with visitors. This feeling was echoed by an Elder on the Blackfoot Gallery Committee who wanted the exhibit to help people understand the Blackfoot: 'we need to be perceived as human beings' (Glenbow 1999b:10). At Head-Smashed-In, the late Lorraine Good Striker recalled:

> Some people actually come here and have never seen a Native person in their life. Some of the visitors see it as such an honour to see a Native person

they are just dying to touch your hair or skin, and they say 'I touched an Indian person!' Some people still have the idea that when you meet a Native person they still say 'How!' and that's real Hollywood. Some people think that there is a buffalo jump hunt that is going to take place in a matter of hours, 'when is the next buffalo jump going to take place?'.

(Interview, Good Striker 2006)

Good Striker highlights the level of ignorance of some visitors to Head-Smashed-In, and shows that guides have to endure and counter stereotypes before they can be heard in their own right by audiences. Community guides have to fill the voids left by inadequate education systems, biased grand narratives and Hollywood misrepresentations of Blackfoot and Indigenous peoples. Community guides are empowered to speak, but to audiences who are often unable to hear what is being said.

The line between empowerment and exhibition is especially blurred when considering the interpretation of difficult histories such as the residential schools (see chapters two and seven for further details). Guides at Glenbow and Blackfoot Crossing give tours and run cultural awareness workshops for professional groups such as police and social workers, which include interpretation of the residential school era. As part of the interpretation some Blackfoot guides share personal stories about their own residential school experience. The aim is to expose hidden histories to visitors in a powerful and compelling way to help to educate and decolonise Canadian mainstream thought by 'truth telling'(Lonetree 2009).

Guides chose when, if and how to share their personal stories. However, placing individuals in situations where they recount personal suffering for visitors multiple times a day as part of their daily job has the potential for negative consequences that must be carefully considered. Such memories are painful and often close to the surface. A former Blackfoot Glenbow staff member stated 'I hated the whites for what happened to me at the residential school' (Interview, Crane Bear 2008). The sensitive nature of the subject can be heard in Glenbow interpreter Adrian Wolfleg's description of when and why he shares his story:

With the more personal stuff it depends on the group. If they're sitting there and they are nodding off then I'm not going to pour my heart out to them, but also I wouldn't necessarily pour my heart out to any group because I am there to provide some education, not there to be trying to get compassion there in any shape or form, or to validate anything that has happened to me. When we look at the comparing cultures, I share my experience that I was punished for speaking my language. And at four years old I didn't know that I knew more than one language, I just respect-fully responded politely in my Native tongue. I was asked to pass a slice of bread. I passed a slice of bread and said . . . Blackfoot for 'here you go' and was brought to the bathroom. Had my head hit against the sink. Had

to chew soap. Chew it and swallow it. And they were helping me, they were putting it in my mouth. I don't use soap today. I can't stand the smell.

(Interview, Wolfleg 2008)

Personal accounts of the horrors of the residential school system help expose hidden narratives, described by the Director of Blackfoot Crossing as a 'black eye on Canadian history' (Interview, Royal 2008a). However, it is vital for museums to balance the educational needs of their audiences with the emotional needs of their guides who recount these experiences.

Residential school testimony from survivors including many who were victims of child abuse are currently being collected by the Truth and Reconciliation Committee in Canada. Guides who share their experiences through first-person interpretative tours for visiting tourists can help further understanding of this hidden history, which was particularly important prior to its official recognition in 2008. Yet, once again it very much places individuals on show, potentially 'standing for' a traumatic history rather than being seen by visitors as individuals employed for their skills and knowledge.

PARTICIPANTS ON SHOW

In addition to guides, community participants who engaged in the creation of exhibits are also exhibited within the museum through the inclusion of their photos, voices, videos, names and wax models. Whilst such inclusion honours their contributions and publically establishes their ownership of the exhibit, it also turns them into part of the spectacle for tourists to 'gaze' at.

Such inclusions are a complex issue because it is culturally appropriate to cite your sources, namely the Elders who taught you, thus it is appropriate to include the participants' names. Elder Pam Heavy Head explains:

> . . . they should acknowledge the people that they get their information from, specific knowledge, because that way . . . I can only tell it the way that it was told to me and I can only give it the way it was given to me. But I have to always acknowledge that this is the person who told me.
>
> (Interview, Heavy Head 2008)

Arguably the inclusion of photos, videos and wax models moves from acknowledgement to display. The inclusion of wax model replicas of community members in dioramas suspends them between the living and the dead. Conal McCarthy, on describing the representation of Māori in New Zealand, sums up the diorama's historic use:

> Wax figures have a long association with public display and with the representation of the Other (Atlick 1978: 333–49; Jacknis 2002). Suggestive of corpses, they are 'equiposed [sic] between the animate and the inanimate, the living and the dead' (Kirshenblatt-Gimblett in Karp and

Lavine 1991:398) . . . eventually appearing in New Zealand museums in the late nineteenth century. When real Māori proved to be too much of a handful or refused to live up to their ethnic stereotype, wax models were found to be a much more malleable substitute, their mortuary pallor signifying their fate in a much more acquiescent way.

(McCarthy 2007:42)

Kirshenblatt-Gimblett describes that 'human displays teeter-totter on a kind of semiotic seesaw' between living and dead (1998:35). 'The semiotic complexity of exhibits of people, particularly those of an ethnographic character, may seem to be in reciprocities between exhibiting the dead as if they are alive and the living as if they are dead, reciprocities that hold for the art of the undertaker as well as the art of the museum preparator' (Kirshenblatt-Gimblett 1998:35). Focusing on wax figures in dioramas, she describes Boas' objections to them:

It is precisely the mimetic perfection of such installations, and perhaps also their preoccupation with physiognomy, that so disturbed Franz Boas, who resisted the use of realistic wax mannequins in ethnographic recreations. They were so lifelike they were deathlike. Boas objected to "the ghastly impression such as we notice in wax-figures," an effect that he thought was heightened when absolutely lifelike figures lacked motion. Furthermore, wax as a medium more nearly captured the colour and quality of dead than living flesh, and in their frozen pose and silence wax figures were reminiscent of the undertaker's art.

(Kirshenblatt-Gimblett 1998:39)

Judy Bedford recalled a story that emphasises Kirshenblatt-Gimblett's point. The artist who originally created the mannequins for Buffalo Nations Luxton Museum 'was actually also part of the undertaking office, where his headquarters were. And as the body parts were being made people thought it was dead bodies hanging up' (Interview, Bedford 2008).

Interestingly, despite the concerns within museology about the use of 'deathlike' wax figures freezing cultures in the past, each of the case study museums used them with general Blackfoot approval and even at the request of Blackfoot exhibit team members. At Buffalo Nations Luxton Museum out-dated dioramas depict sacred events using a mixture of realistic and caricatured wax models. Pauline Wakeham, describes Buffalo Nations Luxton Museum's dioramas as a 'Western invention that renders a spectacle of otherness permanently paused for the fascinated surveillance of the white spectator, the diorama subordinates its object matter to a fetishistic colonial gaze' (2008:4). However her analysis has been critiqued by Aaron Glass (2010) in his review of her book *Taxidermic Signs*. Glass argues that 'by refusing to engage in an interpretive practice that might reveal and highlight Indigenous agency—even, or especially, in the face of colonial power—Wakeham is in effect once again silencing "the Indian" as a historical and

contemporary actor in exchange for a presumably political critique of colonial domination' (2010:76).

One might assume such displays of Okan (Sundance) in dioramas at Buffalo Nations Luxton Museum would be disapproved of by the community given their sacred and private nature (see Figure 8.2). However, Glenbow Curator Gerry Conaty recalled a visit to Buffalo Nations Luxton Museum with the respected Blackfoot Weasel Moccasin family, which illustrates the layered complexities of these matters:

> Florence Scout, who was Dan's wife, she was in her 60s, looked at that Sundance diorama and she thought it was terrific. We were talking about the Blackfoot gallery and Allan and some of the others who had been to New York said you've got to do those things that they did in New York with the North-West Coast. Who did those? The name Franz Boaz come to mind? In 1901! So, you know, this idea that we shouldn't be representing any people, might really be mostly a concern of museum professionals. You start talking to people and they really want to create it the way it is; show people how we do things. As long as the dioramas are done carefully.
> (Interview, Conaty 2008)

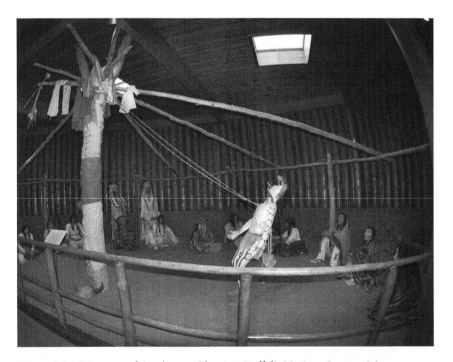

Figure 8.2 Diorama of Sundance (Okan) at Buffalo Nations Luxton Museum.
(Photo by Onciul 2010). Objects belong to the Glenbow Museum. ©Glenbow, Calgary, 2014. Printed with permission of the Buffalo Nations Luxton Museum.

Although the Blackfoot may choose to use wax models, it is unclear as to the extent to which they are attempting (consciously or subconsciously) to fit the confines of the museum as a cultural form. Seeing dioramas in other museums conveys a message that these are what museum audiences expect to see (as discussed in chapter five and Brady 2009:145–146).

At Blackfoot Crossing there is an attempt to disrupt the potential for dioramas to freeze people and culture in time and space, and weight the 'semiotic seesaw' (Kirshenblatt-Gimblett 1998:35) in favour of living culture. The *Creation Tipi* at Blackfoot Crossing displays a diorama of wax mannequins cast from living Siksika members who then feature in the audio-visual film projected onto the canvas above the diorama (see Figure 8.3). The actors play themselves as they tell a story, in English and Blackfoot, of a grandmother teaching her granddaughter berry picking. The exhibit layers wax figure upon audio-visual upon living interpreter creating a living continuum between inanimate, animate and live.

However, drawing from the community to create dioramas adds yet another layer of complexity to display. Dioramas are understood differently by community members compared to tourists visiting exhibitions. For community members the exhibit speaks on a personal level about people they know. Rather than tourists gazing at 'Others', community members see neighbours, Elders, leaders, family, friends, ancestors and possibly even themselves. Community members can draw on a vast resource of insider

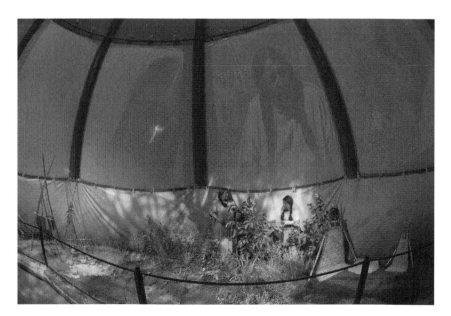

Figure 8.3 Blackfoot Crossing *Creation Tipi* diorama and audio-visual.
(Photo by Onciul 2009). Printed with permission of Blackfoot Crossing Historical Park.

knowledge so that an image, object, symbol, song, word or name can evoke a whole concept of Blackfoot epistemology, or an aspect of community relations, which may not even be apparent to non-Blackfoot curators or exhibit designers.

Blackfoot guides can draw out some of this information for non-community audiences, and can use genealogy to connect community visitors to the display to help to generate pride and ownership of the exhibit. Glenbow Interpreter and School Programmer, Adrian Wolfleg explained:

> The pictures are there for a meaning, for a reason. We personalise it for them [community visitors], especially for the younger ones that might not know. "Did you know that's your great uncle?" Let them have a sense of pride and also let them know that they have a reason to be proud. Going back as reminders for them, they know this stuff, they were raised through this. They may not all have the same experiences, but pulling from them what they actually know: "I remember that!" "Oh that's why my grandfather..!" And so, giving a bit of ownership with it and also making it relational. So they are learning about themselves from what they actually know and experienced, rather than from a website . . . Bringing it home.
>
> (Interview, Wolfleg 2008)

The community-guide-to-community-visitor relationship and interaction is different to that of guide and tourist. Former Glenbow Gallery Interpreter, Sandra Crazybull, explained the difference when interpreting the residential school through her personal experiences:

> [When speaking to non-community members] I make it a connection between what I have gone through in my own personal life and how residential school effects me today and how it effects my entire family, but I don't leave it in a negative kind of mode. I kind of try to present that through the hardships that I've been through I really try to make a difference for my own children . . . If a Native group comes then I do a similar story, but a little bit different because you have to allow for them make connections again. Because they are making connections to how, why, and they get angry sometimes too because there are social problems that are still occurring today, there is still poverty, there is still dysfunction, there are still broken marriages and all these social problems that still happen, that stem from the residential school . . . You have to keep in mind that it is more of a personal story to them.
>
> (Interview, Crazybull 2008)

The potential for personal connections with the history makes telling difficult and emotional subjects particularly sensitive, but it also makes positive, pride-building experiences all the more powerful and influential.

For community visitors the inclusion of community members in displays conveys a wealth of information that tourists may not notice. For tourists such images show examples of Blackfoot people, but for community visitors they represent individuals, and as a result it is vital that people are displayed with respect. This is easier in theory than in practice, as non-community museum employees tasked with working on exhibits may lack the cultural capital and insider knowledge to understand and interpret all the meaning embedded in Blackfoot cultural material and the connections, historical, political and familial, between members of the community. Without a lived experience of Blackfoot epistemology or the ability to think and speak in Blackfoot language, some concepts maybe inaccessible to non-community members as they do not translate into English. Further still without knowing the community intimately interpersonal relations can be overlooked. Put simply, errors can easily occur, despite the best of intentions.

One such mistake exemplifies the potential for negative consequences for those community members on display. Years before becoming a Glenbow interpreter, Adrian Wolfleg posed for casting so that a wax replica could be made of him for inclusion in Glenbow's *Nitsitapiisinni* Gallery as a participant in a diorama of a ceremonial tipi transfer (Figure 8.4).

Wolfleg recalls the process of how he came to be involved and what went wrong:

The Ethnologist had asked me if I would be captured in a cast. So I'm in the tipi and it has toured Switzerland, through Germany, Manchester

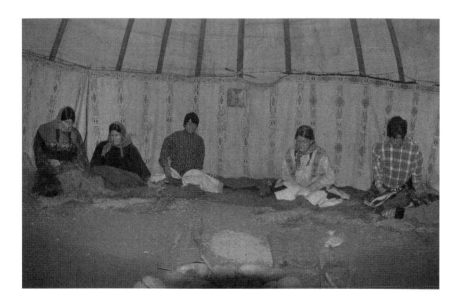

Figure 8.4 Tipi transfer ceremony diorama at Glenbow.

(Photo by Onciul 2009). Printed with permission of the Glenbow Museum. ©Glenbow, Calgary, 2014.

and there is a travelling version of the gallery at the Blackfoot Crossing Historical Park. I had gone out trusting them. But the way it is actually set up in there, there is a contrast between the oral and the visual. The oral, the Elder is talking about how I am another one that is supporting the song. But in the written, that lady is listed as my spouse and that is [actually] my Aunt . . . So there were really some challenges dealing with that because the way it is presented. And our friends come here, people know us, people know our family and it was a shock, but nothing has ever changed. The wording has not been changed and there are so many things that could have been done to have it explained. Even just to go in line with the oral that we are supporters of that, rather than a couple which is derogatory.

(Interview, Wolfleg 2008)

When asked if he had requested the exhibit to be changed Wolfleg continued:

WOLFLEG: We talked about it way back and lots of "yep, yep, yep, yep, yep" but nothing. Directed to someone; directed to someone else. It was so long ago. It was a shock, it was embarrassing and so I am glad that it is not listed as our names.

ONCIUL: . . . could people recognise you?

WOLFLEG: Yeah

(Interview, Wolfleg 2008)

This example illustrates the importance of accuracy and attention to detail when creating community exhibits for community visitors. Errors that tourists will not recognise can be offensive and cause embarrassment to community members if they are represented incorrectly to their own community. Individuals like Wolfleg have to return to their communities and live with the consequences of the way museums have represented them. This leads the discussion on to the cost and consequence of engagement for community members who are held by their community to account for the representations and interpretations they contribute to in museums, discussed in the next chapter.

As explored, museums need to carefully consider the consequences of including participants in the exhibits, where community members can recognise them and visitors can perceive them as part of the collection on display. There is a need for greater appreciation of the challenges guides face when trying to interpret exhibits, and the fine line between showing and being on show.

The exhibiting nature of including community members in displays starts to reveal some of the potential for negative consequences of community engagement for the individuals involved. Community members have a diversity of experiences of engagement. Some gain friendships, knowledge, access

to material culture and even improve their social standing as a result of their engagement; whilst others experience feeling of pressure, derogation, embarrassment and being undervalued. Some even experience accusations from their own communities of being 'sell-outs' exploiting the culture for their own gains and siding with a traditional adversary, the museum (and by implication, the government and oil companies that may fund them). Many experience a combination of both. By engaging with museums, community members become vulnerable to these positive and negative outcomes as their reputations are tied to the museum for the period of engagement and the lifetime of any products they co-produce.

NOTE

1. At the time of interviewing in 2008.

REFERENCES

AFN (Assembly of First Nations) and CMA (Canadian Museums Association), 1992b. Task Force Report on Museums and First Peoples. *Museum Anthropology*, 16(2) pp. 12–20.

Bedford, Judy. 26 Sept 2008. Interview. Calgary.

Brady, M.J., 2009. A dialogic response to the problematized past: the National Museum of the American Indian. In S. Sleeper-Smith, ed. *Contesting Knowledge: Museums and Indigenous Perspective*. London: University of Nebraska Press, pp. 133–155.

Clifford, J., 1997. *Routes: Travel and Translation in the Late Twentieth Century*. London: Harvard University Press.

Conaty, Gerald (Gerry). 20 Nov 2008. Interview. Glenbow.

Crane Bear, Clifford. 8 Oct 2008. Interview. Siksika Reserve.

Crazybull, Sandra. 23 Sept 2008. Interview. Glenbow.

Deutschlander, S. and Miller, L.J., 2003. Politicizing Aboriginal cultural tourism: The discource of primitivism in the tourist encounter. *Canadian Review of Sociology/ Revue canadienne de sociologie*, 40(1) pp. 27–44.

Glass, A., 2010. Review essay: making mannequins mean: Native American representations, postcolonial politics, and the limits of semiotic analysis. *Museum Anthropology Review*, 4(1) pp. 70–84.

Glenbow, 4 Feb 1999a. *Blackfoot Exhibit Team Meeting*. [Minutes] Unlisted. Calgary: Glenbow Archives.

Glenbow, 23 Feb 1999b. *Blackfoot Exhibit Team Meeting*. [Minutes] Unlisted. Calgary: Glenbow Archives.

Goforth, L., 1993. First Nations and museums—a Native perspective. *MUSE*, XI(1) pp. 14–16.

Good Striker, Lorraine. 25 July 2006. Interview. HSIBJ.

Heavy Head, Pam. 18 Sept 2008. Interview. Fort Macleod.

Kaye, F.W., 2003. *Hiding the Audience: Viewing Arts & Arts Institutions on the Prairies*. Edmonton: University of Alberta Press.

King, T., 2003. *The Truth About Stories. A Native Narrative*. Toronto: House of Anansi Press.

Kirshenblatt-Gimblett, B., 1998. *Destination Culture: Tourism, Museums, and Heritage.* London: University of California Press.

Lonetree, A., 2009. Museums as sites of decolonisation. Truth telling in national and tribal museums. In S. Sleeper-Smith, ed. *Contesting Knowledge. Museums and Indigenous Perspectives.* London: University of Nebraska Press, pp. 322–337.

Martin, James (Jim). 24 Sept 2008. Interview. HSIBJ.

McCarthy, C., 2007. *Exhibiting Māori: A History of Colonial Cultures of Display.* Oxford: Berg & Te Papa Press.

Peers, L., 2007. *Playing Ourselves: Interpreting Native Histories at Historic Reconstructions.* Plymouth: AltaMira Press.

Repatriation Office, 2011. *The Repatriation of Ishi, the Last Yahi Indian.* Washington: Smithsonian National Museum of Natural History. [Online] Available from: http://anthropology.si.edu/repatriation/projects/ishi.htm [Accessed 25 Aug 2011].

Rockafellar, N., 2010. *The Story of Ishi: A Chronology.* [Online] San Francisco: University of California. Available at: http://history.library.ucsf.edu/ishi.html [Accessed 25 Aug 2011].

Royal, Jack. 25 Aug 2008a. Interview. BCHP.

Scheper-Hughes, N., 2004. Ishi's brain, Ishi's ashes: anthropology and genocide. In N. Scheper-Hughes and P. Bourgois, eds. *Violence in War and Peace. An Anthology.* Oxford: Blackwell Publishing, pp. 61–68.

Site Manager. 24 July 2006. Interview. HSIBJ.

Smith, P.C., 2009. *Everything You Know about Indians Is Wrong.* London: University of Minnesota Press.

Wakeham, P., 2008. *Taxidermic Signs. Reconstructing Aboriginality.* Minneapolis: University of Minnesota Press.

Weasel Head, Frank. 13 Nov 2008. Interview. Calgary.

Wolfleg, Adrian. 8 Sept 2008. Interview. Glenbow.

Zimmerman, L.J., 2010. Commentary. "White people will believe anything!" Worrying about authenticity, museum audiences, and working in Native American-focused museums. *Museum Anthropology*, 33(1) pp. 33–36.

9 The Cost and Consequence of Engagement

The museum enterprise, built upon a colonial heritage that demanded control of Native people, now has need of Native informants to both correctly identify objects and serve as negotiators between two parties with vested interests.

(Mithlo 2004:757)

When you are trying to bridge two cultures together you get walked on from both sides.

(Interview, Crane Bear 2008)

Museums are increasingly keen to talk to Indigenous communities about collections and display, but few listen to communities' experiences of engaging with museums. This chapter will explore the view from the other side and analyse how community members experience engagement. It is in these accounts that it is possible to hear where the dilemmas remain, new challenges occur and how these issues continue to make museum and community relations unsettled.

Engagement is generally viewed by museums as a positive process for the benefit of the museum and community involved. Community participants are seen as beneficiaries, who gain representation, a voice within the museum, and training. However, community members often view the museum as the main beneficiary. My research reveals that for community members engagement can come at great cost, and they engage knowing the risks because they believe in the importance of their work. However, this agency is often overlooked because the assumption that community members are beneficiaries obscures the potential for consideration of negative outcomes. As beneficiaries, there are expectations placed upon their behaviour. In particular, they are not paid wages, but expected to volunteer their time and knowledge in exchange for representation, training and honorariums.

The chapter aims to show the power of assumptions and to highlight the complicated realities of engagement. The goal is to help find more sensitive ways of working with communities to limit the potential for negative, unwanted and unexpected consequences.

THE RESTRICTING POWER OF ASSUMPTION

Museums assume engagement is good for the museum and the community, and as a result community participants and employees are automatically viewed as beneficiaries. These assumptions belie the possibility that there may also be negative consequences for community members. As such, the reality of engagement from community members' perspectives is an area that is under-explored in current museology, both in theory and in practice (with the exception being Lynch 2010, 2011; Lynch and Alberti 2010).

As beneficiaries, participants' agency and ability to challenge the museum is restricted, limiting what is made possible through engagement. The assumption is paternalistic and patronising. Museums congratulate themselves for *giving* communities an opportunity to correct mainstream misrepresentations of First Nations peoples. Historically Indigenous peoples have been purposefully misrepresented in museums as uncivilized, savage, barbaric and animal-like, being previously included in natural history rather than cultural displays. Museums retain control by generously hosting community members as invited guests. As Bernadette Lynch notes:

> Welcomed into the 'invited space', participants are deftly encouraged to assume the position of 'beneficiaries' or 'clients'. This in turn influences what they are perceived to be able to contribute or entitled to know or decide.
>
> (Lynch 2011:148)

Whilst praising Head-Smashed-In for its inclusion of Blackfoot people, and Glenbow for entering into a power-sharing partnership with the Blackfoot people, Kainai Elder Narcisse Blood states that:

> . . . other museums are very paternalistic, very arrogant. 'We are doing you a favour. This belongs to the people, and helps to educate the people.' That is a nice statement, but it simply isn't true. Because if it was serving its purpose I don't think we would have the kind of racism we have, I don't think the land would be being destroyed and exploited as much.
>
> (Interview, Blood 2007)

One of the clearest examples of the limiting effects of being cast as beneficiaries can be seen in the inequalities of payment. In my interviews Blackfoot participants frequently raised the issue of payment from museums. Community participants are generally expected to work voluntarily or for modest compensation in the form of honorariums, because it is assumed that they are benefiting from the participation in other ways. This is problematic for two reasons. Firstly, without adequate payment only those who have financial support from elsewhere can afford to participate. Secondly, payment is associated with value. All of the case studies claim to work with community

members for their cultural expertise and seek out Elders of high standing, who have specialist cultural knowledge. As such, it seems contrary to then deny them the salary that would be afforded to Western experts. Part of the problem is the difference between community and Western value placed on Indigenous knowledge. Nancy Mithlo notes in Western society, 'typically, Indigenous knowledge is perceived as subjective and restricted while Western knowledge is seen as scientific, objective, and free of restrictions' (2004:743).

In Blackfoot society Elders are viewed as valued experts who keep knowledge on behalf of the community which is vital to the survival of Blackfoot culture and practice.

> These people are like walking text books of knowledge. I mean I can't ever, I could spend days, maybe months with a person like Rosie Day Rider and she will never finish telling me all the stories. That knowledge is so precious, it really is. And you can't get it anywhere else. You know you can't just Google it.
>
> (Interview, Heavy Head 2008)

Elders invest in years of training through participation in sacred societies to gain knowledge and it is customary to exchange something of value for the information they provide. They are the equivalent to Western experts who dedicate their careers to research, speak with authority on their field, and who expect recognition and payment for sharing their expertise. Such customs are not always appreciated by museums, as Elder Pam Heavy Head states: 'There are still a lot of dysfunctional non-Native people on the museum side that are just "what! what! you are going to pay what?!"' (Interview, Heavy Head 2008).

Payment was seen as inadequate by Glenbow participants because it did not reflect the value the community placed upon the knowledge, and was notably lower than that paid to Western experts working on the same Blackfoot Gallery as Piikani Elder Allan Pard recalls:

> It was frustrating working with the museum staff and then I guess the cost, we kept saying a lot of this information didn't come to us without any payment. In our ways we still have to pay for this information; it is like a tuition fee. I go seek information from others; you just don't get it for free. So that was another thing, not that we are money mongrels, but you know, people visiting the museum pay, the museum staff are getting paid. What about the people who own the information? So yeah, convincing them that they had to pay for this information was another matter. Uphill battle. And you know, getting paid appropriately, I am not saying to a point where people were making a killing off it, I think we were barely just getting our costs being paid for, our expenses. But we weren't compensated near what they would compensate [others], it

would be no problem for them to pay one [Western expert] thousands and thousands of dollars. No questions asked about paying him, but it was sure questions when they were to pay some of our Elders.

(Interview, Pard 2008)

Even if it was not the museum's intention, the difference in payment signifies a difference in the perceived value of the individuals' contributions. Valuing Western expertise over Blackfoot knowledge is hardly the decolonising and empowering process engagement claims to be. However, low payment is also linked to the difference in assumed role, with the Blackfoot being 'beneficiaries' they are seen as already gaining from the engagement without payment. Whereas the Western experts are 'at work', something society expects economic compensations for.

Glenbow's former Curator Gerry Conaty addressed the inequality in payment for community participants in his 2006 commentary in *Museum Management and Curatorship*.

Over the past 15 years we [Glenbow] have not significantly increased the honoraria we pay traditionalists for their help, advice, and knowledge. This pay is well below the rate we would pay a museum consultant, and well below the rate we charge others for our own expertise. Yet, these elders represent generations of learning and, in some cases, embody an entire culture. There are several funding agencies that will support assistance from consultants; there are few that will help pay for an elder's help and these endowments are much more limited. We in the museum community need to address this inequality if our 'partnerships' are to have value.

(Conaty 2006:256)

Payment is a delicate subject because there is a fine line between selling culture and honouring a person's contribution and expertise. The Blackfoot Elders do not wish to sell their information. They want their knowledge to be valued. There are many derogative colloquialisms associated with the idea of selling sacred knowledge, such as 'sell-outs' or 'plastic medicine men'. These terms refer to individuals who are accused of selling or sharing cultural information inappropriately, particularly with non-Natives; information that they either do not know, do not have the right to share or are exploiting for their own profit.

The concept of selling cultural knowledge is a very sensitive issue in Blackfoot communities, partly because some members feel that their knowledge is the only thing they have left, as colonialism has stripped away the majority of their lands, resources, language and way of life. Another reason is because oral history, like the Blackfoot's, depends upon the process of passing on information with detailed precision to those individuals in the community who will keep it and teach it. Increasingly Western archaeology and science

is proving that oral history is an effective and accurate way to record history if the process is maintained (for Australian and American examples see: Taçon, Wilson and Chippindale 1996; Makah Cultural and Research Center 2011). Most recently, DNA research on Arctic peoples has confirmed the Inuit oral history about the Tunit people who predated the Inuit and died out around 700 years ago (Raghavan et al. 2014). One of the researchers, Willerslev, said 'I would certainly in the future pay much more attention to oral traditions among indigenous people because they could really guide us into understanding where are the interesting problems to be investigated scientifically' (Willerslev quoted in CBC 2014). As a consequence of the time depth and value of oral history and Indigenous knowledge, it is understandable why it is very carefully guarded, methodically maintained, and often only gradually shared, especially with non-community members.

Subsequently, rather than being beneficiaries, many of the Elders view working with museums to create exhibits as 'doing a favour' for the museum. In their view engagement privileges the museum as the main beneficiary. Glenbow Curator, Gerry Conaty, acknowledged the imbalances and reciprocities in the Blackfoot-Glenbow partnership:

> People bought into it partly because we asked them to participate and to tell us their story and partly because we had already been returning a lot of sacred things to them and going to other museums with them, and I think they felt we would actually listen to them. I also think that their participation in the gallery is a bit of their way of *doing us a favour* because no matter how much we say: 'the exhibit is about all of us,' people still have to come to Glenbow to see it. So it is a little bit more of a, about us, than about them, in that regard. If anybody pushes too much: why did you want to get involved? They wouldn't say 'well because I think the Glenbow was a great place to talk about our culture to educate people,' because that's not what they are interested in. They are interested in their own people, and you do that [teach culture] best at home.
>
> (Interview, Conaty 2008)

With the exception of curators like Gerry Conaty, there appears to be a conflict of perspective with each group generally viewing the other as the beneficiary and themselves as the benefactor.

Issues of payment effect community employment, with Blackfoot guides voicing similar concerns about the level of pay they receive for their expert insider cultural knowledge and skills. At Head-Smashed-In former summer interpreter Kyle Blood explained:

> I dropped an $18.87 job to come here to work here for $9.50. I'm not in it for the money I'm in it for the love of my culture. But in reality, me being a family man, I think the government should take over our wages instead

of passing the buck on to other societies, because if they pay parks and protected areas, their summer staff $20 an hour, why can't they pay us $20 hour too? We are out there dealing with 700 people a day, speaking our heads off, we get tired, especially us boys who dance and sing here. I think they should up the wages especially with this day and age, the cost of gas. Making $9.50 and having a family of four, that is pretty tough.

(Interview, Blood 2006a)

At Glenbow interpreter Adrian Wolfleg described a similar situation. He was dedicated to his job and credited for the way his cultural knowledge enriched the exhibits, yet was faced with job insecurity and economic hardship:

It has been challenging because you get paid when you do the programmes, but if there are no programmes you don't get paid. It's feast and famine, sometimes when you need money like Christmas time there's no tours so there's no income.

(Interview, Wolfleg 2008)

Even at the community run Blackfoot Crossing, Clifford Crane Bear felt his pay did not reflect his expertise or contribution. 'Right now I am fighting with them. I don't work for 75 bucks a day. I work for 200 dollars or when I am in front of a camera it is 350. This is how much they have to pay. So I gave them a break, but I am just going to go and tell them my situation' (Interview, Crane Bear 2008).

Museums often suffer from underfunding which can make it difficult to pay staff members adequately. However, community guides are tarred with the same beneficiary brush as community consultants. Employment of Blackfoot guides meets the requirements set out in the *Task Force Report* (AFN and CMA 1992a,b) and is viewed as an inclusive approach which brings economic revenue and empowerment to the community by enabling them to speak for themselves. In addition community guides are trained in Western museological practice and gain skills and experience that should benefit their careers. As the *Task Force Report* states:

The need for training for both First Peoples and non-Aboriginal museum personnel is critical. To work in established museums, or to develop museums in their own communities, First Peoples need training in all phases of museology.

(AFN 1992b:16)

Nancy Mithlo critiques this approach, noting that:

The policy of inclusion, anticipated by both Native and non-Natives as *the* solution to representational divides places an undue and often unworkable burden upon Native museum professionals to 'bridge'

broad conceptual gaps. Museums are self-perpetuating institutions that generally maintain authority, despite efforts to 'give Natives a voice'.
(Mithlo 2004:746, emphasis original)

She goes on to argue that 'here is the "Red Man's Burden" of today. In an era where Native Americans are still among the nation's poorest, least educated, and most exploited peoples, yet another task is given—to take up the cause of archaeology for educating the "foreign scholars"' (Mithlo 2004:756). Elder Narcisse Blood echoes the need for Canadians, rather than First Peoples, to be educated:

> I think the new comers are the ones who need to be educated, not us. If that could be a goal, I think we could turn things around. Like I said, if it can serve that purpose alone, to educate people, then maybe we have a chance not to destroy ourselves. Again I would like to make the point that it is not us who needs to be educated.
>
> (Interview, Blood 2007)

This highlights yet another common conceptual cross-roads in museum and Blackfoot community thinking, each believing that is it the other who needs to be educated. Whilst both groups learn from each other in the process of sharing information within the engagement zone, Mithlo rightly points out that the burden is placed upon the Indigenous people to educate the museum about their culture and adapt to Western museological practice.

SYMBOLIC ENGAGEMENT

Michael Ames sums up the difficulties First Nations guides face in his critique of the appointment of Aboriginal people to museums in the 1990s.

> First, few positions are available during the present era of declining budgets. Second, it will take years before new appointees reach senior levels—if they bother to stay that long. Third, it exposes candidates in minority positions to allegations of tokenism. Finally, it is difficult to find Aboriginal people who are both interested and qualified to work in museums. Those who do accept museum employment are subject to criticism by other Aboriginal people, because museums as we know them are essentially white European inventions designed to serve the interests of mainstream or non-Aboriginal segments of society.
>
> (Ames 2000:77)

Ames' appraisal of the potential for guides to become tokens, who are exposed to criticism from their own communities, raises two key issues for Blackfoot guides. As the heirs to exhibits they did not create, they gain the dubious honour of becoming the 'public face' of the exhibit. Through their

employment they become both insiders and outsiders of the museum and community. Their identities complicated by their membership in and representation of both. They are not equal members of staff as they have special status to interpret Blackfoot material. Yet they are not simply community representatives because they are paid and contractually required to abide by museum rules and protocol.

Their employment can prevent guides from participating in community events which can create problems when they fail to meet their community's expectations of their duties. For example, guides often complain about not being able to attend community members' funerals due to employment policies on Bereavement Leave. Important community events such as Okan (Sundance) and cultural days also require large time commitments. These pressures can account for some of the high turnover levels of guides at sites like Head-Smashed-In.

The expectation for community guides to bridge the epistemological gap between two cultures and repair a history of colonial relations is a vast burden to place on under-paid, under-valued, often temporary staff members in entry level positions. Former Glenbow and Blackfoot Crossing employee, Clifford Crane Bear eloquently summarises the situation: 'when you are trying to bridge two cultures together you get walked on from both sides' (Interview, Crane Bear 2008). As representatives of the museum and community they can be held to account by both groups and are associated with the positive and negative behaviours of each. Simply for working with a museum, community members can find their loyalty to their community questioned. Clifford Crane Bear explained:

> So all I am trying to say is it is very, very hard for our people, especially for me. When I came back here I wasn't known as Clifford Crane Bear, I was known as "that's that guy who works in the museum" and that was it.
> (Interview, Crane Bear 2008)

At Head-Smashed-In former employee and Elder Blair First Rider highlighted the tenuous position his job placed him in:

> First Nations, when they see you working for the government automatically say you have sold out. Working for the government, working for the enemy, but sometimes it's best to get your foot in the door, you need to make those changes from within, speed things up a bit.
> (Interview, First Rider 2006)

Another Head-Smashed-In staff member explained how his work had affected his relationship with his community and the way other Blackfoot people viewed him:

> I myself was used as an example [in a presentation] by one of the [university] students. It was a Native student, they got up in class and they made

their remarks that: I'm a sell out to the government; I make the government a lot of money; the money that I make from the tipi camp goes into government accounts; which is not true. I was called a 'white man' because I work in the society; that I don't do anything for my own community and never have. So that whole thing, just because I work here. I do get a big backlash because of the work that I do. I would say I have less than half support from my own community for being here and for doing what I like to do. That is why I am not in direct contact with my community anymore, just for that, and that's, you know, I'm fine . . . what I've come to understand is that people from around the world come here to learn and what better place for me to talk to people, rather than going out there and putting a burning car in the road protesting something, I come over here.

(Interview, Kiitokii 2008)

Kiitokii, like First Rider, sees his work as a form of resistance and a way to educate the public for the benefit of his community; however it has been at great personal cost. In her work on best practice in Parks Canada, Kate Hassall observed that the employment of Blackfoot guides at Writing-on-Stone 'must be perceived to be beneficial to the Blood Reserve members to prevent the potential segregation of the guides from the community' (2006:26).

By contrast, some Blackfoot interpreters feel their employment strengthened their position in their own communities. Sandra Crazybull worked at Glenbow and said her relationship with her community had changed:

I think for the better. I think people really look up to me. I think people, well they do, and this is judging from the way that I get invited to different events, they invite me to different gatherings and I am often called upon as a leader, like I am called upon to be a keynote speaker or the person that does the prayer. I am kind of viewed as a person that has a lot of knowledge, like somebody that is well respected in my community.

(Interview, Crazybull 2008)

Crazybull explained that part of the reason for these positive consequences was due to the fact that Glenbow was viewed positively in the Blackfoot community because the Ethnology Curators Gerry Conaty and Beth Carter invested time in building real relationships with the Blackfoot people. She explained that when Blackfoot people came to the museum she would describe the many ways in which the museum engaged with the community, challenging the stereotype of the museum as the enemy (Interview, Crazybull 2008).

These interviews illustrate that community employment in museums has direct and long lasting consequences for the individuals employed and that they can be associated with wider community/museum relations that they may not be able to influence. These individuals return home to their communities and have to live with the consequences of good or bad relations between their employer and their community, sometimes with serious consequences, some even choosing to move away as a result. Thus their positions

are precarious, and without the power to influence and indigenise museum practice they can become little more than symbolic tokens of previous community engagement, rather than empowered employees.

LIVING WITH THE CONSEQUENCES
OF REPRESENTATION

Community participants face similar challenges to guides. As creators of co-produced exhibits their reputations are publically tied to the museums with which they engaged. Being both credited and held responsible for the exhibit they contributed to, there are real-life consequences if things go wrong. For non-Native museum employees there is professional risk, but their personal lives are generally unaffected. For community members the distinction between professional and personal is not so clear cut because representing your own community is personal and will directly effect relations with friends and family.

Mithlo argues that the cross-purpose comparison of community and profession can account for many of the problems encountered in community/museum relations:

> A pan-Native American identity is not a profession, just as anthropologists are not a cultural or political group. . . . This structural problem of comparing a profession with a cultural or political group may well account for the often circular thinking and cross purposes these debates entail.
>
> (2004:748)

I would argue that museums approach engagement as if the community members are professionals, available to work on behalf of their community for the museum to create representation. In attempts to view community members as equals, museums often overlook the additional risks and challenges community participants face, undervaluing the significance and cost of their contributions. Again this relates back to the assumption that participants are beneficiaries. The assumption obscures analysis of the potential for negative consequences for community members and in doing so does not acknowledge the need to compensate them adequately for, or to help to mitigate, the risks they take by participating.

The risks are not new, although with each generation and shift in museology and Indigenous/Western relations, different challenges are created. Since contact community members have found benefits and costs to engaging with the new comers. Mithlo highlights the experience of George Hunt, Franz Boas' Native assistant:

> Hunt's activities with Boas . . . resulted in his life being threatened by his own people. He did continue to collect, playing on his position as

an insider to quell community objections with gift giving and trading for needed cash.

<div align="right">(Mithlo 2004:756)</div>

The community members I interviewed frequently voiced their concerns about working with museums and what their community would think of their actions and the exhibits they helped create. Interviewing Head-Smashed-In's Jack Brink he recalled a common expression the Elders used, they would state that they 'need to do it right':

> . . . because they had seen so many museum type displays done totally without their involvement and done wrong, or done poorly. They said we don't want to do that again because now our name is on this too. Other Native people are going to come here and look at this and if they see something that is all wrong, it is an insult to Native people; it is going to look bad on us.

<div align="right">(Interview, Brink 2006)</div>

At Glenbow the Elders felt the same pressure. At the very first meeting with Glenbow about the development of the gallery Kainai Elder Frank Weasel Head voiced his concerns about their role in the development and how their communities would view their participation.

> How is our community and our politicians going to look at this gallery? Will they react in a positive or negative way? Do we need to go out and talk to them or do we just go ahead? Lots of museums have exploited people, therefore, people are leery. That's why Blackfoot need to be full partners in this gallery—or even consider that the Blackfoot are putting up the gallery with the technical staff from the museum assisting them. The MOU with Mookaakin reflects this approach. Will the people on this committee be under lots of pressure? We can commit to this gallery since we will tell it from our own perspective.

<div align="right">(Glenbow 1998:4)</div>

At the same meeting Elder Pat Provost is recorded as responding by saying:

> Artifacts represent authority. The people on this team all have the rights to speak on the artifacts. With authority, you know how much to discuss without crossing the line. The protesters and politicians don't necessarily have the authority to protest. Elders can be recognised once authority is recognised and identified . . . Various people have different status. For example, Pete has training that only allows him to speak regarding certain things. If protesters protest, and we have the people with authority on the team, then there is nothing to protest about.

<div align="right">(Glenbow 1998:5)</div>

This discussion highlights the Blackfoot teams' awareness of the politics and risks of engaging with the Glenbow Museum. By negotiating their roles, the boundaries between public and private information, the need for authority and right to speak on certain topics, they were developing a discourse to validate and justify their participation to themselves and their community.

For the Elders working on Glenbow's *Nitsitapiisinni* Gallery they had the particular challenge of representing all four Blackfoot Nations. Although they are in a confederacy, they are distinct cultural and political groups. Former Glenbow employee, Clifford Crane Bear explained that his community, Siksika, was least represented within the gallery because the Siksika participants wanted to respect their Elders from the other nations, 'we didn't want to be outspoken', and because they were developing Blackfoot Crossing to tell the Siksika story (Interview, Crane Bear 2008).

Glenbow Ethnologist and Co-Curator of that Blackfoot people have challenged what is on show in the exhibit and she has used the discourse the Elders developed to justify their right to speak on behalf of their community. She gives one such example:

> We've had some people come in from Siksika, who come into the gallery and say: 'well that's not right' and 'where did you get that information?' So we say: 'ok so the Siksika members on our committee were this'. And they say 'oh well!' They may not like them or there's political implications, but they know at least where we got the information. So they may disagree, but it's not just pulled from a book or from the stratosphere somewhere.
>
> (Interview, Carter 2008)

This quote illustrates three important processes at work. Firstly, participants' contributions are honoured and credited by name, citing the source of information, as is customary in Blackfoot culture. Secondly, as is customary, other Blackfoot members respect Elder's rights to speak on their particular area of expertise. Thirdly, Blackfoot Elders are personally held to account for their contributions, individually named, which could impact upon their personal relations with others in their community. As Carter states, there are personal and political implications for the individuals named and their relationship with the questioning Blackfoot visitor. While Carter acted according to cultural protocol and with good intentions, the outcome is to hold individuals to account for something that was produced through cross-cultural team work, consensus and power sharing within the framework of the museum. When considering the limitations and framing the cultural form of the museum places on representation (addressed in chapters five and seven), and the complicated nature of power sharing in the engagement zone (addressed in chapter three), it seems unfair for the community to shoulder the burden of responsibility for representation alone.

Elder Pam Heavy Head explained that the Elders are aware of the potential negative consequences of engaging with museums, but feel it is a necessary risk to set the historical record straight. She argues that the community should focus their anger on representations that are inaccurate and done by others, rather than those created by their own community:

> I know like some of our own people might be upset about it, consider us a 'sell out' you know and stuff like that, and that is to be expected. And some people will, you know, 'why are you selling us out?' Well you know what? It is out there. We need to tell the truth and be mad when it is inaccurate, and be mad when it is being represented by somebody else, because it is out there. There is nothing we can do about it, it's like putting a bridge over the water that is already running . . . you've just got to do it. So to me, you know, we are going to get flack no matter what. People are going to be angry no matter what, but it should be done right.
> (Interview, Heavy Head 2008)

These issues are a constant strain on community participants, even when the exhibits they create are well received by their communities. During an interview with Frank and Sylvia Weasel Head they discussed the pressure Frank felt when their own Blackfoot community members came to view the *Nitsitapiisinni* Gallery Frank had helped to create.

> [At the opening] I was a little bit leery because we've got other, I'm not, I won't say I'm the most knowledgeable from home, I still learn every day, my knowledge is limited. So we still have knowledgeable people at home and some of the other Elders did come to the grand opening and they said you did a marvellous job, you did a wonderful job, it's good as to how you put it together.
> (Interview, Weasel Head 2008)

Frank continued:

FRANK: . . . in the beginning I was on edge. But by the end of the public viewing I was at ease because people kept saying: 'gosh you guys did a good job! You told it our way. Our way!' I tell you there was only one negative remark, had an expert in the language. He came and told me you misspelt this this way, this is the way. And I said to him: 'look there was teamwork and we decided. We put so, so, so, the four persons who come up with the spelling and whatever spelling you come up with we'll back you, so we won't have arguments.' He said, 'Oh, gee that is a good way!' So that was that. And how long it's been there, that has been the only negative remark. But it didn't, I'm not going to say it changed my status on the reserve or anything because I don't, I don't do

those things for that purpose, to gain status. So, you know it didn't change. But a lot of pressure on me for work and by that evening, about 10:30 when it ended we were going to go to the casino, I got to the room and I flopped on the bed and I passed out. You know it was so exhausting.

BRYONY: Yeah, the pressure of everyone . . . ?

FRANK: Yeah, it going right . . .

SYLVIA: I think they were all kind of scared that some people will disapprove

FRANK: Yeah . . .

SYLVIA: So it was a big relief.

(Interview, Frank and Sylvia Weasel Head 2008)

In this discussion Frank Weasel Head gives an example of how he followed the custom of recognising the source of information for the spelling, but emphasised that is was a group decision, rather than holding an individual to account. By emphasising the consensus approach used, which is a traditional Blackfoot decision making method, he won approval for the community groups' action even though a potential mistake had been made.

The Elders recalled a strong sense of being judged by their community for the gallery they produced at Glenbow. Piikani Elder and participant, Jerry Potts, was pleased to note that: 'there were a lot of people who came policing through there just to kind of check it out, but didn't find anything. That is what the beauty was' (Interview, Potts 2008).

Despite the Blackfoot Elder's fears the *Nitsitapiisinni* Gallery was generally well received by the Blackfoot community. The potential for negative consequences was minimised and Elders received positive feedback on their work. Former Blackfoot interpreter for *Nitsitapiisinni*, Sandra Crazybull, praised the work the Elders did:

[When] I came back to visit the museum it was totally different. It was correct. Everything was done properly. Like the way the tipi was faced, wasn't in a wrong direction, like it was when I was a child. There was a lot of little things that people, like a museum environment might not understand or might not know, but because they had our leaders teaching them the way, then I think it really made a difference, like it really made it come alive.

(Interview, Crazybull 2008)

Thus engagement with mainstream museums holds the potential for both positive and negative consequences for community participants working as consultants and partners as they are both credited with and accountable for the co-produced work.

If we re-contextualise the discussion and consider the community participants at Blackfoot Crossing, the literature on engagement theory (Arnstein

1969; Galla 1997) argues that community controlled representation is the most empowering form of engagement, which suggests such risks would be minimised or even removed. However, in practice, it is not so simple. Certainly the Elders were empowered to make decisions about the story, but it still was not possible to represent all of the community, so some members felt left out.

Blackfoot Crossing Director, Jack Royal, states that the Elders who made up the storyline committee were chosen for their expertise and were empowered by the community to decide upon the storyline because of their traditional knowledge and training.

> The Elders had the final say, and I would say there was no argument there. One of the foundations of our culture is the respect. The board was all Siksika members, so we knew that we are not going to question: 'Hey what story are you telling?' Or 'why are you telling it?' Or 'is it just the right story?' Or 'is it true?' Basically they were given a blank piece of paper and said 'we need a storyline, you guys tell us what is appropriate to tell, what is accurate. What kind of stories we should be telling, the whole storyline.' And that was it, there was no argument. They were the bottom line, the storyline committee was. So they had the say on everything we put together. They were given the pen and a blank piece of paper.
>
> (Interview, Royal 2008)

During the development of Blackfoot Crossing there were opportunities for 'blue sky thinking' but by the time the exhibits were being designed the building was underway, so the storyline had to fit within the walls of the exhibit floor. The Elders had to make choices and were both publicly credited and held accountable for them. Exhibit designer at Blackfoot Crossing and former Glenbow employee, Irene Kerr, reflects on the process of the storyline development and recognises the pressure placed upon community Elders.

> It was probably difficult for them because they were definitely sticking their necks out, having to represent this entire [history and culture], and again because of the politics. So I really give them credit for actually taking this on and doing it. And I am sure there is criticism from other people in the community, and rightly so, you are never going to make everybody happy. But we don't bear the brunt of that, they probably do. So that's another thing you have to give [them credit for], and I'm sure it was the same at Glenbow. I am sure you will get someone, probably to this day, that will go up and see, for example, Allan Pard's name there and go back down and say oh Allan why did you . . . you know. So again you have to give them credit for even doing it, I think. They are very brave. And it is something I've never really thought about until

now. Because we just kind of think about it from our perspective, how great they are for us, and how helpful they are to us, without thinking that we are kind of hanging them out to dry in a way. By letting them tell their stories and using what they tell us, it's still kind of, probably not as great for them as we think it is.

(Interview, Kerr 2008)

As Lawlor astutely points out:

A common misunderstanding among reservation tourists, as often enough among academics, is to assume that tribal communities operate more or less in unison on most decisions and plans for collective, public life. This, of course, is manifestly not the case.

(2006:9)

Even with its singular focus on Siksika, Blackfoot Crossing cannot fully represent the whole community, culture and heritage. With approximately 6000 members (Siksika Nation 2011), the Siksika community is a diversity of different groups, identities, opinions and perspectives. Crane Bear claims that Blackfoot Crossing only represents half of the Siksika Nation:

You will never hear about my people [in Blackfoot Crossing]. My people down here are called the Northern Blackfoot and our chief is chief Old Sun of the Medicine Clan people. We have our own history, we have our own stories. The people you hear on this reserve, or you hear in the history books, are about Crowfoot and his people. They are Southern Blackfoots, not Northern Blackfoots. They are two separate families that are there [on Siksika Reserve].

(Interview, Crane Bear 2008)

Blackfoot Crossing Director, Jack Royal, acknowledges the limitations of the story the exhibit tells:

Obviously we can't tell our whole story in one little display downstairs. There are so many aspects, so many components, so many different things that we could communicate, that we can't possible do it in one sitting. So the plan is to eventually have, keep it fresh, keep it continuing in terms of the next portion of the story we want to tell. I anticipate that it would take, if we are changing it every two to three years, maybe twenty years to kind of tell the full story right from our existence to where we are now, and our whole view on life, language, culture, history. Right now we just took flashes of different things. So we focused on the Treaty, we focused on residential school, things that really affected us.

(Interview, Royal 2008)

Blackfoot Crossing employees have voiced their concerns about criticism from their community and feel a need to develop better community relations (addressed in chapter four).

The pressure placed on community participants could be considered an unfair burden if the participants do not have full control over the development of the exhibit. If we consider the fluctuating power within engagement zones (see chapter three), the limitations of the cultural form of museum exhibits (see chapter five) and the limits placed upon engagement by logistics, museum ethos and practices (see chapter six) it is clear that even empowered community participants are not in full control of the creation process or the life of the exhibits they contribute to. Further still, community members generally do not have experience developing exhibits, and it can be difficult for them to envision the finished product or know how their contributions will shape the final product. As such it can come as a surprise when they see the gallery completed. Elder Pete Standing Alone, who worked on Glenbow's *Nitsitapiisinni* Gallery, recalled that 'I was a little surprised in the end; it wasn't really what I had in mind' (Interview, Standing Alone 2008). He had expected to see more representation of a Blackfoot irrigation company than what was included in the final exhibit, and even after seven years passing since the exhibit opened, this was one of the key issues evoked by our discussion of the gallery. Exhibit designer Irene Kerr recalled the development of Glenbow and Blackfoot Crossing and noted that 'when we first started meeting, the storyline committee, we had a bit of trouble getting going because they didn't, it is hard for them to, understand. It is hard for people to understand an abstract concept like putting an exhibit together' (Interview, Kerr 2008).

Acknowledging the contributions of community participants and empowering them to make decisions does give the community a (limited) voice and is an opportunity to begin changing Blackfoot representation in museums. It also values and honours their contributions. Despite the pressures, uncertainties and risks, Elders continue to choose to participate because they believe the work is important.

Museums could greatly benefit from listening to community participants experience of engagement. Assumptions that engagement is automatically beneficial need to be reconsidered if museums wish to build relationships based on equal reciprocity, and potentially empower communities. Both the positive and negative realities of community engagement and employment need to be seriously considered by museums, to minimise potential risks for community members.

Museums need to recognise the value of the contributions community members make, as well as the risks they take by participating. They should compensate community participants and employees adequately and equally to non-community members, not to buy the information but to honour and value participants' expertise and the work they do for the museum.

The most important finding from my interviews with participants was the long term consequences of working with museums. As the 'public face' of

museum work, participants have been credited and congratulated for their work, but have also been criticised and ostracised. Community members' reputations are put at stake through their engagement with museums and they have to live with the consequences as, after engagement ends, they have to return to the community they represented and continue to live in it. The effects are personal and potentially devastating, and seemingly unjust when the individuals do not have complete control over the museums or exhibits with which they work.

Thus engagement can be a double-edged sword for community members, and despite the theory, it is not always as empowering as museums would like it to appear. Current museological discourse and practice undervalues the challenges, difficulties and risks community members' face when they engage with museums to represent their communities. Greater understanding, empathy, acknowledgement and compensation for those difficulties would surely help to improve relations between museums and Indigenous communities.

REFERENCES

AFN (Assembly of First Nations) and CMA (Canadian Museums Association), 1992a. *Turning the Page: Forging New Partnerships Between Museums and First Peoples. Task Force Report on Museums and First Peoples.* Ottawa: Carleton University.

AFN (Assembly of First Nations) and CMA (Canadian Museums Association), 1992b. Task Force Report on Museums and First Peoples. *Museum Anthropology*, 16(2) pp. 12–20.

Ames, M.M., 2000. Are changing representations of First Peoples challenging the curatorial prerogative? In W.R. West, ed. *The Changing Presentation of the American Indian: Museums and Native Cultures.* Washington: Smithsonian Institution, pp. 73–88.

Arnstein, S.R., 1969. A ladder of citizen participation. *JAIP*, 35(4) pp. 216–224.

Blood, Kyle. 27 July 2006. Interview. HSIBJ.

Blood, Narcisse. 12 Sept 2007. Interview. Calgary.

Brink, Jack. 19 July 2006. Interview. RAM.

Carter, Beth. 28 Aug 2008. Interview. Glenbow.

CBC, 2014. *Inuit Were Not the First People to Settle in the Arctic: DNA Research Confirms Inuit Oral History of the Tunit People.* [Online] CBC News. Available at: http://www.cbc.ca/news/canada/north/inuit-were-not-the-first-people-to-settle-in-the-arctic-1.2749691

Conaty, Gerald (Gerry). 20 Nov 2008. Interview. Glenbow.

Conaty, G.T., 2006. Glenbow Museum and First Nations: fifteen years of negotiating change. *Museum Management and Curatorship*, 21(3) pp. 254–256.

Crane Bear, Clifford. 8 Oct 2008. Interview. Siksika Reserve.

Crazybull, Sandra. 23 Sept 2008. Interview. Glenbow.

First Rider, Blair. 24 July 2006. Interview. HSIBJ.

Galla, A., 1997. Indigenous peoples, museums, and ethics. In G. Edson, ed. *Museum Ethics.* London: Routledge, pp. 142–155.

Glenbow, 27 Nov 1998. *Blackfoot Exhibit Team Meeting.* [Minutes] Unlisted. Calgary: Glenbow Archives.

Hassall, K., 2006. *Assess Models for Managing Conservation Areas Through Tourism that Involve Partnerships Between Indigenous Communities, Government and The Private Sector in Canada and South Africa.* [Online] The Winston Churchill Memorial Trust of Australia. Available at: http://www.churchilltrust.com.au/site_media/fellows/Hassall_Kate_2005.pdf

Heavy Head, Pam. 18 Sept 2008. Interview. Fort Macleod.

Kerr, Irene. 20 Aug 2008. Interview. BCHP.

Kiitokii, Trevor. 16 Sept 2008. Interview. HSIBJ.

Lawlor, M., 2006. *Public Native America: Tribal Self-Representations in Casinos, Museums, and Powwows.* London: Rutgers University Press.

Lynch, B.T., 2010. *Whose Cake Is It Anyway? A Collaborative Investigation into Engagement and Participation in 12 Museums and Galleries in the UK.* [Online] Paul Hamlyn Foundation. Available at: http://www.phf.org.uk/page.asp?id=1417

Lynch, B.T., 2011. Collaboration, contestation, and creative conflict. On the efficacy of museum/community partnerships. In J. Marstine, ed. *The Routledge Companion to Museum Ethics. Redefining Ethics for the Twenty-First-Century Museum.* London: Routledge, pp. 146–163.

Lynch, B.T. and Alberti, S.J.M.M., 2010. Legacies of prejudice: racism, co-production and radical trust in the museum. *Museum Management and Curatorship*, 25(1) pp. 13–35.

Makah Cultural and Research Center Online Museum, 2011. *Archaeology.* [Online] Available at: http://content.lib.washington.edu/cmpweb/exhibits/makah/arch.html

Mithlo, N.M., 2004. "Red Man's Burden": the politics of inclusion in museum settings. *The American Indian Quarterly*, 28(3&4) pp. 743–763.

Pard, Allan. 12 Nov 2008. Interview. HSIBJ.

Potts, Jerry. 10 Oct 2008. Interview. Fort Macleod.

Raghavan, M. et al. 2014. The genetic prehistory of the New World Arctic. *Science*, 345(6200) pp. 1255832-0–1255832-9. [Online] Available at: http://www.sciencemag.org/content/345/6200/1255832.full.pdf

Royal, Jack. 25 Aug 2008 Interview. BCHP.

Siksika Nation, 2011. *Oki, (Welcome) Official Website of the Siksika Nation.* [Online]. Available at: http://www.siksikanation.com/

Taçon, P.S.C., Wilson, M. and Chippindale, C. 1996. Birth of the rainbow serpent in Arnhem land rock art and oral history. *Archaeology in Oceania*, 31(3) pp. 103–124.

Weasel Head, Frank. 13 Nov 2008. Interview. Calgary.

Weasel Head, Sylvia. 13 Nov 2008. Interview. Calgary.

Wolfleg, Adrian. 8 Sept 2008. Interview. Glenbow.

10 Where to from Here?

All peoples must have equal dignity and essential worth. Their languages, heritages, and knowledge must be equally respected by public institutions and by all peoples. . . . Equality and respect require cooperative frameworks, efforts, and innovations.

(Battiste and Henderson 2000:292)

Elders are saying: 'just ask us.' And that's what museums failed to do in the past. I don't know how much it has changed.

(Interview, Weasel Head 2008)

Julia Harrison has noted that many museum professionals, such as those at Glenbow and the Royal British Columbia Museum in Victoria, BC, have 'worked with great diligence' and 'achieved very positive results—to ameliorate aspects of the tensions resulting from this problematic history, but the point remains that it continues to be problematic' (2005:196). Engagement is difficult, complex, unpredictable, time consuming, resource heavy and not always successful or beneficial. But it can also be creative, inspiring, life changing and empowering. 'What it means to work collaboratively is not something that can be reduced to a formula' (Harrison 2005:195–196). With the proliferation of community engagement projects, museums are increasingly reflecting on their experiences and considering ways forward. The majority seek gradual improvements, while others propose innovations such as 'radical trust' (Lynch and Alberti 2010), yet there are those who are choosing to abandon the practice (Chandler 2009).

Although engagement is imperfect, it continues to be viewed as an extremely important and worthwhile pursuit by the Blackfoot communities. This is due in part to the important role museums play in authorising heritage, and because current power inequalities in Canada between First Nations and mainstream Canadians mean that small gains are the current route to creating greater societal change that could transform current relations. 'Museums are uniquely placed to foster this sense of interrelatedness, along with the deep respect required for inter-cultural understanding' (Janes and Conaty 2005:14).

Phillips and Phillips have argued that 'the large questions of land and power will not, of course, be resolved within a museum. All a museum can do is to disrupt tired stereotypes and ways of thinking that lead only to dead ends and to stimulate its visitors to think critically about contemporary issues' (2005:702). However, museums can help change attitudes and provide Western validation of culture and history required by courts for land claims as Daniels has demonstrated (2009). As such I would argue museum representation has real social, political and legal power to influence how a community is viewed and treated. The opportunity for Blackfoot people to effect and even control how their culture is represented is very important to the community, not just to decolonise the historical record, engender better cross-cultural understanding and relations, and to assist with legal claims; but to develop respect for, and pride within, a community that has been the subject of abusive colonial policies and institutionalised racism. As Clifford Crane Bear states:

[Blackfoot Crossing] tells the story of our people, it tells the history. And a lot of our young people need to hear that, need to go there, learn that we do have a history. And if you tell the right stories, tell the right thing, it will bring peoples' pride back.

(Interview, Crane Bear 2008)

Viv Golding (2009; 2007a; 2007b) has documented the importance and the ability of museums, through educational programming and community engagement, to help build self-esteem, particularly in disadvantaged youth. Efforts that support Blackfoot cultural pride and heritage are very important given the difficult circumstances community members face on a daily basis. In 2009, First Nation communities were 'on average, the most disadvantaged social/cultural group in Canada on a host of measures including income, unemployment, health, education, child welfare, housing and other forms of infrastructure' (The Make First Nations Poverty History Expert Advisory Committee 2009:10). 'On average, indigenous Canadians can expect to die between five and eight years earlier than other Canadians' (Daschuk 2013:IX). First Nations' infant mortality rate is 1.5 times higher than the Canadian rate (Health Canada 2002). Suicide is more than double the Canadian rate and is among the leading causes of death among First Nations between the ages of 10 and 24 (CFNU 2011:2). While Canadians enjoy consistently high ranking on the UN Human Development Index, Canadian Indigenous people rank towards the bottom of the same index (Daschuk 2013:IX). Consequently, building pride and empowering people who have been so disempowered by dominant society has the potential to change lives.

By conducting a comparative cross-institutional analysis of engagement theory in practice from museum and community perspectives, this research unsettles current understandings and assumptions about community engagement in

an effort to open up space for critical analysis and, potentially, decolonisation. The research indicates that the processes and products of engagement are often less empowering and more limited than current discourse acknowledges. Current discourse on Indigenous engagement is dominated by curatorial and academic perspectives, consequently community participant experiences and perspectives have generally been overlooked and under-analysed. By listening to and presenting Blackfoot perspectives this book highlights key gaps in current understanding—primarily the naturalised assumptions and limitations placed on engagement, the importance of displayed withholding and the potential for short and long term risks and costs of participation.

Janet Marstine has argued that 'institutional bureaucracies, the demands of funding sources and allegiances to common practice have typically prescribed incremental change in the museum, rather than the kind of holistic rethinking required to instil the values of shared authority and of social understanding among diverse communities' (Marstine 2011:5). This research attempts to provide a holistic view of engagement from initial negotiations, to curatorial adaptations, co-created exhibits, institutional indigenisation, community employment and on-going relations after the completion of the project. This perspective enables the tracking of engagement and highlights the way power is negotiated and renegotiated, and illustrates that although museums may set out with one engagement approach in mind, the process is fluid and unstable. Through the course of the relationship engagement changes and produces empowering and disempowering moments. In doing so it can be seen that sharing power is neither simple nor conclusive, but a complex and unpredictable first step in building new relations between museums and communities.

The idea of engagement zones has been used in this research to help to conceptualise power relations within the fluid and changeable processes of engagement and emphasise the importance of inter-community collaboration, in an effort to decolonise both the theory and practice of engagement. What is made possible by engagement within these zones is still limited by external pressures such as logistics and institutional ethos and the wider professional, social and political context in which these museums and communities operate. These limitations need recognition to enable communities and museum professionals to move beyond them and re-frame the way they work together, re-evaluating practice from its most basic and naturalised assumptions.

Although engagement encourages new ways of working and adaptation, the underlying principles of museology currently remain generally intact and residual practices continue, even in community owned centres, because they are enshrined in dominant Western professional and social approaches to heritage management. Indigenous practices continue to be viewed by the majority as unprofessional and unscientific, and therefore secondary to Western approaches. This is a key point that urgently requires change to enable better relations between museums and Indigenous communities.

The findings presented in this book indicate that Canadian museum and Blackfoot community engagements and relations can be improved. Although each engagement is unique and needs to be viewed on a case-by-case basis, changes to museological approaches to engagement, curation and representation of Indigenous peoples would make relations easier. As Marie Battiste and James Henderson argue 'Indigenous peoples must be actively involved in the development of any new convention or laws' because 'their participation will develop new sensitivities to what is sacred, to what is capable of being shared, and to what is fair compensation for the sharing of information among diverse peoples' (2000:292). This can aptly be applied to museums and heritage sites.

The research at Glenbow illustrates the importance of repatriation of sacred material to building meaningful partnerships with the Blackfoot. Kainai Elder, Frank Weasel Head is quoted in the exhibition as stating that: 'This project would not have been possible without the commitment and determination of Glenbow Staff. Together we have shown that co-existence and cooperation is still possible' (Glenbow *Nitsitapiisinni* Gallery, n.d.). Curator Gerry Conaty is also quoted, stating: 'We have all been profoundly changed by the generosity, openness and sincerity of our colleagues from Siksika, Kainai, Apatohsipikani and Ammskaapipikani. They have shown us new ways of understanding our collections, our history and ourselves' (Glenbow *Nitsitapiisinni* Gallery, n.d.). The Ethnology team demonstrated that it is possible to adapt and indigenise museum practice. However, the lack of institutionalisation of engagement at Glenbow meant that other departments within the museum did not adapt, and the ethos of the museum was not fundamentally changed.

Engagement is idealised as an unlimited coming together of ideas, but in practice these ideas must fit within the boundaries of the museum. With changes in staff, leadership and institutional priorities, the relationship between Glenbow and the Blackfoot is vulnerable, due to these changes, the need for funds, resources and institutional backing to support such work. Further still, the pillars of museology—collecting and exhibiting—remain unchanged and many naturalised residual practices continue, apparently unaffected by Blackfoot participation. Thus the change inspired by engagement at Glenbow was important, but localised and limited.

By 2008 Glenbow had demonstrated how far they had come since the 1988 *Spirit Sings*. In 2007–2008 they hosted five First Nations exhibitions: three of which included modern First Nations art[1] and two were permanent exhibits, *Nitsitapiisinni: Our Way of Life, The Blackfoot Gallery* and *Native Cultures from the Four Directions*. However 2008 was also the year Glenbow changed their institutional direction to focus on art. On December 10th 2007 Jeffery Spalding became the new CEO and President of Glenbow, replacing Mike Robinson who had served as CEO for two consecutive terms (Glenbow 2007). Spalding was brought into realise the new 'Art, Dialogue and History' mandate, part of the Glenbow Board of Governors call

for 'Arts Renewal' and the vision of 'Glenbow Enhanced' (Glenbow 2007; Glenbow 2008). Spalding resigned in January 2009, and the leadership of Glenbow changed to Kirstin Evenden and then to Donna Livingstone in 2013 (Glenbow 2009:2; Glenbow 2014). On 6th February 2014 Livingstone announced a new direction for the institution, to become a 'new kind of art museum' (Glenbow 2014). It 'will be more than an art gallery. It will look at its history collections through an art lens to tell a deeper story' (Glenbow 2014).

As this research has shown, relationships between museums and communities tend to be fragile as they are built upon personal relationships between individuals which are subject to change. In the course of the research Glenbow experienced dramatic change. After leading the field in its work with the Blackfoot, Glenbow's shift in focus to the arts changed the funding and exhibition priorities. Extensive staff changes resulted in the original Ethnology team being reduced down to the Director, Gerry Conaty, and a Technician. In 2013 Gerry Conaty tragically passed away. Glenbow's relationship with the Blackfoot Nations was in essence primarily a personal relationship between Gerry and the Elders. While museum staff continue to work with the Blackfoot, the consequences of the loss of Gerry and the museum's change in focus are yet to be fully realised.

In comparison, the Head-Smashed-In case study showed that the institutionalisation of Blackfoot engagement and employment does ensure a long term commitment to a community relationship. However it does not necessarily equalise power relations, as upper-management remains non-Blackfoot and top down consultation means the agenda and veto remain with the non-Blackfoot government employees. Nor does institutionalisation automatically equate to positive relations with, or reputations within, the Blackfoot community and this has a direct effect on those community members employed at Head-Smashed-In and those that participate in consultation. The potential for negative consequences for community staff members is an area that is particularly undervalued and underexplored in current museology. Like some of the other case studies, Head-Smashed-In has undergone changes in management in recent years and this will influence the on-going living relationship with the community.

The case study of Buffalo Nations Luxton Museum provided an example of the external limits on community power. Although run and owned by Indigenous people, the community board members were mostly figure heads as the museum lacked sufficient funds to make changes. Any attempts to adapt or indigenise the exhibits or practice faced the debilitating problem of a lack of resources. This example shows that community control lacks meaning if the resources are not available to enable action and it is important not to judge engagement on its model or face value alone. Importantly the museum has, in the past two years, begun a process of building and exhibit renewal. The effects of these changes on representation and community empowerment will be interesting to see unfold.

The fourth case study of Blackfoot Crossing Historical Park is the first of its kind and demonstrated the ways in which the Blackfoot have adopted and indigenised the idea of the museum for their own community. Importantly it highlighted that although engagement models place community control as the top rung on the ladder (Arnstein 1969; Galla 1997), at Blackfoot Crossing the community employees still had to consult the wider community emphasising the importance of thinking about inter-community engagement, not just cross-cultural work. Blackfoot Crossing also illustrated the outside pressures on Indigenous museums to conform to Western museological standards to gain recognition and participate in professional activities such as the loaning of collections. These restrictions continue to prioritise and privilege Western approaches to heritage management over Indigenous practices. Despite the efforts of theorists and practitioners[2] to create new museology, decentre the museum and highlight Indigenous practice, it appears that non-Western approaches to heritage management are still predominantly viewed as secondary.

I don't know if [Blackfoot Crossing] is ever going to gain the stature or the respectability from the academic museum community. I don't know if it will ever be taken seriously in the museum world. Just because the standards are so high and because the museum is not really a 'proper' museum because the exhibit hall is not climate controlled. I mean it is a beautiful building and I am sure lots of people, academics and curators, will come here. But I don't believe they'll ever, ever think it is up to standard. Because that is just the way it is. You see people study First Nations people and as hard as they try to shed that academic approach, this isn't that kind of place, it just isn't, and it is never going to be. I don't think there are going to be museums lining up at the door to give artefacts back to this place. They wouldn't lend us the [Siksika] Crowfoot railway pass, they lent it to Glenbow. We had to pay to get a replica made. How ironic is that!? Where did it come from!? Who did it belong to!? But I can't see that ever changing. Unless there are people like you or Alison [Brown]; unless there are more people in the museum world and the academic community, in Europe especially, [who understand this issue] then this is never going to change.

(Interview, Kerr 2008)

Museums need to listen to communities, not just to honour their right to have their advice considered in the storage and display of their cultural material (UNESCO 2008) but to gain an understanding of their experiences of engagement to find better ways of working together. Engagement would benefit from greater transparency about the terms of power sharing and the parameters within which the engagement takes place. Understanding the current limits of engagement and restrictions to museum indigenisation will enable collaborative efforts to be strategically utilised to work within and

go beyond current boundaries and facilitate reciprocities that can begin to decolonise relations and enrich both museums and communities.

Whilst Canadian museums operate in a society where relations between Indigenous people and Canadians are far from equal, engagement relations can help minimise asymmetries by acknowledging risks and costs of engagement for participants, by lessening these burdens, and by providing adequate and culturally appropriate compensation. As long as Indigenous experts continue to be paid substantially less than their Western counterparts, Indigenous knowledge is defined as less valuable by museums. If museums decentre themselves and view their action as part of a network of bodies, groups and societies, their contributions to cross-cultural understanding can be combined with other efforts to create greater change. Viv Golding has illustrated this in the UK with her idea of 'museum frontiers—a spatio-temporal site for acting in collaborative effort with other institutions' (2009:2) such as universities and schools (see chapter three).

Indigenous approaches to cultural heritage practice and management should be supported and respected as distinct but equally valid, and potentially complementary, ways of maintaining cultural knowledge and material. Intangible cultural heritage needs to be honoured and balanced with the traditional privileging of tangible heritage by Western museology.

The key is to enable people to remember, practice and live their culture and to share it on their own terms with others, whether this is done in museums, heritage sites, within communities, or in combination. 'Off stage' culture should be respected as such, and museums should return materials to communities when culturally appropriate, particularly if they can be used to maintain intangible culture; for example Blackfoot sacred items need to go back into community use to have meaning and to maintain Blackfoot culture. Repatriation efforts will build reciprocities that will enrich both the community and the museum, as demonstrated by Glenbow. Similarly, finding ways to return the benefit of engagement to communities will be the key to the longevity and integrity of relations between museums and communities who work together.

Although the research findings specifically address Blackfoot engagement, the areas of improvement can apply to others doing engagement elsewhere. The need for mutual respect, sufficient time and resources, open lines of communication, and clearly demarcated boundaries that can be crossed through negotiation, are concepts that have universal transferability to engagement anywhere. Understanding the risks and costs of engagement to participants, as well as the methods to develop meaningful and successful engagement, would benefit all entering into such processes.

It is not enough just to listen; museums need to create relationships built on communication, respect, co-operative action, reflection, equality and reciprocation. To engage superficially makes engagement a tool for modern collecting and a method to maintain the status quo which ultimately benefits neither museum nor community. To engage meaningfully takes courage,

strength and commitment, but it has the potential to enrich museums and communities, and contribute to improving the lives of Indigenous people through building platforms for voice and action, and contributing to the decolonisation of cross-cultural relations.

In 1992, Julia Harrison reflected on the *Turning the Page Task Force Report* and stated that the revolution had not yet begun (1992:11). While this book has documented innovation and indigenisation in museums and heritage sites in Alberta, Harrison's proposal that real change will only occur if it begins at the roots with the categorisation of collections still rings true (1992:11). Museology in Canada has made significant developments in working with First Nations peoples and indigenising and decolonising practice; however there is still a long way to go before these changes could be described as a revolution. A key to building larger scale change will, I propose, come through making connections across communities and nations to develop greater international understanding of Indigenous approaches to caring for cultural heritage. This will help to build recognition of indigenized and Indigenous museologies, and potentially provide routes to help to decolonise and reshape the foundations of museology on a global scale.

NOTES

1. *Situation Rez: Kainai Students Take Action with Art* which opened 1st December 2007; *Tracing History: Presenting the Unpresentable* February 16, 2008–June 22, 2008 which 'invited four contemporary Aboriginal artists: Tanya Harnett, Faye HeavyShield, Terrance Houle and Adrian Stimson, to respond to Glenbow's collections' (Glenbow 2009); and *Honouring Tradition: Reframing Native Art* February 16, 2008 —July 13, 2008.
2. See Ames 1987, 1990, 1992, 1999, 2000, 2006; Brown and Peers 2006; Clavir 2002; Clifford 1997, 2013; Conaty and Carter 2005; Conary and Janes 1997; Conaty 1996, 2003, 2006, 2008; Cooper 2008; Harrison, Byrne and Clarke 2013; Hill and Nicks 1992a 1992b; Karp, Kreamer and Lavine 1992; Kreps 2003, 2005; Krmpotich and Peers 2013; Lonetree 2009, 2012; Lonetree and Cobb 2008; McCarthy 2007, 2011; Mithlo 2004, 2006; Peers and Brown 2003, 2007; Peers 2007; Phillips 2006, 2011; Simpson 1996, 2006, 2007, 2009; Sleeper-Smith 2009; Smith 2006; and Tapsell 2011.

REFERENCES

Ames, M.M., 1987. Free Indians from their ethnological fate. *Muse*, 5(2) pp. 14–19.
Ames, M.M., 1990. Cultural empowerment and museums: opening up anthropology through collaboration. In S. Pearce, ed. *Objects of Knowledge*. London: The Athlone Press, pp. 158–173.
Ames, M.M., 1992. *Cannibal Tours and Glass Boxes: The Anthropology of Museums*. Vancouver: UBC Press.
Ames, M.M., 1999. How to decorate a house: the re-negotiation of cultural representations at the University of British Columbia Museum of Anthropology. *Museum Anthropology*, 22(3) pp. 41–51.

Ames, M.M., 2000. Are changing representations of First Peoples challenging the curatorial prerogative? In W.R. West, ed. *The Changing Presentation of the American Indian: Museums and Native Cultures.* Washington: Smithsonian Institution, pp. 73–88.

Ames, M.M., 2006. Counterfeit museology. *Museum Management and Curatorship,* 21 pp. 171–186.

Arnstein, S.R., 1969. A ladder of citizen participation. *JAIP,* 35(4) pp. 216–224.

Battiste, M. and Youngblood Henderson, J. (Sa'ke'j), 2000. *Protecting Indigenous Knowledge and Heritage: A Global Challenge.* Saskatoon: Purich Publishing Ltd.

Brown, A.K. and Peers, L., 2006. *'Pictures Bring Us Messages' / Sinaakssiiksi aohtsimaahpihkookiyaawa: Photographs and Histories from the Kainai Nation.* Toronto: University of Toronto Press.

CFNU 2011. *Aboriginal Health.* [Online] Available at: https://nursesunions.ca/sites/default/files/2011.backgrounder.aboriginal.health.e.pdf

Chandler, L., 2009. 'Journey without maps': unsettling curatorship in cross-cultural contexts. *Museum and Society,* 7(2) pp. 74–91.

Clavir, M., 2002. *Preserving What Is Valued: Museums, Conservation, and First Nations.* Vancouver: UBC Press.

Clifford, J., 1997. *Routes: Travel and Translation in the Late Twentieth Century.* London: Harvard University Press.

Clifford J. 2013. *Returns: Becoming Indigenous in the Twenty-First Century.* London: Harvard University Press.

Conaty, G.T., 1996. Working with Native advisory groups. *Alberta Museums Review,* 22(2) pp. 52–53.

Conaty, G.T., 2003. Glenbow's Blackfoot Gallery: working towards co-existence. In L. Peers and A.K. Brown, ed. *Museums and Source Communities: A Routledge Reader.* London: Routledge, pp. 227–241.

Conaty, G.T., 2006. Glenbow Museum and First Nations: fifteen years of negotiating change. *Museum Management and Curatorship,* 21(3) pp. 254–256.

Conaty, G.T., 2008. The effects of repatriation on the relationship between the Glenbow Museum and the Blackfoot people. *Museum Management and Curatorship,* 23(3) pp. 245–259.

Conaty, G.T. and Carter, B., 2005. Our story in our words: diversity and equality in the Glenbow Museum. In R.R. Janes and G.T. Conaty, eds. *Looking Reality in the Eye: Museums and Social Responsibility.* Calgary: University of Calgary Press, pp. 43–58.

Conaty, G.T. and Janes, R.R., 1997. Issues of repatriation: a Canadian view. *European Review of Native American Studies,* 11(2) pp. 31–37.

Cooper, K.C., 2008. *Spirited Encounters: American Indians Protest Museum Policies and Practices.* Plymouth: AltaMira Press.

Crane Bear, Clifford. 8 Oct 2008. Interview. Siksika Reserve.

Daniels, B.I., 2009. Reimagining tribal sovereignty through tribal history. Museums, libraries, and achieves in the Klamath River region. In S. Sleeper-Smith, ed. *Contesting Knowledge Museums and Indigenous Perspectives.* London: University of Nebraska Press, pp. 283–302.

Daschuk, J., 2013. *Clearing the Plains: Disease, Politics of Starvation, and the Loss of Aboriginal Life.* Regina: University of Regina Press.

Galla, A., 1997. Indigenous peoples, museums, and ethics. In G. Edson, ed. *Museum Ethics.* London: Routledge, pp. 142–155.

Glenbow, 2007 November 23. *Glenbow Museum Announces New CEO & President.* Media Release. [Online] Available at: http://www.glenbow.org/media/GlenbowMuseumAnnouncesNewCEOandPresident.pdf

Glenbow, 2008. *Annual Report 2007/2008.* Glenbow Museum. [Online] Available at: http://www.glenbow.org/media/GLENBOW-AR-2007-08.pdf

Glenbow, 2009. *Glenbow Museums Annual Report 2008–2009.* [Online] Available at: http://www.glenbow.org/media/2009_GLENBOW_AR.pdf

Glenbow, 2014. *Glenbow.* Media Release. [Online] Available at: http://www.glenbow.org/about/media/Glenbow_New_Direction-Media_Release.pdf

Golding, V., 2007a. Inspiration Africa! Using tangible and intangible heritage to promote social inclusion amongst young people with disabilities. In. S. Watson, ed. *Museums and Their Communities.* London: Routledge, pp. 358–372.

Golding, V. 2007b. Learning at the museum frontiers. democracy, identity and difference. In S.J. Knell and S. MacLeod, eds. *Museum Revolutions. How Museums Change and Are Changed.* London: Routledge, pp. 315–329.

Golding, V., 2009. *Learning at the Museum Frontiers. Identity, Race and Power.* Surrey: Ashgate Publishing Limited.

Harrison, J. 1992. Turning the Page: Forging New Partnerships between Museums and First Peoples Conference—personal reflections. *Alberta Museums Review,* 8(2) pp. 10–12.

Harrison, J., 2005. Shaping collaboration: considering institutional culture. *Museum Management and Curatorship,* 20(3) pp. 195–212.

Harrison, R., Byrne, S. and Clarke, A. eds., 2013. *Reassembling the Collection: Ethnographic Museums and Indigenous Agency.* Santa Fe: SAR Press.

Health Canada, 2002. *Healthy Canadians, A Federal Report on Comparable Health Indicators.* [Online] Available at: http://www.hc-sc.gc.ca/hcs-sss/pubs/system-regime/2002-fed-comp-indicat/index-eng.php

Hill, T. and Nicks, T., 1992a. The task force on museums and First Peoples. *MUSE,* X(2&3) pp. 81–84.

Hill, T. and Nicks, T., 1992b. *Turning the Page: Forging New Partnerships between Museums and First Peoples: Task Force Report on Museums and First Peoples.* 2nd ed. Ottawa: Assembly of First Nations and Canadian Museums Association.

Janes, R.R. and Conaty, G.T., eds., 2005. *Looking Reality in the Eye: Museums and Social Responsibility.* Calgary: University of Calgary Press.

Karp, I. Kreamer, C.M. and Lavine, S.D., 1992. *Museums and Communities: The Politics of Public Culture.* London: Smithsonian Institution Press.

Kerr, Irene. 20 Aug 2008. Interview. BCHP.

Kreps, C., 2005. Indigenous curation as intangible cultural heritage: thoughts on the relevance of the 2003 UNESCO Convention. *Theorising Cultural Heritage,* 1(2) pp.1–8.

Kreps, C.F., 2003. *Liberating Culture. Cross-cultural Perspectives on Museums, Curation and Heritage Preservation.* London: Routledge.

Krmpotich, C. and Peers L., 2013. *This Is Our Life: Haida/Material Heritage and Changing Museum Practice.* Vancouver: UBC Press.

Lonetree, A., 2009. Museums as sites of decolonisation. Truth telling in national and tribal museums. In S. Sleeper-Smith, ed. *Contesting Knowledge: Museums and Indigenous Perspectives.* London: University of Nebraska Press, pp. 322–337.

Lonetree, A., 2012. *Decolonizing Museums: Representing Native America in National and Tribal Museums.* Chapel Hill: UNC Press.

Lonetree, A. and Cobb, A.J., 2008. *The National Museum of the American Indian: Critical Conversations.* London: University of Nebraska Press.

Lynch, B.T. and Alberti, S.J.M.M., 2010. Legacies of prejudice: racism, co-production and radical trust in the museum. *Museum Management and Curatorship,* 25(1) pp. 13–35.

Make First Nations Poverty History Expert Advisory Committee, 2009. *The State of the First Nations Economy and the Struggles to Make Poverty History.* [Online] Available at: http://abdc.bc.ca/uploads/file/09%20Harvest/State%20of%20the%20First%20Nations%20Economy.pdf

Marstine, J., 2011. The contingent nature of the new museum ethics. In J. Marstine, ed. *The Routledge Companion to Museum Ethics. Redefining Ethics for the Twenty-First-Century Museum.* London: Routledge, pp. 3–25.

McCarthy, C., 2007. *Exhibiting Māori: A History of Colonial Cultures of Display.* Oxford: Berg & Te Papa Press.

McCarthy, C., 2011. *Museums and Māori: Heritage Professionals, Indigenous Collections, Current Practice.* Wellington: Te Papa Press. Walnut Creek, California: Left Coast Press.

Mithlo, N.M., 2004. "Red Man's Burden": the politics of inclusion in museum settings. *The American Indian Quarterly,* 28(3&4) pp. 743–763.

Mithlo, N.M., 2006. American Indians and museums: the love/hate relationship at thirty. In *Museums and Native Knowledges.* [Online] Arizona State University. Available at: http://nancymariemithlo.com/American_Indians_and_Museums/

Peers, L., 2007. *Playing Ourselves: Interpreting Native Histories at Historic Reconstructions.* Plymouth: AltaMira Press.

Peers, L. and Brown, A.K., ed., 2003. *Museums and Source Communities: A Routledge Reader.* London: Routledge.

Peers, L. and Brown, A.K., 2007. Museums and source communities. In S. Watson, ed. *Museums and their Communities.* London: Routledge, pp. 519–537.

Phillips, R.B., 2006. Show times: de-celebrating the Canadian nation, de-colonising the Canadian museum, 1967–92. In A.E. Coombes, ed. *Rethinking Settler Colonialism: History and Memory in Australia, Canada, Aotearoa New Zealand and South Africa.* Manchester: Manchester University Press, pp. 121–139.

Phillips, R.B., 2011. *Museum Pieces: Towards the Indigenization of Canadian Museums.* London: McGill-Queen's University Press.

Phillips, R.B. and Phillips M.S., 2005. Double take: contesting time, place, and nation in the First Peoples Hall of the Canadian Museum of Civilization. *American Anthropologist,* 107(4) pp. 694–704.

Simpson, M.G., 1996. *Making Representations: Museums in the Post-Colonial Era.* London: Routledge.

Simpson, M.G., 1997. *Museums and Repatriation: An Account of Contested Items in Museum Collections in the UK, with Comparative Material from Other Countries.* London: Museums Association.

Simpson, M.G., 2006. Revealing and concealing: museums, objects, and the transmission of knowledge in Aboriginal Australia. In J. Marstine, ed. *New Museum Theory and Practice. An Introduction.* Oxford: Blackwell Publishing, pp. 153–177.

Simpson, M.G., 2007. Indigenous heritage and repatriation—a stimulus for cultural renewal. In M. Gabriel and J. Dahl, eds. *UTIMUT Past Heritage—Future Partnerships: Discussion on Repatriation in the 21st Century.* Copenhagen/Nuuk: IWGIA/NKA, pp. 64–77.

Simpson, M.G., 2009. Museums and restorative justice: heritage, repatriation and cultural education. *Museum International,* 61 pp. 121–129.

Sleeper-Smith, S., ed., 2009. *Contesting Knowledge: Museums and Indigenous Perspective.* London: University of Nebraska Press.

Smith, L., 2006. *Uses of Heritage.* London: Routledge.

Tapsell, P., 2011. "Aroha mai: Whose museum?": The rise of indigenous ethics within museum contexts: A Māori-tribal perspective. In J. Marstine, ed., *The Routledge Companion to Museum Ethics. Redefining Ethics for the Twenty-First-Century Museum.* London: Routledge, pp. 85–111.

UNESCO, 2008. *United Nations Declaration on the Rights of Indigenous Peoples.* Geneva: United Nations. [Online] Available at: http://www.un.org/esa/socdev/unpfii/documents/DRIPS_en.pdf

Weasel Head, Frank. 13 Nov 2008. Interview. Calgary.

Glossary

Aamsskáápipikani—American Blackfoot Nation called Southern Piikani or Blackfeet

AFC—American Fur Company

AFN—Assembly of First Nations

AMA—Alberta Museums Association

BCHP—Blackfoot Crossing Historical Park

Blackfeet—American Blackfoot Nation, also known as Amsskáápipikani, Peigan or Southern Piikani

Blackfoot—a generic term for the people of the Blackfoot Confederacy, also the name of the language spoken by the Blackfoot

Blackfoot Confederacy—Siksika, Kainai, Piikani and Blackfeet

Blackfoot Crossing—Blackfoot Crossing Historical Park (BCHP) and the location of the signing of Treaty 7 in 1877

Buffalo Nations Cultural Society—represents several distinct Aboriginal cultural groups, including the Cree nations, members of the Blackfoot Confederacy (Siksika, Peigan and Blood), the Tsuu T'ina, Nakoda and Métis

Buffalo Nations Luxton Museum (BNLM)—formerly the Luxton Museum in Banff

Bundle—bundles are sacred items in Blackfoot culture and are considered to be living beings. Each bundle is unique and has a particular origin and personality (Lokensgard 2010:57). Bundles are associated with different events and sacred societies and are opened at specific times of the year by their keeper according to protocol.

Ceremonies—Sacred cultural events

CMA—Canadian Museums Association

Dog Days—a period of history prior to the arrival of the horse circa 1730 (Bastien 2004:14; Conaty 1995:404)

Elder—custodian of traditional and sacred knowledge. They teach traditional knowledge to the new generations through age-graded societies, ceremonies and cultural events (Bastien 2004:222).

Firewater—a term for alcohol used in the Whiskey Trade (Dempsey 2002)

Glenbow—Glenbow Museum

HBC—Hudson Bay Company

Head-Smashed-In—Head-Smashed-In Buffalo Jump Interpretive Centre World Heritage Site

Ihtsipaitapiyo'pa—a Blackfoot term for the 'source of our life'. The Sun Naato'si is 'the greatest manifestation of Ihtsipaitapiyo'pa' (Lockensgard 2010:77–8).

Indian Act—1876 Act that imposed colonial rules and cultural oppression on First Nations in Canada

Inniskim/Iinnisskimms—a Blackfoot word for a sacred buffalo calling stone (Lockensgard 2010:83)

Jump (the)—Head-Smashed-In Buffalo Jump Interpretive Centre

Kaaahsinnooniksi—a Blackfoot term for Elders, the custodians of the traditions (Bastien 2004:222)

Kainai—Canadian Blackfoot Nation also known as Bloods, Many Chiefs or Many Leaders

Ksaahkommitapiiksi—a Blackfoot term for the Earth People including low-flying birds, plants and animals (Lockensgard 2010:79; Blackfoot Gallery Committee 2001:9)

Ksissta'pitapii—a Blackfoot term used to refer to 'nothing people' or 'crazy people' who do not 'possess or aspire to the characteristics valued among the Siksikaitsitapi', also known as ghosts (Lockensgard 2010:80; Bastien, 2004:49–50)

Matapiiksi—a Blackfoot term for person, living beings (Lockensgard 2010:77–8)

Mookaakin Society—a Kainai Cultural and Heritage Society

MOU—A Memorandum of Understanding was signed between Glenbow and the Kainai Mookaakin Society to formalize a working relationship between the museum and community in 1998

Naato'si/Natoas—a Blackfoot term for Sun (Lockensgard 2010:77–8), also spelt Natoas, and related to the Sundance, Okan, ceremony

Napi—a trickster from the origin stories, also called Old Man

Napiohke—a Blackfoot term for firewater, whiskey, White Man's Water (Dempsey 2002:7–8)

Niitawahssin—a Blackfoot term for their original territory (Lockensgard 2010:16)

Niitsisskowa—a Blackfoot term for the landscape of the traditional territory (Lockensgard 2010:16)

Niitsitapi/Nitsitapii—a Blackfoot term meaning 'real people', humans (Bastien 2004:212)

NMAI—National Museum of the American Indian

NWC—North West Company

NWMP—North West Mounted Police

Okan—Sundance

Okotoks—a Blackfoot term for a Big Rock that features in the Napi stories and is located west of the modern town of Okotoks in Alberta

Piikani—Canadian Blackfoot Nation also called (Northern) Peigan or Aapátohsipikáni

RAM—Royal Alberta Museum, Edmonton

RAMM—Royal Albert Memorial Museum, Exeter UK

RBCM—Royal BC Museum, Victoria

RCMP—Royal Canadian Mounted Police

Red Coats—North West Mounted Police

ROM—Royal Ontario Museum

Siksika—Canadian Blackfoot Nation also known as Blackfoot or Northern Blackfoot

Siksikaitsipoyi—a Blackfoot term meaning 'Blackfoot-speaking real people' (Bastien 2004:212)

Smudge/smudging—the ceremonial burning of sweet grass, sage, tobacco or sweet pine

Soyiitapiiksi—a Blackfoot term for the Underwater People such as fish, beaver and wetland animals (Lockensgard 2010:79; Blackfoot Gallery Committee 2001:9)

Sspommitapiiksi—a Blackfoot term for the Above People including the Sun, Moon, stars, planets and high-flying birds (Lockensgard 2010:79; Blackfoot Gallery Committee 2001:9)

Treaty 7—signed in 1877 between the British Crown and the Kainai, Piikani, Siksika, Tsuu T'ina and Stoney Nakoda

UBC MOA—University of British Columbia Museum of Anthropology, Vancouver

Writing-on-Stone—a Provincial Park within traditional Blackfoot territory, it is a large sacred rock art site

REFERENCES

Bastien, B., 2004. *Blackfoot ways of knowing: The Worldview of the Siksikaitsitapi.* Calgary: University of Calgary Press.

Blackfoot Gallery Committee, 2001. *Nitsitapiisinni: The Story of the Blackfoot People.* Toronto: Key Porter Books.

Conaty, G.T., 1995. Comments and reflections: economic models and Blackfoot ideology. *American Ethnologist,* 22(2) pp.404–409.

Dempsey, H.A., 2002. *Firewater: The Impact of the Whisky Trade on the Blackfoot Nation.* Fifth House Publishers. Calgary

Lokensgard, K.H., 2010. *Blackfoot Religion and the Consequences of Cultural Commoditization.* Farnham: Ashgate.

Appendix
List of Participants

This book was made possible by the people and institutions who participated in the research. I am forever grateful for their kindness and generosity in sharing their thoughts and facilities with me.

INSTITUTIONS

1. Blackfoot Crossing Historical Park, Siksika Reserve, Alberta
2. Buffalo Nations Luxton Museum, Banff, Alberta
3. Glenbow Museum and Archives, Calgary, Alberta
4. Head-Smashed-In Buffalo Jump Interpretive Centre, near Fort Macleod, Alberta
5. Royal Alberta Museum, Edmonton, Alberta

INTERVIEWEES

Ordered alphabetically by last name:

1. Anonymous Interview 19 Sept 2008. Blackfoot Crossing.
2. Anonymous Interview 24 Sept 2008. Head-Smashed-In.
3. Anonymous Interview 12 Nov 2008. Head-Smashed-In.
4. Bastien, Betty Interview 19 Nov 2008. Piikani. Associate Professor University of Calgary.
5. Bedford, Judy Interviews 26 Sept 2008a and 2008b. Non-Blackfoot. Board Member Buffalo Nations Luxton Museum. Consultant for Blackfoot Crossing.
6. Blood, Narcisse Interviews 18 July 2006b and 12 Sept 2007. Kainai Elder.
7. Blood, Kyle Interview 27 July 2006a. Kainai. Former Head-Smashed-In Seasonal Guide.
8. Breaker, Shane Interview 16 Oct 2008. Siksika. Blackfoot Crossing Vice-President of Marketing & Public Relations at Blackfoot Crossing.

9. Brewster, Pete Interview 14 Oct 2008. Non-Blackfoot. Former Executive Director of Buffalo Nations Luxton Museum 1992–2005.

10. Brink, Jack Interviews 19 July 2006 and 26 Sept 2008. Non-Blackfoot. Head Archaeologist and Consultant for Head-Smashed-In and Curator of Archaeology at the Royal Alberta Museum.

11. Carter, Beth Interviews Sept 2007 and 28 Aug 2008. Non-Blackfoot. Former Glenbow Ethnology Curator, Blackfoot Gallery Team Member and Project Manager for *Nitsitapiisinni.*

12. Clarke, Ian Interview 12 Nov 2008. Non-Blackfoot. Regional Manager/ Southern Operations including Head-Smashed-In.

13. Conaty, Gerald (Gerry) Interviews 26 Sept 2007 and 20 Nov 2008. Non-Blackfoot, Honorary Blackfoot Chief. Blackfoot Gallery Team Member, and former Curator and Director of Indigenous Studies at Glenbow.

14. Crane Bear, Clifford Interview 8 Oct 2008. Siksika. Blackfoot Crossing Exhibit Team Member and Glenbow Blackfoot Gallery Team Member.

15. Crazybull, Sandra Interview 23 Sept 2008. Kainai. Glenbow Interpreter and Native Liaison.

16. CrowChief, Michelle Interview 2 Sept 2008. Siksika. Exhibit Team Member and Assistant Curator at Blackfoot Crossing.

17. Crowshoe, Quinton Interview 25 July 2006. Piikani. Site Marketing/ Program Coordinator at Head-Smashed-In.

18. Crowshoe, Reg Interview 19 Aug 2008. Piikani Chief 2007–2011.

19. Day Rider, Rosie Interview 25 Nov 2008. Kainai Elder. Glenbow Blackfoot Gallery Team Member. Head-Smashed-In Consultant.

20. Devine, Heather Interview 12 September 2014. Special Services Program, Provincial Museum of Alberta (1991–1993). Now Associate Professor of History, University of Calgary.

21. First Rider, Blair Interview 24 July 2006. Kainai Elder. Former Senior Interpreter and On-Site Archaeologist at Head-Smashed-In.

22. Good Striker, Lorraine Interview 25 July 2006. Kainai Elder. Former Head of Interpretation at Head-Smashed-In.

23. Goodfellow, Ron Interview 18 Nov 2008. Goodfellow Architect for Blackfoot Crossing.

24. Healy, Harold Interview July 2009. Kainai Elder. Former President and Board Member of Buffalo Nations Luxton Museum.

25. Heavy Head, Pam Interview 18 Sept 2008. Elder and member of Kainai. Co-created Glenbow's *Situation Rez: Kainai Students Take Action with Art* (December 1, 2007 to December 2008).

26. Houle, Terrance Interview 22 Aug 2008. Kainai Artist. Contributed to Glenbow's *Tracing History: Presenting the Unpresentable* (February 16—June 22, 2008).

27. Janes, Robert (Bob) Interview 14 Oct 2008. Non-Blackfoot. Former President and CEO of Glenbow 1989–2000.

28. Kerr, Irene Interview 20 Aug 2008. Non-Blackfoot. Glenbow Black-foot Gallery Team Member. Exhibit Team Member and Exhibit Designer at Blackfoot Crossing.
29. Kiitokii, Trevor Interviews 25 July 2006 and 16 Sept 2008. Piikani. Former Revenue Generating Officer at Head-Smashed-In.
30. Knowlton, Stan Interview 16 Sept 2008. Piikani. Head of Interpretation and On-Site Archaeologist at Head-Smashed-In.
31. Many Guns, Linda Interview 2 Dec 2008. Siksika. Blackfoot Crossing Consultant.
32. Martin, James (Jim) Interview 26 July 2006 and 24 Sept 2008. Non-Blackfoot. Former Education Specialist and In-House Film Project Manager at Head-Smashed-In. Current Manager.
33. Pard, Allan Interview 12 Nov 2008. Piikani Elder. Glenbow Black-foot Gallery Team Member.
34. Pietrobono, Darren Interview 16 Oct 2008. Siksika. Vice-President of Finance and Administration Blackfoot Crossing.
35. Potts, Jerry Interview 10 Oct 2008. Piikani Elder. Glenbow Blackfoot Gallery Team Member.
36. Provost, Angie Interview 2006. Piikani. Former Interpretive Guide at Head-Smashed-In.
37. Robinson, Mike Interview 2 Oct 2008. Non-Blackfoot. President and CEO of Glenbow 2000–2007.
38. Royal, Jack Interview 19 Sept 2007 and 25 Aug 2008a. Siksika. Exhibit Team Member and Director of Blackfoot Crossing.
39. Royal, Judy Interview 27 Nov 2008b. Siksika. Exhibit Team Member Blackfoot Crossing.
40. Scalplock, Irvine Interview 5 Sept 2008. Siksika. Exhibit Team Member and Curator at Blackfoot Crossing.
41. Site Manager Interview 24 July 2006. Non-Blackfoot. Former Head-Smashed-In Site Manager.
42. Sitting Eagle, Colleen Interview 4 Sept 2008. Siksika. Exhibit Team Member and Archives Director at Blackfoot Crossing.
43. Sitting Eagle, Gerald Interview 5 Sept 2008. Siksika. Exhibit Team Member Blackfoot Crossing.
44. Sitting Eagle, Laura Interview 16 Oct 2008. Siksika. Interpreter at Blackfoot Crossing.
45. Spalding, Jeff Interview 28 Oct 2008. Non-Blackfoot. Glenbow CEO December 2007–January 2009.
46. Standing Alone, Pete Interview 19 Nov 2008. Kainai Elder. Glenbow Blackfoot Gallery Team Member.
47. Starlight, Anthony (Tony) Interview 17 Oct 2008. Tsuu T'ina Elder. Buffalo Nations Luxton Museum Director.
48. Weasel Head, Frank Interview 13 Nov 2008. Kainai Elder. Glenbow Blackfoot Gallery Team Member.
49. Weasel Head, Sylvia Interview 13 Nov 2008. Kainai Elder.

50. Wesley, Jackson Interview 21 Oct 2008. Nakoda. Buffalo Nations Luxton Museum Gift Shop and Admissions Staff Member.
51. Wolfleg, Adrian Interview 8 Sept 2008. Siksika. Glenbow *Nitsitapiisinni* Gallery Interpreter and Schools Programmer.
52. Wright, Beverly (Bev) Interview 4 Sept 2008. Cree. Exhibit Team Member and Vice-President of Programming and Development at Blackfoot Crossing.

Index

Page numbers in *italics* refer to illustrations.